RENOIR

HIS LIFE AND WORKS IN 500 IMAGES

RENOIR

HIS LIFE AND WORKS IN 500 IMAGES

A STUDY OF THE ARTIST, HIS LIFE AND CONTEXT, WITH 500 IMAGES,
AND A GALLERY SHOWING 300 OF HIS MOST ICONIC PAINTINGS

SUSIE HODGE

LORENZ BOOKS

This edition is published by Lorenz Books,
an imprint of Anness Publishing Ltd,
108 Great Russell Street, London WC1B 3NA;
info@anness.com

www.lorenzbooks.com; www.annesspublishing.com;
twitter: @Anness_Books

Anness Publishing has a new picture agency outlet
for images for publishing, promotions or advertising.
Please visit our website www.practicalpictures.com
for more information.

© Anness Publishing Ltd 2016

Publisher: Joanna Lorenz
Project Editor: Anne Hildyard
Designer: Sarah Rock
Production Controller: Stephanie Moe

PUBLISHER'S NOTE
Although the information in this book is believed to
be accurate and true at the time of going to press,
neither the author nor the publisher can accept any
legal responsibility or liability for any errors or
omissions that may have been made.

Page 1: *A Girl Crocheting*, Renoir c.1875.

Page 2: *The Road to Essoyes*, Renoir 1901.

Page 3: *A Garden in Montmartre*, Renoir c.1890s.

Page 4: *Maternity or Child with a Biscuit*, Renoir 1887.

Page 5, top left: *La Coiffure*, Renoir 1888.

Page 5, top middle: *Vase of Flowers*, Renoir c.1884.

Page 5, top right: *The Spanish Guitar Player*,
Renoir 1894.

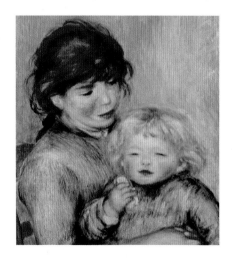

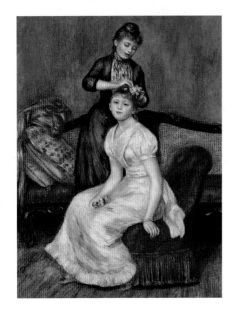
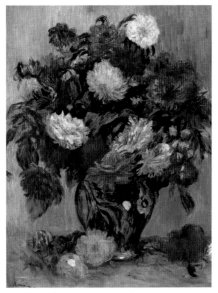
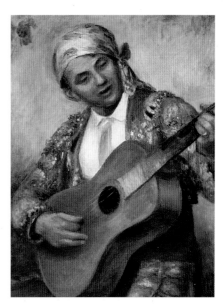

CONTENTS

INTRODUCTION

The career of Pierre-Auguste Renoir, one of the leaders of Impressionism, spanned 60 years.
Despite changing his style many times, he never digressed from his aims of creating images that
celebrate beauty and happiness, and he remains one of the most popular artists of all time.

With the exception of Picasso, Renoir is probably the most prolific artist in history. Over the course of his long career, he produced approximately 6,000 oil paintings, as well as pastels, drawings and sculptures. All his works depict a world without problems or uncertainties, full of carefree radiance, luminous colour and light. Many convey an impression of being painted spontaneously and effortlessly. Loved for the sensuous beauty he portrayed, his vivid colours and the exuberance of his subjects, Renoir has also been criticized for his apparent lack of depth and substance. His critics complain of

the sentimentality and idealistic nature of his art, while his admirers love the elegance and *joie de vivre* he portrayed. He remains a significant figure in the history of art, among the foremost Impressionists, and one of the most accessible and enduring artists of the 19th and early 20th centuries.

CLASSICAL AFFINITIES

Renoir's classical leanings distinguish him from most of the other Impressionists, yet he also embraced the modern world. People were more important to him than landscapes, which contrasts with Monet, while his subjectivity diverges from Degas' objective observations. The novelist Émile Zola (1840–1902) wrote of Renoir: 'Renoir is above all a painter of people. The dominant feature of his work lies in his range of tones and the way in which they are combined

in a wonderful harmony. You feel that you are seeing Rubens illuminated by the fiery sun of Velázquez.'

THE SECOND EMPIRE

Born into a lower-middle-class family, Renoir grew up in France when it was one of the leading world powers. As a result of the 1848 Revolution when Renoir was seven, the Second Empire was established, led by Napoleon III and run by the bourgeoisie. It was a time of exceptional economic growth and commercial prosperity, witnessing some of the most important inventions in the 19th century, including photography, the electric motor and the steam-powered locomotive. Although Napoleon III had little interest in the arts, during that time, writers, artists, musicians and philosophers gathered in Paris to discuss their new ideas, and to try to introduce society to innovative sights,

Below: This photo of Renoir was taken in 1885, when he was 44 years old. It shows a tall, elegant and slightly built man, who was by then a successful artist.

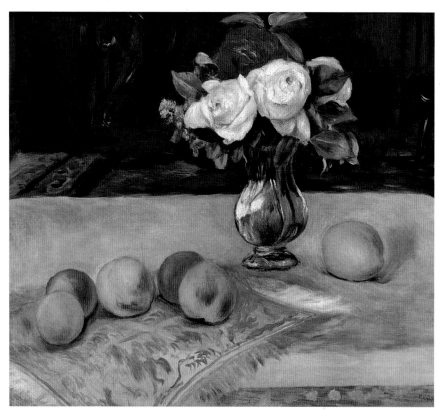

Right: Still Life, *1880. Throughout his career, Renoir painted still lifes, particularly flowers. 'I just let my brain rest when I paint flowers', he said.*

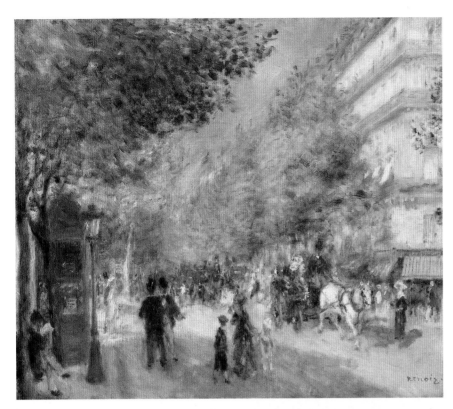

Left: In 1875, Renoir painted The Grand Boulevards, *which illustrates Paris as he saw it: sophisticated, stylish and spacious.*

Below: Always aiming for naturalness, in Portrait of Mademoiselle Georgette Charpentier, *1876, Renoir depicted the daughter of his patron as relaxed and happy.*

of his career. He was never as fascinated with changing weather conditions and the effects of light as were other Impressionists such as Monet, Pissarro and Sisley, nor was he as concerned with stylistic experimentation as much as Pissarro. However, although his work seems to be the most easily appreciated of the group of artists, the more he is studied, the less straightforward and more contradictory his art appears to be.

sounds and experiences. This was difficult as there remained a fundamental nostalgia for the past, especially for the 17th and 18th centuries. Nevertheless, in 1852, Georges-Eugène Haussmann was hired by Napoleon III to modernize Paris and create safer streets, better housing and more sanitary communities. The extensive rebuilding programme transformed the entire city, which added to the feeling of optimism that had followed the revolutions.

THE IMPRESSIONIST

This was the world in which Renoir grew up, and after an artisan apprenticeship, he emerged as a skilful artist and one of the most significant members of the unconventional group that became celebrated as the Impressionists. Although his work underwent several developments and changes, and his endeavours and beliefs were often far from the others' aims, his participation in the evolution of Impressionism is undeniable.

For several years, his close association with Monet established the characteristics of the movement, even though he went on to produce independent work for the main part

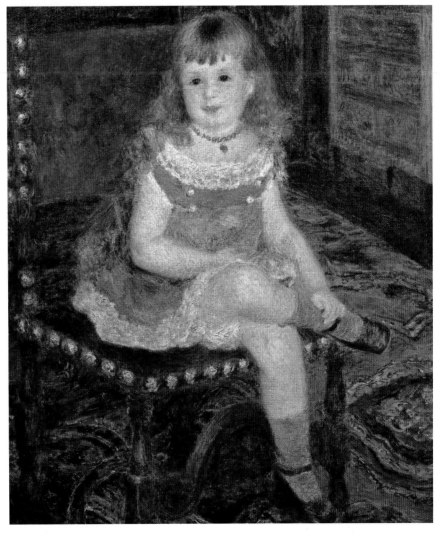

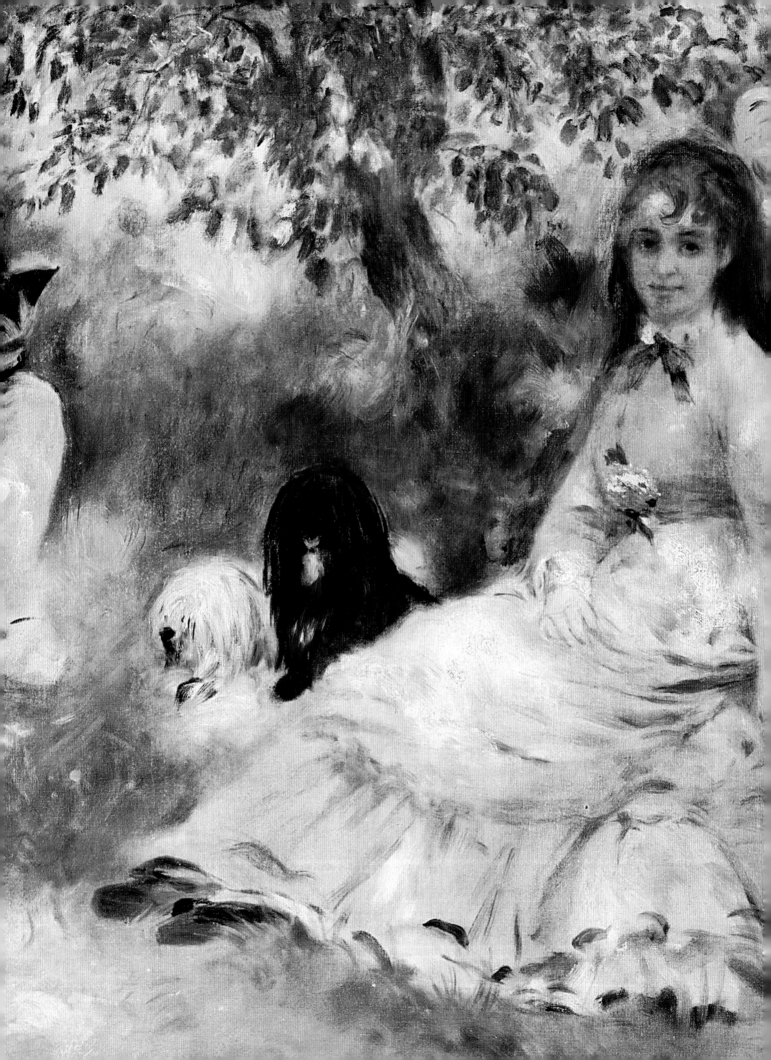

RENOIR, PAINTER OF BEAUTY

To contemporary eyes, Renoir's paintings are celebrations of beauty. But for the first 15 years of his career, his work was ridiculed and scorned by the official art academies. They expected art to conform to refined conventions concerning light, shadow, perspective, imperceptible brush marks and close attention to detail. A photographic likeness was the main objective, and themes such as commemorations of historical or mythological moments, or powerful portraits were esteemed. At first, his style was fairly formal and realistic, but with the encouragement of Monet, Renoir soon began to work in a looser, more exuberant style, often painting out of doors in front of his subject.

Left: The Henriot Family, c.1871. While his friends were chiefly attracted by landscape, Renoir preferred group studies and portraits such as this image of 19th-century Parisian society.

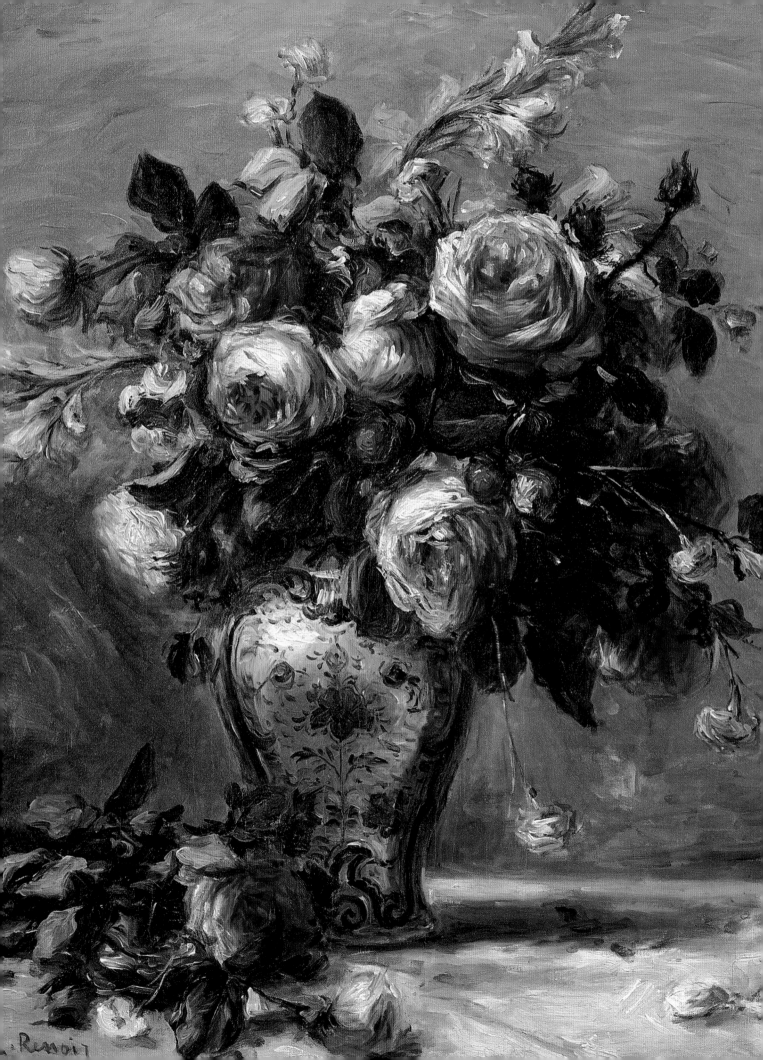

A NEW STYLE

From the start, Renoir had the skills of a great artist. He could work in different styles, was a natural colourist and handled paint masterfully. His early training at a porcelain painting factory helped, but there is no disputing his precocious talents. When he entered the studio of Charles Gleyre in 1861, he joined a highly respected artistic institution that had been established by the Neoclassicist Jacques-Louis David. Gleyre provided academic discipline without stifling originality, which was perfect for Renoir's development.

Above: After years of experimentation, Renoir returned to a more Impressionistic style, as seen here in The Painter's Garden, *c.1908.*
Left: The clear and luminous brushwork in Vase of Roses *of 1870–72 can be interpreted as Renoir's way of trying to invoke order into his life after the tragic and disruptive events of the Franco-Prussian War and the Commune.*

FAMILY LIFE

When Renoir was born, on 25 February 1841, the liberal constitutional monarchy headed by King Louis-Philippe had ruled France for nearly 11 years. But the regime was inept, and within seven years France had changed irrevocably. In 1848, after revolutions in Europe, Louis-Philippe was swept off his throne.

During the 1848 Revolution, Louis-Napoléon, the nephew of Napoleon I, was elected by popular vote to be president of the Second Republic. Consequently, he named himself Napoleon III and ruled France as a dictator, although in some aspects, an unexpectedly enlightened one. Once in control, he supported universal

Below: This 1849 print shows a working tailor. Unlike Renoir's father Leonard, he seems to have a more thriving business.

suffrage; expansion of the railway system; improvements of ports, canals and education; recognition of trade unions; and the renovation of Paris, as well as several military ventures. His beautiful wife Eugénie encouraged the arts, encompassing fashion, literature, painting, architecture, opera and ballet.

PARIS
Renoir grew up at this time of transition and saw huge changes in the appearance, culture and atmosphere of Paris.

Left: Paris was being elegantly redesigned as Renoir grew up, as illustrated by this scene in Saint-Germain, drawn by Thomas Allom in 1845.

Born in Limoges, a city about 500km (300 miles) south-west of Paris, known chiefly for its porcelain, he was the fifth of seven children, although the first two died in infancy long before he was born. At the time of his birth, his elder brother Pierre-Henri was eleven, his sister Marie-Élisa was seven and Léonard-Victor was five. Three years later, another brother, Edmond, was born.

Their father Léonard was a tailor and their mother Marguerite a seamstress. By the time Renoir was four years old, financial difficulties led the family to move to Paris in an attempt to earn more money in the capital.

THE YEAR OF REVOLUTIONS

After a series of economic crises and crop failures in the mid- to late 1840s, thousands of French and other European peasants and the working urban poor were starving. Changes in technology and industry had radically altered the lives of the working classes anyway and unrest bubbled under the surface. Reformers and politicians were starting to try to reshape national governments when, in 1848, a series of uprisings broke out, starting in France and spreading rapidly across Europe. Most of these were quickly suppressed, but even so, tens of thousands of people were tortured and killed in the process and the repercussions of the revolutions in many countries were extensive.

Left: Attack of a Barricade on the Bridge of the Archevêché *(23 June 1848), Philippe-Marie Chaperon. The seven-year-old Renoir heard and saw much of the rioting of the 1848 Revolution.*

The Renoirs moved to the Louvre area, initially to the rue de Bibliothèque, which was destroyed for the rebuilding of the rue de Rivoli, and then to a small apartment at 23 rue d'Argenteuil. Léonard continued to work as a tailor from this cramped home, using his bed as a tailor's bench by day. Yet, despite the difficulties and hardships he endured, Renoir recalled a happy childhood and, from their central location in Paris, the family saw many of the riots of the 1848 Revolution.

A FUTURE CAREER

Renoir attended a local state school, Les Frères des Écoles Chrétiennes, where it was discovered that he had an excellent singing voice. At the age of nine, he joined a choir at the Église St-Eustache where he was given voice lessons by the master and future composer Charles-François Gounod. Gounod tried to persuade Renoir's parents to let him follow a career in singing and found him a possible place in the chorus of the Paris Opera, but by the age of 13, Renoir showed a preference for drawing. In any case, the family's financial situation, which had not improved much in Paris, precluded paying for a musical career.

Like many children, Renoir filled his school exercise books with drawings. These were not especially skilful, but his elder brother Pierre-Henri, who was an engraver of heraldry, encouraged him to draw more, and in 1850 his sister took him to the Louvre for the first time.

Below: At the time the Renoirs lived in Paris, hot-air balloons were a frequent sight. This lithograph by A. Provost shows one ascending from the National Arena in January 1845.

PORCELAIN PAINTER

In contrast with many other great artists, Renoir's parents encouraged rather than opposed his artistic aptitude. By training as an artisan, he would be sure of earning a regular wage. Thus, in 1854, at the age of 13, he was apprenticed as a porcelain painter at a Parisian factory.

During his apprenticeship with the Lévy brothers in the rue des Fossés-du-Temple, Renoir spent his time copying pictures. His earliest known assignments were pencil copies of birds, flowers and musical instruments. Next, he moved on to paint plates, cups, teapots, bowls and vases. By the time he was 15, he was a fully fledged porcelain painter, earning money from his craft. Single-mindedly, he applied himself to his occupation and became so skilful that his fellow workers nicknamed him 'Monsieur Rubens'. He was soon given the task of painting Marie-Antoinette's profile on to delicate white cups, for which he earned eight sous a piece. Always concerned with the development of his artistic skills, he continued his studies at the end of the day, by taking drawing lessons with the sculptor Callouette, who was the director of the École Gratuite de Dessin (free drawing school). His brother Edmond recalled: 'When the day was over, equipped with a portfolio bigger than himself, he would go to attend free courses in drawing…there happened to be a nice old gentleman whose passion was to do oil painting at home: perhaps happy to have a pupil, he offered to share with the youngster, his supply of canvases and paints.'

VISITING THE LOUVRE

During his lunch breaks, Renoir often visited the Louvre to study paintings by artists such as Watteau, Fragonard, Boucher and Delacroix, which he loved for their sense of happiness (or in the case of Delacroix, drama) and the light and colour with which they were imbued. One of his favourite works, however, was not a painting, but a 16th-century structure, *The Fountain of the Innocents,* which was embellished profusely with carved reliefs by the Renaissance sculptor Jean Goujon (*c.*1510–1572). Many of Renoir's later paintings resemble some of Goujon's graceful figures from this work.

EFFECTS OF THE INDUSTRIAL REVOLUTION

The Industrial Revolution affected many workers at that time. Mechanization threatened Léonard Renoir's tailoring business, and after four years at Lévy brothers, Renoir's job came to an end when a machine for printing pictures on china took the place of hand-painting. These early experiences of the negative effects of technological developments on skilful workers shaped Renoir's attitude for the rest of his life.

Left: The Porcelain Collector, *Alfred Stevens, 1868. Painted porcelain was extremely fashionable during the 19th century.*

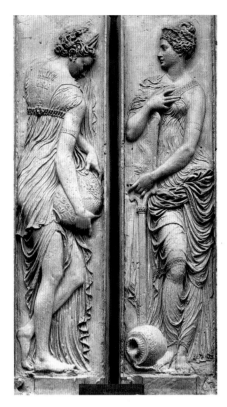

Above: Fountain of the Innocents, *Jean Goujon, 1547–50. Renoir was extremely enthusiastic about these figures from Goujon's Renaissance relief.*

Above: In Roses in a Sèvres Vase, *c.1895, Renoir depicted the porcelain that he had originally intended to paint on.*

He was nostalgic for a lost culture in which craftspeople took pride in their work before the machine-age arrived and changed their lifestyle forever.

Nevertheless, Renoir continued working at similar jobs, painting fans and church banners for overseas missionaries and then, for a short time, painting murals on café walls. On 24 January 1860, when he was 19, he registered for a year's pass to copy paintings at the Louvre, to learn from the masters how to paint and draw.

When the Louvre first opened as a museum in 1793, showing former royal collections, its objective was to enable the artists of the future to learn from celebrated artists of the past.

Right: Jardin des Plantes, Paris, *Auguste Bry, 1860, lithograph. The modernization of Paris reflected society's new-found confidence and optimism.*

'Each visitor should be able to put his easel in front of any painting or statue to draw, paint or model as he likes,' declared an early official. But copying became so popular with artists and students that officials began issuing permission forms and limiting the hours that the authorized copyists could spend there. By the mid-19th century, requests from artists to become copyists were increasing as clients ordered reproductions of famous masterpieces. Museum visitors would see an artist copying a particular work and order their own versions then and there. For artists, this way of earning was a big attraction – and, for a struggling student, the Louvre was warm and dry.

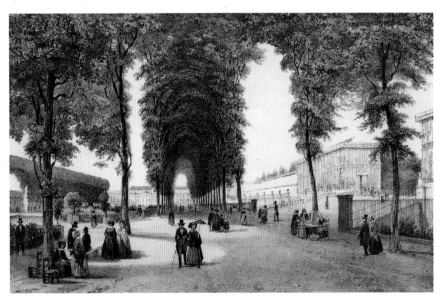

STUDYING ART

From January 1860 to April 1864, Renoir continued as a copyist in the Louvre. During that time, he earned money painting fans, blinds, banners and café walls, and in 1861 he had saved enough to pay to study art academically. He enrolled in the private studio of a Swiss painter, Charles Gleyre.

The most popular method for artistic training in Paris during the 19th century was to study with an established artist in his *atelier* or studio – similar to the master-apprentice workshops of the Renaissance. Most of these artists insisted that their students copied works by the great masters in the Louvre. By the 1860s, Paris had more art schools than any other city, and Renoir chose Gleyre's.

Below: Art students crowded into the most popular studios in Paris. Gleyre's was one of the few that used life models.

GLEYRE'S STUDIO
In 1843, Gleyre had taken over the studio of the artist Paul Delaroche, which had also belonged to Jacques-Louis David and Antoine-Jean Gros. Gleyre was popular with students for the unconventional way he ran the studio. For a start, his fees were low (just 10 francs a month to cover the

Right: Floral still lifes were inexpensive to produce and sold readily. As he told a friend: 'When I paint flowers, I feel free to try out tones and values and worry less about destroying the canvas'.

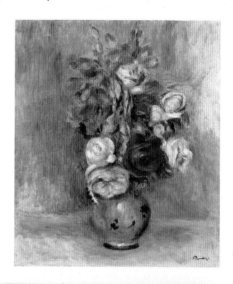

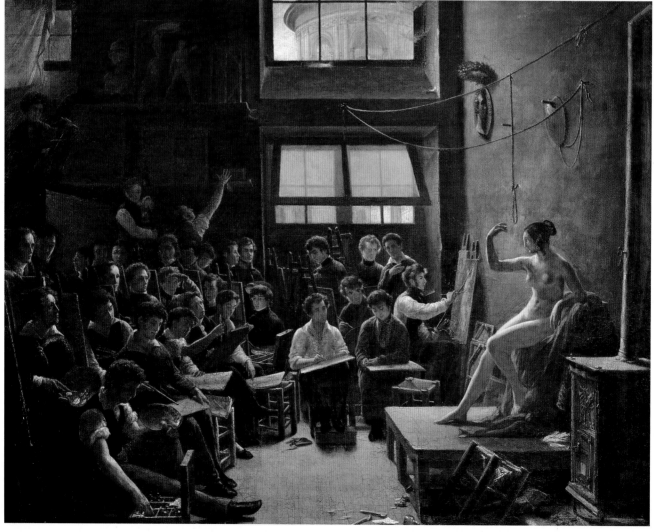

THE ÉCOLE DES BEAUX-ARTS

In 1648 the Académie des Beaux-Arts in Paris was founded in order to educate talented students in drawing, painting, sculpture, engraving and architecture. Over two centuries later, in 1863, Napoleon III made the school independent from the government, changing its name to the École des Beaux-Arts and dividing it into two academies, which were the Academy of Painting and Sculpture and the Academy of Architecture. Even when independent, however, tuition in both academies trained students to follow the classical styles of ancient Greece and Rome.

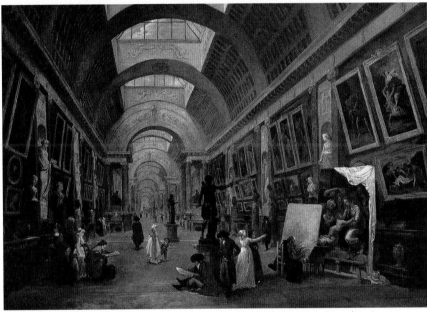

Top: The Departure of the Apostles, *Charles Gleyre, 1845. Gleyre's work was admired from early in his career.*

Above: Great Gallery in the Louvre, *Robert Hubert, oil on canvas, c.1796. As an art student, Renoir spent part of most days in the Louvre.*

cost of rent, models and materials, but not teaching fees), he was fairly easy-going and, unlike other contemporary art tutors, he was tolerant of modern ideas about painting and he emphasized the importance of originality. His students drew and painted regularly from life models, not from plaster casts of ancient Greek and Roman statues, which was common at the time. They also copied from drawings, engravings and paintings by Old Masters, either in the Louvre or from reproductions, and they were encouraged to paint landscape studies.

Students of all ages and abilities attended Gleyre's studio. Every day except Sundays, from eight till twelve and for two hours in the afternoon except on Saturdays, about 30 or 40 students drew and painted from the nude model. Male and female models alternated each week. Renoir's approach and ideas about colour conflicted with Gleyre's and they often clashed, but as late as 1890, Renoir described himself as 'a student of Gleyre,' indicating the respect he felt for his former tutor.

Perhaps even more significant to his development as an artist, however, were the friendships he made while studying there. Within a year of each other, three other men also joined Gleyre's studio. They were Alfred Sisley (1839–99), Claude Monet (1840–1926) and Frédéric Bazille (1841–70). Despite their varied backgrounds, the four became friends. Monet introduced them to Camille Pissarro (1830–1903), Paul Cézanne (1839–1906) and Edgar Degas (1834–1917), who became part of their circle, and formed the core of the group later known as the 'Impressionists'.

A THOROUGH EDUCATION

Early in 1862, Renoir took the entrance exam to the Académie des Beaux-Arts. Out of 80 hopefuls, he came 68th and began attending classes there. Two weeks later, he came 5th out of 27 in a drawing examination and in seven competitions, his results varied from 10th out of 10, to 10th out of 106. He was eager to learn and industrious, but he was also in favour of new ideas. When he used a strong red, his teacher Émile Signol warned: "Be careful not to become another Delacroix!" To Renoir, however, this was a compliment, and thus an approach to be practised.

THE SALON DES REFUSÉS

The focal point of the Paris art world was the Salon. This annual exhibition was held originally for final-year students of the Académie des Beaux-Arts. By the end of the 18th century it was open to everyone, and it was the only way for artists to have their work displayed to a wide public.

Called 'The Exhibition of Living Artists', the Salon was the most esteemed artistic competition in Europe, attracting over 20,000 visitors a day. Sponsored by the government since 1673, it reflected the conservative tastes of the Académie des Beaux-Arts, then the École des Beaux-Arts, and it could establish or ruin an artist's reputation.

Applications were overwhelming, so a selection procedure was set up. A jury chose the works to be shown, decided where they would be hung and awarded prizes and medals. Despite adjustments in the process,

Below: The Birth of Venus, *Alexandre Cabanel, 1863. This picture of a modest goddess was in the style of painting favoured by Parisian art officials.*

the jury system caused resentment and in 1863, when fewer than half of around 5,000 works submitted were accepted, the rejected artists understandably were furious. Rejected paintings were stamped on the back with a red 'R', which was humiliating for the artists and deterred potential buyers. In 1863, the rejected artists complained bitterly and their grievances reached the emperor.

OUTRAGE

Wanting the public to realize that the jury was right and to calm the rebuffed artists, Napoléon III held another exhibition. Everyone whose work had been declined was invited to exhibit, and two weeks after the official Salon opened, about 1,000 works were

ACADEMIC REALISM
The favoured style of art selected by the Salon jury was known as Academic Realism. This style of painting featured precise, almost photographic detail, meticulous *chiaroscuro*, invisible brush marks, smooth paint and literary, historical or mythological subjects, as well as nudes and portraits. Although Renoir said that he 'ground away at academic painting' and 'studied the classics', his painting was not considered academic enough.

displayed in another part of the same building in the Salon des Refusés. Thousands of visitors attended, mainly

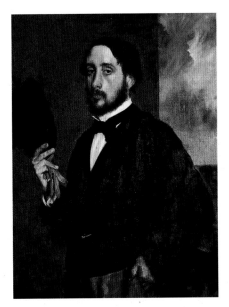

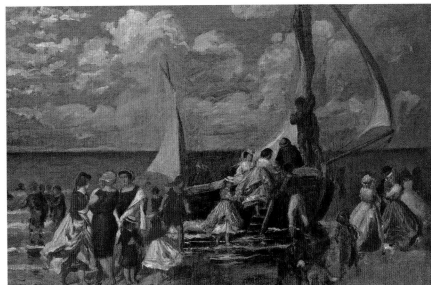

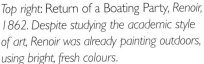

Top right: Return of a Boating Party, *Renoir, 1862. Despite studying the academic style of art, Renoir was already painting outdoors, using bright, fresh colours.*

Top: Self-portrait, *Degas, 1863. Degas became friends with the growing band of artists who had similar ideas about modernizing art.*

to laugh at the work, but some became aware that the jury of the government-sponsored Salon selected only a particular style of art and that talented artists with different ideas were being treated unfairly. Among those exhibiting at the Salon des Refusés were James McNeill Whistler (1834-1903), who was a former pupil of Gleyre's, Paul Cézanne, Édouard Manet (1830–83) and Pissarro. Whistler's *The White Girl* was one of the most admired works in the exhibition, while Manet's *Le Déjeuner sur l'Herbe*, a sketchy, brightly painted canvas featuring one semi-clad and one naked woman picnicking with two fully dressed men, was considered the most outrageous. Although nudes were common in paintings, this nude was not named after an ancient goddess, and neither was she suitably coy, instead staring boldly out of the painting at the viewer. The juxtaposition of classical forms with modern dress and nudity, painted with coarse brushstrokes, was deemed shocking. The Salon des Refusés may have been degrading for most of the participants,

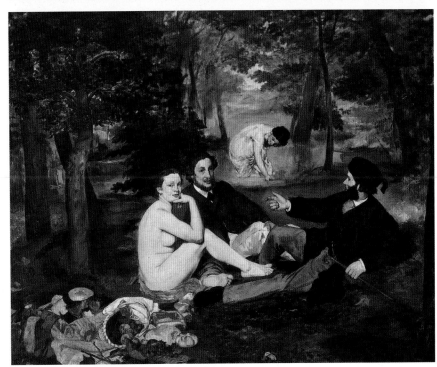

but it revealed the growing unrest within the French art community. It was repeated in 1864 and 1873, and it forced changes in the rules of the Salon. Younger artists who had not necessarily been trained at the École des Beaux-Arts received greater recognition, but it took a long time for new styles to be accepted over traditional Academic Realism.

THE AVANT-GARDE
In contrast with the majority of visitors to the Salon des Refusés, Renoir and several other young artists and art critics were amazed and impressed by

Above: Le Déjeuner sur l'Herbe, *Manet, 1862, caused a scandal at the Salon des Refusés – and inspired radical changes in painting.*

Manet's original attempts to modernize painting. Delacroix died in the summer of 1863, leaving the avant-garde without their leading light. From then on, Manet was perceived by many of the forward-thinking artists as the leader of the avant-garde art world. His fresh approach to painting inspired new ideas and theories, and many now believed that art needed to change.

PAINTING *EN PLEIN AIR*

Although Renoir joined his friends in wanting to modernize art, he still aimed to be accepted by the official Salon. The year after the Salon des Refusés, he submitted a painting illustrating a scene from Victor Hugo's novel *Notre-Dame de Paris*, which was accepted but virtually ignored.

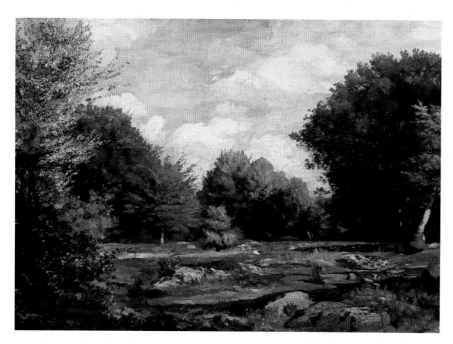

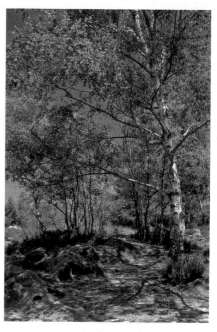

Above: Renoir's Clearing in the Woods *of 1865 was painted in the Forest of Fontainebleau and shows the clear influence of the Realism of the Barbizon painters.*

Above: This photograph shows the picturesque Forest of Fontainebleau, a favourite spot for many painters in the 19th century.

After Manet's 1863 sensation at the Salon des Refusés, some of the artists and writers who had admired his work began meeting near to where he was living: the working-class and bohemian Paris area of the Batignolles. They began gathering regularly at the Café Guerbois in the avenue de Clichy. Along with Manet himself, the group included Renoir, Monet, Degas, Pissarro, Cézanne, Sisley, Bazille, Zola, Charles Baudelaire (1821–67) and Henri Fantin-Latour (1836–1904).

Manet had met Degas copying in the Louvre in 1862, and Monet had introduced Renoir and the others from Gleyre's to 33-year-old Pissarro and 24-year-old Cézanne, whom he had met at the Académie Suisse. Cézanne introduced his childhood friend Zola, and the group of young artists and writers grew. With their passionate views about art, and the

Right: Le Pave de Chailly in the Forest of Fontainebleau, *Monet, 1865. Monet was captivated by the challenge of representing weather effects on canvas.*

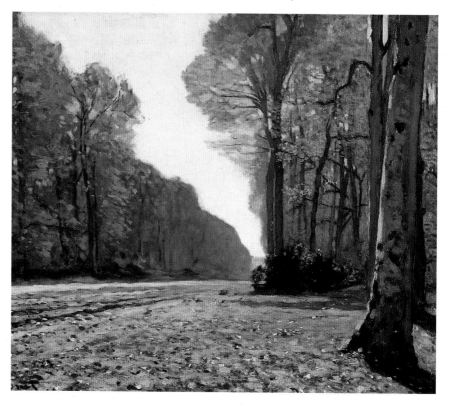

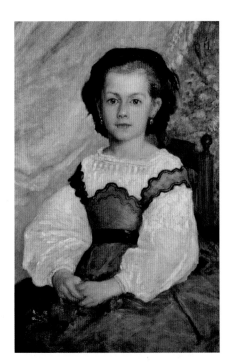

Above: Little Miss Romaine Lacaux, *Renoir, 1864. This was one of Renoir's first commissioned portraits.*

THE BARBIZON SCHOOL

Renoir and his friends were following a tradition that was started by the English landscape artists, particularly John Constable (1776–1837) and J.M.W. Turner (1775–1851). They painted landscapes as finished paintings, rather than as backgrounds to other themes, and during the 1848 Revolution, some French artists followed their ideas. Focusing on realism, they painted in the village of Barbizon near the Forest of Fontainebleau, making nature the subject of their paintings. The Barbizon painters included Jean-Baptiste-Camille Corot (1796–1875), Théodore Rousseau (1712–78), Jean-François Millet (1814–75), Charles-François Daubigny (1817–78), Jules Dupré (1811–89), Constant Troyon (1810–65) and Narcisse-Virgile Diaz de la Peña (1807–76). Several of these artists were still working in the area when Renoir and his friends began painting there.

direction it should be going in, lively and often heated debates ensued, but Renoir rarely spoke. Although he was friendly and interested, he did not regard himself as an academic, and he preferred to listen to the views of others rather than voice his opinions.

THE FOREST OF FONTAINEBLEAU

That spring, Monet organized a group of artists to go to Chailly-en-Bière, a village in the Forest of Fontainebleau not far from Paris, to paint the landscape. It was fairly common practice at the time for art students to go to the Forest of Fontainebleau, where they could paint, sketch and visit the local inns. Most used their paintings of the natural surroundings as preliminary studies for backgrounds, but Renoir and his friends were focused on painting *en plein air* – which meant completing an entire painting in the open air directly from nature, rather than using it just as a sketch.

At first, Renoir was not taken with the idea of painting outdoors, but he went along with his more enthusiastic friends.

STUDIO CLOSURE

Early in 1864, his eyesight failing and in financial difficulties, Gleyre closed his studio. Renoir, Monet, Sisley and Bazille

continued to support each other and Renoir began assimilating all he had learned so far, from Gleyre's advice, to the technique *au premier coup* (at first), which he had learned when brushing Rococo style decorations on to fans and delicate white porcelain. His unique style of fluency, colour and classical application soon began to emerge.

MILITARY TRAINING

Because he could not pay for a substitute, in 1862 and 1864, Renoir underwent two sessions of compulsory military service, for two months each time. Conscription of French national citizens was devised during the Revolution of 1798 to ensure that the Republic could defend itself from European monarchies. Defence of the Republic was the responsibility of all citizens, and so every unmarried, able-bodied man between 18 and 25 was called up to train, in case a national army became necessary at some point in the future.

Below: In 1862 and 1864, as a French citizen, Renoir completed two periods of compulsory military service, each lasting for two months. This contemporary painting shows men being trained for the French army.

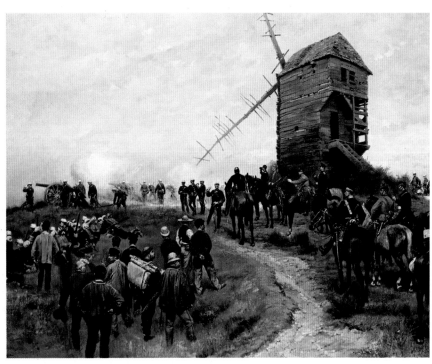

INFLUENCES

In April 1864, a few weeks after he finished his military service, Renoir came 10th out of over 100 candidates in a sculpture and drawing examination at the École des Beaux-Arts. A month later, his work *La Esmeralda* was accepted for the Salon.

Considering the furore of the preceding year, the 1864 Salon jury was slightly more broad-minded and rejected fewer works. This made the second Salon des Refusés seem rather dull after the sensations of the first. Although he was delighted to have been accepted for the official Salon, Renoir's jubilation soon descended into disappointment when his work was virtually ignored in the exhibition. He subsequently destroyed the painting and left the École des Beaux-Arts.

FRIENDSHIPS

Renoir's friend Bazille had been studying medicine, and only attended Gleyre's studio in his spare time, but in the spring of 1864, he failed his medical exams and returned to Paris to study painting full time. Coming from a wealthy background, Bazille was financially secure and extremely generous, and he often helped Renoir and Monet, who struggled to make ends meet. In 1865 he shared a studio with Monet, and the following year he shared his studio with Renoir, paying the rent and the bulk of the bills. Along with the Café Guerbois, Bazille's studio, also in the Batignolles quarter, became an additional meeting place for the avant-garde artists.

ROMANTICISM AND REALISM

Two of Renoir's favourite contemporary artists were Eugène Delacroix and Gustave Courbet, and in different ways, they both represented a break with traditionally accepted art, or Classicism. Classicism comprised set ideas of representation, and required certain standards of beauty. Delacroix, as a Romanticist, believed in greater freedom and spontaneity, and in his exotic, imaginative works, he represented untamed nature and emotion. In contrast, Courbet had agitated the art world in 1848 with his realistic paintings that depicted simple, objective everyday scenes. The Realists aimed for truth and accuracy and showed the artist's view of the world and art's place within it.

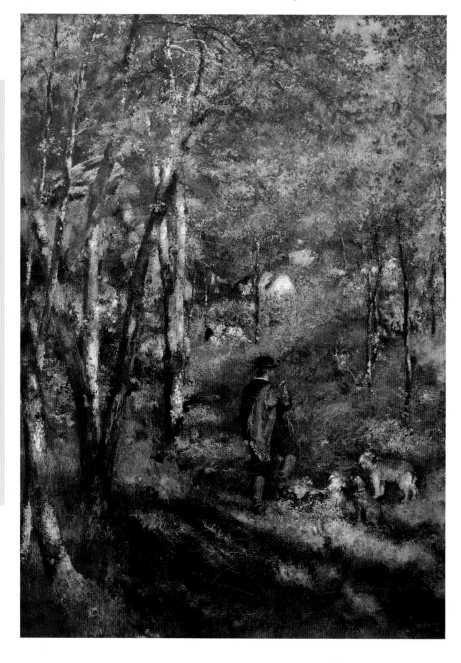

Right: Jules Le Coeur in the Forest of Fontainebleau, *Renoir, 1866. Using palette knives, Renoir created a lively depiction of his friend, the painter Jules Le Coeur, with his dogs in the forest. Le Coeur owned a property there, at Marlotte.*

Another artist friend who had started by pursuing another career was Jules Le Coeur (1832–82). After training as an architect, he had decided to become a painter, and he often invited Renoir to stay at his parental home in Marlotte on the southern edge of the Forest of Fontainebleau. The Le Coeurs were a wealthy Parisian family and were impressed with Renoir's talent. The entire family befriended him. From early on, they commissioned him to paint portraits, still lifes and even some internal decorations for a house.

In 1865, Léonard Renoir was suffering badly with arthritis and was forced to give up his tailoring business. He and Renoir's mother, Marguerite, moved to Ville-d'Avray, a suburb of Paris. Renoir stayed with them regularly, but more often, he stayed with various artist friends in their Parisian studios.

ADVICE AND INSPIRATION
Despite his love of colour, many of Renoir's early paintings featured bitumen, a brownish-black substance,

Below: The Jean de Paris Heights, *Diaz de la Peña, 1867. One of the Barbizon School, Diaz de la Peña was particularly influential on Renoir.*

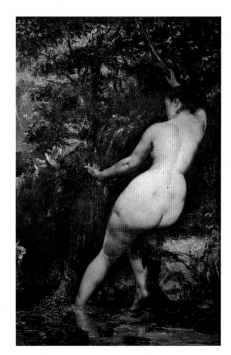

Above: La Source (The Spring), *Courbet, 1868. After Courbet unexpectedly placed his figure in a natural background, Renoir frequently did the same.*

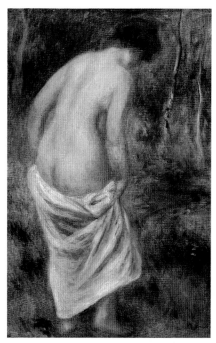

Above: Standing Nude in a Landscape, *Renoir, c.1910–2. Throughout his life, Renoir never tired of painting nudes in natural landscapes.*

which was used quite commonly by oil painters of the time to create deep shadows. While painting at the Forest of Fontainebleau, Renoir met several of the Barbizon painters who had been painting there for years, including

Gustave Courbet (1819–77), whom he admired greatly. He became particularly friendly with Diaz de la Peña, who had also started his career painting in a porcelain factory and was a skilled colourist. Cheerful and kindly despite a tragic background, de la Peña advised Renoir on his painting techniques and particularly against the use of black. Becoming aware of Renoir's insecure financial circumstances, he also made his own paint-dealer's charge account available to his young friend, thus discreetly providing him with necessary art materials for a while. From that time, Renoir stopped using bitumen and began to paint with brighter colours.

Openly admitting his admiration of numerous diverse artists, Renoir frequently demonstrated the effect that different artists had on his paintings, including some of the ideas and methods of painters such as Jean-Auguste-Dominique Ingres (1780–1867), Jean-Baptiste-Camille Corot, Gustave Courbet, Eugène Delacroix (1798–1863), Diaz de la Peña and Charles-François Daubigny.

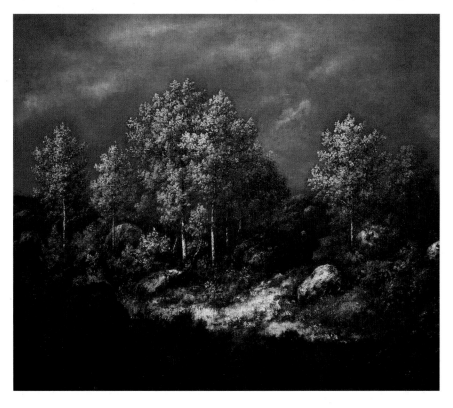

MATERIAL HARDSHIP

A landscape and a portrait by Renoir were accepted for the 1865 Salon, but once again, his work received no critical acclaim. That year, scandal surrounded another painting by Manet of a reclining prostitute, *Olympia*, and Monet's two accepted works received journalistic attention.

It is not surprising that Renoir still failed to attract any notice from the Press. Unlike Manet, Monet, Cézanne and some of the other young artists, his style was quite conservative. For several years following the closure of Gleyre's studio, he painted with two distinct approaches. Commissions and works intended for the Salon were smooth, realistic and detailed, almost Classical in manner, while works he painted for himself and for friends were generally loose, sketchy and colourful, heralding the Impressionist style of the 1870s.

FINANCIAL SUPPORT

Renoir was one of the poorest of the group of artist friends. Unlike many of the others, he did not receive any allowances from his family and had to rely on his own resources to support himself. When the Salon acceptances did not enhance his reputation, he continued to strive for commissions, but the few he received did not provide enough for him to live on. He began asking friends and acquaintances who valued his work to help him. Many welcomed him into their homes, put him up in their studios, gave him money for food, paints and canvases and commissioned paintings from him. He was a sociable and even-tempered guest, with a large circle of friends, and most believed that they were assisting an artistic genius who would soon be recognized.

LANDSCAPE PAINTING

Renoir's works that had been accepted for the Salon of 1865 were a portrait of Sisley's father and a landscape, painted on an outing with Sisley. The two young men were similar in temperament, and from 1865 until Sisley's marriage the following year, Renoir often stayed with his family in Porte Maillot, Paris. The two artists also

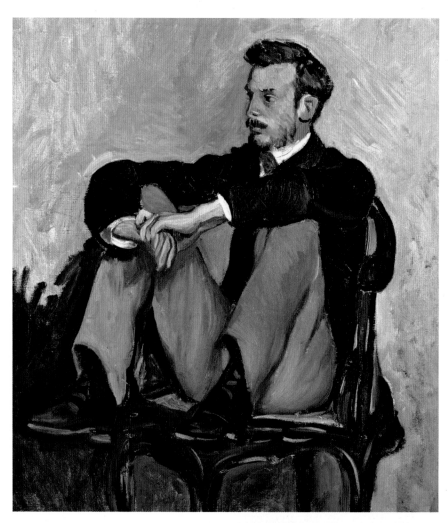

Above: While sharing a studio, Renoir and Bazille painted each other. For this portrait by his friend in 1867, Renoir sat with his legs characteristically drawn up.

Right: Lane Near a Small Town, *1864–65 is one of Sisley's earliest known works, probably painted alongside Renoir and more sombre than his later style.*

travelled around northern France to paint and enjoy the sights along the way. In the summer of 1865, they travelled along the River Seine in a sailing boat to Le Havre to see the regattas. From their boat, they painted the river and its banks.

In 1866, Renoir submitted two landscapes to the Salon. Anxious for the decision, he waited for members of the jury to emerge from their judging. Corot and Daubigny appeared first. Too shy to admit he was asking about his own work, Renoir pretended he was

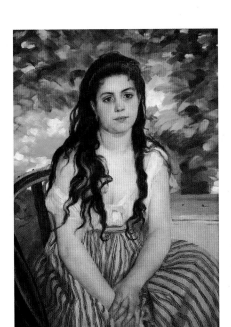

Above: Summer (Study), *Renoir, 1868. Also known as* Lise *or* The Gypsy Girl, *this was one of Renoir's many portrayals of Lise Tréhot and was exhibited at the 1869 Salon.*

Right: Boy with a Cat, *1868. One of Renoir's rare male nudes, this was painted with cool colour harmonies and more detail than the sketchier works he was painting with Monet at the time.*

asking about a friend. Daubigny replied: "We're very sorry about your friend, but his painting was rejected. We did all we could…we asked for that painting to be reconsidered ten times…there were six of us in favour against all the others. Tell your friend not to be discouraged, there are great qualities in his painting. He should get up a petition for an exhibition of rejected paintings." This was a bitter-sweet result: the great Barbizon artists had liked his work, but others had rejected it. Nonetheless, the sketchier landscape of his two submissions was accepted, but Renoir withdrew it and vowed never again to submit a landscape to the Salon. From the studio he shared with Bazille, he and his colleagues signed a petition asking for another Salon des Refusés, but the government rebuffed the suggestion. The artists discussed holding their own independent exhibition, but without sufficient funds, their plans did not materialize.

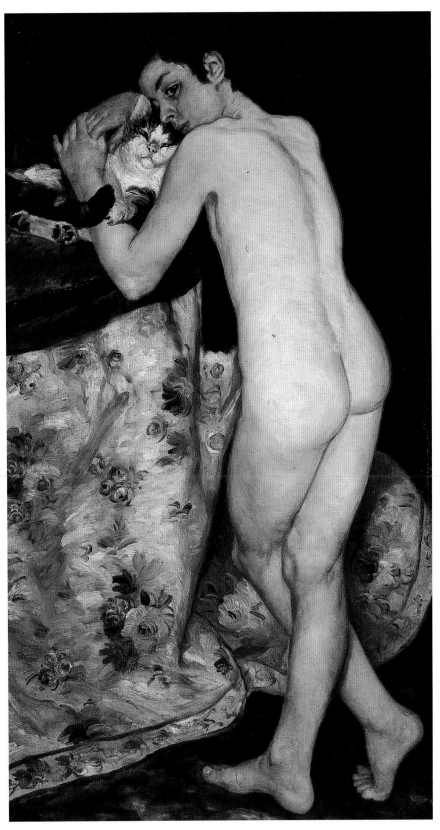

LISE TRÉHOT

At the end of 1865, Le Coeur introduced Renoir to the sister of his mistress, 17-year-old Lise Tréhot. With her dark features and voluptuous figure, Renoir was attracted to Lise, and she became his model and mistress. Between 1865 and 1872, he painted her more than 20 times. In 1867, he painted her as Diana, goddess of the hunt, showing his training and his admiration of Courbet's realism, but the work was rejected from that year's Salon.

LA GRENOUILLÈRE

After Sisley's marriage in 1866, Renoir worked with Bazille, sharing his Parisian studio. Bazille wrote to his father in 1867: 'I'm putting up one of my friends; a former student of Gleyre's who hasn't got a studio at the moment. Renoir – that's his name – works very hard.'

In 1868, Bazille and Renoir moved to a new studio closer to the Café Guerbois. That year, the Salon accepted his full-length portrait of Lise in a white dress from 1867. It attracted attention for its freshness and bold brushwork.

INTERIORS
In March 1868, through the architect Charles Le Coeur (the brother of Jules), Renoir was commissioned to decorate Prince Georges Bibesco's house in Paris. He painted two ceilings in the style of Tiepolo and Fragonard, and produced a wall decoration for the café in the Cirque d'Hiver, an enclosed circus built in 1852, but the café went bankrupt, and Renoir kept the painting.

Sisley took a studio in the same building as Bazille and Renoir, and that November, Manet asked Monet, Renoir and others who met at the Café Guerbois to form an alliance that they would call the Batignolles Group. Despite financial problems, Renoir felt optimistic, but Monet was suffering.

MONET
With a mistress and baby son, Monet's father had stopped his allowance and in a desperate plea for help, he wrote to

Below: Barges on the Seine, *Renoir, c.1869. The study of water played an important role in the development of Renoir's early style.*

Below: Renoir's paintbox has been lovingly preserved, in recognition of his importance. He often had difficulty finding the money for materials.

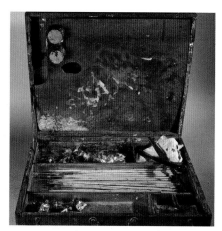

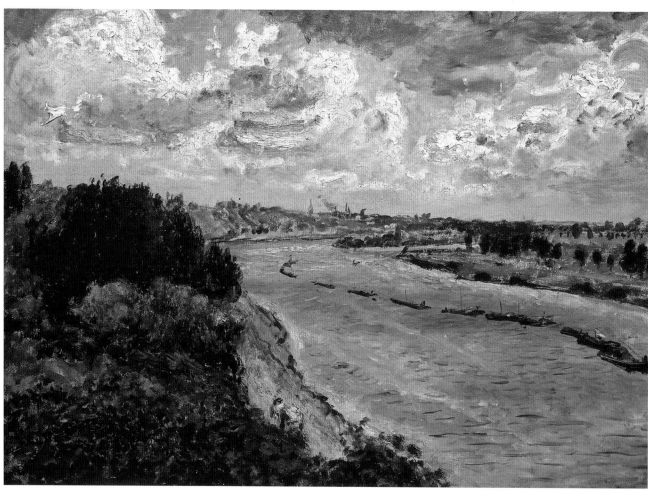

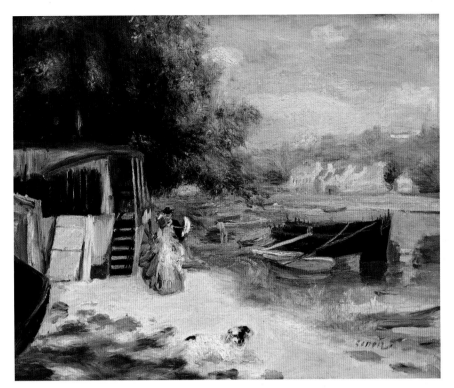

Left: La Grenouillère, Renoir, c.1869.
*The bond between Renoir and Monet,
forged at La Grenouillère, lasted years.*

both men were often downhearted, but at the end of his life, Renoir recalled: 'I never had a fighter's temperament and I would have given up many times over had not my good friend Monet, who had it himself – a fighter's temperament – bucked me up.'

In 1869, Renoir and Monet went painting often. Renoir wrote to Bazille: 'We don't eat every day, yet I am happy in spite of it.' They went to La Grenouillère (the Frog Pond – frog was a slang word for young women), on the River Seine at Croissy, to the west of Paris. The two artists produced several paintings there, each capturing a casual moment of daily life in small, visible brushstrokes, vivid colours and shimmering light on to canvases that they had prepared with pale coloured paint rather than duller coloured surfaces. With their reflections, coloured shadows, sketchiness and juxtaposed complementary colours, these paintings are a foretaste of Impressionism.

Below: La Grenouillère, Renoir, 1869.
Using rapid strokes, dots, flicks and dashes of paint, Renoir captured the atmosphere of this popular resort.

Bazille from his new home in Bougival, implying that he had tried to drown himself. Bazille sent him paints, but was not able to help him financially at that time, so Renoir, who was in dire straits himself, took him bread, and accompanied him on painting trips in the surrounding countryside. In 1869, with another painting of Lise accepted for the Salon and again virtually ignored, Renoir moved into his parents' new

home in Louveciennes, a small town to the west of Paris, close to Monet. The bond of friendship between Renoir and Monet grew stronger. When Monet grew despondent, Renoir cheered him up, and when Renoir considered giving up, Monet gave him courage. Renoir wrote to Bazille: 'Monet is a good companion,' but he added 'I'm doing almost nothing because I haven't much paint.' In their straitened circumstances,

THE FRANCO-PRUSSIAN WAR

In 1870, Monet married his mistress, and Renoir stayed with Bazille in Paris. Renoir had two works in that year's Salon, but normal life ended abruptly following France's declaration of war against Prussia. Renoir was conscripted and, although he knew nothing about horses, was posted near Bordeaux with the 10th Cavalry Division, far away from the fighting. Bazille enlisted in the 1st Zouave Regiment, Monet moved to London and Manet endured the Siege of Paris. Within months, Renoir contracted dysentery, and Bazille was killed in action.

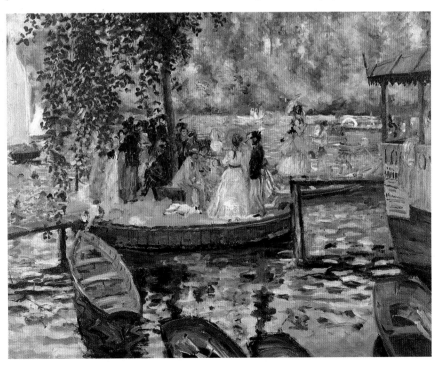

AFTER THE WAR

In four months in the army, Renoir never saw any fighting. He fell gravely ill with dysentery and suffered a complete nervous collapse. By France's defeat in January 1871, he had rejoined his regiment. He returned to Paris in late spring, then left to stay with his parents in Louveciennes.

After Paris surrendered, a French National Assembly was elected to negotiate peace with the Prussians. First, though, it raised taxes and stopped paying the National Guards. Hundreds of angry civilians rebelled and organized their own government, which they called the Commune of Paris. Unconcerned, Renoir continued painting on the banks of the River Seine. He was attacked by Commune members who thought he was a spy, but was rescued by their leader.

RESUMING WORK

In June, Renoir returned to the city. Shocked and sorrowful after learning of Bazille's death, he soon left to visit friends in Bougival and Marlotte. The Le Coeurs once again helped him find commissions and, with his earnings, he rented his first studio near the Louvre. The Batignolles

Below: The Boat Studio on the Seine, *Monet, 1875. Monet and Renoir worked together on studio boats.*

Group were now reunited, and slowly they started to resume their pre-war enthusiasm.

PAUL DURAND-RUEL

While in London during the Franco-Prussian War, Monet had met the art dealer Paul Durand-Ruel (1831–1922). Art dealing was a relatively new career in the 19th century. Rather than commission work as traditional patrons did, dealers bought work from artists and sold it on, earning a percentage. Most opened small galleries where customers could view artwork for sale. Durand-Ruel had two galleries, in Paris and London, and as soon as he returned to Paris, Monet introduced him to Renoir. Durand-Ruel immediately bought two of Renoir's paintings: a flower still life for 400 francs and a view of the Pont des Arts, Paris,

Below right: Bather with her Griffon, *1870. Inspired by Courbet, this painting of Lise by Renoir was exhibited at the 1870 Salon.*

RENOIR'S METHOD

Renoir, Monet, Pissarro and Sisley discussed the avant-garde style they were developing. Many of their paintings did not make sense when seen from close up, but from a distance, details became clear. Renoir developed a looser style, but it was never as uninhibited as the others, because of his fascination with flesh, features, clothing and textures. He started each painting with small dabs of thinned colour all over the canvas, to give him an idea of colour relationships. Next, he blended them together, creating a soft shadowy image, then he began to define and build up each area, increasing the proportion of oil to turpentine as he worked. Although he also used some new ideas about composition, he never completely abandoned Classical arrangements, always maintaining harmony and balance.

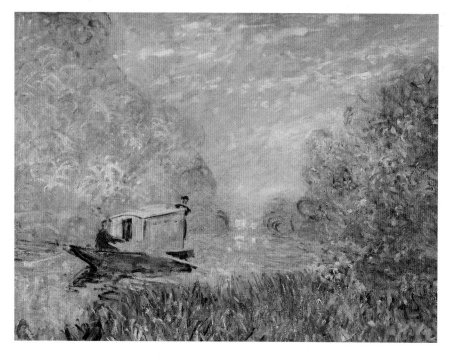

for 200 francs. Both works are modern in their approaches, and the cityscape, in particular, shows the influence of photography, with the sense that the image continues beyond the edges of the canvas.

HOMAGE TO DELACROIX

In 1872, Renoir submitted a large canvas to the Salon, painted specifically with the jury in mind. Called *The Harem* or *Parisian Women Dressed as Algerians*, it depicts an exotic brothel in Paris and was painted in homage to Eugène Delacroix's *Women of Algiers* of 1834, a painting that was to be a source of inspiration to many painters, such as Jean-Baptiste-Camille Corot (1796–1875) and Pablo Picasso (1881–1973). However, the post-war

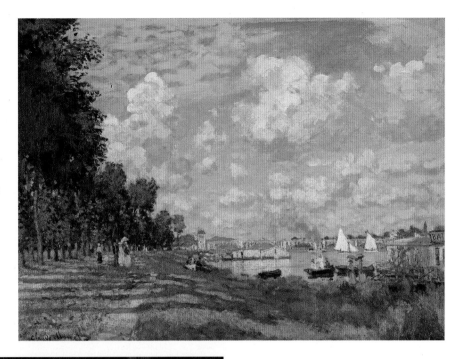

Above: Le Bassin d'Argenteuil, *Monet, 1872. In 1872, Renoir stayed with Monet in Argenteuil, where they painted together once again.*

jury was particularly conservative, and since the work was not in the Academic Realist style, it was rejected. Renoir signed another petition for a Salon des Refusés, but again the government ignored it. That year's Salon submission was one of the last occasions that Lise sat for Renoir. He only painted her portrait once more, presenting it to her as a gift, and in the spring of 1872 she married an architect. Although she kept the paintings Renoir had given her, she destroyed all of their correspondence, and she never saw him again.

After their seven-year relationship, Renoir does not seem to have been broken-hearted, but spent the summer with Monet and his family, painting tranquil works in and around their new home in Argenteuil, a town to the north-west of Paris built on the River Seine. In a boat moored nearby, Renoir and Monet worked side by side just as they had before the Franco-Prussian War.

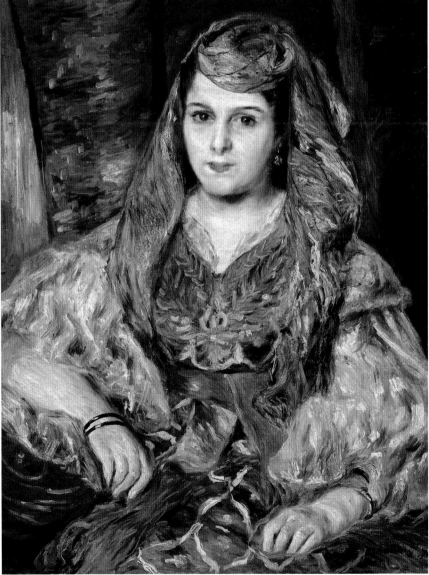

Left: Madame Clementine Stora in Algerian Dress, *or* Algerian Woman, *1870.*

THE INDEPENDENTS

Thanks to Durand-Ruel's purchases, Renoir gained some independence. Durand-Ruel also held several exhibitions of the group's paintings in his galleries and more buyers began to show interest. Most critics were derogatory, but two journalists – Castagnary and Burty – wrote about Renoir favourably.

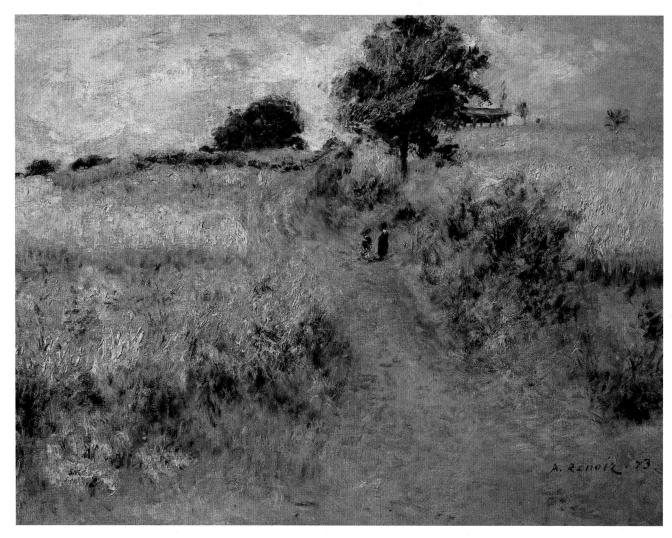

Durand-Ruel was not as interested in Renoir's work as he was in the other avant-garde artists, but he bought some of his paintings, and Renoir was also beginning to attract other collectors, including Henri Rouart, an engineer and amateur painter, and Théodore Duret, journalist, author and art critic, who became his friend and one of his greatest supporters.

Through this slightly better financial position, in the autumn of 1873, Renoir moved to a large studio at 35 rue St Georges in Montmartre. He occupied the top floor and his brother Edmond took an apartment on the floor below.

The two men were very close. Edmond wrote articles promoting his brother's art and often posed for him. The following spring, two works that Renoir had painted specifically for the Salon were rejected. They were displayed instead in the third and final Exposition Artistique des Oeuvres Refusés that the government had decided to hold that year. Not considered as scandalous as the first Salon des Refusés of a decade earlier, visitors did not jeer and Renoir's works were quite positively received. But he was convinced that the Salon jury was excluding him

Above: The Watering Place, *Renoir, 1873. In Argenteuil, Renoir painted several landscapes alongside Monet, using small brushstrokes and bright colours.*

deliberately, which made him even more disposed toward the idea of an independent exhibition.

WITH MONET AGAIN
During the summer and autumn, Renoir went to stay with Monet in Argenteuil again. Once more, they painted in the open air, often side by side, and avidly discussed their ideas and opinions about painting as they worked.

Right: The Reapers, *Renoir, 1873.*
At the end of the summer, Renoir used
new ideas about composition, but
continued to make figures his main focus.

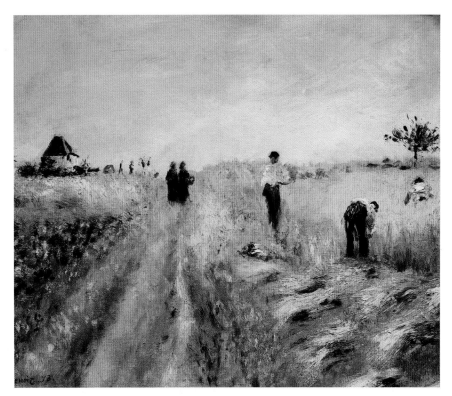

Renoir consciously painted the fall of light on objects as Monet did, and they both regularly used small, comma-like brush marks and painted complementary colours in shadows, rather than the greys that most painters used. In June, they met Gustave Caillebotte (1848–94), a young man from a wealthy family that had made its fortune in the textile industry, then in property because Baron Haussmann was rebuilding Paris. That year, Caillebotte inherited his father's fortune, rendering him financially independent for the rest of his life. An engineer by profession, he was also a former student of the École des Beaux-Arts, and shared many of Monet's and Renoir's views on art.

Since the Commune, many of the painter's friends had left Paris, and that summer several of them also visited Monet. They included Pissarro, Sisley and Manet, and during the summer, strolling or painting on the banks of the Seine, they discussed their antipathy for the narrow-minded official art world of Paris. They became more firmly bound together, and determined not to let the establishment override them any longer.

INDUSTRIAL CRISIS

Immediately after the Franco-Prussian War and the Commune, France experienced an economic boom, but in 1873 an international economic crash and depression occurred. Durand-Ruel found himself in severe financial difficulties and was forced to reduce the payments he had been making to Renoir, Monet and the others for their paintings. The withdrawal of his support, and the continual refusal of Salon judges to accept the works of Renoir and the others, spurred decisive action.

THE ANONYMOUS SOCIETY

At the end of 1873 a group of artists, including all of the future Impressionists, met in Renoir's studio to sanction the foundation of an independent association of artists. They called themselves the Société Anonyme des Artistes, Peintres, Sculpteurs et Graveurs and planned to promote their own innovative styles of art, mainly through independent exhibitions, and so evade the constraints of the Salon, while providing artists with opportunities to show their work freely to the buying public. At that meeting and at further discussions in the Café de la Nouvelle-Athènes, which replaced the Café Guerbois as their meeting place, they planned to hold their first exhibition.

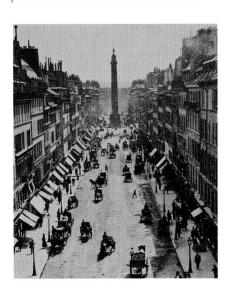

Below: Paris, rue de la Paix and Place Vendôme, c.1873. *Despite long sojourns with friends and family, Renoir was pleased to return to his studio in Paris.*

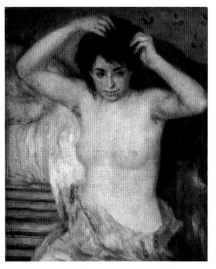

Below: Torso, c.1873–75. *No longer assimilating others' styles, this soft rendition of the female form shows Renoir's own style emerging strongly.*

THE BIRTH OF IMPRESSIONISM

The first exhibition of the Société Anonyme des Artistes, Peintres, Sculpteurs et Graveurs was held in a photographer's studio in April 1874. Although by then most of the artists were used to their work being criticized, no one had anticipated the scathing hostility that many of them received.

Thirty-three artists assembled for the exhibition that aimed to free them from the insularity of the Salon. Manet abstained, but most of the Batignolles group exhibited, including Renoir, Monet, Sisley, Pissarro, Cézanne, Degas, Armand Guillaumin (1841–1927) and Berthe Morisot (1841–95). The bulk of the exhibitors, however, were not connected with them, but had joined the Société Anonyme des Artistes, which was open to anyone prepared to pay 60 francs a year. The photographer Nadar (1820–1910) lent them his studio, at 35 boulevard des Capucines. A flight of stairs led from the street to a series of large rooms on two floors.

CATALOGUE AND COMMITTEE

Renoir's brother Edmond edited the exhibition catalogue, which caused him a few problems. Degas did not bring his work until the last minute and Monet was rather repetitive in naming his. Monet later recalled an incident over one of his paintings of Le Havre, featuring

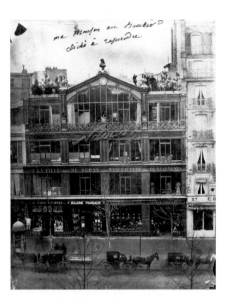

Right: A contemporary photograph of Nadar's studio at 35 boulevard des Capucines, where the first Impressionist exhibition was held.

Below: Impression, Sunrise, *1872–3 was the painting by Monet that triggered the name 'Impressionism'.*

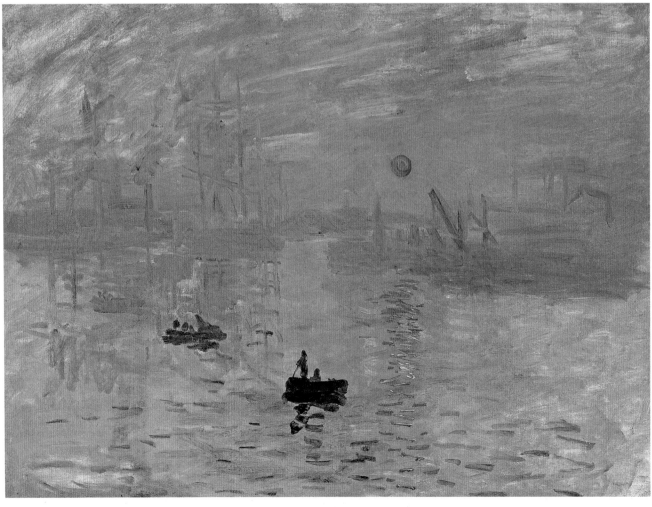

THE FIRST EXHIBITION

At 10 a.m. on the morning of 15 April 1874, the exhibition opened for a month, timed deliberately to draw attention away from the Salon. It stayed open until 10 p.m., with just two hours' closure between 6 and 8 p.m. Like the Salon des Refusés of 1863, it was fairly well-attended, but again, most visitors turned up to laugh. Critics were rather contemptuous of the Batignolles artists' work, mainly about their lack of precision and their 'ordinary' subject-matter. Ten days after the opening, the satirist Louis Leroy published a scornful article in the journal *Le Charivari*, called 'Exhibition of the Impressionists,' based on the title of Monet's Le Havre painting. Another critic wrote: '…The famous Salon des Refusés, which one cannot recall without laughing…was a Louvre compared to the exhibition on the boulevard des Capucines.' While prominent critics did not actually review the exhibition, some friends of the painters wrote favourable articles. When the exhibition closed on 15 May, 3,500 people had visited – compared to the 400,000 who went to the Salon. Commercially, the exhibition was a failure as the artists did not make enough to cover their outlay, but historically, it brought them into the public eye.

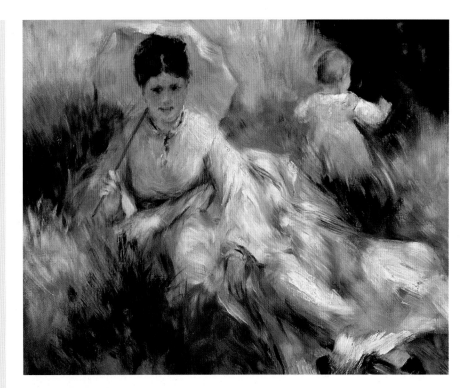

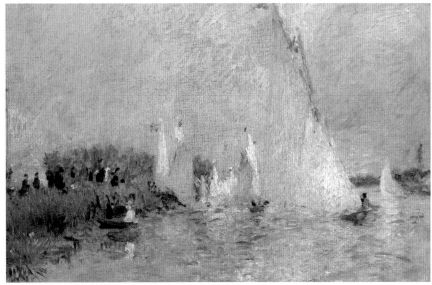

a hazy sun reflecting on the sea. "I was asked to give a title for the catalogue; I couldn't very well call it a view of Le Havre, so I said, put Impression." In the catalogue, Edmond Renoir titled the work *Impression: Sunrise*.

Renoir was the chair of the hanging committee, but the others left him to arrange the show practically alone. The 165 works for the exhibition varied so much that Renoir struggled to hang them with some kind of consistency. He arranged works according to size and in order of artists' names, in no more than two rows deep.

Top: Woman with a Small Child on a Sunlit Hillside, *1874. With the dappling sunlight on the figures, this was in Renoir's most intense Impressionist phase.*

PAINTINGS PRAISED

Renoir displayed six canvases and one pastel, and many praised his paintings. His only negative criticism came from Leroy, about his painting *The Dancer*, who said her legs were 'as cottony as the gauze of her skirts.' Renoir sold only one painting for 180 francs, but to his relief managed to sell another after the exhibition had closed.

Above: Regatta at Argenteuil, Renoir, *1874. In July, Renoir stayed with Monet again and the two artists painted together around Argenteuil.*

That summer, a misunderstanding occurred with the Le Coeur family, rumoured to have been over a note Renoir wrote to Charles Le Coeur's 16-year-old daughter. Whatever the reality, abruptly, the ten-year friendship ended. Renoir lost the family's support, as well as opportunities to stay with them and paint near their home in Fontainebleau.

MIXED FORTUNES

After the first exhibition, undeterred, Renoir and the others continued producing colourful, sketchy paintings. But despite their determination, they were no closer to achieving recognition. Renoir convinced Monet, Morisot and Sisley that they should hold an auction of their paintings.

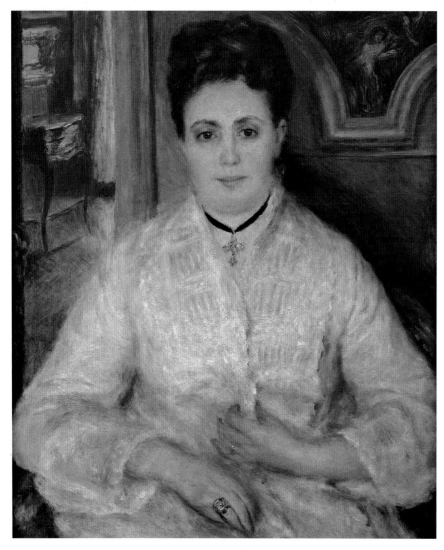

Above: Madame Chocquet, *1875. Victor Chocquet commissioned portraits of himself and his wife in front of one of his Delacroix paintings.*

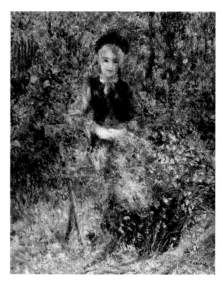

Above: Girl at the Bank, *1875. Focusing on complementary colour contrasts of blue and yellow, Renoir demonstrates his interest in Impressionist ideas.*

Renoir took the lead in organizing the auction, held in March 1875 at the Hôtel Drouot. This was a state-controlled auction house often used by artists as a saleroom and gallery. Once again, visitors turned up to scoff at their work, and the hostile crowd became violent. The police were called to break up fights and the paintings failed to reach adequate prices. Surprisingly, Renoir was the least successful of the four, with many of his works not even reaching 100 francs. To prevent them from selling too cheaply, he and his friends bought several of his own paintings back. In the end, he sold 20 works for a total of 2,000 francs, at a time when an established Salon artist could sell one painting for 200,000 francs.

DESPERATION

Renoir's financial situation went from bad to worse. He began writing to friends begging for help. In several letters to Duret, he asked for 40 francs before noon, because he needed it desperately and only had 3 francs to his name. Liked for his warmth, magnanimity, charm and optimism, he never displayed anger, moodiness or self-pity, and this amiability endeared him to his large circle of friends, making them inclined to help him. Duret, for example, lent him money, bought his paintings, invited him to balls and other social gatherings, and introduced him to further potential patrons.

NEW PATRONS

Over the year, Renoir met several new and prospective buyers. Victor Chocquet, a customs official, attended the Hôtel Drouot sale. From the start, he admired Renoir's work, and commissioned portraits of himself and his wife Caroline, featuring paintings he owned by Delacroix in the background. Renoir became good friends with Chocquet and, as usual, thought of ways he could help others. He introduced Chocquet to Julien

Right: At the Theatre, *1876. Renoir often depicted Parisians at the theatre, although it was not a conventional subject.*

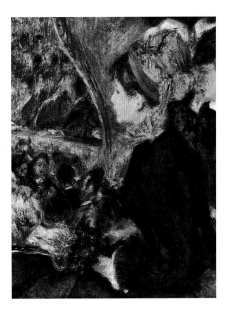

('Père') Tanguy, who sold painters' supplies, and helped the artists by taking their works in exchange for materials. In Tanguy's shop, Renoir showed Chocquet paintings by Cézanne, who was struggling against condemnation. Renoir believed Cézanne to be the greatest artist of their group, and wanted others to recognize this. In response, Chocquet began buying both Renoir's and Cézanne's works regularly.

SADNESS AND JOY
At the end of 1874, Renoir's father had died. His mother stayed with his sister and her husband at Louveciennes and Renoir visited them often. After a

Below: The Bridge at Chatou, *pastel, 1875. Using the reflections, buildings and light as sources of vibrant colour, Renoir continues in his Impressionist mode.*

period of sadness he began using a new model, Margot (Marguerite) Legrand (c.1856–79), who probably became his mistress. With her vivacious personality, their cheerfulness was compatible, and she appeared in many of his major works over the next four years.

THE CHARPENTIERS
In 1875, Georges Charpentier, a publisher of contemporary writers, including Zola, Flaubert and Maupassant, invited Renoir to his home. His wife Marguerite was a celebrated hostess, renowned for her salons and soirées, where a mixture of writers, artists, composers, statesmen, actors and singers gathered. Although the Charpentiers entertained mainly conventional artists along with the eminent politicians, literary figures and fashionable society, Renoir was welcomed and commissioned to paint for them. As friends and enthusiasts of his work, over the next few years, the Charpentiers introduced him to other patrons, and used their influence to ensure that his paintings were exhibited, giving him greater exposure and helping him to financial security..

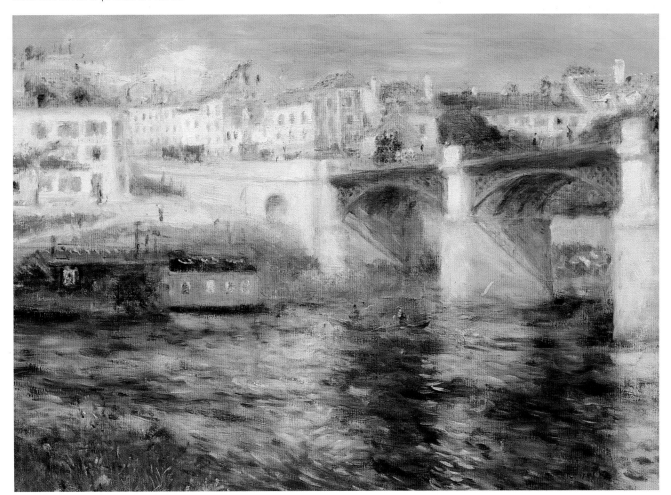

IMPRESSIONIST EXHIBITION

Chiefly through his contacts with Georges and Marguerite Charpentier, from the mid-1870s onward, Renoir built a circle of friends and acquaintances among fashionable, wealthy art lovers. The portrait commissions he gained from these contacts were virtually his sole livelihood from 1876 to 1880.

Above: Portrait of a Young Woman, *1876. Painted with soft, undulating strokes, this fine work shows some of the techniques that Renoir was using.*

The upsetting experiences of the sale at the Hôtel Drouot discouraged the group from holding another exhibition, as they had planned to do in 1875. The following year, however, they felt ready to try again. The number of participants were few, because many did not care to be ridiculed or linked with the Impressionists. The term 'Impressionism', originally used disrespectfully, was already beginning to be accepted by the

Below: At Renoir's Home, rue St Georges (The Artist's Studio, rue St Georges), *1876. Renoir has captured an informal conversation among his friends in his Montmartre studio, including Georges Rivière (central figure) and Camille Pissarro (bald, bearded man, partially hidden at the right).*

circle of artists, despite Renoir's aversion to anything that might give them the appearance of trying to establish a new and coherent 'school' of painting.

PORTRAITS

Degas suggested that they made it a rule that artists could not submit work to both the Salon and the group exhibition. As Renoir had unsuccessfully submitted work to the Salon for the previous four years, he resolutely focused on planning and organizing the second group exhibition. He invited

THE MOULIN DE LA GALETTE

In 1875, Renoir had started working on his most ambitious Impressionist genre painting. *The Moulin de la Galette* was a dance hall in Montmartre. Known for its relaxed atmosphere, young men and women went there on Sunday afternoons to dance and socialize. Renoir chose it as the setting for a large-scale painting, in which he could focus on portraying dappled sunlight passing through the trees on to dancing and chatting figures. The canvas followed Manet's precedent, *Le Déjeuner sur l'Herbe*, and Monet's work of the same name, both from the 1860s, in capturing ordinary lives in such large dimensions. As he needed to work in a studio close to the dance hall, Renoir leased a small house with a garden at 12 rue Cortot in Montmartre, from January 1875 until the summer. He made preparatory paintings, and as the final canvas was too large to move easily, his friends went to the house in rue Cortot and posed for him in the garden.

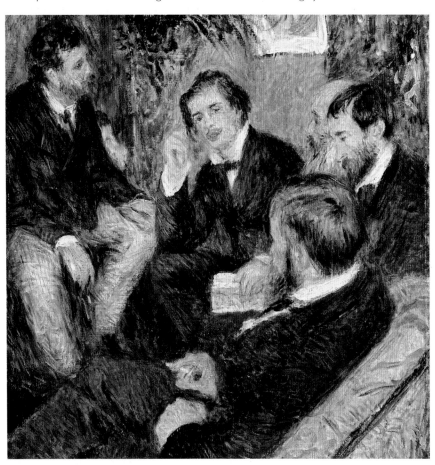

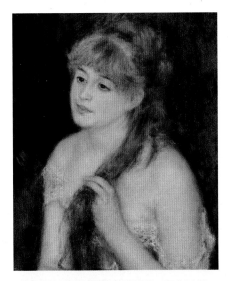

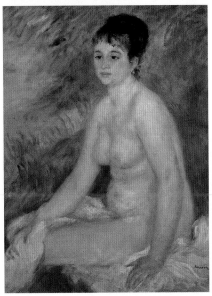

Top: Young Woman Braiding her Hair, *Renoir, 1876. This delicately modelled work, with shaded flesh tones, represents one of Renoir's ideals of femininity.*

Above left: Bather after the Bath, *1876, displays Renoir's proclivity for painting nudes* en plein air, *creating his images in veils of soft colour and small brushstrokes.*

Above: Conversation in a Rose Garden, *Renoir. This exuberant, sketchy work epitomizes Impressionism, with its fast brushwork, pure colours and generous application of paint – capturing a fleeting moment.*

other artists, including Caillebotte, to exhibit with them and he discussed the plans with Durand-Ruel, who agreed to rent them two rooms in his gallery at rue Le Peletier. Eventually, 19 artists displayed 252 paintings, with nearly 100 coming from Renoir, Monet, Degas, Pissarro, Sisley and Morisot. They also included two paintings by Bazille as a memorial to their friend. In the first exhibition, Renoir had deliberately not included any of his commissioned portraits, which constituted his main income. Two years later, he decided to exhibit the works that appealed to the majority of his buyers, hoping to

encourage further commissions. To that end, he displayed twelve portraits, three scenes of daily life and one nude. Twelve of these paintings belonged to patrons and were lent for the show.

REVIEWS
One of Caillebotte's eight exhibited paintings, *The Floor Strippers*, created a sensation at the exhibition and Renoir also received several complimentary reviews, although these were mainly written by friends. In general, the vaguely positive reviews were outnumbered by harshly critical ones. One article, written by Albert Wolff,

the art critic for *Le Figaro*, was a vitriolic attack on Renoir's painting, *Study: Torso, Effects of Sunlight*, which affected visitors' opinions detrimentally; but Chocquet visited every day, and pointed out the good qualities of all the paintings to anyone viewing them. Fewer visitors attended than two years earlier, but the artists were able to pay Durand-Ruel the 3,000 francs they owed for renting his gallery, while also recouping their own advances. So while they did not reap profits, at least they did not lose money.

THE *JOURNAL D'ART*

In January 1877, Caillebotte invited Renoir, Monet, Manet, Degas, Pissarro and Sisley to dinner to plan their third Impressionist exhibition. They were still determined to achieve public recognition. Renoir endorsed the idea of an Impressionist journal as another way of promoting their ambitions.

Once again, Renoir took the lead in planning and organizing the exhibition. He used his studio in the rue St Georges as their meeting place (he only used the rue Cortot occasionally), he and Caillebotte sent invitations to potential participants and he, Monet, Pissarro and Caillebotte formed the hanging committee.

THE THIRD EXHIBITION

From 4 to 30 April, the exhibition was held in a five-room apartment opposite Durand-Ruel's gallery. Caillebotte paid the rent on the agreement that he would be reimbursed out of the admission fees. At this time, the group was labelled Les Impressionistes, Les Indépendants or Les Intransigeants, meaning they were stubborn. No name was meant to flatter, but after a vote between the members of Société Anonyme des Artistes, they called the show, 'L'Exposition des Impressionistes'.

Eighteen artists participated. Some previous exhibitors kept away and some newcomers joined. All those we now recognize as Impressionists were there, including, for the first time, Mary Cassatt (1844–1926). In all, 241 works were displayed, each of the Impressionists contributing more paintings than before. Renoir exhibited 21 paintings, including *Ball at the Moulin de la Galette* and other images of Parisian modern life, 12 portraits and 5 landscapes. After the cutting comments by Wolff the year before, he did not show any nudes. Altogether, about 8,000 people visited, so there was no problem in compensating Caillebotte for his outlay.

L'IMPRESSIONISTE

A main focus of this exhibition, discussed by the group at Caillebotte's January dinner, was to promote their work as a collective and unified style.

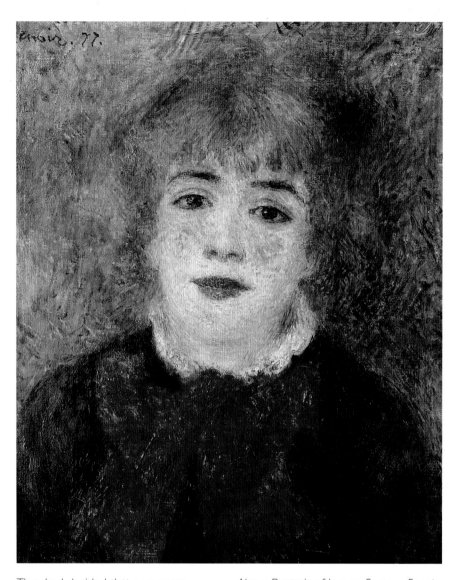

They had decided that as a group, called the Impressionists (or whatever name they might have chosen), they would be a strong force to counter their critics. This was not met with agreement by all, for instance, Degas and Cézanne, in particular, felt that their aims were at variance. Nevertheless, they all supported each other, and Renoir pushed an idea that he had wanted to carry out for some time: to publish a small journal defending the painters and responding to attacks from critics. Every Thursday for the four

Above: Portrait of Jeanne Samary, *Renoir, 1877. At the Charpentiers', Renoir met Jeanne Samary, a well-known actress from the Comédie-Française.*

weeks of the exhibition, *L'Impressioniste, Journal d'Art* was published. Renoir occasionally contributed, but his friend, 22-year-old Georges Rivière, wrote most of the articles. He explained that the artists had adopted the name 'Impressionists' to clarify the difference between their work and academic art, but his writing was a little clumsy, and

Right: Young Woman in Boat (Canoeist), *Renoir, 1877. This picture combines two of Renoir's artistic interests, a portrait and a scene of everyday life.*

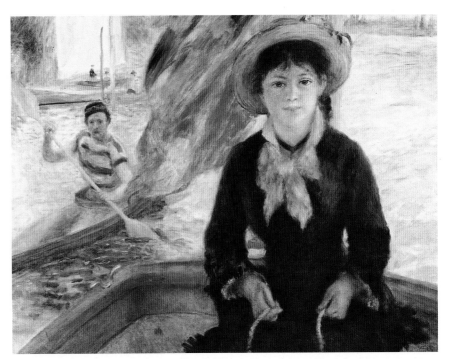

his connection with the Impressionists was too obvious for critics to take him seriously. Altogether there were about 50 reviews of the show, and both Wolff and Leroy once again showed their contempt, with Leroy commenting on Renoir's paintings: 'So many studies done at the morgue to reach such a result!' The general opinion seemed to be that many of the artists had talent, if only they would paint as 'real' artists did and not try to shock gratuitously.

Below: Jeanne Samary lived near Renior's studio; they became friends and she modelled for him.

Right: Little Girl in a Pink Feathered Hat, *Renoir, 1877. Always captivated by children, Renoir sought to convey their unaffected naturalness.*

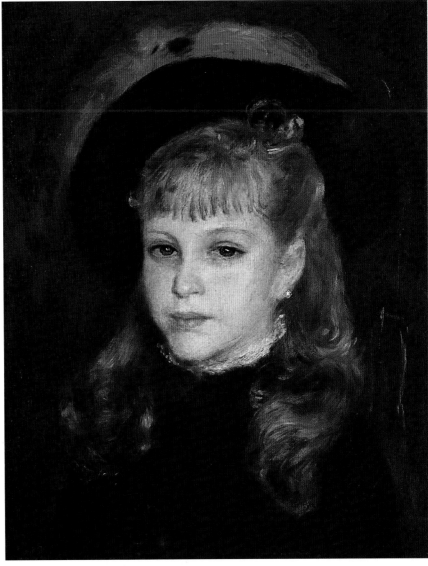

CAILLEBOTTE'S WILL

Caillebotte bought several of Renoir's paintings, including *Torso, Effects of Sunlight,* helping Renoir to pay the rent on two studios. Although only 28, Caillebotte was convinced he would die young, and in November 1876, he wrote his will, stating that his collection of Impressionist paintings should go to the Louvre. He asked his close friend Renoir to be his executor.

THE SALON

By the end of 1877, Renoir was fed up with fighting against insulting critics and the scornful public. He decided to concentrate on earning a living as a portraitist to wealthy Parisians, who appreciated him, and to try to gain recognition through the Salon.

Late in that year, another name joined the large circle of Renoir's friends. Eugène Murer, a widower who ran a pâtisserie and small restaurant, was a childhood friend of Guillaumin's, who introduced him to Renoir and Pissarro. Murer asked them to decorate his restaurant and bought about 30 of Renoir's canvases, including *The Harem*, which had been rejected from the 1872 Salon. He also bought more of the Impressionists' works, set up a system like Père Tanguy whereby he would give an impoverished artist a meal in exchange for a painting, and began holding dinners for artists each Wednesday evening. Renoir and the other Impressionists began dining there regularly. Murer also invited non-artists who were sympathetic to the Impressionists' aims, such as Dr Gachet (now recognized as van Gogh's physician), the dealer Alphonse Legrand and Père Tanguy.

APPEALING TO BUYERS

Renoir had never wanted to be labelled a revolutionary. While he was more original and pioneering than he gave himself credit for, he was not as radical as some of his friends, such as Manet, Monet or Cézanne, and coming from a less affluent background, he felt an inherent responsibility to earn a living through his own efforts. By classifying himself as a portraitist, he hoped to put an end to the derogatory comments about his work, and so alienate fewer potential patrons. His financial needs were so pressing that although he did not stop painting in the Impressionist style, his choice of themes became more appealing to his upper-class friends and acquaintances.

About half of his paintings from 1878 to 1880 were portraits, and about half of these were commissioned. works. Increasingly, the soft-focus

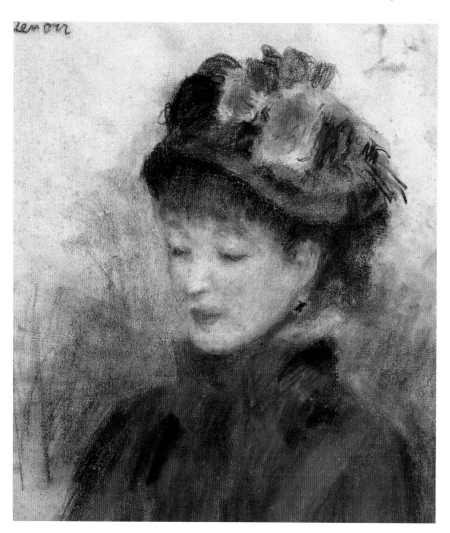

Left: Young Woman with Flower Hat, *1877. This work demonstrates that Renoir's pastel paintings are as soft and luminous as his oils.*

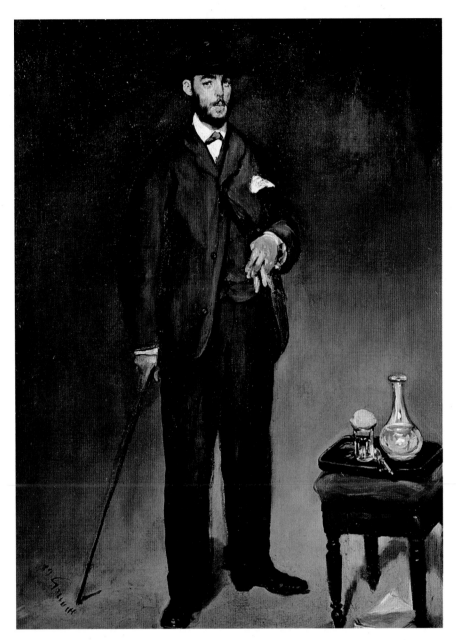

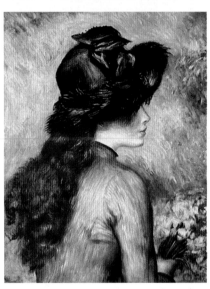

Above: Théodore Duret, Manet, 1868. *A friend and admirer of their work, Duret had a life-long association with the Impressionist artists, and wrote favourably about Manet and his fellow Impressionists.*

Above right: Peonies, 1878. *With thick paint, small marks and a limited palette, in this painting Renoir captures the softness and subtle colour of a bouquet of peonies.*

Above: Young Girl Holding a Bouquet of Tulips, Renoir, 1878. *This charming portrait is a good example of Renoir's amalgamated style in one of his favourite subjects.*

Impressionistic work was combined with more structured and modelled forms. This was partly in response to becoming closer to Cézanne, since he had introduced him to Chocquet, and to a certain extent the result of his natural leanings toward Classicism, which was also appreciated by many of his buyers. He successfully integrated this with the bright colours, dynamic brush marks and surface design of Impressionism.

AN ACHIEVEMENT

For the first time in eight years, in May of 1878, Renoir had work accepted at the Salon. *The Cup of Chocolate*, posed by Margot, was a large canvas, created once again with the Salon in mind, and probably promoted by the Charpentiers, who were friends with one of the jury members. Painted in Renoir's current amalgamated style, it once again failed to attract any noteworthy attention. Continuing with his usual optimism, later

that year he painted two significant portraits. One, his first major commission, was a portrait of Madame Charpentier and her children. For six weeks he painted them in the Japanese salon of their Parisian townhouse, creating an image that captured their likenesses in a colourful, natural and flattering work. He also painted an almost life-size, full-length portrait of the actress, Jeanne Samary, in the foyer of the Comédie-Française.

SUCCESS AT THE SALON

The Charpentiers paid Renoir the substantial sum of 1,000 francs for the portrait of Marguerite Charpentier and her children. Before he submitted it to the 1879 Salon, he arranged for several people to view it as he needed reassurance that it was good enough.

Despite holding meetings in the preceding year on the matter, Renoir had not become involved in the fourth Impressionist exhibition. It was held in April 1879 with 15 participants. Of the Impressionist group, Renoir, Sisley and Cézanne refrained from exhibiting, and several of the still hostile reviewers commented that as a cohesive group, the Impressionists were finished.

THE LAUNCH

Through the encouragement of Marguerite, in April 1879, Georges Charpentier published the first edition of a weekly magazine on art, literature and society gossip, called *La Vie Moderne*. Dedicated to promoting the work of the Impressionists, the first issue announced that the magazine had an art gallery on its premises that opened on to the street, 'intended to transfer the

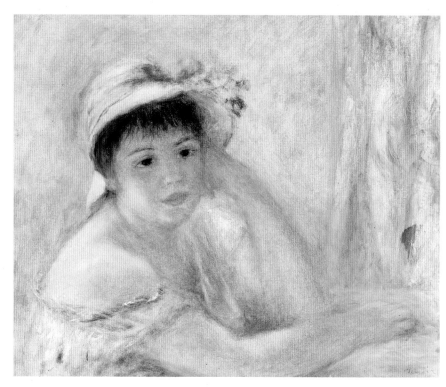

Below: On the Island of Chatou, 1879. *Renoir had not abandoned plein-air painting or Impressionism completely.*

Above: Woman in a Straw Hat, 1879. *Renoir's chosen colour palette at this time included plenty of fresh yellows.*

atmosphere of an artist's studio to the boulevard; a hall which will be open to everybody'. Georges Charpentier was the magazine's administrative editor, Renoir was artistic contributor and he provided several illustrations, while his brother Edmond was literary co-ordinator.

SUCCESS

Renoir submitted the full-length painting of Jeanne Samary and *Madame Charpentier and her Children* to that year's Salon. Both were accepted along with two pastel portraits of men. Once again, Marguerite used her considerable influence, and urged her acquaintances on the jury to hang her portrait in a prominent position, where it would attract attention amid the 3,000 other works on display. As the Charpentiers had anticipated, the painting was a great success, drawing large crowds, and some complimentary reviews. After the Salon, Durand-Ruel bought Renoir's portrait of Jeanne Samary for 1,500

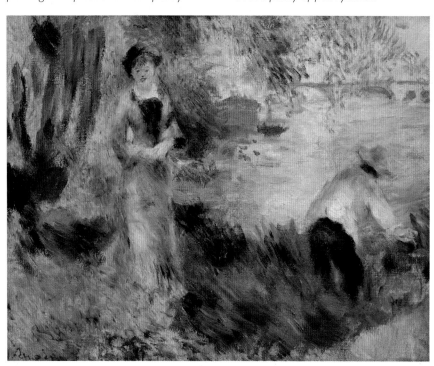

Right: La Place St Georges, Paris, *Grandjean, 1879. This engraving depicts the area around Renoir's studio.*

francs and a number of buyers emerged to commission him. For the first time in his life, he was earning good money and his work was creating a stir.

ONE-MAN SHOW

Making the most of his new-found success, Renoir asked the Charpentiers if he could have a one-man show at the gallery on the premises of *La Vie Moderne*. They agreed and his first solo exhibition ran from mid-June to the beginning of July. It opened as the Salon closed, so they were not in competition, and he included some of his portraits of patrons and their children, which were popular. On the day the show opened, Edmond wrote a flattering article about his brother's work and talents.

Even when he was busy working on commissions, Renoir thought of others. After the Franco-Prussian War, Sisley's father William had lost his successful business and since then, Sisley, his wife and two children had lived in poverty. In 1879, William Sisley died, leaving none of his former wealth. That year, Sisley was once again rejected from the Salon. Just before Renoir's exhibition was due to open, he asked Georges Charpentier to put on an exhibition for Sisley 'as soon as possible'. He said: '…It would be very nice of you; he has 40 pretty canvases and he would certainly sell some of them. If it is at all possible… I'll give him the good news this very day.' Although Charpentier agreed, he did not hold Sisley's exhibition for 18 months.

PRIVATE TRAGEDY

In January 1879, Margot contracted smallpox. Renoir asked his friend Dr Gachet to attend to her. However, he was put out of action owing to a minor accident. Dr de Bellio visited Margot, but her case was hopeless and she died at the end of February.

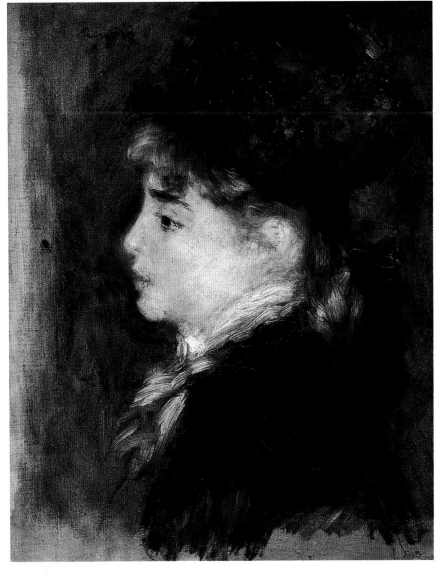

Right: Renoir presented this 1878 portrait, said to be of Margot, to Dr Gachet after her death.

GROUP DIFFERENCES

Although critics had been wrong to claim that the Impressionists were finished as a group, a strain did develop between some of them through differences of opinion. In 1880, they argued over the title of their next exhibition, and Renoir, Cézanne, Monet and Sisley refused to take part.

After Margot's death, Renoir had lost his impetus. Not usually depressed, he decided on a change of air. He spent the summer at Berneval on the Normandy coast, and also visited a new patron, the banker and diplomat Paul Bérard, at his spacious home, the Château de Wargemont in Normandy. Despite their contrasting backgrounds, Renoir and Bérard soon became close friends, and Renoir was invited to spend time at the 18th-century château. Bérard commissioned many works from Renoir, including family portraits, still lifes, landscapes and the decoration of some wooden panels. During his first visit there, which lasted from July to September 1879, he painted 20 pictures. Later, he returned to Chatou, where he had produced such ebullient works in 1869 and 1875, and painted there, too.

NEW MODEL

Toward the end of 1879, Renoir met Aline Charigot, a young laundress and dressmaker, from Essoyes in Burgundy who was 18 years his junior. She lived on the rue St Georges near Renoir's studio with her mother, also a dressmaker. When Renoir and Monet were in Paris, Aline washed their clothes, and soon began modelling for Renoir. In January 1880, he fell off his bicycle and broke his right arm. Although this would have precluded most artists from working, Renoir was ambidextrous, so he carried on painting. One of his commissions was painting ostrich eggs for an exhibition at *La Vie Moderne* in March. Manet and Pissarro also painted eggs for the show.

INDEPENDENT ARTISTS

Because of the dispute over their name, artists participating in the fifth exhibition in 1880 called themselves 'A Group of Independent Artists'. Without Renoir,

Left: Portrait of a Little Boy, c.1880. *Still calling himself an Impressionist, Renoir continued to apply broken brushstrokes characteristic of the movement.*

Below: Still Life with Geraniums in a Bronze Bowl, *1880. Capitalizing on their popularity, Renoir painted various elaborate still lifes during the 1880s.*

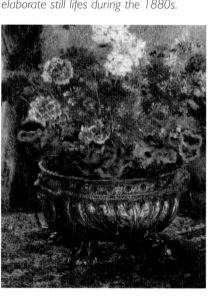

Right: Young Woman Reading an Illustrated Journal, *c.1880–81. This is one of Renoir's many small, freely-painted informal modern-life paintings.*

Monet, Cézanne and Sisley, it did not have the excitement of the previous exhibitions, and did not seem to be an Impressionist show. This time, even critics who had previously been quite favourable complained that the vision that had been emerging from the group had disappeared. Renoir was busy producing two pastel portraits and two genre paintings for that year's Salon. By now, with his influential contacts, the jury viewed him quite positively and all four of his submissions were accepted. Without Marguerite Charpentier's influence, however, they were not displayed prominently and did not receive much attention.

A PLAN FOR THE SALON

Monet had also been disappointed that his accepted Salon works had been hung in obscure places, and he and Renoir wrote a joint letter to the Minister of Fine Arts, objecting to the Salon displays. In *Le Voltaire*, Zola published the letter and four articles commenting on the subject. He also

denounced the pomposity of the Salon, and he criticized the Impressionists, which dismayed them as he had previously supported them. Murer sent

Below: Closing Time, *François-Auguste Biard (1798-1882), 1847. The Salon remained extremely popular throughout the 19th century.*

Renoir's plan for the reorganization of the hanging, which included a place for the Impressionists, to the *Gazette des Tribuneaux*. But all their efforts were ignored by those who had the power to change things. Disappointed, that summer, Renoir returned to Chatou in an attempt to find subjects that gave him pleasure.

RENOIR'S PALETTE

At the end of 1879, Renoir began teaching the 18-year-old son of another new patron: Jacques-Émile Blanche. He gave his student a list of his recommended palette of colours: Flake White, Chrome Yellow, Naples Yellow, Yellow Ochre, Raw Sienna, Vermilion, Rose Madder, Viridian Green, Emerald Green, Cobalt Blue and Ultramarine Blue. He added that 'one can do without' Yellow Ochre, Naples Yellow and Raw Sienna because they could be made using other colours. This was the brightest palette of Renoir's career and one of the periods in which he refrained from using black. His early work showed a lot of black, from using bitumen.

ALGERIA

Renoir's continued portrait commissions were lucrative and welcome, but some of his wealthy sitters were difficult to please, and the work was time-consuming. Wearying of spending so much time painting what others wanted, he determined to work on more subjects of his own choice.

In the late summer of 1880, Renoir stayed at Croissy with his old friends the Fournaise family, who owned the restaurant at Chatou. He spent several weeks with them, painting a number of works in and around the area, featuring various friends in blithe scenes. Later, he recalled the period: 'when life was a perpetual holiday and the world knew how to laugh.'

TRAVEL

In 1881, Durand-Ruel started buying Renoir's work again regularly, and for the first time in his life, the artist could afford to travel. His first holiday abroad followed the footsteps of his hero Delacroix, and responded to collectors' tastes for the Oriental, with a trip to North Africa. He found the life, light, colours, scenery and costumes of Algeria inspirational. Although owing to language barriers he had difficulties in persuading the local girls to pose for him, he produced some richly coloured landscapes and started several figure paintings.

BACK IN CHATOU

Duret was living in London, and had been inviting Renoir to visit for some time. Renoir had been determined to go, but on his return from Algiers, he revisited Croissy, and found that he could not tear himself away. He wrote to Duret: 'I am struggling with blossoming trees, with women and children and I don't want to see anything beyond that. I wonder if you will easily swallow my womanish caprices. The weather is very good and I have models: that's my only excuse.' His models were all friends and he worked at Chatou with renewed enthusiasm, completing several lively paintings and in particular, a large canvas he had started the previous year, featuring friends lunching on

Top: Sunny Landscape, *1880–81 is a typical Impressionist plein air painting of a passing moment depicted in terms of light and colour.*

Above: La Baie d'Alger, *1881. Applying paint with vigorous strokes, Renoir captures the effects of the Algerian light at midday.*

Above: Still Life with Lemons and Oranges, *1881. Renoir placed the complementary colours of blue and orange in juxtaposition to produce maximum impact.*

the terrace of the Restaurant Fournaise. Like *Le Moulin de la Galette* of five years earlier, this large-scale work, *Luncheon of the Boating Party*, is a scene of contemporary urban society with the upper and lower classes mingling together. While staying there, Renoir met the artist James McNeill Whistler (1834–1903), who recommended that he visit Italy and Venice in particular.

EXHIBITIONS

In spite of the fact that Renoir still called himself an Impressionist, and frequently painted with his distinctive fragmented brush marks, colourful palette and lively style, in 1881, he once again refrained from exhibiting with the group. Monet, Sisley, Cézanne and Caillebotte also kept away. Yet Wolff, who had so harshly criticized them previously, still found it necessary to insult them. Reviewing that year's sixth exhibition in *Le Figaro*, he wrote: 'Renoir or Claude Monet,

Right: Still Life with Peaches, *1881. Painted at Bérard's château, Renoir included this in the Impressionist exhibition of 1882.*

Sisley, Caillebotte or Pissarro, it's all the same thing…they are just as prone to routine as are the painters who do not belong to their brotherhood. Who has seen one picture by an Independent has seen the works of all of them…'

Pissarro was the only artist from the five that Wolff named who was actually represented at the exhibition, but this does not seem to have mattered to him.

ACCEPTANCE

Although he was not in Paris at the time, that year, in his absence, Renoir had two portraits accepted for the Salon. In a letter to Durand-Ruel he explained his (purely financial) reasons for wanting to take part: 'There are barely 15 collectors in Paris who are capable of liking a painter they have not seen at the Salon.' That summer, he returned to stay with his friend and patron Bérard, in Normandy.

SALON CHANGES

In 1881, the French government withdrew its official sponsorship from the Salon and a group of painters and sculptors took responsibility, creating a Société des Artistes Français. While the first members of this Society were mainly traditional artists working in the Academic Realist style, at least they did not belong to the former conservative and academic juries, who refused to accept any picture that was not traditional. The new order understood artists' difficulties, which heralded new hope for all artists.

ITALY

At the end of October 1881, Renoir left France to travel around Italy for a three-month-long tour. He wrote: 'I have suddenly become a traveller and I am in a fever to see the Raphaels… I have started in the north and am going to the toe of the boot.'

Partly on the recommendation of Whistler, and partly through his own desire to see the works of the Renaissance artists he had admired for so long, Renoir could barely wait to get to Italy. He was quite secretive about it, but accompanying him for at least part of the trip was Aline Charigot, who had become his mistress.

By the beginning of November, Renoir was in Venice. He wrote to his friends of his impressions, enthusing about the light and colour. He then moved on to Rome, Naples, Calabria, Capri, Padua, Florence and Palermo, filling a small sketchbook that he had also taken to Algeria. Wherever he went, he crammed the sketchbook with pencil drawings of the scenery, buildings, vegetation and people. As in Algeria, finding models was difficult, because he did not speak the language. He wrote to his friend and patron Charles Deudon (1832–1914): 'To get someone to pose, you have to be very good friends and above all speak the language.' Still, he produced numerous paintings in Italy, which he confessed to Durand-Ruel would need completing on his return to Paris. As well as enjoying the environment, he admitted to his friends at home that he was painting to appeal to wealthy collectors, critics and the Salon jury.

But all thoughts of home evaporated when he saw Raphael's frescoes in Rome. 'They are full of knowledge and wisdom…they are wonderful' he marvelled. He wrote to Marguerite Charpentier: 'Raphael never worked in the open air, but he still used to study the sun, as his frescoes are full of it.' For the rest of his life, Raphael's work had a profound effect on him.

ITALIAN LIGHT

Renoir was also amazed by the paintings from Pompeii that he saw in Naples, and he soon began experimenting with capturing the pervading light that he had seen in all these ancient frescoes. He wrote enthusiastically to Durand-Ruel, Bérard and Deudon, describing his experiments with materials and techniques that had been inspired by the works he had seen. He tried applying parallel strokes to create shimmering surface effects of light and colour, and he tried mixing his paint with various materials such as wax.

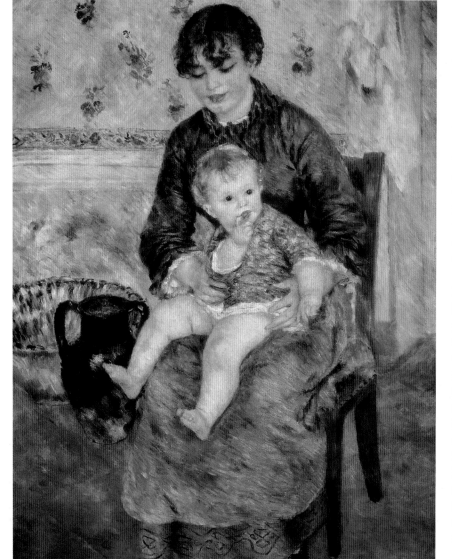

Left: Mother and Child, *Renoir, 1881. This painting echoes the pose of many traditional Madonnas, but the mood is more relaxed and informal.*

Right: A Garden in Sorrento, *1881. Idyllic and dreamlike, Renoir's colours and approach evoke the Rococo styles of the 18th-century.*

However, even though he was dissatisfied with his results, his Italian visit furnished him with the beginnings of a change in his painting style.

AN AIR OF THE ETERNAL

In Naples, as well as admiring the Pompeian frescoes, Renoir painted several works, including a portrait of a young woman with a baby on her knee, in his characteristic small brush marks and bright colour palette. He said: 'The Italians don't deserve any praise for creating great painting. They only have to look around them. The Italian streets are full of pagan gods and biblical figures. Every woman who nurses a baby is one of Raphael's Madonnas.' His painting of the young Italian woman and the baby creates an impression of a modern-day Madonna and child.

While Renoir was away, he still managed to maintain the strong links he had forged with his many friends,

Below: A photograph of Renoir at about the age of 40, c.1881, in which he looks quite dapper, and has a rather thoughtful expression.

and corresponded with them as often as he could. In writing to Chocquet from Capri, he said: 'Give a handshake to Cézanne when you see him.'

Below: The Bay of Naples with Vesuvius in the Background, *1881. From a high viewpoint, Renoir has summarized the view in pale, dazzling colours.*

Next, he wrote to Manet, who was still waiting for official confirmation that he had been nominated as a chevalier of the Légion d'Honneur. 'I hope it is only postponed,' Renoir wrote, 'and that when I enter the capital, I will have to greet you as the officially recognized painter loved by all.'

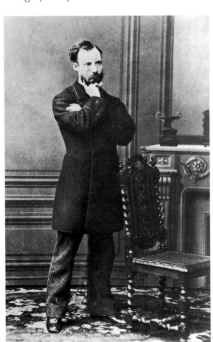

A LACK OF UNITY

Renoir returned from Italy via Marseille and L'Estaque, with renewed enthusiasm. However, he contracted pneumonia and on his doctor's advice, returned to Algeria to convalesce. By now, the Impressionist group had lost unity, and he did not wish to participate in their seventh exhibition.

From the time he used to sing, Renoir had loved music, and he had been an admirer of the composer Wagner for about 20 years. So when he heard that Wagner was completing his opera *Parsifal* in Palermo, he went to Sicily, hoping to meet him.

WAGNER

After some delays, Wagner eventually granted Renoir an interview on 14 January 1882 and a sitting of just over half an hour the following day. This was an achievement as Wagner had never allowed anyone to paint him from life before. Renoir wrote of their meeting: 'He is very handsome, very courteous and he shakes my hand, urges me to sit down again and then the most absurd conversation begins, strewn with uhs and ohs, half French, half German, with guttural endings.' After painting the portrait, Renoir told a

Below: Two Girls in Black, c.1881. Smooth brushstrokes and a harmonious palette of three main colours herald Renoir's new style.

friend: 'Wagner was in a jolly mood, but I was very nervous and I regret that I am not Ingres.'

RETURN TO FRANCE

Two days later, from Naples, Renoir wrote to Durand-Ruel, promising 'a crateful' of canvases on his return. Shortly after that, he wrote again to Durand-Ruel from the Hôtel des Bains in L'Estaque: 'I'm staying here for another two weeks…I've met Cézanne and we're going to work together.' Even with their contrasting personalities,

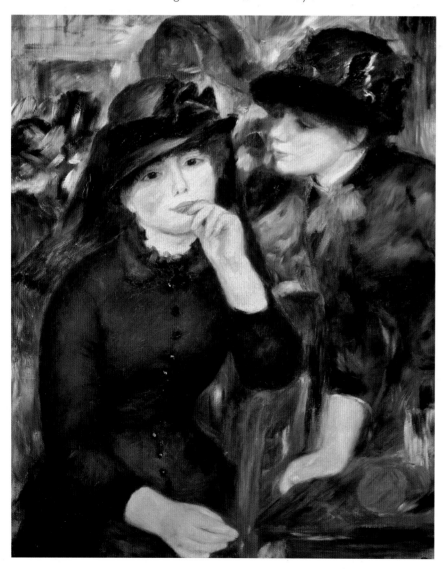

THE SEVENTH EXHIBITION

The Impressionists were now scattered around France and although they were inspired by Impressionism, they all seemed to be developing in individual directions. Following their constant disagreements over their next exhibition, Durand-Ruel decided to organize it himself. Once again he had money problems, and needed buyers. Renoir and Monet chose not to exhibit, but Durand-Ruel implored them to change their minds. In the end, from his sickbed in L'Estaque, Renoir, who believed that exhibiting with the Impressionists would ruin his chances of success, told Durand-Ruel that he would send no new works, although Durand-Ruel was welcome to exhibit any works he already owned. Caillebotte organized the hanging of the exhibition, which opened in March 1882, and was called the 'Exposition des Artistes Indépendants', and Durand-Ruel included 25 paintings by Renoir. Reviews of his work were mixed.

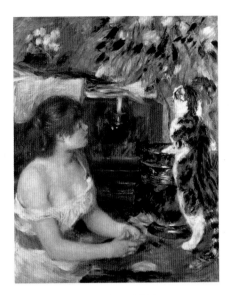

Above: Girl with a Cat, *1882.*
This is one of Renoir's works that
Durand-Ruel included in the seventh
Impressionist exhibition.

Renoir worked well with Cézanne. They
both admired Raphael and
other great masters, and Cézanne's
unusual approach inspired Renoir
to pay closer attention to the structure
of his compositions. The influence of
Cézanne, together with the art he
had seen in Italy, brought him toward
a style that he felt was more in accord
with his ideas, and he felt he was
achieving something more than just
Impressionism, which he had never
been completely at ease with.

ILLNESS

During his time with Cézanne,
Renoir fell seriously ill with pneumonia.
He wrote to his friends in Paris
about how Cézanne's mother travelled
straight to L'Estaque from Aix-en-
Provence in order to nurse him,
along with Cézanne. Known as a
difficult, moody person, Cézanne
showed his gentler side, and in
February, Renoir wrote to Chocquet:
'I can't tell you how nice Cézanne
has been to me.'

Nonetheless, Renoir suffered
with complications from the
pneumonia, the effects of which lasted
for five months. His doctor advised
him to recuperate in Algeria, so
he returned and spent two months
there, painting the whole time.

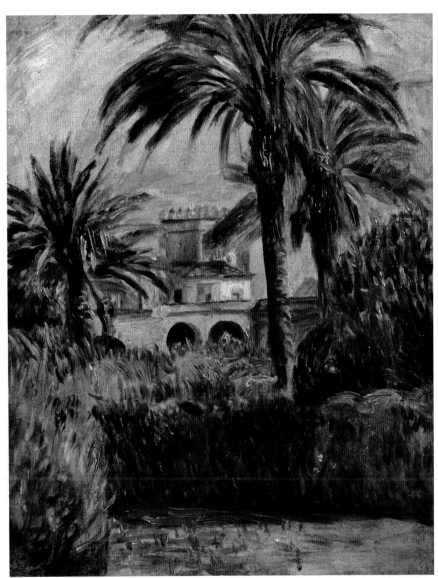

Above: Le Jardin d'Essai, *1882. Planted by*
the French, the Garden of Essai in Algiers
became one of Renoir's favourite themes.
The botanical garden was established for
the preservation and propagation of
Algeria's indigenous plants

DIMINISHED REPUTATION

By May 1882, Renoir had spent
around seven months away from Paris
and despite having two works accepted
for the Salon that year, in his absence,
his reputation had diminished slightly
among the potential wealthy buyers
and the Establishment, partly – as he
had feared – as a result of several
of his paintings being represented
at the Impressionist exhibition.
Also, because the art market was in
a depressed state, he was once again
in financial difficulties.

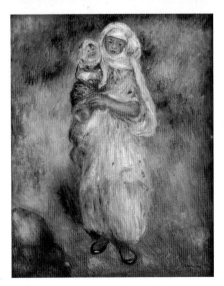

Above: Algerian Woman and Child,
1882. Renoir transformed the locals'
tattered clothes into feminine, lavish
styles, according to his own standards.

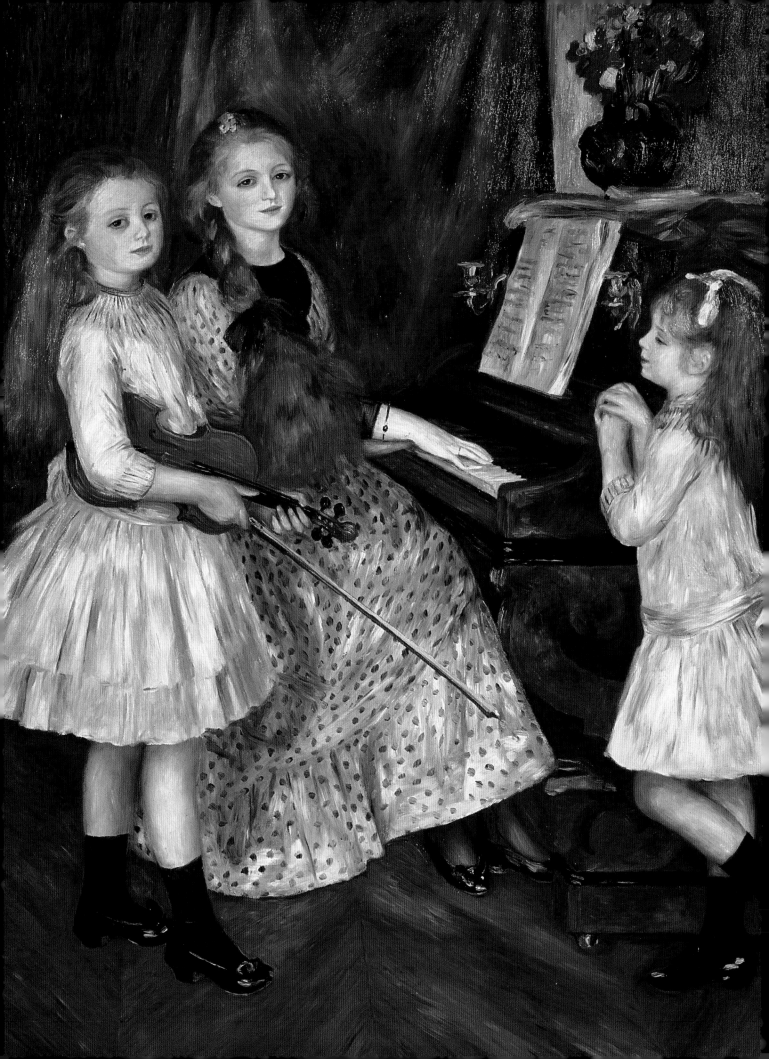

CHANGE
OF DIRECTION

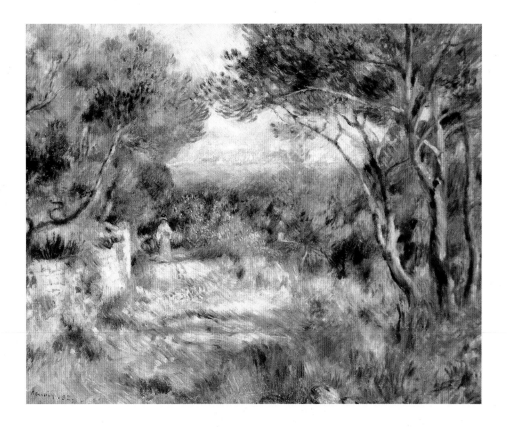

During Renoir's visit to Italy, he marvelled at the art of the great masters such as Titian, Michelangelo, Bernini and Raphael; he was astonished by the incredible colours achieved by the Pompeian fresco artists with their limited range of pigments; and he loved the light and colours of the Italian landscape. The entire Italian experience was one of the factors that led to a change in his style. On his return to France, reluctant to jeopardize the elusive success that he had experienced prior to his travels, he began moving away from the Impressionists and the association that was labelling him a revolutionary. He later recalled that by then he had 'travelled as far as Impressionism could take me'.

Above: L'Estaque, 1882. On his return to France, Renoir stayed with Cézanne in L'Estaque and picked up some new ideas about structure.
Left: The Daughters of Catulle Mendès, 1888. After this charming portrait of Renoir's friend Mendès' three stepdaughters was ignored at the 1890 Salon, it became acclaimed as one of his many masterpieces.

THE DRY STYLE

With the loss of coherence within the Impressionist group, Durand-Ruel suggested that one-person shows might bring greater success for the individual artists. Renoir meanwhile continued modifying his style, modulating tones, experimenting with colours, refining forms and smoothing his brushwork.

After his Italian experiences and wanting to explore new methods, Renoir became increasingly dissatisfied with his work. He later told a pupil, Albert André: 'For my part, I always defended myself against the charge of being a revolutionary. I always believed and still believe that I only continued to do what others had done a great deal better before me.'

FOCUSING ON FIGURES

After seeing Cézanne's attempts at developing a new pictorial language, Renoir became sure that Impressionism had led him astray. He had not exhibited in the fourth, fifth or sixth shows and was grudgingly represented at the seventh. In contrast with Monet, Pissarro and Sisley, he rarely painted pure landscapes, usually placing his emphasis on figures. He said: 'An artist who paints straight from nature is really only looking for nothing but momentary effects. He does not try to be creative himself and as a result, the pictures soon become monotonous...'

Below: In the Luxembourg Gardens, *1883. Illustrating a turning point in Renoir's art, this is an Impressionist-type scene of everyday life in Paris, but in a smoother style.*

ONE-MAN SHOW

At the beginning of 1883, Durand-Ruel planned one-person shows for the Impressionists at his gallery on the boulevard de la Madeleine. Apart from Degas, they all welcomed the idea, and Renoir's exhibition was held in April. Later that month, Durand-Ruel also put on an exhibition in London,

Below: Seated Bather, *1883. Probably painted in Guernsey, this work shows a supple handling of paint and Renoir's characteristic soft contours.*

called the 'Society of Impressionists.' The ten Renoir paintings included did not sell, but several encouraging reviews appeared in the British press. In May, the first Impressionist exhibition created a sensation in Berlin, while in September, the first Impressionist exhibition to be held in the US opened in Boston – although it did not make much of an impact. Nevertheless, it seemed that just as he was being accepted as an Impressionist, Renoir was moving on.

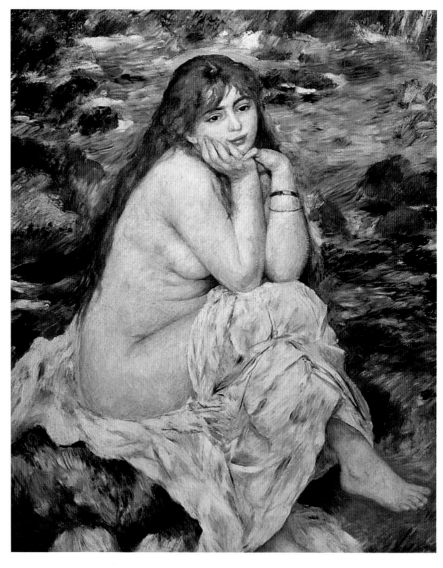

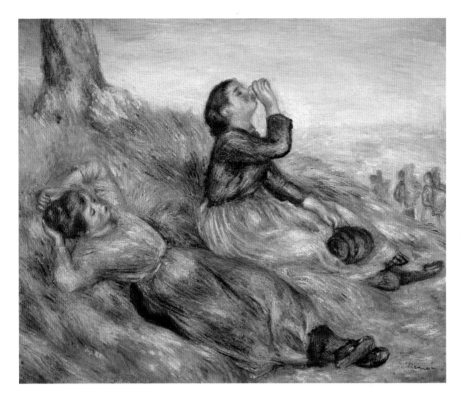

RENOIR'S 'MANIÈRE AIGRE'

Renoir's developing style became more linear with more elongated brushstrokes and cooler colours. He still incorporated his flickering brush marks, but within four years, he had completely abandoned the small marks and vivid colours of Impressionism. He later called this structured style his 'manière aigre' (harsh, dry or sour manner). It also became known as his Ingres style after the Neoclassicist Jean-Auguste-Dominique Ingres, but it was not well received by the critics, and by the 1890s, he softened the style once more, reintroducing smaller brush marks and warmer colours.

HAPPINESS AND SORROW

Along with his commissioned portraits, that year Renoir painted *Country Dance*, *City Dance* and *Dance at Bougival*. In harmonious colours, each painting shows a couple dancing in a different location and integrates features from his two styles. Using his favourite models and close friends, Charigot, Suzanne Valadon (1865–1938), Paul Lhote and Eugène Pierre Lestringuez, he created a triptych of young Parisians of the lower, middle and upper classes enjoying themselves. Valadon lived in Montmartre and modelled for Renoir and other artists while studying their techniques. Eventually Valadon became one of the foremost female painters of her generation.

At the end of April, aged just 51, Édouard Manet died. Renoir and the other avant-garde artists attended his funeral, desolate at the loss of a friend and source of artistic inspiration, a painter who had never been properly recognized by the official art world.

Right: Three Pears, *1884. Clearly showing Cézanne's influence, Renoir built up these well-modelled pears with patches of colour.*

Above: Grape Gatherers Resting, *1884. Along with his more linear style, Renoir's palette appeared bright and delicate, almost iridescent and rather like pastels.*

NEW VISTAS

In the summer, Renoir visited Caillebotte at Argenteuil and later spent six weeks in Guernsey, painting more than 15 canvases there. On his return, he left the rue St Georges and moved to 18 rue Houdon in Montmartre. At the end of the year, he toured the Mediterranean, from Marseille to Genoa, with Monet. On the way, they visited Cézanne, and Renoir wrote letters home, describing the marvellous sights they were seeing. 'Unfortunately our poor palette does not respond adequately. The beautiful, restrained tones of the sea become quite heavy on the canvas despite all the trouble one takes.'

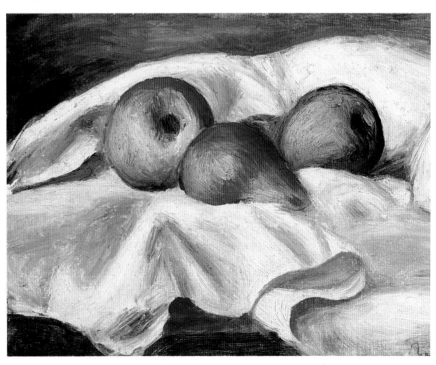

THE SOCIETY OF IRREGULARISTES

On the last day of 1883, Renoir returned to Paris, three years of travelling over and his art in a state of uncertainty because he had not arrived at a style that pleased him and the public. His popularity had lessened, and once again, he was struggling to make ends meet.

A disappointment was in store in the new year. Renoir had planned to return to the Mediterranean with Monet to paint together once more, but Monet had secretly gone by himself. Monet wrote to Durand-Ruel: '…much as I enjoyed travelling with Renoir as a tourist, when it comes to work, it would bother me to do it together. I've always worked better in solitude…'.
He soon wrote to tell Renoir, who without any reproach replied: 'I suppose that this time you will stay long enough to work peacefully.'

LOSS OF SUPPORT
Renoir's patrons did not like his new style of painting, so none of his former supporters bought any of his work. In 1884 and 1885, of all his buyers, only Bérard continued to commission him. Even the Charpentiers had not bought any of his canvases since 1882. Triggered by the collapse of the French General Union Bank, the stock market crash of 1882 was one of the worst catastrophes in the French economy of the 19th century. It had severely depressed the art market, and after five years of relative wealth, by 1884, Renoir was poor again. He could barely afford to pay his rent, and at the age of 43, his self-esteem plummeted. Even his dealer could not help. Because of the economic situation, Durand-Ruel was facing bankruptcy, and planned to reduce the prices of his entire collection, which in turn would have lowered Renoir's market value. But true to his character, even when he was struggling, Renoir put others first. He wrote to Durand-Ruel: 'The help I can give you at this moment doesn't amount to much but if you need me… I will always be at your service and whatever happens, I shall always be devoted to you. As for the paintings, if you are forced to make sacrifices, don't regret it, as I will make you others and better ones.'

A GRAMMAR OF ART
During this difficult time, Renoir planned to start a new artists' society, which he would call the 'Société des Irregularistes'. He believed that French art was losing its charm and imagination as the obsession for artificial flawlessness made it dull and predictable. He aimed to organize exhibitions for artists, designers, architects and craftspeople who took 'irregularity' rather than uniformity as their artistic standard. Members of the Society of Irregularists would not use

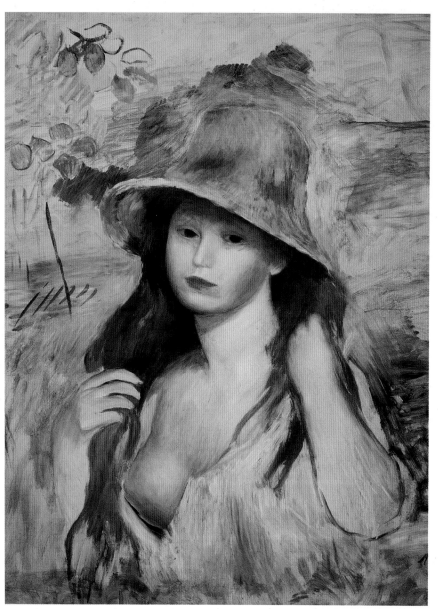

Left: Young Girl with a Straw Hat, *1884.*
In this preparatory work for a vibrant portrait, Renoir's smoother brushstrokes are particularly apparent.

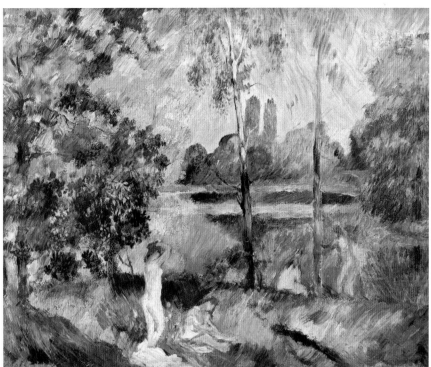

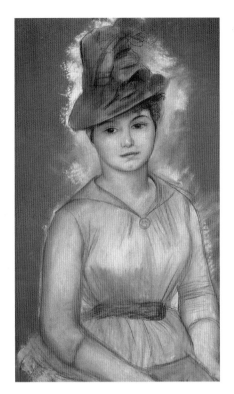

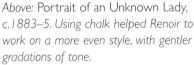

Above: Portrait of an Unknown Lady, *c.1883–5. Using chalk helped Renoir to work on a more even style, with gentler gradations of tone.*

precision instruments, and their work would be based on nature. His reasons for wanting to organize a new society were numerous. He no longer wanted to associate with the Impressionists – his friends Sisley, Cézanne, Caillebotte and Monet did not exhibit with the group any more – and he had decided to stop submitting to the Salon because his work was invariably hung in obscure places, where it was ignored.

RENOIR'S MANIFESTO

He wrote a manifesto, *The Grammar of Art*, for the Irregularists. Renoir was inspired by the Society of Independent Artists formed that summer by Georges Seurat (1859–91), using the motto 'No jury or awards'. Seurat exhibited his *Bathers, Asnières* at the Society of Independent Artists' first show and was immediately recognized as one of the leaders of an avant-garde art movement. Although Renoir abhorred Seurat's style, he was impressed by the impact the young artist had made on the art world. Ultimately, nothing came of Renoir's

Top: Landscape with Bathers, *c.1885. As Renoir searched for a style, he tried out some of Cézanne's ideas.*

society or manifesto, but his plans helped him to clarify his own techniques and aesthetic concerns. Early in the summer of 1884, Renoir went to stay once again with the Bérard

Above: Surroundings of Varengeville, *1885. Applying directional brush marks to convey structure was another experiment inspired by Cézanne.*

family. In a large painting of the children, his new classical style became even more apparent, and it is clear why many labelled it his 'Ingres' style.

A SON

After spending over a year exploring different methods, by the end of the summer of 1884, Renoir longed to return to the outdoors and paint. He painted several pictures of Aline in the open air. The following March, unknown to most of his friends, she gave birth to their son.

On 21 March 1885 in the apartment at rue Houdon, Renoir's son Pierre was born. At 44 years old, Renoir had been feeling depressed. Younger artists were making headlines, and the Impressionists were no longer perceived as avant-garde. Renoir felt that he had not achieved what he set out to do all those years ago at Gleyre's academy, and success and money still eluded him. The year before, he had visited the École des Beaux-Arts to see a posthumous exhibition of Manet's work, and had been saddened that he was 'unable to treat myself to a memento of a lost friend'.

ALINE AND PIERRE

Renoir's mistress came from Essoyes, a village in the southern Champagne region of France. A pretty, plump young woman, her peasant background meant that she had a fairly strong regional accent, which Renoir's friends often teased her about. This was all good-humoured, but her upbringing was incongruous with the upper-class and bourgeois circles that Renoir mixed in, and their relationship would not have been acceptable to those whose support he badly needed. Even without speaking, her figure, dress and demeanour would have singled her out from wealthier, more sophisticated women. So he kept her – and subsequently his son Pierre – a secret from most of his circle.

Among his artist friends, however, it was fairly common to have a lower-class mistress and illegitimate children. Monet, Cézanne and Pissarro all had this arrangement, and against social taboos, they all married their mistresses, so Renoir confided in them about Aline and Pierre. He also told his brother Edmond, Dr Gachet, Murer, De Bellio and a couple of others. Caillebotte knew and became Pierre's godfather, but Morisot, as a woman and from an upper-class family, was not told the secret even though she was a close friend. The mixing of classes occurred in some social situations – as

Below: View of Montmartre, 1885. Renoir's work at this time speaks volumes about his desperate search for a style. In contrast with his 'dry' approach, this resembles some of the earliest Impressionist works.

Right: Seated Nude Resting, *1885. With cool shadows, this nude shows a return to the traditional values Renoir had explored at the beginning of his career.*

Renoir showed in many of his paintings – but marriage between them was considered unacceptable.

RAPHAEL AND INGRES

Increasingly, the lighter tones of the art that Renoir had admired in Italy began appearing in his paintings. He built up cool alabaster skin tones with more fluid paint and longer brushstrokes similar to Raphael's portrayal of forms and light, and reminiscent of Ingres' calligraphic technique. (Ingres was a follower of Raphael.) Yet for backgrounds, Renoir retained his animated, short brushwork. Although he could see that this style was not attracting admirers, he continued pursuing it, still feeling unfulfilled and uncertain. Pissarro, Monet and Cézanne became angry when they reached a certain age without having achieved their aims. Renoir, with his gentler nature, could not feel angry or express discontent, so he became withdrawn and gloomy – for the first time in his life.

BUILDING UP HOPE

Delighted with his baby son, however, that summer Renoir took his family to La Roche-Guyon near Monet in Giverny, where they were joined by Cézanne, his mistress Hortense and their 13-year-old son, Paul. Some weeks later, Renoir took Aline and Pierre to Essoyes, Aline's home village, and in the winter, he returned once more to the Bérards' château at Wargemont. He painted the entire time, particularly images of Aline and the baby.

Far right: Aline Charigot and her Son, Pierre, *1885. This was the first of a series of paintings Renoir produced of Aline breastfeeding Pierre. The light handling gives it the look of a watercolour.*

Right: Aline Charigot and her Son, Pierre, *1885. Colour is the dominating feature in this consciously impressionistic version of Aline feeding Pierre.*

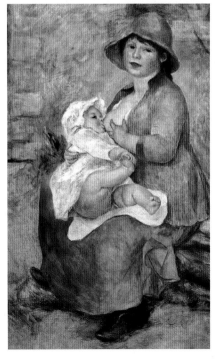

THE END OF AN ERA

'I want to find what I am looking for before giving up,' wrote Renoir to Bérard in 1885. But although he carried on experimenting, instead of becoming clearer about the direction he was moving in, he became more dissatisfied. His previously outgoing personality had become a self-conscious and cautious one.

For several years, Renoir produced seemingly spontaneous, colourful and sketchy plein-air paintings with careful studies from works in museums in an attempt to reproduce the brilliant light he admired in classical art. He frequently amalgamated linear, sculptural and Realist styles with Impressionist areas, and many of his friends and previous followers disliked the results. Morisot was one of the few friends who admired his work. She wrote in her diary: 'He is a first-class draughtsman…I don't think that one can go further in the rendering of form.'

THREE EXHIBITIONS

Impressionism seemed to have come to an end without ever having really been accepted. Pissarro, Monet, Sisley and Durand-Ruel were all suffering too, so in 1886, Renoir was pleased to be asked to participate in three separate exhibitions. The first was held in February in Brussels and was called Les XX (Les Vingt or The Twenty). For the last three years, the Brussels lawyer, publisher and entrepreneur Octave Maus (1856–1919) had organized exhibitions for 20 Belgian painters, designers and sculptors with Impressionist and Post-Impressionist leanings, along with 20 international artists. The exhibitions were intended to bring new ideas in art to a wider public. Durand-Ruel communicated with Maus, and that year the international artists included Renoir, Monet and Odilon Redon (1840–1916), who each

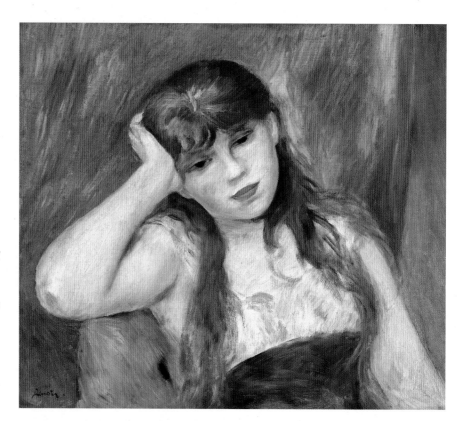

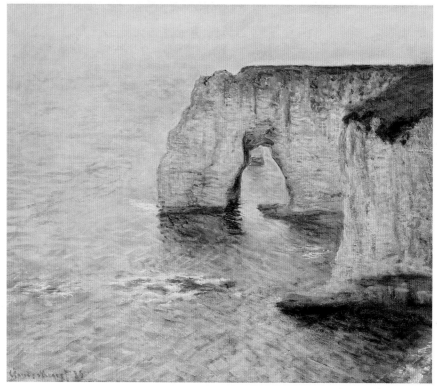

Top: Young Blonde Girl, *1886. Despite his self-doubt, Renoir still had the knack of putting sitters at ease.*

Right: The Manneport, Monet, *1885. Just as Renoir's work was unpopular, Monet was beginning to attract favourable attention.*

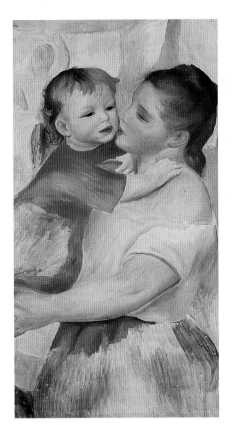

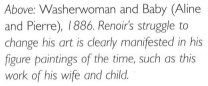

Above: Washerwoman and Baby (Aline and Pierre), *1886. Renoir's struggle to change his art is clearly manifested in his figure paintings of the time, such as this work of his wife and child.*

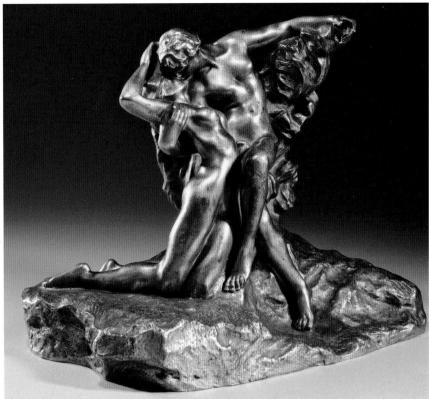

Above: Eternal Springtime, *Rodin, bronze, 1884. Using rough, seemingly unfinished surfaces, Rodin was sometimes associated with the Impressionists, and his work was shown in the same exhibition as Renoir's.*

sent eight paintings. From April to June, Durand-Ruel instigated another exhibition for them, this time in New York. Called 'Works in oil and pastel by the Impressionists of Paris,' the exhibition was sponsored by the American Art Association and contained the largest number of Impressionist works ever assembled anywhere. Thirty-eight of Renoir's oils and pastels were included, and once more, reviews of his work were mixed, although in general, the visitors in New York were more appreciative than the Parisians. Durand-Ruel managed to sell six of his works at respectable prices, and encouraged by this, he planned another exhibition there later in the year. Two years later, he opened a branch of his gallery in New York.

THE LAST EXHIBITION

In May 1886, the eighth and final Impressionist exhibition was held, but, mainly through Degas' involvement,

disagreements between the artists occurred. Renoir did not exhibit and neither did Monet or Cézanne. Instead, at the beginning of June, the art dealer Georges Petit (1856–1920), Durand-Ruel's greatest rival, held an exhibition of works by Renoir, Monet and Auguste Rodin (1840–1917). Petit's Parisian gallery, which opened in 1881, had become a popular alternative exhibition space to the Salon, and his private views had become social occasions.

From 1882, he held a series of exhibitions and Renoir's, Monet's and Rodin's works were included in one of these. Renoir was reluctant to exhibit since he felt disloyal to Durand-Ruel but encouraged by Monet, he went ahead. Reviews about his new style were varied. Durand-Ruel expressed an open dislike, while the journalist and art critic, Octave Mirbeau (1848–1917), published a complimentary article about Renoir in the journal *Le Gaulois.*

DESTRUCTION

Despite the exposure, Renoir was still poor. He moved to a cheaper apartment closer to the Sacré-Coeur and spent the summer at La Roche-Guyon, Essoyes, La Chapelle and Saint-Briac-sur-Mer, to paint. In preparation for the second New York exhibition, planned for that December, he worked furiously, but the dealer did not like the work. This prompted him to scrape the paint off the canvases he had completed.

LOYALTY

Even while his popularity and finances diminished, Renoir remained loyal to Durand-Ruel. In their deprived circumstances, Monet, Pissarro and Sisley had sold paintings to Adolphe Goupil (1806–93), another of Durand-Ruel's rivals, but despite his poverty, Renoir refused to do the same. He remembered how Durand-Ruel had helped him in years past, and he quipped: 'Life is more fun when you have to worry about money coming in. It stirs you up; you don't have time to get bored.'

CRITICAL RECEPTION

The 1886 exhibition in New York was a defining moment for the Impressionists. While the French were slow to appreciate their work, the Americans viewed it without any of the French academic prejudices of tradition. In 1887 another exhibition that included Renoir's work was held in New York.

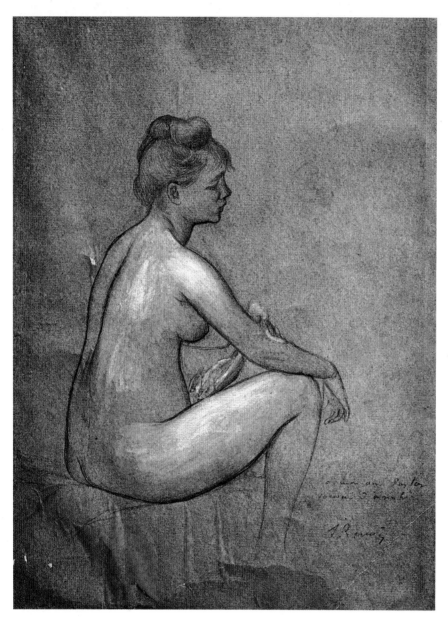

Left: Seated Bather, drawing, *1885. Once Renoir moved away from Impressionism, he also changed his working methods, preparing several studio-based drawings before painting.*

Michelangelo, François Girardon (1628–1715), Raphael, and François Boucher (1703–70). He intended to celebrate the female nude in a painting that would rank alongside the Old Masters. Nudes in the open air that he often called Bathers had been appearing more frequently in his work, but this large painting was intended to surpass them all. He made more than 20 preparatory studies, from simple sketches to detailed coloured chalk drawings and jewel-like watercolours. The resulting painting, *The Bathers*, was a meticulously worked composition of porcelain-skinned young women relaxing by a river, showing the exuberance of an instant as they boisterously enjoyed themselves in a stylized 'traditional' composition. His principal models were his favourites, Aline and Suzanne Valadon. The work is a culmination of the five years he had spent exploring 'Irregularism', Realism, Impressionism and Classicism. It was an attempt to appeal to bourgeois tastes, and to emulate the styles he admired at the same time. With so many influences and intentions, it is not surprising that in the end, the work was not successful. He exhibited it at Petit's sixth International Exhibition of Painting and Sculpture, which was held concurrently with the New York exhibition in 1887. Initially, his friends marvelled at it and within a few days, Renoir wrote to Durand-Ruel in New York: 'The Petit exhibition has opened and is not doing badly…it's so hard to judge about yourself. I think I've made a step forward in the public esteem, a small step, but it's something.' However, the

After an auction in New York in May 1887, which included five paintings by Renoir, a second exhibition of French artists' work opened there. Durand-Ruel selected the work, which included none of Renoir's latest paintings.

Postponed from December 1886 to May 1887, the second New York exhibition, unlike the first, was not just an Impressionist show. Included were works by Delacroix, Courbet, Jean-Léon Gérôme (1824–1904), Puvis de Chavannes (1824–98) as well as Renoir, Sisley, Pissarro and Monet. The exhibition was popular, but owing to a tax problem, Durand-Ruel could not sell any of the works.

BATHERS

In 1885, Renoir had started preparing for a large composition that he based on several influences, including Ingres,

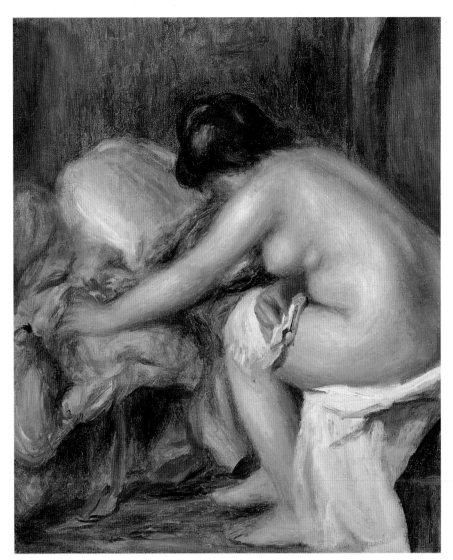

Left: Seated Bather, *1898. Nudes were one of Renoir's favourite subjects; in this he may have been influenced by Titian and Rubens, both of whom he admired very much.*

negative evaluations increased. In his efforts to manage classical methods, it was perceived that he had lost some of his natural spontaneity and dynamism.

MEETING PISSARRO

At the end of September, Renoir visited Murer in Auvers-sur-Oise, where Pissarro joined them. He and Renoir had not been in agreement, with Pissarro disliking Renoir's dry style, and Renoir feeling the same about Pissarro's Pointillist experiments. However, they were pleased to reinvigorate their friendship. Some months later, Pissarro wrote to his son Lucien: 'I have been chatting with Renoir for a long time. He has confessed to me that everyone, Durand, old patrons, came complaining to him, deploring his efforts to escape from his romantic period.'

Below: New York Harbour with Brooklyn Bridge, *lithograph c.1887 by Raphael Tuck & Sons, from a painting by Andrew Melrose (1836-1901).*

WARNING SYMPTOMS

In 1888, Durand-Ruel opened a Manhattan branch of his gallery. Although Renoir was cautious, he was hopeful about the American market. He began to work on a new style, but just as he was beginning to feel more positive, he experienced the first debilitating symptoms of rheumatoid arthritis.

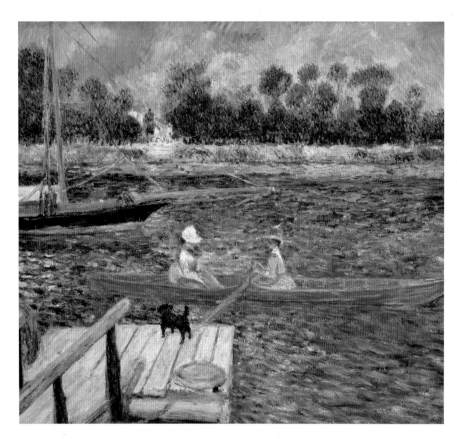

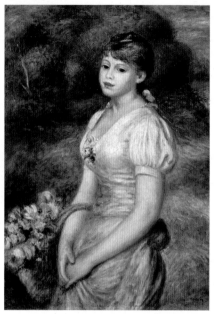

Above: Young Girl Carrying a Basket of Flowers, *1888. Moving away from his dry style (manière aigre), Renoir once again uses softer marks and richer colours.*

When Durand-Ruel opened his American gallery, Renoir wrote to him: 'To give up Paris in order to find the same difficulties somewhere else seems to me unwise.' Despite these reservations, Renoir was less despondent. He visited his friend, the poet Catulle Mendès, and told him: 'There's something good about figure paintings. They're interesting, but nobody wants them!' He painted Mendès' three stepdaughters and exhibited the work in Durand-Ruel's spring Paris exhibition. Knowing that Mendès was also struggling for money, he did not ask for payment for months.

BOHEMIAN
Renoir's large circle of upper-class friends and acquaintances welcomed his genial company, and they enjoyed associating with the bohemian artist,

Above: Red Boat, Argenteuil, *1888. These vivid colours lifted Renoir's spirits. The red boat contrasts with the blue water and sky and the trees bathed in shimmering light.*

who was so different to their own social set. Although he was always elegant, Renoir never conformed to the norms of fashionable society. His hair was fairly long, his table manners imperfect, and his absent-mindedness was mentioned in gossip columns. Throughout his life, he often changed his mind and his opinions. In 1887, Pissarro wrote of him: 'Who can understand the most changeable of men?' These uncertainties manifested themselves in his paintings, which he always felt to be inadequate. During the late 1880s in particular, he felt unhappy about his work, and although he became more

optimistic again, he continued to remain dissatisfied with his achievements to the end of his life.

MOVING AROUND FRANCE
In February 1888, Renoir, Aline and Pierre visited Cézanne and stayed in his family home, the Jas de Bouffan in Aix-en-Provence. Renoir was looking forward to days painting with Cézanne, but they left after a few days. Renoir complained to Monet of the 'dismal meanness' of Cézanne's mother. They moved to the Hotel Rouget in Martigues, in the south-east of France, but left there because of his own mother's ill-health and went to her in Louveciennes. When she was out of danger, he returned to complete some landscapes.

In May and June, Durand-Ruel included 19 paintings and 5 pastels and gouaches by Renoir in his spring

Right: Little Girl Gleaning, *1888. Using vibrant colours and shorter marks, Renoir's later style was rich, bold and decorative.*

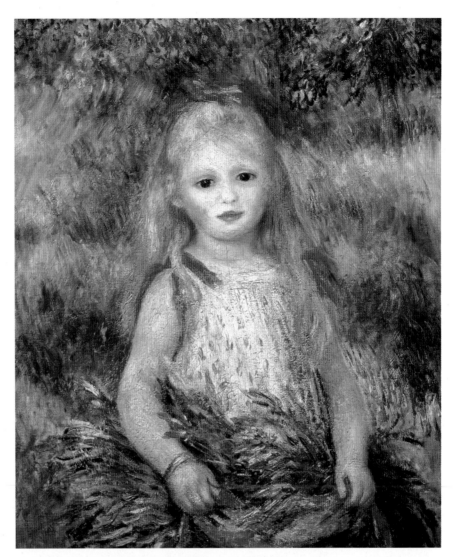

exhibition in Paris, but the work attracted little attention from the public or critics. Renoir spent the summer with Caillebotte at Argenteuil and then took Aline and Pierre to Essoyes for three months. During that time, Renoir began changing his style again, intensifying his palette and integrating figures more into the landscape. He wrote to Manet's brother, Eugène: 'I'm becoming more and more of a countryman… I'm returning reluctantly to Paris…but I'm not planning to stay there long… The blue sea and the mountains attract me constantly; it's only if my means won't allow it that I will shut myself up in the stuffy studio, unless there should be important commissions for portraits, which would surprise me a lot.'

PARALYSIS

In December 1888, Renoir experienced early symptoms of rheumatoid arthritis with an attack of facial paralysis. He wrote to Charpentier and Durand-Ruel: 'I'm pinched by awful neuralgia. It's as though half my face is paralysed. I can neither sleep nor eat.'

Right: The Bridge at Argenteuil, *1888. While staying with Caillebotte, Renoir's new style emerged, powerful and vibrant.*

NEW STYLE

Never inclined to overestimate himself, in 1888, Renoir realized that his 'manière aigre' was not achieving what he had hoped. His natural feel for colour, spontaneity and decoration was being suppressed, and he began reintroducing luxuriant hues to his canvases that were even richer than he had used previously. He shortened his brushstrokes, and he wrote to Durand-Ruel: 'I have returned to the old painting, soft and light… It's nothing new, but it follows the style of 18th-century pictures.'

HOLDING BACK

By mid-February 1889, Renoir's health was improving. He wrote to Dr Gachet: 'I'm getting slowly better, but this better is uncertain.' Also uncertain were his finances. Like Pissarro and Sisley, he was still having trouble selling his paintings, but as Monet's work was selling well by then, he felt hopeful.

Aline and Pierre accompanied Renoir to Provence again that summer, but they rented a house from Cézanne's brother-in-law, Maxime Conil. Renoir spent time with Cézanne painting his friend's favourite motif, the Mont Sainte-Victoire.

A SUPPORTER

The critic Téodor de Wyzewa (1863–1917) had long been an admirer of Renoir and through his complimentary comments in the press, had become a friend. When Octave Maus invited Renoir to participate in the 1889 Les XX exhibition in Brussels, Renoir refused, claiming not to have any work worthy of exhibiting. Wyzewa, realizing that Renoir was simply lacking confidence, wrote to Maus himself, saying that there had been a misunderstanding, and he persuaded Renoir to send five works to Brussels.

INSECURITY

All Renoir's friends were concerned about his health. He had undergone some electrical treatment to relieve his symptoms and, early in 1889, Monet

wrote to Morisot: 'Poor Renoir has been quite stricken, they were afraid it was a facial paralysis, but he's much better and fortunately he didn't panic.' Everyone was hoping that it was just neuralgia, but Renoir probably realized that it was more serious than that. In April, he visited his brother in Villeneuve in the south-west of France,

Above: At the Exposition Universelle de Paris of 1889, the Eiffel Tower was opened, electricity was used for the first time, and Thomas Edison showed his first motion picture.

and told Dr Gachet that he hoped to visit him too. He was working intensely on his new style and had already received some favourable comments from friends and acquaintances, but his years of disappointment had taken their toll, and he was still assailed by doubts.

The year before the Exposition Universelle, the critic, collector and journalist Claude Roger-Marx began organizing a Centennial Exhibition of French Art as part of the Fair, to display the talents of French artists over the last century. Roger-Marx asked Renoir to contribute, but although the other artists represented included Manet, Monet, Cézanne and Pissarro, Renoir declined, writing to Roger-Marx: 'Flattered as I am by your kind invitation, I am obliged to refuse it, not

Left: The art exhibition at the 1889 Exposition Universelle. Renoir did not feel confident enough to exhibit.

Above: The Boulevard des Capucines and the Vaudeville Theatre, *Louis Beraud, 1889. A lively scene of a bustling Parisian boulevard in 1889.*

THE EXPOSITION UNIVERSELLE

In May 1889, the Exposition Universelle opened in Paris, where it was dominated by the Eiffel Tower. The massive iron structure served as the entrance to the exhibition that marked the centenary of the French Revolution. Since the mid-19th century, these World's Fairs had been held in Paris every 11 years. The 1889 Exposition was the largest interior space in the world at the time, and was filled with a spectacular display of exhibits, mainly glorifying French achievements, but including contributions from around the world.

having anything interesting enough to show to a public accustomed to seeing beautiful things. Everything I have done is bad and it would cause me a great deal of pain to see it exhibited.'

PROMISING SIGNS

Renoir continued to change his style, exploiting a rich palette and lively brushwork. By late December 1889, his mood began to lift. American buyers liked his work, and in Paris interest was growing. Renoir wrote to Durand-Ruel: 'I think it will work this time, it's very soft and coloured, but clear.' He wrote to Bérard: 'I'm in demand again on the market and I worked a lot in the spring: if nothing happens to disturb my work, it will go like clockwork.' He had not abandoned portrait painting and, as he frequented Berthe Morisot's soirées in Paris, he found many sitters there. He painted several portraits of her and her daughter Julie and she introduced him to the poet Stéphane Mallarmé (1842–98).

Right: The Washerwomen, *1889. In his changing style, Renoir has depicted five-year-old Pierre talking to Aline behind two figures at the riverbank.*

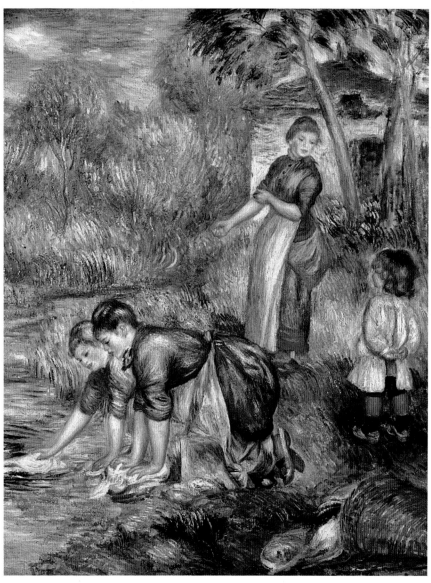

MARRIAGE

Renoir's new style was inspired by the art of Jean-Honoré Fragonard (1732–1806) and Jean-Antoine Watteau (1684–1721). The transition from his dry style proved popular, and his financial situation improved. Plump, maternal Aline continued to be his favourite model, and in 1890 he married her.

Henry Lerolle (1848–1929) was a painter and art collector who originally studied at the Académie Suisse with some of the Impressionists. He bought works by Degas and others in Renoir's circle. His daughter was a friend of Julie Manet and Renoir met Lerolle during one of his visits to the home of Berthe Morisot and her husband Eugène Manet. Once Renoir's style had softened, Lerolle commissioned him to paint several pictures of his daughters, Yvonne and Christine, and a portrait of himself.

NEW POPULARITY

In 1890, one of Renoir's paintings of Yvonne and Christine Lerolle, *Young Girls Reading,* was bought by an American for 2,100 francs. Durand-Ruel, who sold the painting, became distinctly more interested in his work again. In 1889, he had bought two of Renoir's figure paintings but the following year, he bought seventeen. Uplifted by his improving situation, after seven years of abstaining, Renoir entered a work for the Salon.

His portrait of Catulle Mendès' stepdaughters was accepted, but it was once again displayed in an obscure location. He later recalled: 'When I sent the little Mendèses, they were put under the awning where no one saw them.' That was the last time he showed work at the Salon.

FRICTION BETWEEN FRIENDS

Although they had been friends for nearly 30 years, Renoir and Monet fell out. Monet was selling his work for

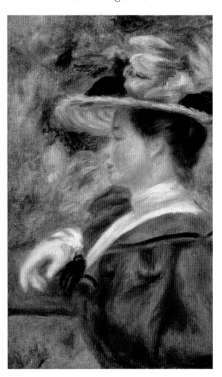

Above: Girl with a Glove, *1890. During the 1890s, Renoir returned to painting sun-dappling effects, including a narrow band of light across the facial contours.*

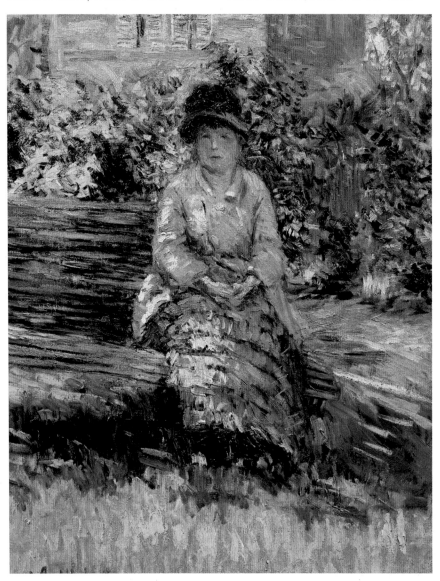

Left: Madame Renoir in the Garden at Petit-Gennevilliers, *Caillebotte, c.1891. In 1881, Caillebotte moved to his property on the banks of the Seine at Petit-Gennevilliers. Renoir and Aline often stayed with him there.*

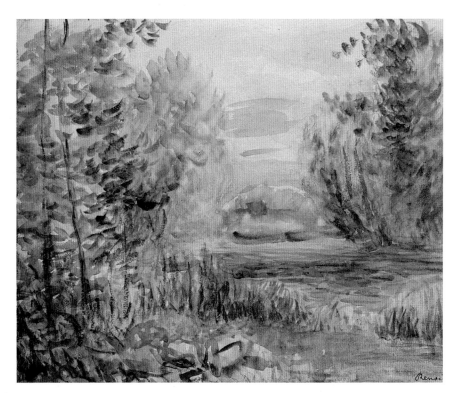

Left: Landscape, *1890. Watercolour was not Renoir's favourite medium, but its fluidity helped him to explore his natural affinity with colour.*

One of the main reasons for the marriage was to legitimize Pierre and this was distinctly documented in the marriage licence.

During that summer, Renoir spent over two weeks at La Rochelle and then stayed with Morisot and her family at their country home at Mézy-sur-Seine, in the Île-de-France region. Renoir and Morisot spent time painting together. Back in Paris, he moved to a large house with a garden near the place des Abbesses, which was not far from the Moulin de la Galette.

A FLATTERING ESSAY

In December 1890, Renoir's friend de Wyzewa wrote an essay in a short-lived journal, *L'Art dans les Deux Mondes*, which had recently been launched by Durand-Ruel. The essay praised Renoir's work, and explained his various changes of style. As a respected critic, the commentary helped to enhance Renoir's reputation.

Below: The harbour of La Rochelle, in south-west France on the Atlantic coast, where Renoir spent nearly three weeks just after his marriage.

much higher prices than Renoir by 1890 and had been increasingly successful since the 1886 New York exhibition. It was not a full-blown quarrel, but an irritation that manifested itself in sarcastic comments that upset their mutual friends. They had bolstered each other during hardship and to fall out when they were achieving success, albeit unequally, seemed a pity. The estrangement lasted for over a year, but once reconciled, their friendship returned to its previous warmth.

FAMILY LIFE

As sales of his work increased, Renoir became more confident of his ability to provide for his family, although he had actually supported them since Pierre's birth five years earlier.

That spring he married Aline on 14 April 1890, at the Town Hall of the ninth arrondissement in Paris. Renoir, Aline and Pierre gathered with four witnesses – Renoir's friends of over 20 years: Lhote, Lestringuez, Pierre Franc-Lamy and Federico Zandomeneghi.

AN HONOUR REJECTED

In May, despite the snub from the Salon and in consolidation of his growing success and recognition of his work, the French government at last offered Renoir the Légion d'Honneur. But as Monet had done less than two years earlier, Renoir refused it. It happened while he and Monet were not talking, but Monet, who was against official decorations, wrote to Caillebotte of the news: 'I congratulate him…true, it would have been useful, but he has to succeed without that. It's smarter that way.'

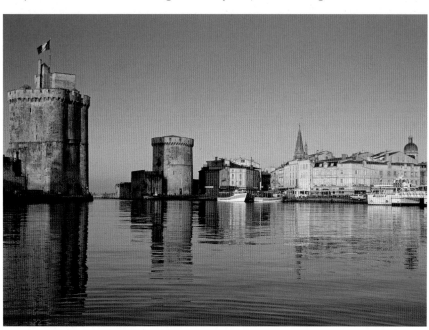

VISITING FRIENDS

With his increasing success, Renoir no longer felt the need to mingle with the upper classes in the hope of attracting their patronage. Instead, he spent 1891 visiting friends, where he painted, relaxed and tried to keep warm in order to ward off further symptoms of rheumatoid arthritis.

In February of 1891, Philip Hamerton, the editor of the British art magazine *The Portfolio*, published an extremely constructive review of Impressionism as part of a series, 'The Present State of the Fine Arts in France'.

ESCAPING THE COLD
From February to April, Renoir, Aline and Pierre stayed with de Wyzewa and his wife at their house, the Villa des Roses in Tamaris-sur-Mer, a seaside village near Toulon. They travelled there via Nîmes, Martigues and Aix-en-Provence, visiting Cézanne on the way. In an attempt to prevent a repeat of further painful symptoms, Renoir tried to spend the coldest months of the year working in warmer climates. He also discovered fresh material for new canvases when travelling around the countryside. As he was preparing for an exhibition, he updated Durand-Ruel regularly: 'I'm trying very hard to succeed without groping my way

any more. Four days ago I turned 50 and if at that age one is still searching, indeed it's a little old. I do what I can, that's all I can say.' Writing again a short time later, he said: 'This landscape painter's craft is very difficult for me, but these three months will have taken me further than a year in the studio. Afterward I'll come back and be able to take advantage at home of my experiments…to do a lot of figures for you.'

Renoir then took his family to Le Lavandou, along the south coast from Tamaris, and stayed at the Hôtel des Étrangers for the month. There he was saddened to learn of Chocquet's death. Like Renoir, Chocquet was a good-humoured, sensitive, man who had championed Renoir when he had little public support.

Below: Two Girls Drawing, c.*1890.*
In the early 1890s, Renoir's colourful paintings of elegant young girls contributed significantly to his success.

NOT 'MUCH OF A STIR'
As planned, Durand-Ruel held an exhibition for Renoir in Paris in July 1891. For the first time in years, the dealer included recent works by Renoir, but as Pissarro later reported to his son, the exhibition did not cause 'much of a stir.' By that time, Renoir and the other Impressionists were no longer perceived as rebellious or as breaking new ground, since younger artists had taken over that role and some had tragically been in the headlines. Vincent van Gogh (1853–90) had died the previous July and that March Seurat had died – both young, revolutionary painters – and other artists, such as Paul Gauguin (1848–1903) and Paul Signac (1863–1935) were still producing plenty for the art establishment to complain about, the public to scoff at and the critics to condemn. Nevertheless, although Renoir did have expectations of creating much agitation at the

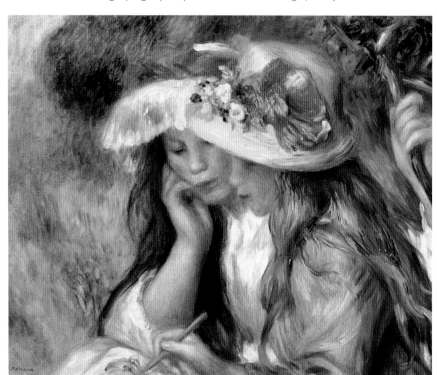

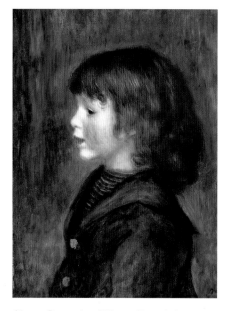

Above: Portrait of Pierre Renoir in a Sailor Suit, *1890. Renoir's paintings of Pierre as he grew up show that his son inherited his father's sweet nature.*

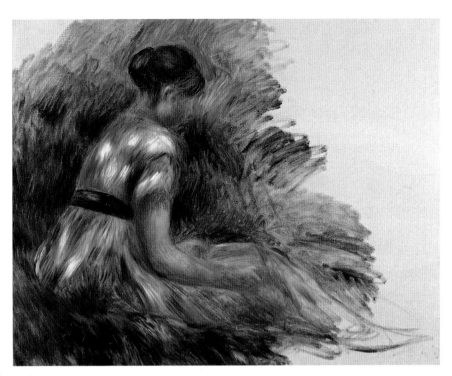

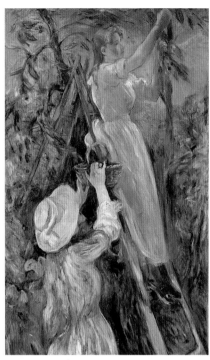

Above: Alice Gamby in the Garden (Young Girl Sitting on the Grass), *1891. Madame Gamby and her daughter Alice were friends of the Manet family who sat for works by Manet, Renoir and Morisot.*

Below: Girl in a Lace Hat, *1891, was painted by Renoir in the feathery strokes which he used frequently at that time, and the soft, cool blue tones that he favoured.*

Above: The Cherry Pickers, Berthe Morisot, *1891. Having watched her make preliminary sketches during his visit, Renoir urged Morisot to finish this painting of her daughter and niece picking cherries.*

Durand-Ruel exhibition, he would certainly have liked to have received greater approbation.

SURPRISING MORISOT

In August, Renoir was invited again to stay with Morisot and her family at their country home in Mézy. Having been close friends for nearly 20 years, Morisot was taken completely by surprise when Renoir introduced her and her husband to his wife and six-year-old son. He had not told Morisot of his marriage, just as he had not informed her of Pierre's birth, because he did not want to offend her refined sensibilities. In the 19th century, this would not have seemed as peculiar to Morisot as it might have done today.

After a month with Morisot, Renoir went to Petit-Gennevilliers near Argenteuil, to stay with Caillebotte, who lived there almost permanently. He was surrounded by a lush garden and his large Impressionist collection, which inspired him and his visitor, and that summer Renoir's influence noticeably pervaded Caillebotte's painting.

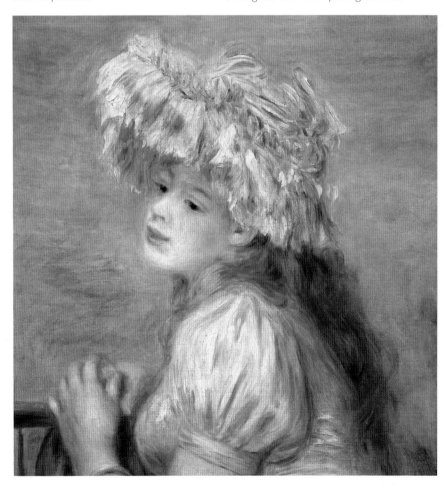

RETROSPECTIVE

In 1892 Mallarmé and Roger-Marx, both involved in the arts, decided it was time that Impressionist works were represented in national museums. Meanwhile, friends of Renoir were exasperated that in spite of his efforts, the French State had never made any official purchase from Renoir.

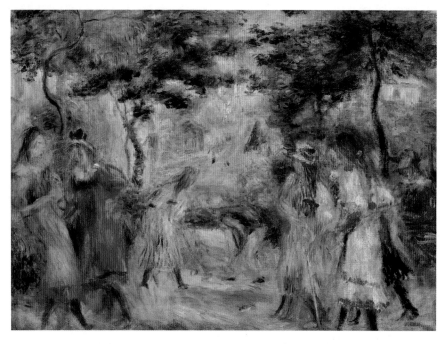

Below: In the Meadow, *1892. Renoir painted many works featuring two graceful young girls in natural surroundings. They were particularly popular with patrons.*

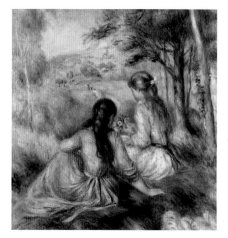

By the beginning of 1892, Renoir's income took an upward turn, and was flourishing as it had done after the success of *Madame Charpentier and her Children*, when it was shown at the Salon of 1879.

His success began to escalate further as patrons from Europe and America started to pay higher prices for his work than he had earned previously.

RENOIR'S NUDES

Although throughout the early 1890s Renoir produced numerous landscapes and paintings of charming and appealing young girls and children, he never abandoned the female nude. By the 1890s, his nudes had become fleshier, more voluptuous, their skin especially pearly and gleaming, and more like traditional portraits of mythological goddesses than ever. He famously said: 'I never think I have finished a nude until I think I could pinch it.'

Above: Children in the Garden, Montmartre, *1893. In complementary colours of red and green, the agitated brushwork gives a feeling of movement.*

MALLARMÉ AND MORISOT

Renoir had got along well with Mallarmé since first meeting him at Morisot's soirées. Mallarmé invited Renoir to his own regular gatherings in his home, along with Monet, Degas, Whistler, Gauguin and numerous other artists and writers of the day. At the beginning of 1892, Renoir began to paint Mallarmé's portrait, but had to stop because of poor health. He wrote to Mallarmé, dismissing his indisposition as toothache, chills and a fever, with a 'head like wood'. Eventually, he completed the portrait at the end of the year and presented it to the poet, inscribing it to his friend.

In April, Eugène Manet died. The younger brother of the celebrated artist was only 58 and had been extremely supportive of his wife's painting career. Suddenly, 14-year-old Julie Manet was fatherless, and at just 51, Morisot's hair

rapidly turned white and her health deteriorated. Already close friends to the family, Renoir and Mallarmé became even closer to Berthe and Julie, watching over them carefully and helping to manage their interests. Before her husband's death, Morisot had planned an exhibition at the Boussod & Valadon gallery in Paris, but as she was in mourning, she did not go to Paris for it. Renoir acted on her behalf and reported on its success.

A STATE PURCHASE

Just before Morisot's exhibition, Durand-Ruel held a one-man show for Renoir. Displaying 110 paintings produced over 20 years and lent by 19 collectors, it was the largest of Renoir's solo exhibitions to date. There were few derogatory reviews and critics were mostly complimentary about the retrospective. Prior to this, Renoir's friends had unanimously expressed the opinion that the State should have bought some of his work for national museums. Mallarmé and Roger-Marx had repeatedly urged the Ministry of

Fine Arts to purchase work by him and, in due course, they persuaded their friend Henri Roujon, the recently appointed director of fine arts, to buy a Renoir. By May 1892, the State had purchased his painting *Young Girls at the Piano*, and by November it was on display in the Musée du Luxembourg.

TRAVELLING

Although many of Renoir's former patrons did not buy his new works, several new buyers emerged, and they were prepared to pay fairly high prices for the paintings. Paul Gallimard, the owner of the Théâtre des Variétés in Paris, became one of his greatest patrons, and as frequently happened with Renoir, also became a close friend. Renoir painted a portrait of Gallimard's wife and, during the summer, the two men travelled to Spain. They stayed in Seville and Madrid, visiting the Prado where Renoir was especially impressed by the paintings of Velázquez. In the late summer, Renoir took his family on a tour of Brittany, to Pont-Aven, Pornic and Noirmoutiers, painting in each location.

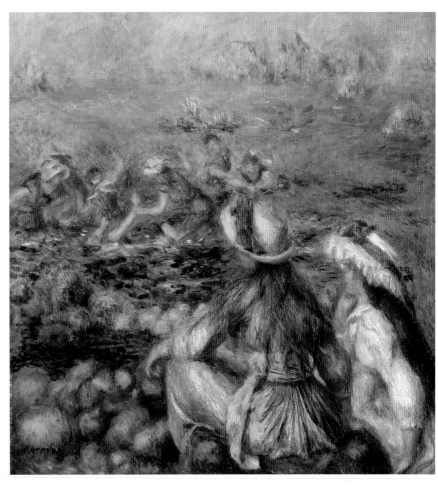

Below: View from Montmartre, 1892. *In the winter of 1892, Renoir moved to a studio close to the Sacré Coeur, from where he painted this view across the rooftops of Paris.*

Above: Bathers, 1892. *With a vibrant palette, small brush marks and a sense of vivacity and spontaneity, Renoir seems to have captured a mature form of his personal Impressionist style.*

Below: Bouquet of Roses in a Blue Vase, 1892. *By this time, Renoir was beginning to attract new patrons, and his flower paintings were proving to be particularly popular.*

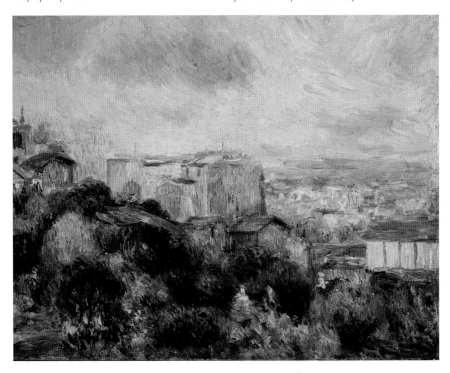

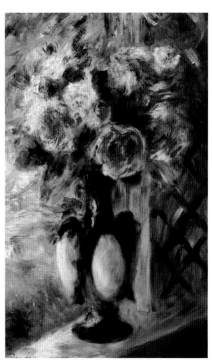

SUMMER IN PONT-AVEN

As Renoir's symptoms worsened and he realized that his illness was intensifying, he spent more time in the south of France where warmer temperatures helped to ease the pain and stiffness in his head, legs and hands. He stayed at Pont-Aven, which was popular owing to Gauguin having worked there.

At the end of April 1893, Renoir wrote to Gallimard from Beaulieu-sur-Mer near Nice: 'I think I will bring you back a landscape. I will only be able to know its real value when I get to Paris and see it in good lighting. I haven't sent a case of paintings, because I have worked much too much at my studies over a period of months.'

JEANNE BAUDOT

While in Beaulieu Renoir also wrote to Bérard, describing some of the paintings he was doing. After his return to Paris, he spent the whole of May working in his new studio on the paintings he had started in Beaulieu. In addition, he produced his first lithographs, and from 1893 to 1895, Roger-Marx and another journalist published a series of his prints.

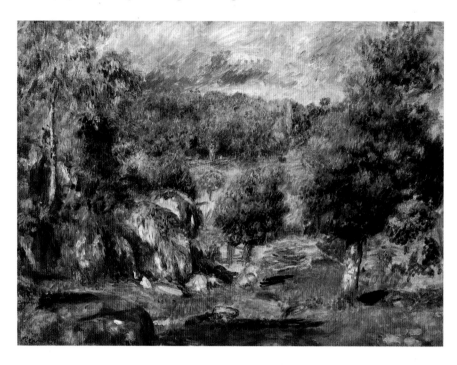

Below: Young Women and a Boy in a Landscape, *1893. This painting of Aline, Pierre and a friend returns to the dappled impressions of Renoir's pre-1880 works.*

Above: Pont-Aven, *1892. From Pont-Aven, Renoir wrote to Morisot that landscape was the only way that one could learn about one's craft.*

Below: Renoir continued to develop his unique portraiture style, blending empathy without sentimentalism, as in Young Woman in a Red Dress, *c.1892.*

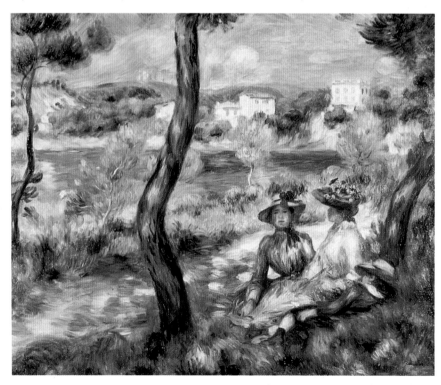

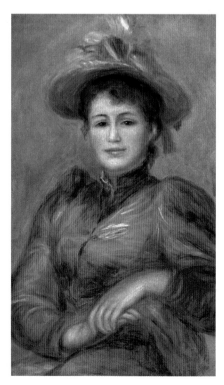

GAUGUIN

At Degas' instigation, Durand-Ruel held an exhibition of Gauguin's work in November 1893. Gauguin was fast becoming a legendary figure, having broken all the rules of life and art. He had left his wife and five children in order to pursue his artistic ambitions, and painted flat, decorative pictures, heavy with symbolism and enriched with bold colours. Currently living in Tahiti, his Durand-Ruel exhibition coincided with his return to France for a short time, and Renoir and Monet – now reconciled – visited the exhibition together. The show received a mixed reception, however, and Renoir expressed his abhorrence of Gauguin's work.

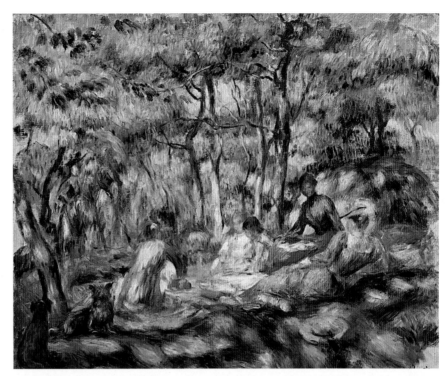

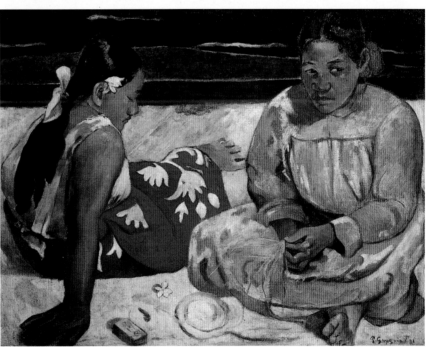

In June, he travelled to Gallimard's home in Bénerville near Deauville, to show him some paintings he had produced – Gallimard was one of his most avid patrons at the time. There, he was introduced to a close friend of Gallimard's, a physician, Dr Baudot, who gave him advice on his health, and whose 17-year-old daughter wanted to learn to paint. Jeanne Baudot (1877–1957) was a gentle and earnest girl, and Renoir was willing to teach her, but what neither anticipated, considering the 35-year age gap, was that they would become lifelong friends. From the moment Renoir began teaching Jeanne, she showed an understanding, sensitivity and maturity that would be of great comfort to him as his illness worsened, and a positive influence when he inevitably doubted his abilities.

NORMANDY AND BRITTANY

After visiting Gallimard, Renoir travelled to Essoyes, via Falaise and Domfront in Normandy and Chartres in the Loire Valley. In July, he once again travelled to the Normandy coast, this time to Saint-Marcouf near Cherbourg. He stayed for a week in July, without Aline and Pierre. Letters survive that Aline wrote to Renoir while he was away. They are evidence that theirs was a warm and loving relationship and that she missed

Top: Picnic, c.1893. With rich, iridescent colour, Renoir's patchy brush marks create an effect of light and warmth.

him when he was away, spending the time sorting out chores for him, such as a leak in his studio roof or having curtains made to subdue the light. In August, she, Renoir and Pierre spent a fortnight at Pont-Aven. From the 1850s, painters had started to travel there, often living in groups, as it was

Above: Women of Tahiti, Gauguin, 1891. To a mixed reception, Gauguin's brilliantly coloured paintings were shown at Durand-Ruel's gallery in 1893. Renoir hated them.

unspoilt and unaffected by tourism, and the high prices of Paris had not yet reached Pont-Aven. Since Gauguin first worked there in 1886, it had become more popular with artists who sought to capture landscapes and figures unsullied by technological progress.

A NEW MODEL

In December 1893, Renoir had commented that he was surrounded by sick friends, but he had not realized the enormity of the situation. In 1894, he was devastated by the deaths of his good friends Caillebotte, De Bellio and Chabrier. Later, his spirits were slightly lifted by a new model.

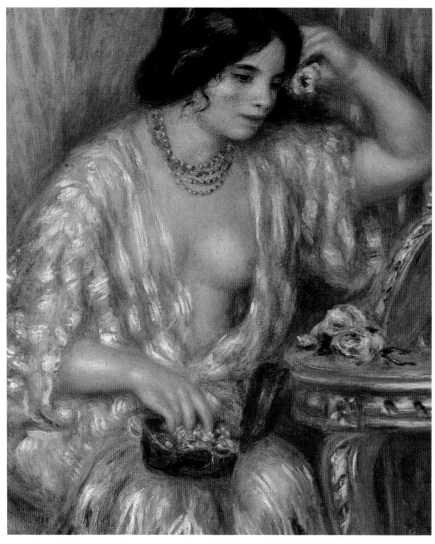

Above: Self-portrait, *Gustave Caillebotte, c.1889. Generous, clever and a good friend to the Impressionists, Caillebotte died suddenly at his home of pulmonary congestion. He was just 46.*

In January 1894, indicative of his increased prestige, several works by Renoir were included in an exhibition in London, and the following month he was represented, along with Morisot, Sisley and others, at the first exhibition of La Libre Esthétique in Brussels, Maus' new venture after Les XX had dissolved. His reputation was spreading rapidly around Europe and the US.

TOLERANCE AND FRIENDSHIP

By the 1890s, the Impressionists had been exhibiting for over 20 years. Many of them were beginning to sell their

Above: Gabrielle Wearing Jewels, *1910. Renoir never tired of creating richly-hued, decorative images of Gabrielle.*

work for high prices, while younger artists were creating the current shock waves. So they were irritated by the establishment's view of the Caillebotte legacy (see box opposite). The Academic Realist Jean-Léon Gérôme (1824–1904) had declared 'Morality would indeed be at a low ebb if the State accepted such filth.' Throughout the Caillebotte controversy, Renoir saw Morisot often. He kept her busy, inviting

her and 15-year-old Julie to dinner with friends, making portraits of her and her growing daughter, and painting with her in his studio. Morisot encouraged his friendship with Degas. The two men had not been close since Degas had started organizing the Impressionist exhibitions, but now, in their 50s, they were more tolerant, and discovered that they shared many opinions.

THE DURET SALE

Renoir's old friend Théodore Duret had recently suffered substantial business losses, and in 1894 he had to sell a large part of his art collection. The works were auctioned at the Hôtel Drouot and Julie Manet wrote about the sale in her diary: '…As for M. Renoir's paintings, they're really lovely – one landscape and one picture of a nude combing her hair; the head, which is slightly foreshortened, is delightful and the whole picture is painted in very attractive, pleasant colours.'

Right: With close connections to music throughout his life, Renoir often painted young women and men playing a guitar. This delicate work, Music, 1895, formed part of a series of works on the same theme and composition.

JEAN AND GABRIELLE

On 15 September 1894, Renoir became a father again when Aline gave birth to Jean, their second son. Overjoyed, Renoir immediately wrote to Morisot to tell her the news, as he had not been able to do when Pierre was born. He also informed many other friends and asked his dealer's son, 28-year-old Georges Durand-Ruel, to be Jean's godfather, and 18-year-old Jeanne Baudot to be godmother.

A month before the birth, Aline's 15-year-old cousin, Gabrielle Renard, moved to Paris from Essoyes to take care of the children. She became an important member of the family, and that summer, Renoir painted the first of many portraits of her. Her looks were very arresting, and she became his favourite model. Renoir featured her in some of his most engaging images of women and children.

Below: Head of Gabrielle, c.1901. This small portrait of Gabrielle is just one of many ingenuous images Renoir captured of her.

THE DEATH OF CAILLEBOTTE

On 21 February at the age of 46, Caillebotte died suddenly while he was in his garden at Petit-Gennevilliers. Renoir was his executor, and in his will Caillebotte had bequeathed his large art collection to France, stating that it should remain together and be displayed in the Musée du Luxembourg, which was devoted to living artists. His collection included many works by Renoir, Pissarro, Monet, Sisley, Degas, Cézanne and Manet. Despite their increasing popularity, however, French art officials still condemned the Impressionists' work and rejected the paintings – there was not enough space to hang the entire collection anyway – so Renoir housed the 67 works in his studio. He managed to negotiate with the art officials and, three years later, they accepted 38 works from the legacy. Most of the paintings they refused were by the original Impressionists. Of those artists, they accepted six paintings by Renoir, two by Manet, eight by Monet, seven by Pissarro, two by Cézanne and seven by Degas.

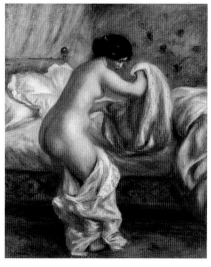

Above: Gabrielle Arising, c.1909. Capturing the delicacy and grace of 18th-century paintings, this shows Renoir's thoughtful organization of colour.

FRIENDS AND FAMILY

During this time of relative calm, Renoir continued to attract buyers, but he was suffering with debilitating symptoms. He carried on working despite the pain, travelling around France and staying with friends. In January 1895, he stayed at the home of his pupil Jeanne Baudot and her parents.

Continuing to avoid the cold as much as possible, in mid-January, Renoir was pleased to be invited to stay with Dr Baudot and his family in Carry-le-Rouet near Martigues. That spring, Gallimard and Renoir visited England and The Netherlands.

SHOCKING NEWS
During the preceding year, Renoir had experienced an attack of rheumatoid arthritis, and had undergone some thermal bath therapy, which eased the symptoms briefly. His spell in the south of France with the Baudot family uplifted him, and he also visited Cézanne before returning to Paris. At the beginning of March, he received the distressing news that Morisot, aged just 54, had died of pneumonia. She bequeathed paintings to Renoir, Monet and Degas, and she named Renoir and Mallarmé as Julie's guardians. Later, Julie recalled Renoir's reaction to the news of her mother's death: 'He was in the midst of painting

alongside Cézanne when he learned… He closed his paint box and took the train – I have never forgotten the way he came into my room on the rue Weber and took me in his arms.' Renoir wrote to a friend: 'We have just lost a dear friend, Berthe Manet. We are taking her to her last resting place, friends only, Tuesday morning at ten.' Deeply affected by the death of another close friend, Renoir's compassion and kindness was never more evident. Sixteen-year-old Julie

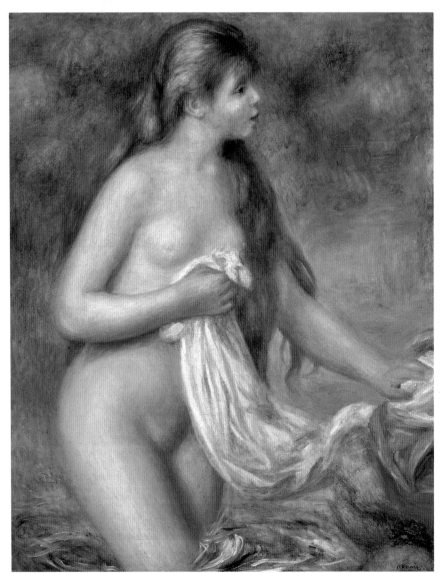

Above: A photograph of Julie Manet at 16 years old, taken in 1894 before her mother died.

Left: Bather with Long Hair, c.1895. With a subdued palette, diffused lighting and soft gradations of tone, Renoir created an ethereal, almost classical image.

AMBROISE VOLLARD

Born on the French island of La Réunion, Vollard moved to Paris to study law in 1887, when he was 21. However, rather than pursue a law career, he went against his father's wishes and started art dealing from a tiny garret in Montmartre. His first breakthrough was to persuade Manet's widow to let him buy Manet's unfinished paintings. In 1893, he opened his own small gallery on rue Lafitte and rapidly became a hugely successful dealer, who helped to shape the public's idea of modern art. Renoir became a lifelong friend.

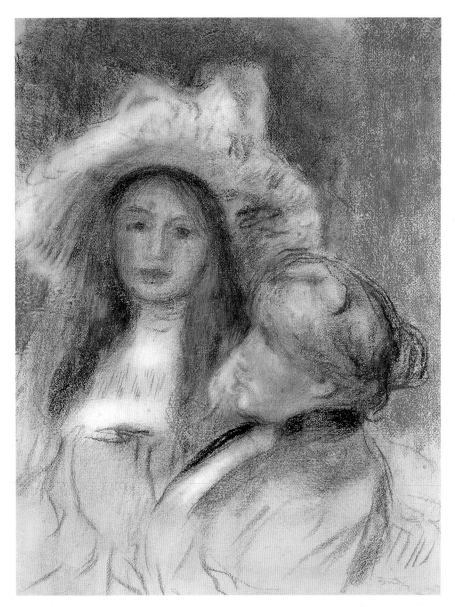

went to live with two cousins, also orphaned, and in August Renoir took the three girls with his family to Brittany. While there, he gave the girls painting lessons. Renoir remained close to Julie for the rest of his life.

A NEW DEALER

Toward the end of 1894, Morisot had introduced Renoir to the dealer Ambroise Vollard (1866–1939), who had opened his Paris gallery on rue Lafitte in 1893. He soon became one of the most discerning art dealers of his generation. Although Renoir was still loyal to Durand-Ruel, by that time he was successful enough to be able to have more than one dealer, so he also sold work to Vollard. In November 1895, Vollard held an exhibition of Cézanne's work, which he had been buying against popular opinion for some time. At the exhibition, Renoir and Degas were so keen to buy a particular painting of pears by Cézanne, that they drew lots for it. Degas won and duly purchased the work. Renoir later bought a number of other paintings by Cézanne.

That April, the American Art Association in New York held a sale of works by Renoir, Degas, Guillaumin, Monet, Pissarro and Sisley and, in May, Murer held an exhibition of works by Renoir, Pissarro, Monet and Sisley at a hotel he had bought in Rouen.

Above: Berthe Morisot and her Daughter, *Renoir, 1894. This pastel was a preparatory sketch of Morisot and Julie. Renoir greatly admired Berthe Morisot's intelligence and talents.*

THE HOUSE IN ESSOYES

Renoir had lived in many rented places in Paris, and had spent much time staying with friends – he had never yet bought a home of his own. At the end of 1895, he rented a house in Essoyes and three years later he bought it, with the aim, he said, 'of retiring to the country and fleeing the expensive models of Paris'.

Right: The house that Renoir bought in Essoyes. The village and surrounding countryside were sources of inspiration.

LA REVUE BLANCHE

In memory of Morisot, in March 1896, Monet, Degas, Renoir and Mallarmé organized a retrospective exhibition of her work at Durand-Ruel's Paris gallery. Julie Manet collected the 300 paintings together and Renoir, despite being in poor health, oversaw the hanging with Monet and Degas.

After the opening of the Morisot retrospective, Renoir wrote to Julie, congratulating her on its success. The loose brushstrokes and bright colours of Morisot's paintings proved popular with both the public and critics, and there were many positive reviews. In the 19th century, it was very difficult for a woman to be accepted in the world of work, and particularly as an artist. Renoir shared the general opinion that women should run their homes and bring up children, while men dealt with the world outside the home. Yet against his beliefs, Renoir encouraged and helped Morisot to do both.

FLATTERING ARTICLE

As soon as Morisot's exhibition closed, Renoir began preparing for two exhibitions of his own. In May, as in the previous year, Murer put on another exhibition of works by Renoir, Monet, Pissarro, Sisley and Guillaumin at his hotel, the Hôtel du Dauphin et d'Espagne in Rouen. He included 30 paintings by Renoir. Simultaneously, Durand-Ruel held a one-man show for Renoir at his Paris gallery, and displayed 42 of his paintings.

La Revue Blanche was an influential literary and artistic journal, published in Paris by the brothers Thadée, Alfred and Alexandre Natanson from 1891 to 1903. Supporting the avant-garde, the magazine included translated articles and stories by leading foreign writers, such as Tolstoy, Ibsen, Kipling and Twain, and by French writers, including Zola, Gide, Proust and Mallarmé. Most exhibitions of 'modern' artists were reviewed in it and in June, Thadée Natanson published an article about Renoir's solo show at Durand-Ruel's gallery. In a positive appraisal, Natanson described Renoir's 'religious enthusiasm for the ancients, his warm reverence for the 18th century'. Most of the reviews were also complimentary; only a few criticized the work.

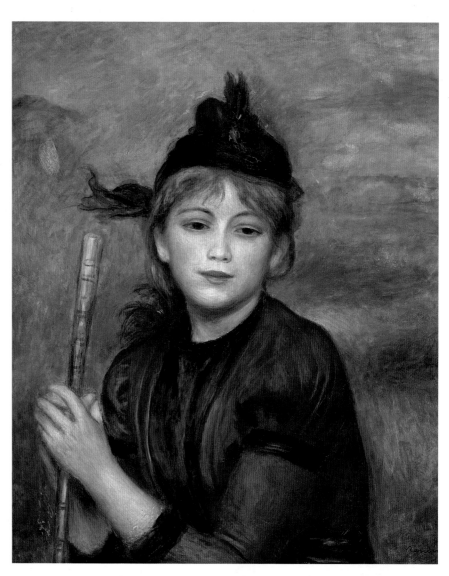

Above: The Excursionist, 1896. In Renoir's mature style, he painted this woman with finely applied layers of soft, glowing colours.

GERMANY

Once again, Renoir moved from his Parisian apartment. In 1896, for the first time in 23 years, he moved from Montmartre to a location slightly nearer to the centre of Paris. His new

Right: Taken c.1892, this photograph is a record of the close friendship between Renoir (seated) and Mallarmé.

Right: Eugène Manet on the Isle of Wight, *Morisot, 1875. The first woman to join the Impressionists, despite the protests of her upper-class friends and family, Morisot continued to make art her life's work.*

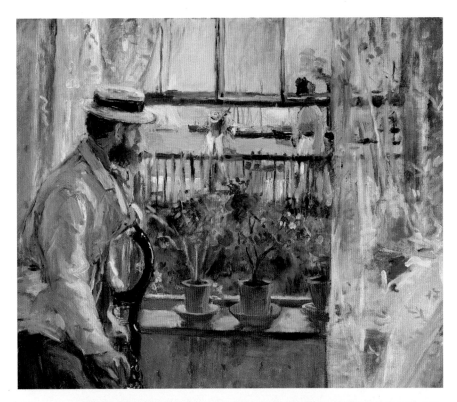

apartment was on the fifth floor at 33 rue de La Rochefoucauld, close to the place Pigalle, and he rented a studio at number 64 in the same road.

In July, he travelled to Germany with Caillebotte's brother Martial and went to a four-day event of Wagner operas in Bayreuth. Although he had always been an admirer of Wagner's, Renoir was unexpectedly bored by the music and left Bayreuth before the four days were over. He travelled to Dresden to visit the museums and was impressed with the new ideas emerging there.

At the end of 1896, Renoir's mother died aged 89. Despite his own failing health, he had continued to visit her regularly in Louveciennes.

Right: Girl with a Letter, c.1890–95. *Throughout his career, no matter what his style at the time, Renoir always painted beautiful, almond-eyed women.*

RENOIR'S MATURING TECHNIQUE

Jean Renoir wrote a book about his father's life. He described his methods and palettes, which in his mature work included flake white, Naples yellow, yellow ochre, raw sienna, red ochre, madder red, terre verte, Veronese green, cobalt and ivory black. Having not used black during his Impressionist years, Renoir subsequently claimed it was 'the queen of colours' and used it often. He was never wasteful with his paints, and had no faith in new methods that had not withstood the test of time, so his pigments were always ground by hand in a traditional colourman's workshop. By the 1890s, rather than using stretched canvases, he bought large rolls and cut off pieces of the size he required, pinning them to a board as he worked.

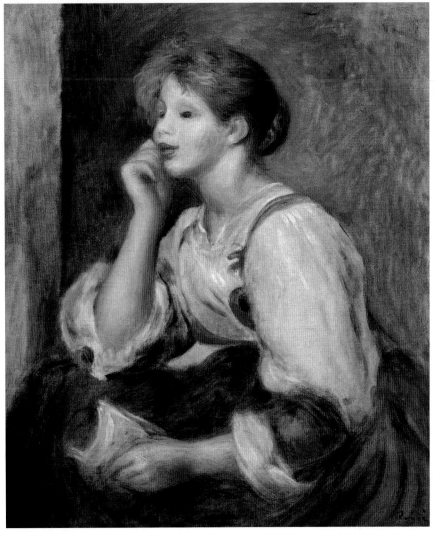

THE CAILLEBOTTE BEQUEST

By 1897, even Sisley, who had struggled when his friends' fortunes were improving, began earning more for his paintings. Impressionist exhibitions were held in various venues across Europe, and the work was largely well received. Renoir and Monet in particular began to command high prices.

In February, Durand-Ruel sent 11 paintings by the Impressionists to an international exhibition in Dresden. The prestigious New English Art Club also included work by Renoir in an exhibition in London that spring. By that time, the Art Nouveau movement was becoming established, in Paris, Dresden and some other cities.

THE MUSÉE DU LUXEMBOURG
After three years, Renoir had finally managed to negotiate with French art officials over Caillebotte's legacy. Henry Roujon, the director of the Beaux-Arts, and Léonce Bénédite, the director of the Louvre and Luxembourg museums, had suggested that they would hang some works in the Musée du Luxembourg and send the rest to museums in other parts of France. Renoir and Martial rejected the proposal. Eventually, in February 1897, in a newly built wing in the Musée du Luxembourg, the 38 paintings selected from the bequest were displayed. Pissarro complained that the works were in cramped conditions, and Monet described the 'little corridor where all the paintings are touching, very narrow'. Whatever the shortcomings of the hanging, the works were the first group of Impressionist paintings displayed in a national museum. Because of Caillebotte's generosity to his friends in life, after his death, Impressionism forced its way into the public domain, and acknowledged the abilities of the artists concerned.

AN ACCIDENT
In September, while in Essoyes, Renoir fell off his bicycle on to a pile of rocks and broke his right arm, just as he had done in January 1880. Once more, he had to paint with his left hand, but once again, it did not make much difference to his work, as Pissarro commented later: 'Didn't Renoir, when he broke his right arm, do some ravishing paintings with his left hand?'

By 1897, Renoir was no longer searching for a new style. He continued to draw on methods of the Old

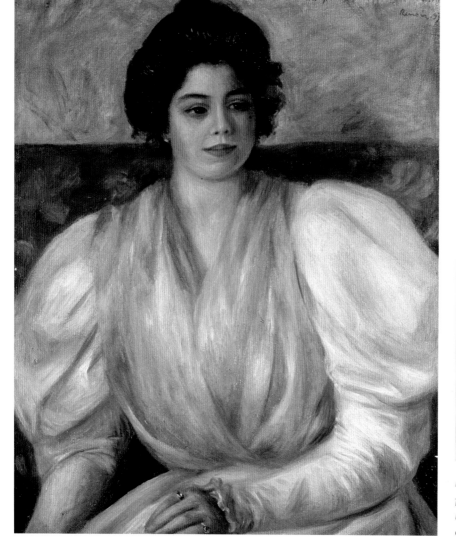

TEACHING

While Renoir's arm was in plaster, Julie Manet arrived to stay with them at Essoyes. He continued teaching her as he had done during their stay in Brittany. By that time he was regularly teaching Julie, her orphaned cousins, Jeanne and Paule Gobillard, and Jeanne Baudot. He advised them to spend as much time as they could copying at the Louvre. Back in Paris, he met them every fortnight at the Louvre, advising them on their drawing and painting techniques.

Left: Christine Lerolle, *1897. Renoir painted the daughters of his friend Henry Lerolle several times. This is his eldest daughter at 17 years old.*

Above: View of a Room in the Musée du Luxembourg, *c.1897, by an unknown artist, shows where the Caillebotte bequest was eventually housed.*

Masters he admired, as well as more modern artists and his own experiences. In contrast with the paintings of his dry period, his figures were now carefully integrated and harmoniously related to each other within their settings. His working methods were classical, as the painter Maurice Denis (1870–1943) observed: 'Renoir draws on tracing paper and modifies his painting by means of successive tracings.' He also returned to themes of social interaction such as those he had painted earlier: visits to the theatre, friends mingling and fashionably dressed women. Women appeared more frequently and men less so; figures seemed heavier and his brushstrokes and tonal contrasts portrayed softness yet solidity.

Above: The Alphabet, *1897. Jean at four years old with Gabrielle. Small boys wore what we now perceive as girls' clothes.*

He continued visiting friends, reviving many of the friendships he had made over the years. At these friends' homes, he painted members of the family or surrounding locations. In the late 1890s, he often visited his friend Lerolle and

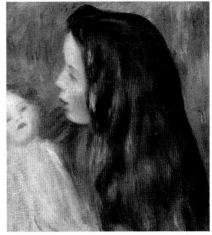

Above: Girl with a Doll, *c.1897. A warm, muted palette and directional brushstrokes add to the illusion of gentleness.*

painted his daughters. He also continued to visit Gallimard, and often accompanied him to the Théâtre des Variétés, where he was inspired by theatre-related themes as he had been in the 1870s and 1880s.

ADMIRING REMBRANDT

By the end of the 1890s, the Impressionists were better known. International exhibitions had become popular and by the turn of the 20th century, they had been included in exhibitions in New York, Stockholm, Venice, Berlin, Brussels, Florence, London, Munich and Vienna among other places.

After their participation in several international exhibitions, the Impressionists' reputation was growing outside France. In 1898, works by Renoir, Degas, Monet, Manet and Sisley were included in an exhibition of the International Society of Artists in London, and, helped by his son, Durand-Ruel also organized exhibitions of their work in Berlin and Munich.

THE MEDITERRANEAN COAST

Because of the continuing deterioration of his health, in February 1898, Renoir travelled to the south of France in search of sun and warmth. He discovered Cagnes-sur-Mer on the Mediterranean coast between Antibes and Nice. Its mild climate and beautiful landscape instantly appealed to him, and he constantly enthused to his friends about it. From then on, he returned to the resort often and painted the surrounding area, bathed in its distinctive golden light.

Right: Young Woman with a Flower over her Ear, *1898. Renoir never tired of exploring and repeating soft, sensuous visions of femininity.*

Below: Near Berneval, *1898. A soft-focus scene of the Renoir family relaxing in the Normandy countryside.*

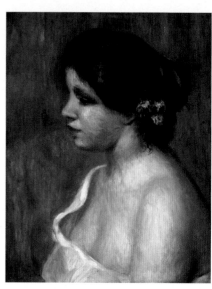

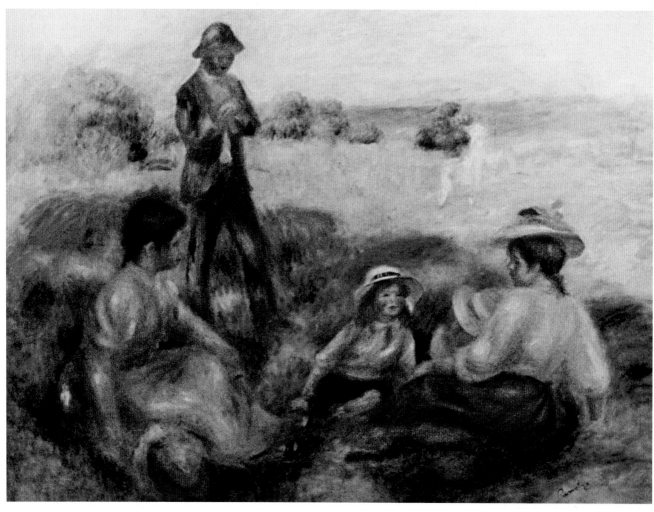

Right: Renoir and friends, photographed the day after Mallarmé's funeral on 12 September 1898.

SUMMER

From May to June, Durand-Ruel staged an exhibition at his Paris gallery, featuring works by Renoir, Monet, Pissarro and Sisley, with an entire room devoted to Renoir. In June, works by Renoir, Monet, Degas and Pissarro were exhibited at the Guildhall Art Gallery in London, and in July, Whistler organized another exhibition in London that included work by Renoir, Degas, Monet, Manet and Sisley. By this time, nearly all reviews of Renoir's work were favourable, and even the few that were uncomplimentary could not

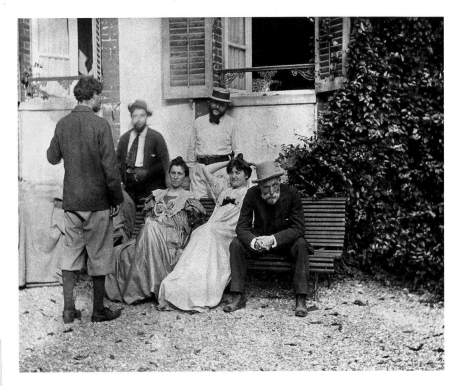

Right: Renoir and friends, photographed the day after Mallarmé's funeral on 12 September 1898.

DEATH OF MALLARMÉ

While in Essoyes, Renoir learned of his close friend Mallarmé's sudden death of an infection of the larynx at just 56 years old. It was another shocking upset. Mallarmé and Renoir had been close friends since Morisot had introduced them in 1889. They shared the responsibility of guardianship of Julie Manet, as well as many friends and opinions. A poet and prose writer and champion of the Impressionists, Mallarmé was an influential literary figure of the 19th century. Renoir took Julie to the funeral in Valvins, Fontainebleau. She wrote of it in her diary: '…It was horrible to see the charming interior without M. Mallarmé and instead of hearing him talk in the garden under the chestnut tree…to see his coffin was atrocious…. He and M. Renoir were both great friends… I never thought that last winter we enjoyed their conversations together for the last time… Writers and peasants, with whom Mallarmé was so pleasant, were gathered in large numbers in the garden to follow the funeral and it was particularly distressing to see the pain on every face.'

adversely affect his by now secure status. In July, he rented a chalet for his family and Julie Manet at Berneval near Dieppe. Julie's cousins Jeanne and Paule travelled to stay with them for several days, and Renoir continued to teach them painting skills. The Renoirs spent the rest of the summer at Berneval, and returned to their house in Essoyes in September.

INCREASING INFIRMITY

In October, accompanied by his friends Bérard, Durand-Ruel's son Georges and two others, Renoir travelled to The Hague and Amsterdam. In Amsterdam he saw a major Rembrandt exhibition and was impressed and astonished by the paintings, with their strong tonal contrasts, balanced palettes, graphic brush marks and expressive, evocative atmospherics.

On his return to France, Renoir's health took a turn for the worse and he wrote to Durand-Ruel: 'I haven't mentioned my health because it's a little difficult; one day bad, one day better: in short I think I'll have to get used to living in this way.' Julie wrote: 'It is so painful to see him in the morning not having the strength to turn a doorknob.'

In the winter, Durand-Ruel again staged exhibitions for the Impressionists in Munich and Berlin, and Renoir stayed with Gallimard, producing designs for some decorative interior panels for him, which he never completed.

Above: The Environs of Berneval, *1898. In an impressionistic style, Renoir captured long, golden shadows as they suffused the landscape.*

CAGNES-SUR-MER

At the start of 1899, Renoir travelled to Cagnes-sur-Mer to receive treatment for the rheumatism that was beginning to dominate his life. Another tragedy occurred at the same time. At the age of 59, Sisley died of cancer of the throat, leaving his family with large debts.

Less than three months after his wife died of throat cancer, Sisley, one of the founding Impressionists, also died of the same disease. Consistently, he had remained faithful to their original aims of painting 'en plein air' throughout his life, but although he had been on the cusp of recognition, when he died, he left his family destitute.

Renoir and Sisley had not been friendly since Manet's death in 1883, but Renoir naturally still felt saddened by his former friend's passing. When Monet organized a posthumous exhibition at Petit's gallery that April to raise money for Sisley's family, Renoir contributed one of his paintings, as he said to 'benefit the Sisley children'. At only 58 years old himself, he was feeling ill and miserable. In February, Jeanne Baudot travelled with him to Cagnes-sur-Mer, where he underwent treatment to ease his

Above: Cagnes, Les Collettes, Renoir, 1910. The blaze of colour and lightness of brushwork encapsulates the affection Renoir felt for the location.

painful rheumatism. Jeanne spent around two weeks with him, and he stayed on until May.

PROMOTING RENOIR
On the whole, Renoir still remained loyal to Durand-Ruel, even though most of the other Impressionists were selling their work to several dealers. Durand-Ruel continued to promote Renoir and the other Impressionists. In January and February 1899, 12 of Renoir's works were displayed in an exhibition in St Petersburg and four paintings were shown in another international exhibition in Dresden. In April, a major joint exhibition of works by Renoir, Monet, Pissarro and Sisley opened at

Above: Girl with a Red Hat, 1899. The happiness that imbues all Renoir's work gives no hint of the pain he was suffering.

DONATING A PAINTING

From Grasse, Renoir wrote to Durand-Ruel and asked him to send his painting *Portrait of Jean Renoir as a Child* as a gift to the municipal museum in Limoges, in recognition of his birthplace. The museum gratefully accepted his donation.

Right: The Loing Canal at Moret, *Sisley, c.1892. In 1880, Sisley settled in Moret-sur-Loing, near Fontainebleau. Untiringly, he painted the local landscape, remaining faithful to the original Impressionist ideals of painting in the open air.*

Durand-Ruel's Paris gallery, including 41 Renoirs, and he was also represented that month at two London exhibitions: at the International Society of Sculptors, Painters and Gravers (Whistler was the society's president) and at the Grafton Galleries. The following month, the sale of the collection of Count Armand Doria was held in Paris. It included ten Renoirs and Durand-Ruel paid a record 22,100 francs for one from 1877. In July, Chocquet's collection was auctioned – his widow having died earlier in the year – and the Renoirs commanded high prices there. Durand-Ruel paid 20,000 francs for one produced in 1879.

Renoir received no money from these resales. In fact, as his expenses were so high, he was short of money. He was paying for medical treatment: doctors and dentists; employing servants and models; entertaining guests; and he had sent Pierre to boarding school. Because of financial difficulties, he sold the pastel by Degas that he had acquired from the Caillebotte estate, in order to buy a painting by Corot. Insulted, Degas wrote him an angry letter and a rift occurred, which upset their mutual friends. Some weeks later, however, they met and resolved their quarrel. They had been through too much to allow the quarrel to spoil their friendship.

That summer, Renoir rented a house at Saint-Cloud, where he was visited by his friends Vollard and de Wyzewa. He then travelled to Essoyes with Aline and the children, and invited Julie Manet and Jeanne and Paule Gobillard to stay with them in August. Then, following the advice of Dr Baudot, he went to Aix-les-Bains in south-eastern France to take thermal bath treatments. He stayed there for two weeks, hoping to cure his painful symptoms, but felt only temporary relief.

Left: Farmhouse at Cagnes, *Renoir, c.1907. From the first time he visited it, Renoir loved Cagnes-sur-Mer and captured many views of the unspoilt countryside.*

THE PARIS WORLD FAIR

At the turn of the 20th century, the Impressionists' reputation was thriving. Increasingly, they were represented in exhibitions and museums and written about in articles and books. The Exposition Universelle in 1900 featured a Centenary Exhibition that included works by many of them.

In 1900, Renoir's work had soared in value. His canvases commanded far higher prices than any of his friends'. An average price for one of his paintings was about 22,000 francs, while Monet's were selling for about 10,000, Pissarro's for about 8,500 and Cézanne's for about 6,000 francs.

LÉGION D'HONNEUR

As a consequence of his popularity, Renoir's work was shown in five exhibitions that year. In January, he was represented with over 60 paintings at Bernheim-Jeune, a Parisian gallery, then in April, 21 of his works were included in a shared exhibition with Monet at Durand-Ruel's New York gallery, and further paintings were sent to Berlin and Glasgow. At the 1900 Paris Exposition Universelle, 11 of his works were displayed in a grand Centenary Exhibition, celebrating the skills of French artists. That year, he was once

Above: Renoir, looking older than his 59 years, stands between Gabrielle and Aline in the sunshine of the south of France, c.1900.

again asked by the State to become a chevalier of the Légion d'Honneur. Unlike his reaction a decade previously, this time, on 16 August, he accepted. Most of his friends and family were delighted that he had finally been recognized, but Monet, who scorned such things, felt differently. In two letters to Monet, Renoir tried to justify his actions: 'I let them decorate me. Be assured that I am not letting you know to tell you whether I am wrong or right, but so that this little piece of ribbon does not become an obstacle to our old friendship.' Three days later, he wrote again: 'I wonder what difference it makes to you whether I am decorated or not. You are admirably consistent in your behaviour, while I have never been able to know the day before what I would do next.' Monet, it

Left: Landscape at Noon, c.1900. Renoir said of the south of France: 'In this marvellous country, it seems as if misfortune cannot befall one; one is cosseted by the atmosphere.'

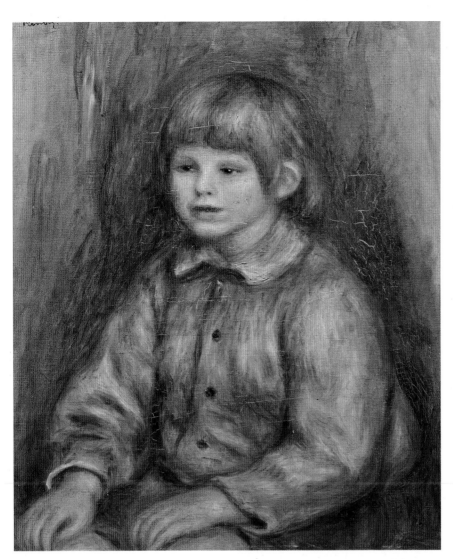

Left: Seated Portrait of Claude Renoir, 1900. Renoir tried out some new pigments – here, the addition of emerald green to his palette adds vibrancy to a static portrait.

THE CENTENARY EXHIBITION

Renoir continued to travel about France, hoping the warmth would relieve his symptoms. From January to May, he rented a house near Magagnosc, not far from Grasse. Following that, he spent several days in a hotel in Avignon on his way to Saint-Laurent-les-Bains, near Aix-les-Bains, where he underwent further therapeutic treatment. In August, he stayed with his siblings at Louveciennes, and from November, he returned to Magagnosc for six months. He only spent June and July in Paris, when he visited the Exposition Universelle. Lasting from 15 April to 12 November, the exhibition celebrated the achievements of the past century. Many buildings were constructed for it, including the Gare de Lyon, the Gare d'Orsay, the Grand Palais and the Petit Palais, and more than 50 million people visited. The Petit Palais was built especially to house the retrospective fine-art exhibition that demonstrated the diversity and developments of French art over the last century. Initially, Renoir, Monet and Pissarro refused to exhibit, but in the end they all submitted work that had previously been spurned by the establishment.

seems, did not judge his friend by his own standards as their friendship continued unharmed.

JULIE'S ENGAGEMENT

When Julie Manet told Renoir that she was engaged to Ernest Rouart, the son of his old friend and patron Henri, he was delighted and wrote back: 'A thousand bravos! My dear Julie, this is a piece of good news that fills my wife and me with joy. Now I can tell you that he was the fiancé of our dreams. My wife had spoken of it to Degas while coming back together from a dinner at your house…Our wish has been fulfilled. Again bravo! …as the old man of the

mountain, I send you this old saying: when happiness comes into the house, you must count to three. We kiss you all…and I'm ordering a new suit.'

Right: Pavilions of the Nations along the River Seine during the 1900 Paris Exposition. It is hard to imagine the extravagance of the building that was undertaken for the Exposition Universelle.

VENICE BIENNALE

If Renoir had been healthy, his life by 1901 would have been perfect. After years of disrespect, he was highly esteemed; his work was exhibited at internationally acclaimed exhibitions, and was commanding high prices. That year, Aline gave birth to his third son.

For the first years of the new century, Renoir travelled to various parts of the south of France, making long stays in Saint-Raphael, Cagnes-sur-Mer, Cannes, Magasnosc, Le Cannet, Marseille and Aix-les-Bains. He also spent time in Essoyes and Fontainebleau. Doctors prescribed various cures, including walks, baths, massages and light diets.

Renoir's status kept growing. Dealers and collectors continued to buy his paintings and every few months, his work was shown in prominent exhibitions. In January 1901, Durand-Ruel organized a London exhibition of work by Renoir, Monet, Pissarro and Sisley. A German art dealer and publisher, Paul Cassirer, had collected his work in recent years, and from October to December 1901 he held a major exhibition of Impressionist paintings in his Berlin gallery, including 23 of Renoir's canvases. The following June, 40 Renoirs were featured in a one-man show in Durand-Ruel's Paris gallery, and in April 1903 works by Renoir, Monet, Pissarro and Sisley were exhibited at the Venice Biennale. Originally called the International Art Exhibition, the first Venice exhibition had been held in 1895. It focused on the avant-garde, and national artists were judged by a jury, while foreign artists were invited to participate. It was a great honour for Renoir to be asked.

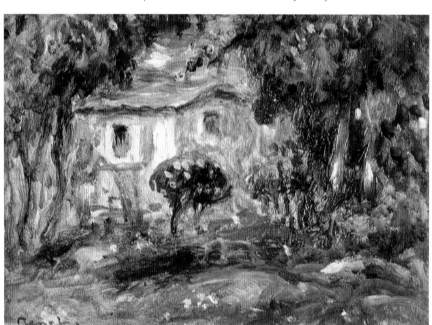

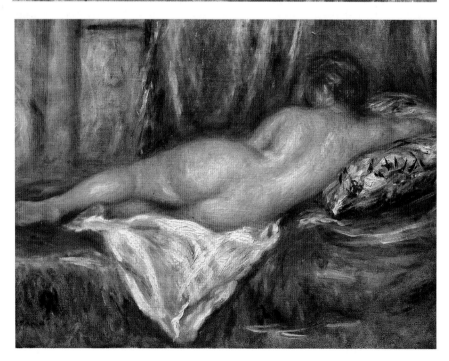

ANOTHER ACCOLADE
In January 1901, Renoir wrote from Magagnosc to Durand-Ruel, asking him to send his 1897 painting *Woman Playing a Guitar* to the Musée de Lyon, as they had purchased it – another honour. That May, Durand-Ruel attended the sale of paintings owned by Abbé Gaugain, the headmaster of a private school in Paris, who had risen from poverty and had developed a passion for Impressionism. He had bought regularly from Durand-Ruel as well as directly from Renoir and Pissarro. At the Hôtel Drouot, Durand-Ruel bought Gauguin's entire collection for 101,000 francs.

Above left: Landscape, Le Cannet, *1902. Renoir travelled to undergo various treatments, but his debilitating attacks still left him increasingly infirm.*

Left: Nude Seen from Behind, *1909. Even though Renoir was weak and his hands twisted and gnarled, he continued to produce voluptuous, lavish-looking nudes.*

Right: Girl in a Spanish Jacket, *1900, is a loosely worked painting that makes much of the current French fashions for Spanish styles, particularly 17th-century Spanish art and Spanish dress.*

JOY AND PAIN

While staying in hotels, Renoir wrote to his friends and dealers. He and Vollard wrote in a teasing banter. Renoir joked with him about the pampering he was receiving – the good food, massages and thermal baths – and he asked for payment for works that Vollard had purchased. Another of his dealers was Alexandre Bernheim-Jeune (1839–1915), who had opened a gallery in Paris in 1865. Considering the disabilities and pain that Renoir was experiencing, it is astonishing that he continued to produce paintings as cheerful, bright and accurate as he did. His integration of Classicism and Impressionism, using expressive brushstrokes and vibrant colour, was exceptionally popular, and he continued working on his many commissions, almost without stopping. However, by 1901, when he was 60, his hands were stiff and swollen, his fingers twisted, he walked with a stick, and during the summer he suffered partial atrophy of the nerves in his left eye. His hair turned completely white, and he became susceptible to colds and other viruses. While he was thinner and frailer, Aline, always plump, was fatter, and often suffered with respiratory problems. That August, she gave birth to their third son, Claude (Coco), in Essoyes. As always, Renoir was overjoyed. They were a close family, and Renoir often painted his beloved sons.

THREE DEATHS

In 1903, three of the great avant-garde artists died. In May in the Marquesa Islands, Gauguin died at 54; Toulouse-Lautrec died in September in Paris at just 36; and also in Paris, in November, Renoir's old friend and fellow Impressionist Pissarro died at 73 years old.

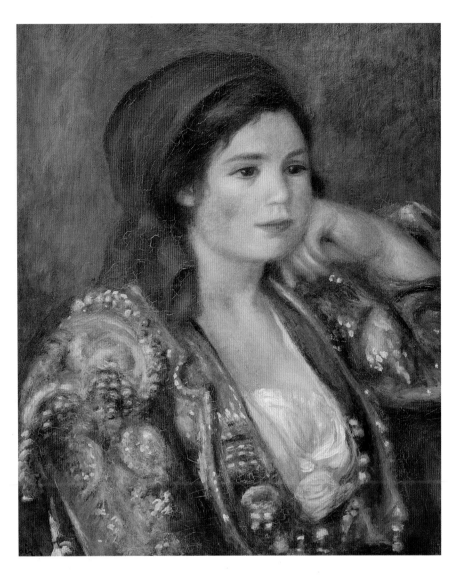

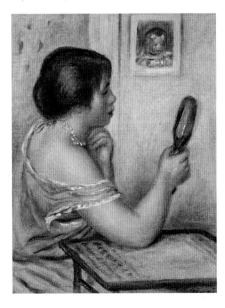

Below: Marie Dupuis with Mirror, *c.1903–05. Marie was a servant in the Renoir household. Here she sits in front of a portrait of Claude.*

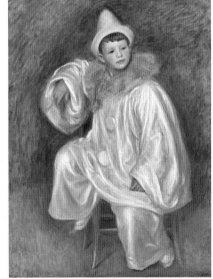

Below: The White Pierrot *of 1901–02 is a portrait of Renoir's son, Jean. The blue background intensifies the fluidly painted white costume.*

ACCEPTANCE AT LAST

By 1905, Renoir's art was quite traditional in comparison to the radical work by younger artists. Henri Matisse (1869–1954) and his circle were producing vivid paintings that earned them the derogatory nickname of *Les Fauves* (Wild Beasts), and the art establishment's antipathy toward Renoir was over.

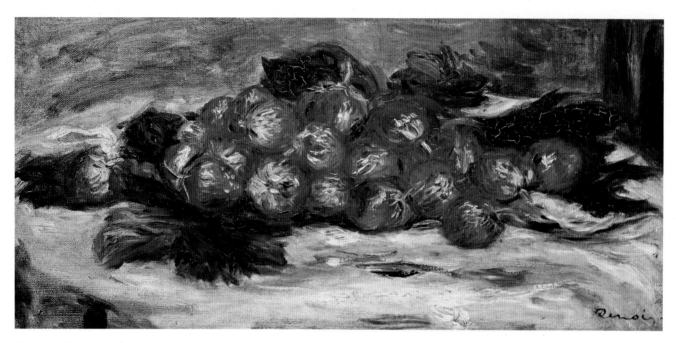

Rheumatoid arthritis can cause chronic inflammation of the joints, tissue around the joints and in other organs in the body. In 1904, Renoir complained to a friend: 'I can't move a finger.' He was paralyzed by the inflammation. He dropped below 44kg (97 pounds) in weight so that even sitting was painful. Accompanied by Aline, Gabrielle and his two younger sons, he spent August in Bourbonne-les-Bains in north-eastern France, for thermal treatment.

UNABLE TO PAINT

By September, Renoir was back in Essoyes, but the treatment had not alleviated his symptoms. He wrote to Julie Rouart: 'I don't see any effect from the waters. I've seen a lot of people arrive crippled and go away cured, so it's tiresome not to be like anyone else, but I must get used to it. I'm trapped.' Regardless of his inability to produce

Right: Terrace at Cagnes, 1905. Relishing the colours and architecture, Renoir captured the golden light of Cagnes many times.

new paintings, Durand-Ruel sent many canvases to exhibitions, for instance to Berlin and Brussels and to a World's Fair in St Louis, Missouri. He also sent 35 Renoirs to the Paris Salon d'Automne.

Above: Strawberries on a White Tablecloth, 1905. Once he could use his limbs again, Renoir painted fervently, including this vividly coloured fruit on a dazzling white cloth.

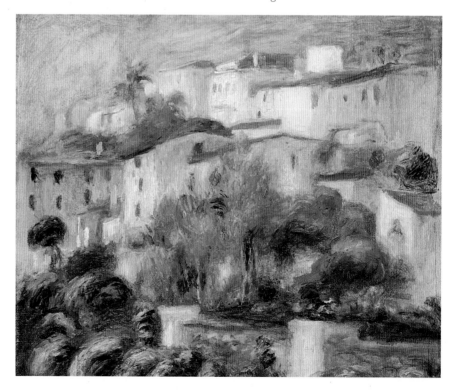

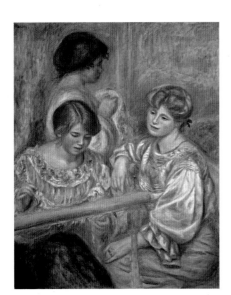

Above: Embroiderers, c.1904. Renoir built up the sheen on the fabrics with a layer of brown, then ivory, white and coral in soft brushwork.

SALES AND FORGERIES

Renoir was worried that prices for his work were rising to inflated levels. Patrons, dealers and collectors were all selling his canvases for what he described as 'ridiculously high prices'. He felt that the sudden rise would be counteracted by a sudden drop. In the midst of this, another problem emerged. In December 1903, the collector Georges Viau was accused of having forged Renoir paintings and pastels. Early in January, Renoir registered a complaint about the allegations with the Procureur de la République, but on the advice of a solicitor, later withdrew his accusations.

Despite Renoir's fears that he would never be able to paint again, once his period of acute paralysis eased, he began producing some of his most sensual and curvaceous figure paintings. Indeed, none of his work showed any sign of the disability that was dominating his life. In January and February 1905, Durand-Ruel sent 59 of his works to the Grafton Galleries in London for a huge Impressionist exhibition. Twelve thousand people

Right: Claude in Arab Shirt, c.1906. Emulating French 18th-century paintings, Renoir created several charming portraits of his sons.

attended, but few sales were made. In March, his old friend Bérard died. Although Renoir had not stayed regularly at the Château de Wargemont for some time, the two friends continued to meet, and correspond. At Renoir's request, Bérard had presented him with the insignia of the Légion d'Honneur five years earlier. Two months after Bérard's death, his collection, which included 18 Renoirs, was auctioned at Petit's gallery in Paris and raised a huge amount of money. The next year at another sale, Renoir's works brought even higher prices.

In October 1906, another of Renoir's close friends died. Cézanne was just 66 when he died of pneumonia. He had previously written: 'I despise all living painters except Monet and Renoir.' Always inspired by Cézanne, in the years immediately following his death, Renoir included even more of his friend's structural ideas in his work.

THE SALON D'AUTOMNE

In Paris in 1903, the first Salon d'Automne opened to counteract the still restrained official Salon, as an alternative exhibition. It followed several other exhibitions that aimed to create a platform for avant-garde artists, including the Impressionists' original shows, the Salon des Refusés and the Society of Independent Artists. The Salon d'Automne became the focus of developments and innovations in 20th-century painting and sculpture, and was where Fauvism first came to public notice in 1905. In 1904, 33 paintings by Cézanne and 35 by Renoir were displayed in their own rooms. Reviews were complimentary, many comparing Renoir favourably to Fragonard and Watteau.

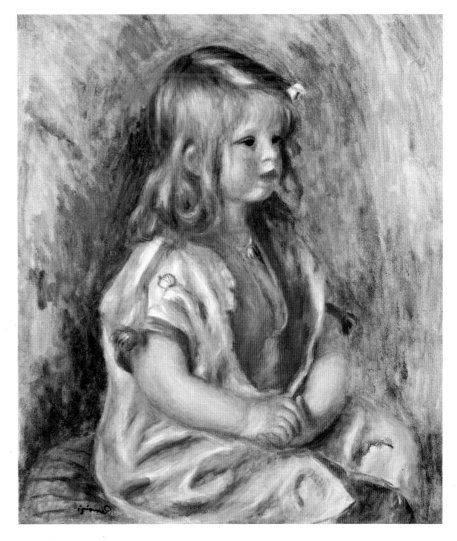

HIGHEST ACCLAIM

After exhibiting at the Salon d'Automne again in 1905, Renoir, who was becoming weary of constantly travelling about, stayed in Cagnes for the winter. He did the same the following winter, and in June 1907, he bought Les Collettes, a gardener's house in Cagnes with ancient olive trees in the garden.

The house at Les Collettes, with its wooden balcony and green shutters, was not big enough for Renoir, Aline, Pierre, Jean, Coco and their two servants, so he had a larger house built in its place. Rather than allow the architect to erect the elaborate villa he proposed, Renoir stipulated that the house should be simple enough to blend in with the surroundings. He also preserved the old olive and orange trees, refusing to be persuaded to replace them with more fashionable palm trees.

Fourteen years Renoir's junior, Georges Rivière had remained friends

Below: View of the Sacré-Coeur, 1905. The Basilica of the Sacré-Coeur, Paris, was dedicated to the lives of the 58,000 Frenchmen who lost their lives in the Franco-Prussian War. Building work was started in 1875, but not completed until 1914.

Right: The Promenade, 1906 – from this time, colour played an even more important part in Renoir's compositions. In particular, touches of red help to form the structure of this work.

with Renoir since he had written the articles in their short-lived journal *L'Impressioniste* in 1877. Rivière was also good friends with Renoir's brother Edmond and had often helped to acquire patrons and commissions for Renoir. By the early 20th century, Rivière had become a widower with two daughters in their 20s. They were frequent guests at Renoir's house in Essoyes and stayed in the villa Renoir rented while his house at Les Collettes was being built. Once the house was completed, the Rivières stayed there too. Renoir once said to Rivière: 'It doesn't seem as if misfortune could ever reach you in this wonderful region. We live a completely sheltered existence.'

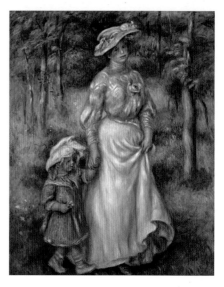

GREATER RECOGNITION

As if to corroborate his high status, in 1907, Renoir was named as Honorary President of the Salon d'Automne, although he did not exhibit there that year. In March 1908, the Royal Society in Brussels wanted to honour him, too. He

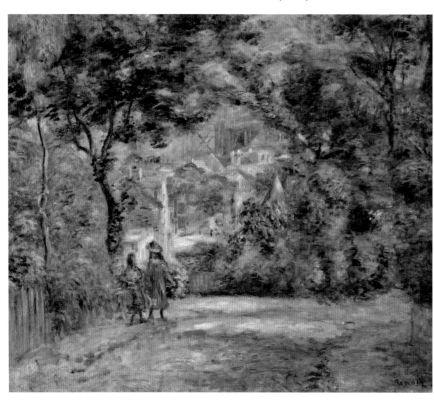

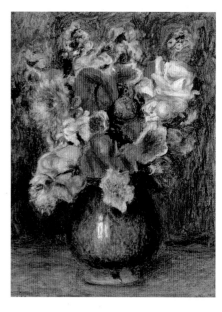

Above: Flowers in a Bouquet, Renoir, 1905. In the summer of 1905, Renoir had a new studio built at Essoyes and, as if to celebrate, painted in even brighter colours than usual.

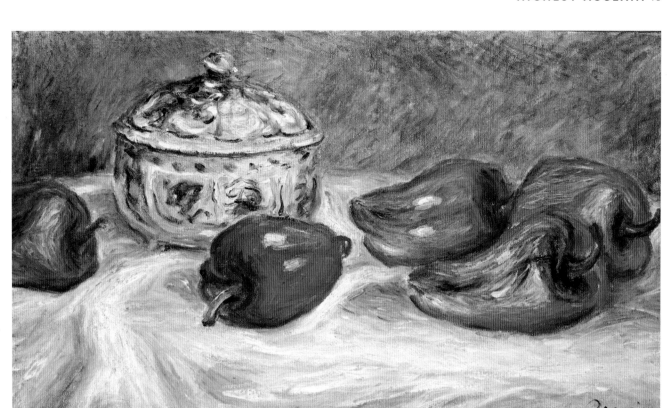

wrote to Durand-Ruel: 'I don't know whether to accept this new glory of being a member of the Royal Society of Brussels. I would do so with pleasure if I thought it would cause you to sell one more painting, but I don't think so at all… I'm still sending you my acceptance…you can do what you like with it.' Durand-Ruel dispatched Renoir's acceptance to Brussels along with 12 paintings for an exhibition there. He also displayed 42 of Renoir's still lifes in an exhibition in his Paris gallery in April and May, shared with Monet, Cézanne, Pissarro, Sisley and three other artists, and 37 of his landscapes in the Paris gallery from May to June, shared with Monet.

RECORD PRICE
From November to December, 41 Renoirs were in a one-man exhibition in Durand-Ruel's New York gallery, and the dealer also sent additional Renoir canvases to Cincinnati, London and Zurich that year. In 1907, two years after the death of Georges Charpentier, and three years after the death of his wife Marguerite, their art collection was sold at the Hôtel Drouot. The Renoirs went for high prices, in particular,

Above: Modelled with great delicacy, the yellow, red, green and blue colour scheme of Still Life with a Blue Sugar Bowl and Peppers, c.1905, *appears particularly fresh and striking against the white tablecloth.*

Madame Charpentier and Her Children, which was bought by the Metropolitan Museum in New York for 84,000 francs.

MAILLOL
During the summer of 1908, the sculptor Aristide Maillol (1861-1944) stayed with Renoir, and he proved to have an effect on Renoir's art that few had anticipated.

Maillol had met Renoir through Vollard and, although there was a 20-year age gap, the two artists had a lot in common. They both favoured classical styles and the female form, and Maillol encouraged Renoir to take up sculpture. Renoir found that the emphasis on three dimensions suited him, despite his physical problems. While Maillol was there, Renoir produced his first wax sculptures, and just after, he made a medallion and a bust of Coco. At the end of 1908, the house at Les Collettes was finally

completed, and once he moved in, Renoir drew up a will, and invited friends to visit; one of the first to arrive was Monet, who stayed there in December on his return from Venice with his wife Alice.

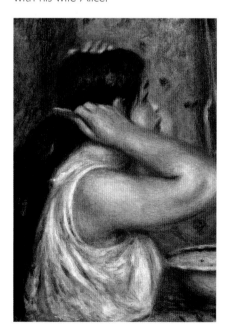

Above: The Toilette (Woman Combing Her Hair), *1907–08. This painting of an unknown model, produced in Cagnes, is a fine example of Renoir's unwavering touch.*

SCULPTURE

Once Renoir had moved into the house at Les Collettes, it was clearer than ever that he had left his poor origins far behind him. All the years of struggling had paid off, and even his new interest in sculpture, with the help of an assistant, proved to be successful and lucrative.

Les Collettes had everything that Renoir needed, including internal and external studios and spectacular views of the Mediterranean, Cap d'Antibes and the town of Cagnes. He delighted in welcoming his friends to stay, and in spite of his worsening symptoms, continued to paint, although he produced fewer large works. 'The older I get, the longer it takes me to work,' he wrote to Durand-Ruel. 'I admire Monet for being able to do such interesting things in so short a time. He has an energy that I am far from having.'

WORKING IN ADVERSITY
By 1910, Renoir's fingers were completely paralyzed, and the skin had become so tender that wooden paintbrush handles wounded him. To counteract this, he squashed a piece of cloth into his palm to cushion brush handles. Friends, family, models or servants prepared his palette and brushes, but eye-witnesses were always astonished at how he still managed to work. The artist Albert André (1869–1954) observed: 'The brush, once chosen and gripped between his paralyzed fingers, moves rapidly from the canvas to the turpentine tin where it is rinsed and goes back to the palette to take a little paint and carry it once more to the canvas.'

FURTHER ACCOLADES
Between April and October, the ninth Venice Biennale held a Renoir retrospective, and that June, Durand-Ruel held a large Impressionist exhibition in Paris. At the end of the summer, the entire Renoir family travelled to Munich at the invitation

of a Dr Franz Thurneyssen so Renoir could paint his wife and daughter. While in Munich, Renoir visited the Alte Pinakothek and studied works by Rubens. His resulting portrait of Frau Thurneyssen shows the clear influence of Rubens' colourful opulence.

On Renoir's return to Paris, he resumed work on a writing project he had started in 1909. It was a preface to a 15th-century artists' handbook by a descendent of Giotto that he had become involved with through another artist friend. His preface reveals his own Classical inclinations and his belief in craftsmanship. In 1911, the State raised

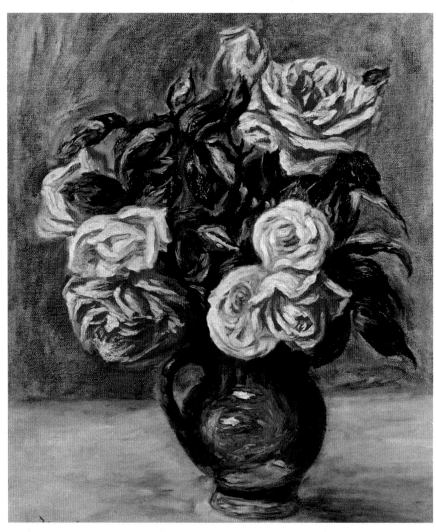

Right: Roses in a Jug, *1908. In the late 1890s, Renoir recommended still life painting to Julie Manet, 'in order to teach yourself to paint quickly'.*

WORKING IN THREE DIMENSIONS
As Renoir's hands became ever more twisted and he was confined to a wheelchair, in April 1913, Vollard suggested that he work with Richard Guino (1890–1973), who had been Maillol's assistant. Renoir produced sculpture with Guino from 1913 to 1917, and with another young sculptor from Essoyes, Louis Morel, from 1917. Renoir gave exact instructions as his assistants formed the works.

Right: Bather with a Cloak, *1913. When Renoir produced this, his assistant Guino worked completely under his supervision.*

his status to Officier of the Légion d'Honneur. Julius Meier-Graefe, a German critic and exhibition organizer, published the first biography on him, including 100 images of his work. It was translated into French the following year.

FURTHER HEALTH PROBLEMS

In 1911, Renoir and Aline moved into another apartment in Paris, and he continued to see doctors wherever he was living at the time. His friends often visited and wrote to him and each other. Everyone was concerned about his health. In 1912, he wrote to Rivière: '…I have lost my legs. I am unable to get up, sit down or take a step without being helped. Is it forever?' A few weeks later, he had a stroke and his arms were paralysed, but with his usual determination, within a couple of months he was painting again. Those around him helped him mix paints and push brushes into his hands, but he painted all his works himself, and never allowed a hint of his suffering to appear in his paintings. He continued to paint voluptuous nudes, colourful figures and sensitive portraits.

Right: The Small Washer, *1916. To create a sculpture, Renoir made a few sketches to show how he conceived the work and then directed his assistant with a stick.*

Above: Flowers, *1908. By the 20th century, Renoir was selling large numbers of small paintings such as still lifes and flowers.*

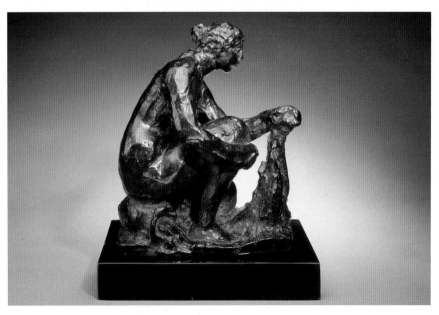

LAST YEARS

Up to the outbreak of World War I, Renoir's work was still widely exhibited. In 1913, a huge retrospective was held at Bernheim-Jeune's gallery. In 1914, Pierre and Jean were called up to fight at the Front and within weeks both were badly wounded.

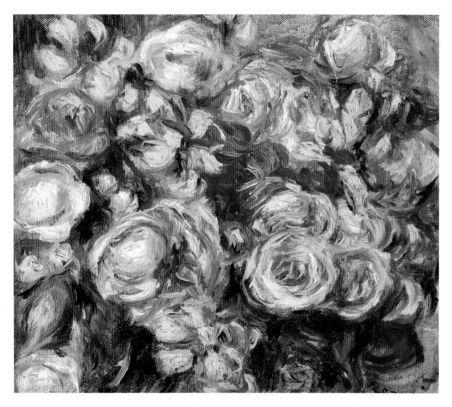

Above: Tilla Durieux, 1914. Wearing the costume she wore in Pygmalion, the German actress Tilla Durieux, wife of art dealer Paul Cassirer, posed for Renoir just before the outbreak of World War I.

Continuing to work prolifically, early in 1914, along with his paintings and sculptures, Renoir designed a tapestry for the Gobelins factory. More books and articles appeared about him, and many younger artists travelled to Les Collettes to meet him, including Denis, Signac, Matisse and Picasso (1881–1973).

ALINE, PIERRE AND JEAN
As soon as war broke out in August 1914, Renoir's two eldest sons, Pierre and Jean, were conscripted. Within a short time, both young men were wounded in action. Aline rushed to visit them – they were recuperating in different parts of France. When told that the doctors wanted to amputate Jean's gangrenous leg, Aline opposed them, instead allowing another doctor to circulate distilled water through the leg, which was successful. But Aline herself was ill. Very overweight, she was diabetic and, on her return to Renoir from

Above: Roses, 1915. Pierre and Jean had been wounded by that year and Renoir and Aline were in poor health. Yet this vivid painting gave no hint of his problems.

seeing Jean, she suffered a heart attack and died. At 56 years old, she had been with Renoir for 36 years. She had been a steadfast and caring wife and mother, competently organizing all their households. Renoir was so ill that he could not travel to Jean to tell him of his mother's death, so he sent a friend. Some weeks later, father and son met. Jean later recalled: 'My mother's death had destroyed him completely and his physical condition was worse than ever.'

EXHIBITIONS AND DISPLAYS
Renoir's friends and family continued to rally round him. Among those who visited were his brother Edmond, Gabrielle, who had married early in 1914, Jeanne Baudot, Julie Rouart and her cousin Paule, the Bernheim-Jeunes, the Durand-Ruels, André, Cézanne's son Paul, Rivière, Vollard and more. Monet – also a widower, in poor health and whose son had recently died – wrote often. In 1917, exhibitions containing Renoir's works were held in cities in neutral countries, including Zurich,

THE FINAL MASTERPIECE

After World War I, Renoir painted a large new work, *The Bathers*. Based on the works of Titian and Rubens as well as traditions from ancient Greece and Rome, it continues his explorations of nudes in the open air with no reference to the contemporary world.

Right: Bather Washing her Leg, 1914 –
*one of several paintings depicting a bather
drying her leg, the graceful figure dominates
the picture space, but is highlighted by the
surrounding vivid, contrasting colours.*

Stockholm, Barcelona and New York
(before America entered the war). That
year the National Gallery in London
inherited *The Umbrellas* through the will
of an Irish collector. About 100 British
artists and collectors signed a letter to
Renoir: 'From the moment your picture
was hung among the famous works of
the Old Masters, we had the joy of
recognizing that one of our
contemporaries had taken his place
among the great masters of the
European tradition.'
 Renoir wrote to Durand-Ruel: 'I am
pleased to hear that collectors are
more forthcoming…But that will not
stop me from going on as I have always
done, as though nothing had happened.'
More was published about him,

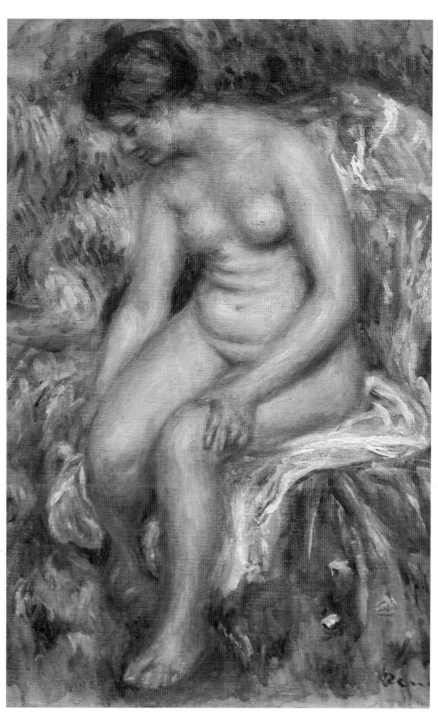

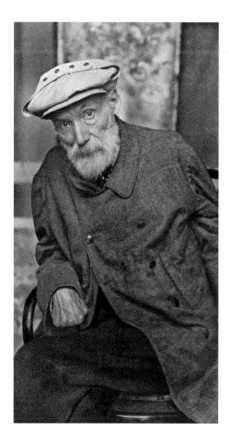

Right: Renoir, c.1912. *Just after Renoir's
death in 1919, this photo was widely
circulated. It shows his frailty and the
dreadful deformation of his fingers.*

including a piece by Matisse in a
catalogue in Oslo; another book
featuring 40 of his paintings; and a large
volume by Vollard, which contained
nearly 700 reproductions of his work.

SHIFTING EMOTIONS
In September 1917, Renoir learned
of Degas' death. Rodin and Wyzewa had
also died that year. In 1919, he
was made Commandeur of the Légion
d'Honneur and an exhibition of his work
was held in Durand-Ruel's New York

gallery. He wrote to André, who had
published a monograph on him: 'My
dear friend, while reading your preface, I
saw only one thing: it is written with
love and also out of friendship.'
 In August he was an honoured
guest at the Louvre, where his *Portrait of
Madame Charpentier* was on display.
Back in Cagnes, he caught a cold
painting a landscape in the garden
which turned into pneumonia.
He died at Cagnes on 3 December
1919, aged 78.

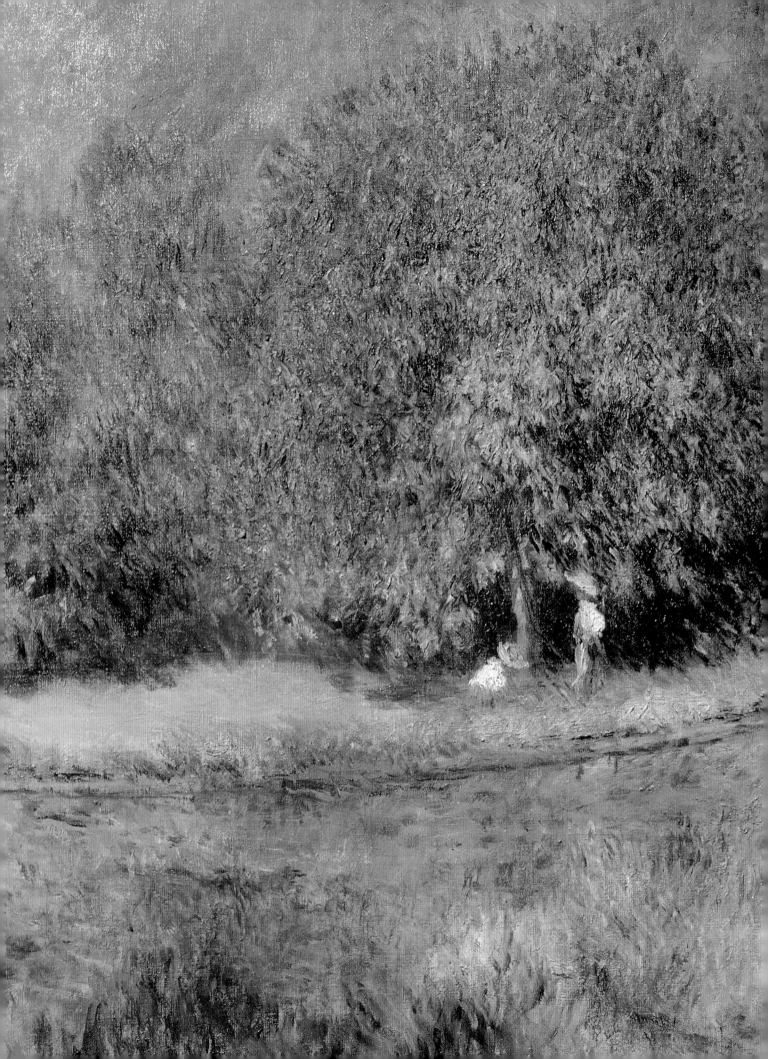

THE GALLERY

Recognized the world over for his images of sun-filled café scenes, sparkling riverside landscapes, flowers, children and almond-eyed women, no matter what troubles he endured, Renoir's art always captured his own optimism and enjoyment of life. 'Why shouldn't art be pretty?' he once said, 'There are enough unpleasant things in the world.' This sense of happiness pervades everything he produced, from his society portraits, to his Impressionist works and classical-style paintings. His work often featured his upper-, and middle-class friends, because despite his humble origins, his warmth, loyalty and enthusiasm for life attracted acquaintances from all backgrounds and age groups. Always individual, he drew on a vast range of influences, including Delacroix, Corot, Courbet, Manet, Degas, Rubens, Boucher, Titian, Velázquez, Goya, El Greco, Watteau, Fragonard, Michelangelo, Raphael, Rembrandt and Monet, as well as ancient Greek and Roman art.

Left: Chestnut Tree in Bloom, *1881, oil on canvas, Nationalgalerie, Berlin, 71 x 89cm (28 x 35in). Renoir's experience as a porcelain painter helped him to develop his technique of painting translucent colour over pale grounds. Painted toward the end of his Impressionist period, this still features his small, dabbing, layered brushstrokes. Balanced by dark and light patches on the foliage, the colours seem to vibrate and shimmer.*

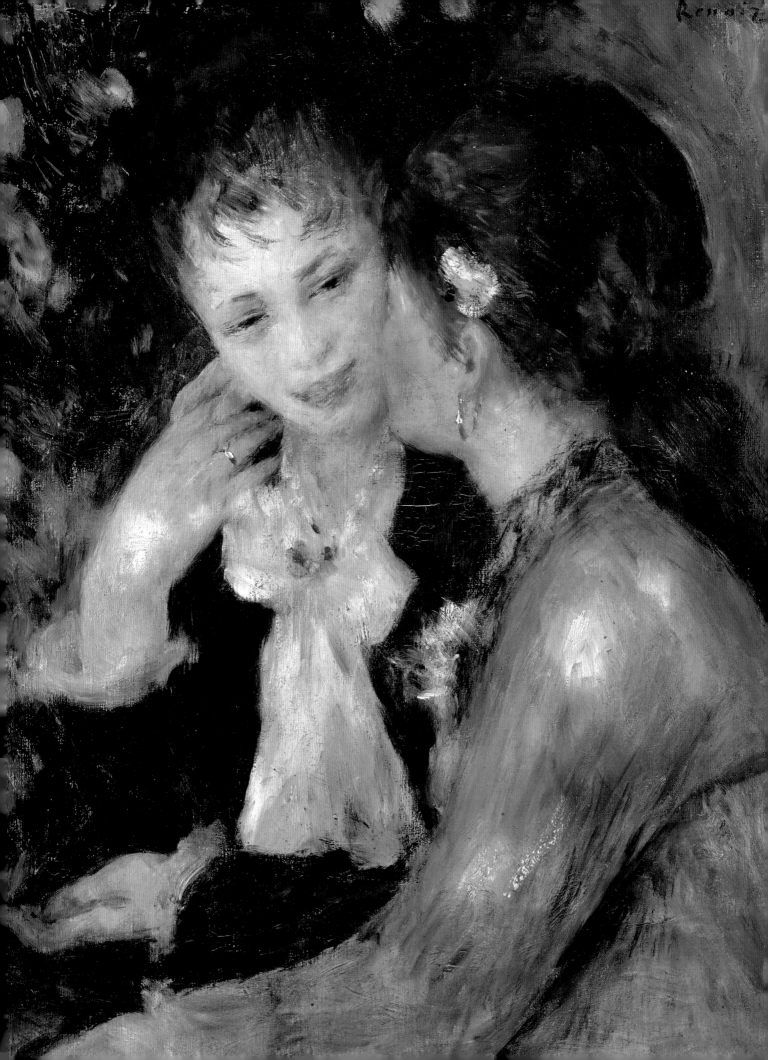

CAPTURING LIGHT

Renoir was not as complex a character as some of his contemporaries, but he was nevertheless a man of contradictions. Throughout his life, he ignored academic narrow-mindedness and produced his unique style of art that matched his visions of a world filled with light, colour and beauty. In some ways his attitude was modern – he was indifferent to social opinion and conventions – yet he abhorred new technology, such as modern buildings, electricity and railways. Even when his reputation and fortunes rose, however, he remained a modest man, relying on his vibrantly coloured brushstrokes to convey his optimistic outlook.

Above: Forest Path, c.1875, oil on canvas, Private Collection, 49.5 x 62.8cm (19 x 25in).
Capturing dappled sunlight in cool and warm tones, Renoir used mainly wet-on-wet paint across the canvas. His vibrant effects consist predominantly of the complementary colour contrasts of yellow-orange and blue-violet.
Left: Confidences, 1878, oil on canvas, Oskar Reinhart Collection, Winterthur, Switzerland, 50 x 62cm (20 x 24in).

Portrait of Renoir's Mother,
1860, oil on canvas,
Private Collection,
45 x 38cm (18 x 15in)

Although this is unfinished,
it is an honest portrayal of
Renoir's mother, painted
when he was 19 years old.
Although she looked much
older than her 53 years, the
work has been painted with
affection, and before Renoir
began to experiment with
new styles. He possibly
abandoned it because it was
too brutally honest, and not
flattering enough for his eye.

Return of a Boating Party,
1862, oil on canvas,
Private Collection,
50.8 x 61cm (20 x 24in)

Gleyre's teaching stayed with
Renoir throughout his life.
Gleyre taught traditional
methods, emphasizing the
importance of ordered
compositions and strong
relationships between dark
and light gradations. He also
encouraged his students to
paint *en plein air*. By 1862,
Renoir had met Monet,
Pissarro, Sisley and Bazille
and through Monet,
Eugène Boudin (1824–98),
who had introduced Monet
to the pleasures of painting
seaside views.

Bather Sunken into Sleep, 1861, oil on canvas, National Museum, Belgrade, Serbia, 31 x 22cm (12 x 9in)

Showing the strong influence of Rembrandt, Renoir painted this after he had become a regular copyist in the Louvre. Already, his soft touch can be seen clearly and his sombre palette, reminiscent of classical art, has not yet been abandoned. His overriding aim was to be accepted for the Salon – which would have established his status as an artist.

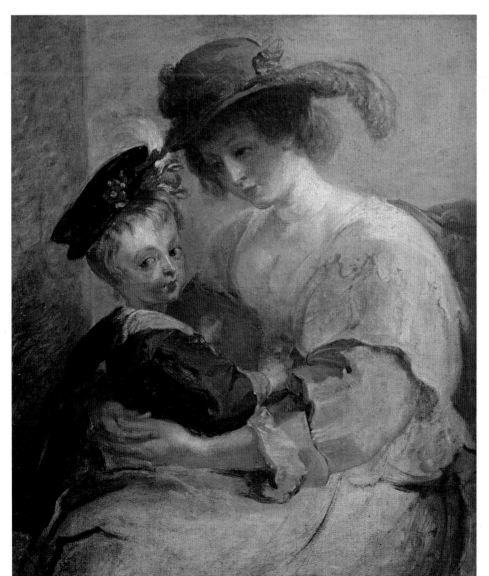

Helene Fourment (after Rubens), 1863, oil on canvas, Private Collection, 73 x 60cm (29 x 24in)

Peter Paul Rubens (1577–1640) painted his second wife Helene Fourment with his children in 1635–6. In the Louvre, Renoir copied the painting, but not in its entirety. Omitting one of the children, he carefully blended a similar palette, and matched the soft, flowing lines and tones of the 17th-century master he so admired. In the 19th century, an artist was judged by his or her copying skills.

Flowers in a Greenhouse, 1864, oil on canvas, Hamburger Kunsthalle, Hamburg, Germany, 130 x 98cm (51 x 38in)

This is one of two paintings of the same subject, shown from slightly different angles. The composition demonstrates Renoir's technical skills, and the spring flowers appear particularly bright against the dark green background. He later wrote: 'Painting flowers is a form of mental relaxation. I do not need the concentration that I need when I am faced with a model.'

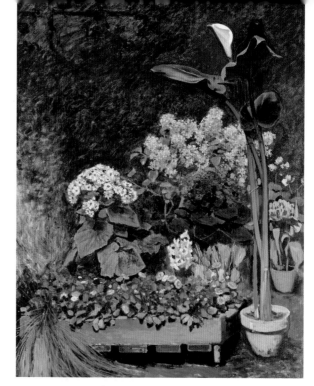

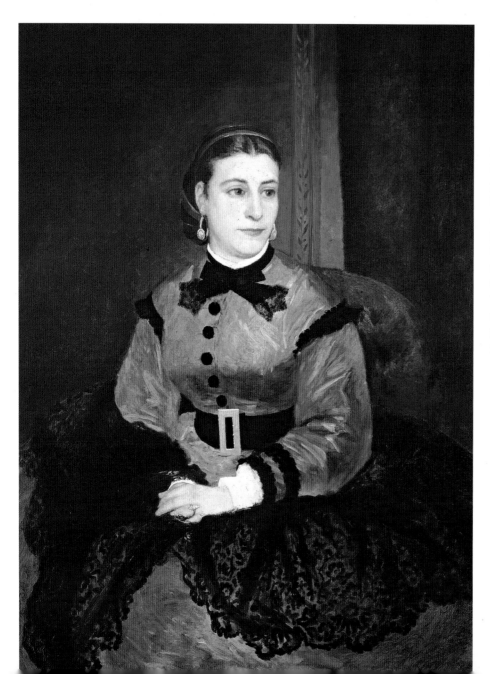

Mademoiselle Sicot, 1865, oil on canvas, National Gallery of Art, Washington DC, USA, 16 x 90cm (46 x 35in)

In 1865, Renoir was no longer at Gleyre's studio. He was trying to produce paintings that would sell, but that also suited his ideals. He had experimented with palette knives, which Courbet used, and was now using small brushes to produce delicate marks. The rich colours and strong tones in this painting derived from his admiration of the Old Masters.

Landscape at Fontainebleau,
1865, oil on canvas,
Private Collection,
47 x 56cm (18 x 22in)

At this time, Renoir spent several weeks painting in the Forest of Fontainebleau, particularly with Sisley. He admired the already established Barbizon painters, but kept his distance from Corot, as he commented: 'He was always surrounded by a crowd of fools and I didn't want to get caught up in it. I admired him from a distance.'

Portrait of William Sisley,
1864, oil on canvas,
Musée d'Orsay,
Paris, France,
82 x 66cm (32 x 26in)

This image of the prosperous father of Renoir's friend and fellow student is the first of many portraits Renoir painted of middle-class clients. It was exhibited at the Salon in 1865 along with an evening landscape. A successful businessman at the time, William Sisley was director of an artificial flower-importing business. The half-length pose and clear tones show the influence of both Ingres and Manet.

In the Park at Saint-Cloud,
1866, oil on canvas,
Private Collection,
50 x 61cm (20 x 24in)

Overlooking Paris, the Park
at Saint-Cloud is a vast park
that contains the ruins of
the Château de Saint-Cloud,
which was built in 1572 and
destroyed by fire in 1870
while occupied by Prussian
troops during the Franco-
Prussian War. When Renoir
painted there in 1866, it had
not yet been damaged by
the Prussians, and this work
shows the Impressionist
style he would soon be
experimenting with
even more.

Spring Bouquet, 1866,
oil on canvas,
Fogg Art Museum,
Harvard University,
MA, USA,
105 x 80cm (41 x 32in)

Renoir delighted in
painting bright flowers
simply bunched together
with no deliberate artifice or
set arrangements. Already a
master of colour and tone,
he later wrote to his friend
Rivière, explaining: 'When I
am painting flowers I can
experiment boldly with
tones and values without
worrying about destroying
the whole painting. I would
not dare do that
with a figure…'

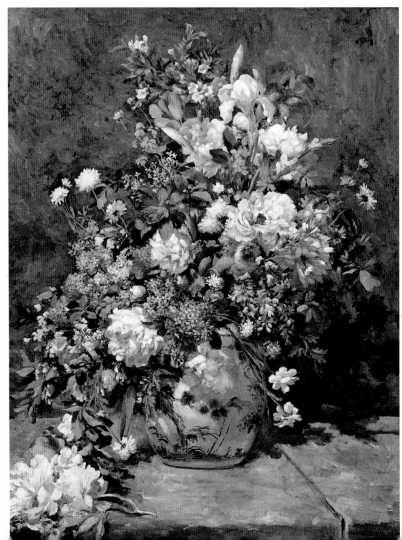

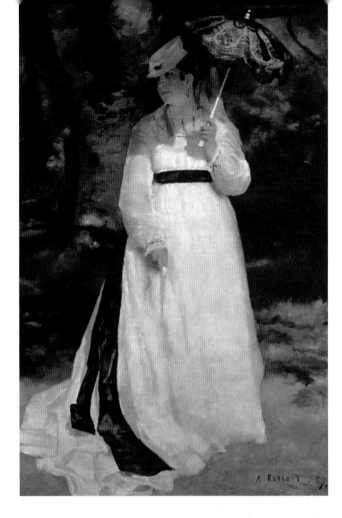

Lise with a Parasol, 1867, oil on canvas, Museum Folkwang, Essen, Germany, 183 x 114cm (72 x 45in)

Accepted by the Salon in 1868, Zola praised this painting, describing it as a blending of elements in a modern style. In depicting Lise holding a parasol, Renoir was paying homage to the central figure of Courbet's *Les Demoiselles de Village* (1851), and also drawing on ideas from Monet's work *Camille in a Green Dress*, which had been exhibited at the Salon during the previous year.

*Portrait of Lise, c.*1868, oil on canvas, The Barnes Foundation, Philadelphia, PA, USA, 46 x 38cm, (18 x 15in),

This is Lise Tréhot, daughter of a former postmaster, Renoir's favourite model of the period and his mistress for about seven years. He painted more than twelve likenesses of her and his love of painting women seems to have developed from this time. Courbet was one of his strongest influences during the 1860s, as can be seen in the tight linear qualities and strong contrasts in this work.

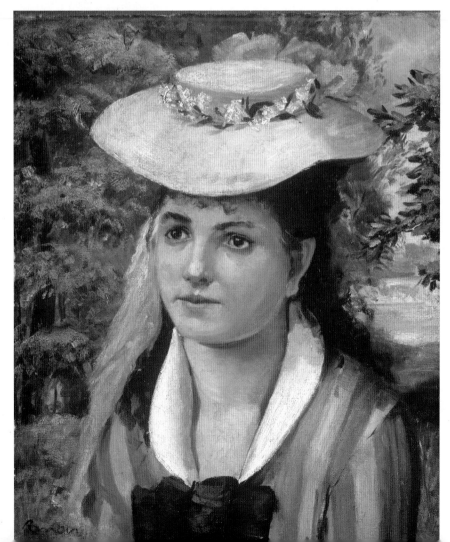

Frédéric Bazille, Renoir, 1867, oil on canvas, Musée d'Orsay, Paris, France, 105 x 74cm (41 x 29in)

Predominantly worked in beiges and greys, Bazille sits at his easel painting a still life. Renoir painted this while living with Bazille and in turn, Bazille painted Renoir. Sisley was also painting the same still life as Bazille and in the background is Monet's *The Cart, Snow-covered Road in Honfleur*, so this work appears to represent the closeness of the young artists at that time.

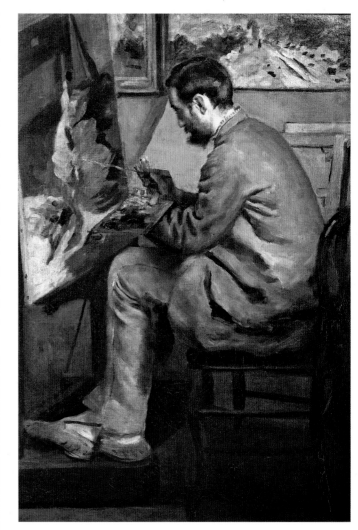

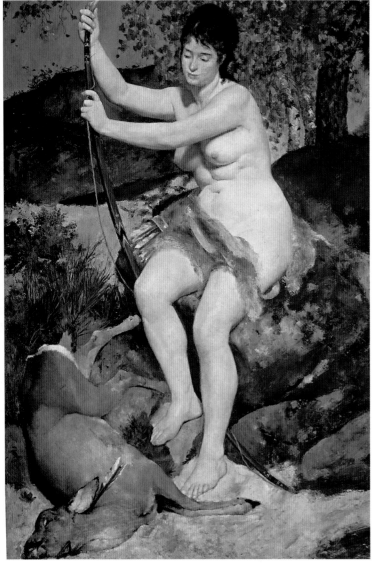

Diana, 1867, oil on canvas, National Gallery of Art, Washington DC, USA, 200 x 130cm (79 x 51in)

Applying the paint with a palette knife in response to Courbet, Renoir painted this specifically for the Salon. A naturalistic studio work, he placed Lise in a traditional life-class pose, and later claimed that he had added the bow, dead stag and deerskin to convert her into Diana, the ancient goddess of hunting, to please the conventional Salon jury, but the painting was rejected.

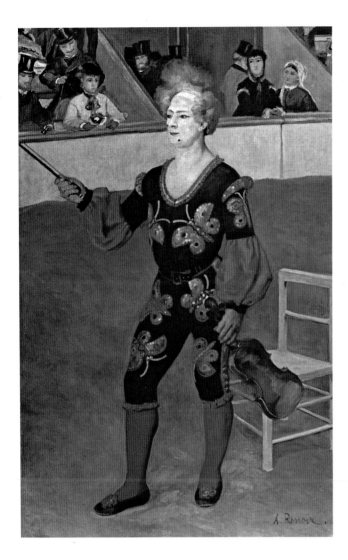

The Clown, 1868,
oil on canvas,
Kröller-Müller Museum,
Otterlo, The Netherlands,
193 x 130cm (76 x 51in)

In 1868, Renoir was
commissioned to produce
a wall decoration for the
Paris Café of the Cirque
d'Hiver. He painted this
large portrait of the
clown-violinist, James
Bollinger Mazutreek from a
high viewpoint, emphasizing
perspective with clear focus
in the foreground and
blurring the background.
Renoir had been promised a
payment of 100 francs for
the painting, but the café
went bankrupt, so he
kept the work and
received nothing.

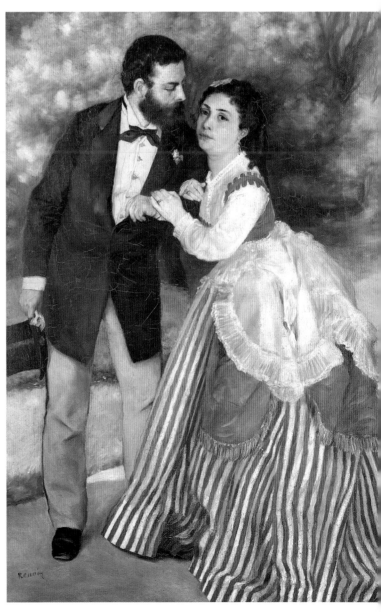

The Engaged Couple or
The Sisley Family, c.1868,
oil on canvas,
Wallraf-Richartz Museum,
Cologne, Germany,
106 x 74cm (41 x 29in)

The woman who is
dramatically resting on
Sisley's arm as he leans
toward her may be his
future wife, Eugénie
Lescouezec, or Sisley may be
simply posing with Lise for
Renoir to create a genre
work. It seems likely to be
the latter, indulging Renoir's
penchant for full-length
portraits at the time.
The work later inspired
a series of drawings
by Picasso.

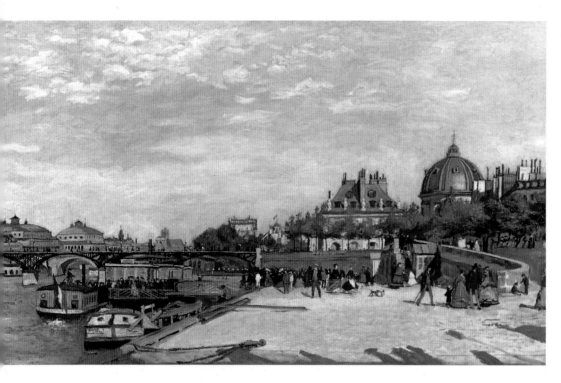

The Pont des Arts, 1867–8, oil on canvas, The Norton Simon Museum, Los Angeles, USA, 61 x 100cm (24 x 39in)

Capturing a contemporary view of Paris, Renoir emphasized the light with strong tonal contrasts and lively brushwork. The Palais Richelieu and the Institut de France are outlined against the sunlit sky and the Pont des Arts. Clusters of figures stroll across the bridge or queue for a river trip. Renoir sat outside a café painting this while his brother Edmond stopped passers-by so Renoir could quickly sketch them.

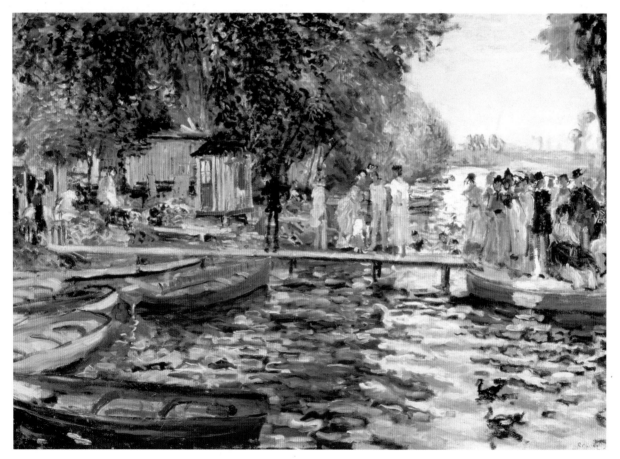

La Grenouillère, 1869, oil on canvas, Oskar Reinhart Collection, Winterthur, Switzerland, 65 x 92cm (26 x 36in)

La Grenouillère was a restaurant and bathing place on a branch of the Seine at Croissy. With a station nearby, it became popular among weekend trippers, particularly after the Emperor Napoleon III and his wife visited in 1869. This is one of several views that Renoir painted alongside Monet that year. It records the effects of sunlight in thick dabs of paint.

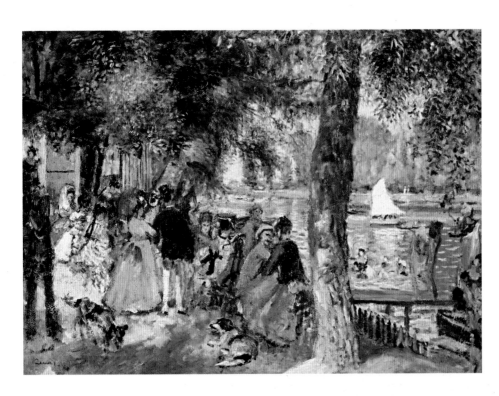

La Grenouillère, 1869, oil on canvas, The Pushkin Museum of Fine Arts, Moscow, Russia, 59 x 80cm (23 x 31in)

Through painting light and water *en plein air*, Renoir and Monet discovered that shadows are not black or grey, but the reflected colour of objects surrounding them, an effect now called 'diffuse reflection'. During the late 1860s, they painted together and worked out the main principles of Impressionism. In this location, they captured scenes of contemporary life using small strokes of colour, focusing on the effects of light.

Madame Théodore Charpentier, c.1869, oil on canvas, Musée d'Orsay, 46 x 39cm (18 x 15in)

Painted during the period when Renoir and Monet were taking regular painting trips together, this shows how they influenced each other with ideas about painting light effects in small brush marks. This is one of Renoir's first impressionistic portraits, when he moved away from academic precision and imbued the work with a softer, less defined style. His ability to impart the sitter's personality remained with him throughout his life.

A Nymph by a Stream,
1869–70, oil on canvas, The
National Gallery, London, UK,
67 x 123cm (26 x 48in)

Once again in a painting of
Lise, the influences of both
Ingres and Courbet can be
seen clearly. In one of his
favourite themes of a female
nude in natural surroundings,
Renoir used loose, free
brushstrokes, creating pearly
white flesh that contrasts
starkly with the dense, dark
greens and browns of the
foliage and the wreath of
leaves in her hair.

*Madame Pierre Henri Renoir
(Blanche-Marie Blanc),* 1870,
oil on canvas,
Fogg Art Museum, Harvard
University, MA, USA,
81 x 65cm (32 x 26in)

Blanche-Marie Blanc was
the illegitimate daughter
of a poor seamstress.
She became the companion
of a medallist, Samuel Daniel,
and met Renoir's brother
Pierre-Henri when he
trained with Daniel for a
career as a medallist himself.
Pierre-Henri fell in love with
her, and despite the social
taboos, married her in 1861.
When Renoir painted this
portrait, his brother had
an extremely successful
business as a medallist.

Portrait of Mademoiselle Marie Le Coeur, 1870, oil on canvas, Musée d'Art Moderne et Contemporain, Strasbourg, Switzerland, 41 x 33cm (16 x 13in)

Marie Le Coeur (1858–1937) was the daughter of the architect Charles Le Coeur. From the early 1860s, while Renoir was close to the Le Coeur family, he often stayed in the family home in Fontainebleau. He painted this small portrait during one of his lengthy stays with them, between the excursions he went on with Jules Le Coeur (the subject's uncle), Sisley, Monet and other painters from Paris.

Odalisque, 1870, oil on canvas, National Gallery of Art, Washington DC, USA, 69 x 123cm (27 x 48in)

Once again, the model is Lise. In contrast with the Salon's rejection of *Diana*, this was accepted by the Salon and received high praise. Arsène Houssaye (1825-96), writing in the journal, *L'Artiste*, commented on its similarities to a painting by Delacroix called *The Women of Algiers*, which was highly acclaimed. Other critics praised the figure's sensuality and the colours in her clothes.

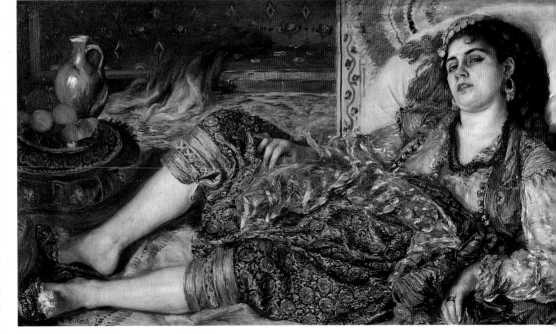

Portrait of Rapha, 1870–1,
oil on canvas,
Private Collection,
130 x 83cm (51 x 33in)

This full-length portrait is
of Rapha, the mistress of
Renoir's friend Louis-
Edmond Maître, a civil
servant who championed
avant-garde artists. Renoir
painted three portraits of
Rapha while staying with the
couple during the 1870s.
In this fairly formal work,
Rapha wears a fashionable
gown, holds a fan and
glances at a birdcage.
A modern trellis-patterned
wallpaper and flowers add
to the decorative effect.

Rapha Maître, c.1870–1,
oil on canvas,
The Smith College Museum
of Art, MA, USA,
38 x 32cm (15 x 13in)

Believed to be painted at the
same time as the full-length
portrait of Rapha (who took
her boyfriend's surname), this
is a smaller and more
intimate portrait altogether.
Renoir possibly painted it
when relaxing with his
hosts, just after the Paris
Commune. Maître and
Rapha remained in Paris
throughout the dreadful
events of the Siege and
the Commune, and were
pleased to welcome
their friends back once
it was over.

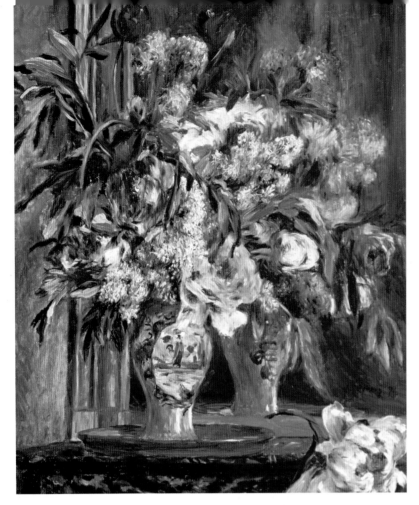

Vase of Flowers, 1871,
oil on canvas,
Private Collection,
32 x 26cm (13 x 10in)

Using a mirror to double the
appearance of the blooms
was a device that had been
employed by many other
traditional painters of the
past. The result is a canvas
filled with colour. Renoir's
style is quite classical here
as the work was created to
appeal to potential buyers.
As always with Renoir,
composition and colour
naturally harmonize with
each other.

Woman with a Parrot, 1871,
oil on canvas, Solomon R.
Guggenheim Museum,
New York, USA,
92 x 65cm (36 x 26in)

Although not named, this
work is almost certainly
another portrait of Rapha.
Renoir has incorporated
various natural elements
into the work that he was
exploring in his *plein air*
paintings, including an
abundance of foliage and
loose, easy brushstrokes.
Once again the model is
occupied with her pet bird,
as in *Portrait of Rapha*
opposite, but this appears
more spontaneous
and unguarded.

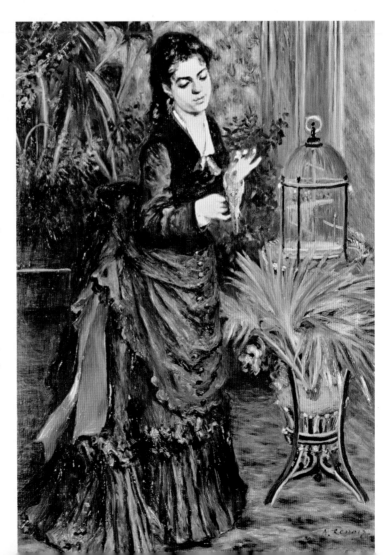

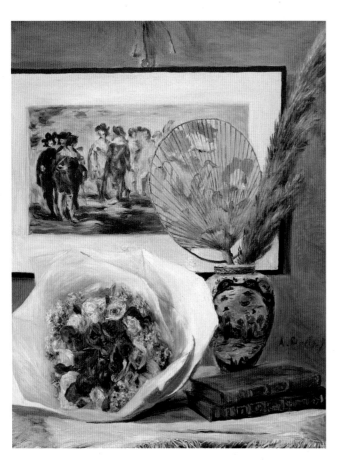

Still Life with a Bouquet, 1871,
oil on canvas,
The Museum of Fine Arts,
Houston, TX, USA,
74 x 59cm (29 x 23in)

This was painted in homage
to Manet as every object
refers to him. The sepia-
coloured print hanging on
the wall is signed 'Ed. Manet,
after Velázquez;' the bouquet
is practically identical to the
flowers in Manet's painting
Olympia of 1863, while the
books, Japanese fan and
feathery grass plume in
the small Chinese vase all
echo objects in Manet's
Portrait of Zola, which he
painted in 1868.

Captain Édouard Bernier
(formerly known as *Captain
Paul Darras*), 1871,
oil on canvas,
Gemäldegalerie,
Dresden, Germany,
81 x 65cm (32 x 25in)

This is one of the few works
that Renoir produced during
the Franco-Prussian War. At
the end of October 1870,
when the war began, Renoir,
along with many other
Frenchmen, was called for
active service. From January
1871, he spent two months
in Château Tarbes in the
south of France, and was
'treated like a prince' by
Captain Bernier (1822–80)
and his family.

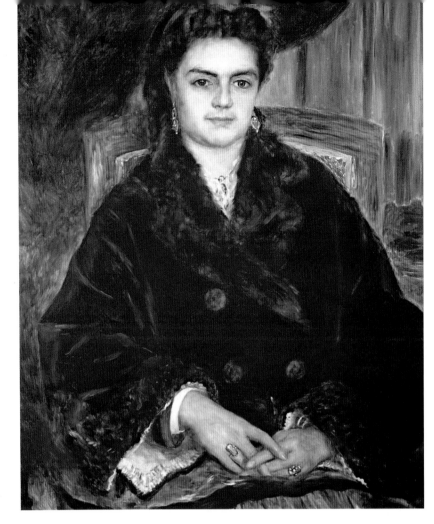

*Madame Édouard Bernier
(née Marie-Octavie-Stéphanie
Laurens)*, 1871,
oil on canvas, Metropolitan
Museum of Art,
New York, USA,
78 x 62cm (31 x 24in)

For many years, this work
was believed to portray
Madame Darras, but the
sitter has now been
identified as Marie-Octavie
Bernier, wife of the
commander of Renoir's
regiment during the Franco-
Prussian War. During
Renoir's stay with the
Bernier family in 1871,
he taught their daughter
to paint. The lady's lavish
attire sets off her dark looks,
which originate from her
Corsican mother.

Snowy Landscape,
c.1870–5, oil on canvas,
Musée de l'Orangerie,
Paris, France,
50 x 65cm (20 x 25in)

Because of Renoir's sanguine
nature, most of his works
are of sunny scenes. This is
one of his extremely rare
snow scenes – probably
painted with Monet. It was
clearly started in the open
air, but worked up in the
studio. The ground and sky
are built up with layers
of strokes of contrasting
and complementary hues,
showing that snow reflects all
the colours surrounding it,
and should never just be
portrayed as white.

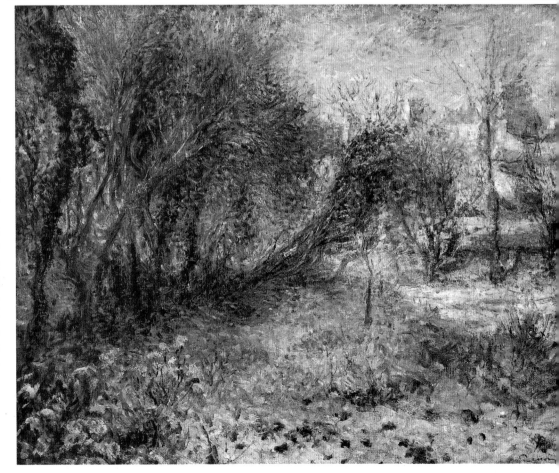

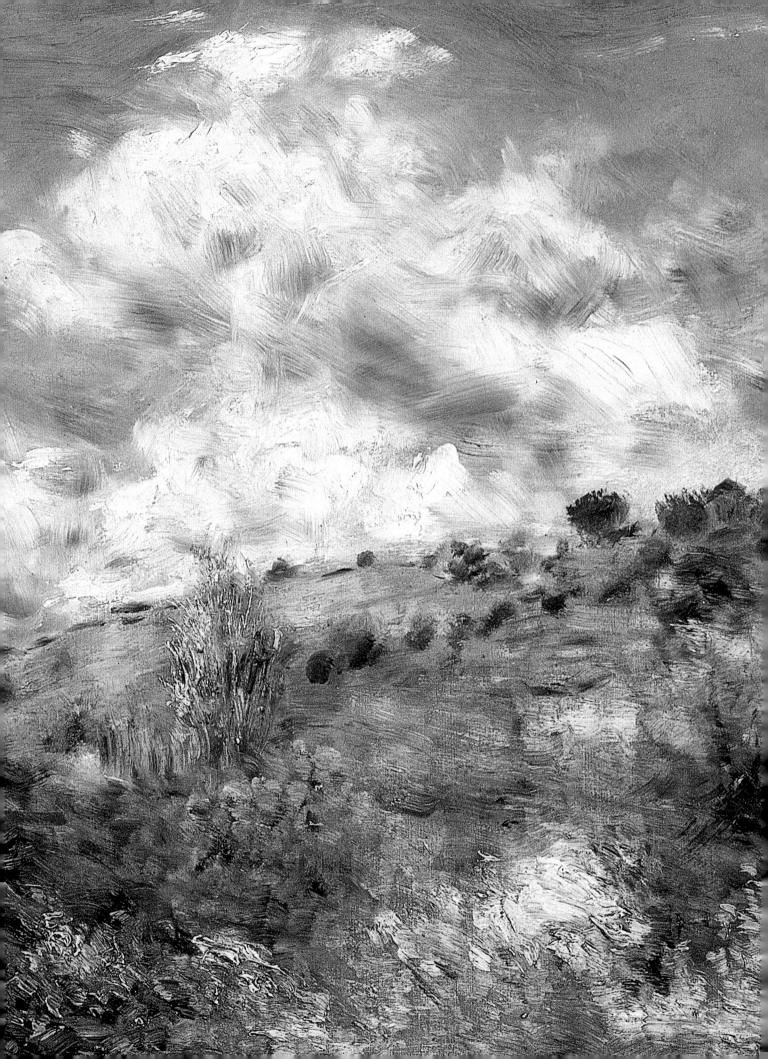

IMPRESSIONISM

Before the first independent group exhibition in April 1874, Renoir and several of his friends were already Impressionists, even though the name had not yet been coined. The ideas that they were all exploring from early in the 1870s, including painting directly in the open air where the light could not be controlled, placing colours side by side without blending them, in making brushwork visible and in putting complementary colours in shadows, were all methods that became known as Impressionism.

Above: The Old Port of Marseilles, c.1912, oil on canvas, Private Collection, 30 x 46cm (12 x 18in). Here Renoir has sketchily captured the Old Port of Marseilles, returning to some of his most impressionistic techniques.
Left: The Gust of Wind, 1872, oil on canvas, Fitzwilliam Museum, University of Cambridge, Cambridge, UK, 52 x 82.5cm (20 x 32in). With no figure in this scene, the impression of wind becomes the central theme. Using a variety of effects, this work contrasts with the highly finished works that were admired and accepted by society and the art establishment.

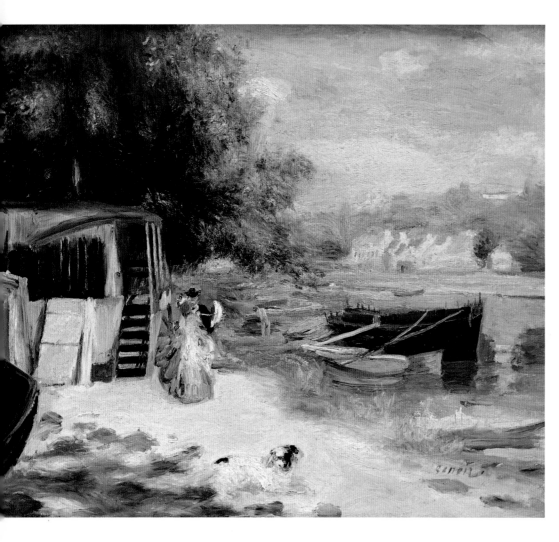

View of Bougival, 1873, oil on canvas, Milwaukee Art Museum, WI, USA, 49 x 57cm (19 x 22in)

Previously thought to represent La Grenouillère, this has recently been identified as a view of the Seine at Bougival. Focusing on a fleeting moment, foliage, two figures, boats, a deserted shed and a dog are described in light, bright colours, accented by white and touches of black, with coloured shadows and reflections. Each of these notions was at the heart of Impressionism.

The Seine at Argenteuil, c.1873, oil on canvas, Musée d'Orsay, Paris, France, 46 x 65cm (18 x 25in)

In the summer of 1873, Renoir stayed with Monet at Argenteuil, where Monet was renting a house with his young family. Neither artist had any money, but with Renoir's cheery nature and Monet's fortitude, they encouraged each other to paint with determination to assure future success. The result was a series of brightly executed, impressionistic scenes, painted out of doors with fresh clear colours.

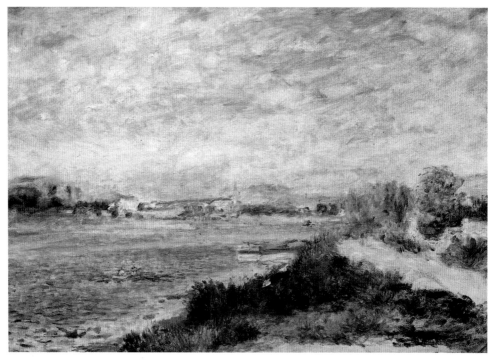

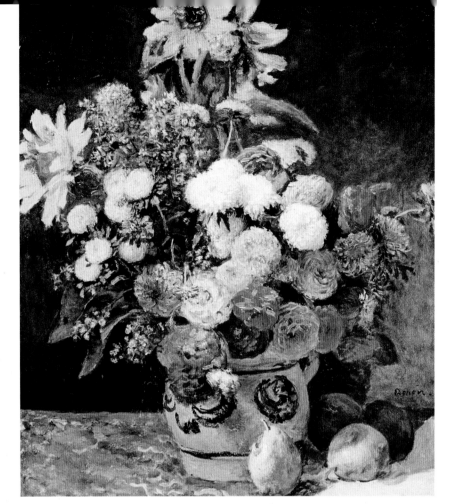

Mixed Flowers in an Earthenware Pot, c.1869–72, oil on paperboard, mounted on canvas, Museum of Fine Arts, Boston, MA, USA, 64 x 54cm (25 x 21in)

Displaying his technical skills, many of which were picked up during his apprenticeship in the porcelain-painting factory, Renoir portrays the effects of light filtering through lavender shadows, allowing the flowers to burst forth from the darker background. He proves in this work that he is a master of chiaroscuro (strong contrasts of light and dark), and that he can paint flowers in a variety of styles.

Parisian Women Dressed as Algerians, 1872, oil on canvas, National Museum of Western Art, Tokyo, Japan, 156 x 129cm (61 x 50in)

Once again Lise appears as Renoir's model, but this was one of the last occasions she did so, as she soon married an architect and moved away. This work once again refers to *The Women of Algiers* by Delacroix of 1834, a painting which Renoir admired greatly. Renoir restricted the colours in this work, creating a mainly golden and amber-toned picture with a deliberately diagonal composition.

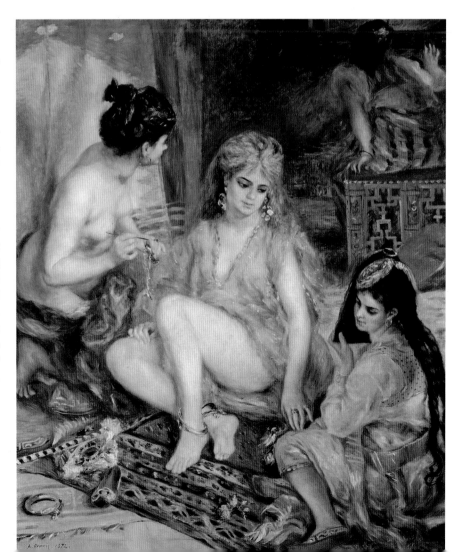

The Pont Neuf, 1872, oil on canvas, National Gallery of Art, Washington DC, USA, 75 x 94cm (29 x 37in)

Renoir had already painted a view of the Pont des Arts in 1867 and several other urban views of Paris. Here, he was probably influenced by Monet, who also painted scenes of Paris at this time. This is a view of one of the oldest bridges in Paris. As before, Renoir's brother Edmond stopped arbitrary passers-by with any excuse, giving Renoir a chance to sketch them.

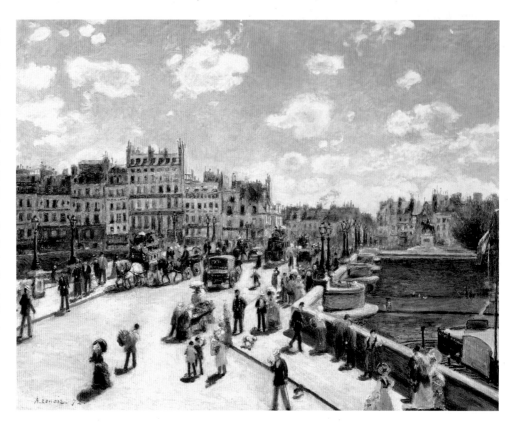

Portrait of Madame Claude Monet, 1872, oil on canvas, Private Collection, 36 x 33cm (14 x 13in)

Renoir made numerous portraits of Monet's wife Camille when he stayed at their house in Argenteuil in 1872. There are three portraits of her in this stylish blue dress, each in a different format. Painted with quick, efficient brushstrokes, Camille's delicate features are enhanced by her dark hair as she glances downward. Rather than detract from it, the blue wall behind Camille emphasizes the blue of her dress.

Madame Monet Reading,
1872, oil on canvas,
Sterling and Francine Clark
Art Institute,
Williamstown, MA, USA,
61 x 50cm (24 x 20in)

In greater detail, with smaller, less visible brushwork than in his other portraits of Camille painted at the same time, this composition is also more complex with foreshortening, detailed textures, patterns and shadows and evidence of the contemporary craze for Japanese art in the fans on the wall. Renoir has cleverly painted one of his favoured full-length portraits even though the model is sitting down.

Portrait of Madame Claude Monet, 1872, oil on canvas, Museu Calouste Gulbenkian, Lisbon, Portugal, 53 x 72cm (21 x 28in)

This portrait of Camille has once again been captured with quick, sketchy brush marks as she reads a newspaper. The small canvas was painted in one sitting during one of Renoir's visits to his friends. He made a feature of the light pouring into the room as it touches every object in the painting.

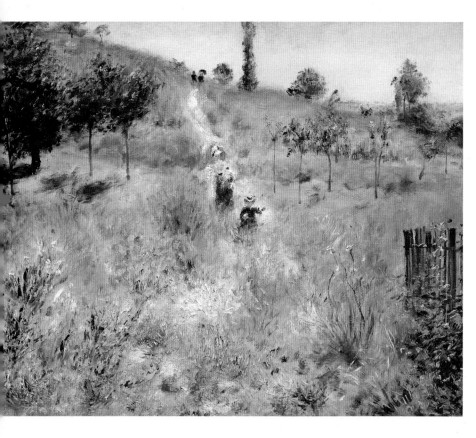

Path Rising Through Tall Grass, c.1872–4, oil on canvas, Musée d'Orsay, Paris, France, 60 x 74cm (24 x 29in)

Struggling financially, with Salon acceptances receiving little attention, Renoir worked more in the avant-garde Impressionist style. This was probably painted in Argenteuil near Monet's house. The image has been built up with small, energetic brushstrokes and thick paint. The vivid scarlet of the poppies lift the overall colour intensity of the work, in contrast with the dark green of the trees and bushes.

Claude Monet Reading, 1872, oil on canvas, Musée Marmottan, Paris, France, 61 x 50cm (24 x 19in)

From their first meeting in Gleyre's studio when they were in their early 20s, Renoir and Monet became firm friends. Their mutual respect for each other remained more or less constant throughout their lives. This intimate portrait of Monet enabled Renoir to express himself with intricate brushwork that added depth to the painting. The dark colours contrast with the luminosity of the face, lit up with orange and pink.

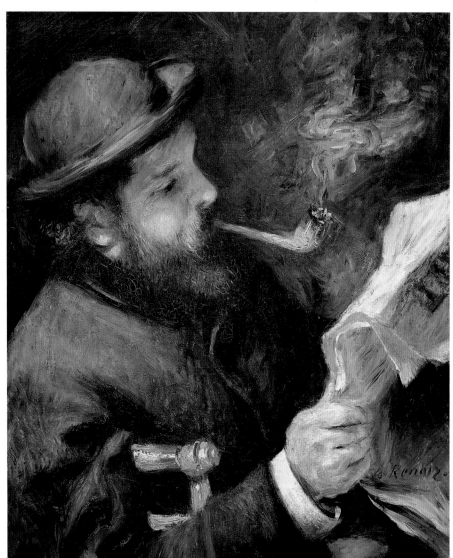

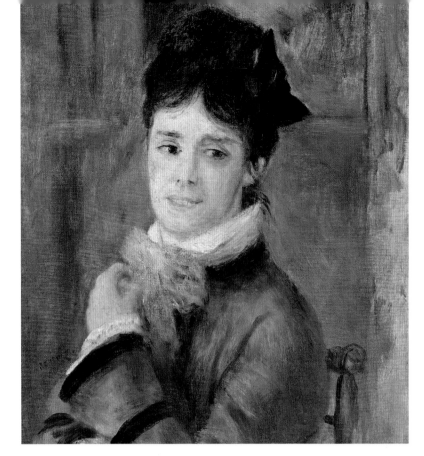

Portrait of Madame Claude Monet, 1872, oil on canvas, Musée Marmottan, Paris, France, 61 x 50cm (24 x 20in)

To complement Monet's portrait opposite, Renoir also made a portrait of Camille. Using short, directional marks, he applied the paint vigorously and assuredly. Throughout his life, Monet kept the two works, happy reminders of his time in Argenteuil, often spent with his close friend. When Renoir died, Monet commented: '[It] is a sad blow to me. With him a part of my life disappears.'

Women in a Garden, c.1874–6, oil on canvas, Private Collection, 54 x 65cm (21 x 26in)

Painted in the garden of the studio Renoir had rented since 1873, this includes a sun-filled path, a riot of coloured flowers, a fashionable young woman holding a white parasol, and another young woman who is almost hidden in the shadows. Renoir's flexible impressionistic technique is at its height. The figures establish a scale for the flourishing garden that is rendered in diversely textured brushstrokes.

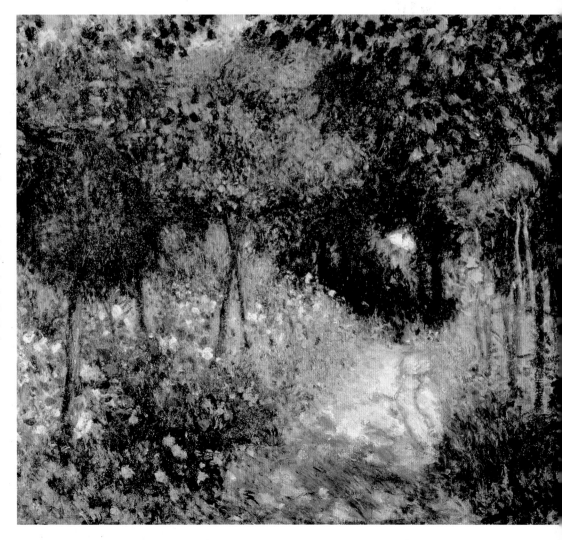

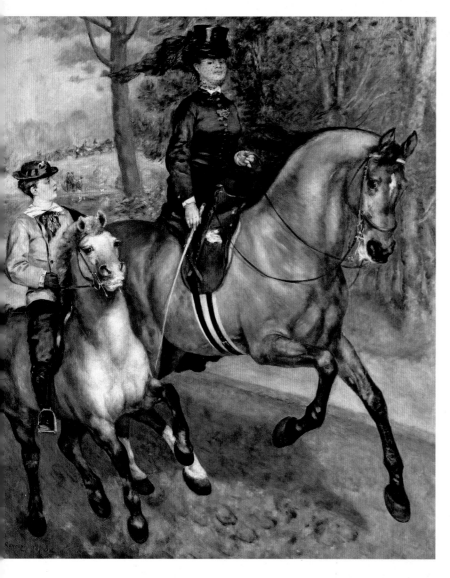

*Riding in the Bois de
Boulogne*, 1873,
oil on canvas,
Hamburger Kunsthalle,
Hamburg, Germany,
261 x 226cm (103 x 89in)

After the Franco-Prussian
War, Renoir decided to try
for the Salon again. He
submitted this monumental
canvas of Madame Darras
and Charles Le Coeur's
son Joseph on horseback.
But the subject matter of
ordinary people undertaking
an everyday activity did not
impress the Salon jury and it
was refused. Instead it was
shown at that year's
*Exposition Artistique des
Oeuvres Refusés*.

Madame Henriette Darras,
*c.*1873, oil on canvas,
Musée d'Orsay,
Paris, France,
48 x 39cm (19 x 15in)

Madame Darras and her
husband were introduced to
Renoir by Le Coeur. The
elegant spotted veil fascinated
Renoir and he painted this as
a study for his larger work
above. He still used black,
taking his influence from
Manet. Madame Darras looks
paler in this work than in the
final painting in which Renoir
enhanced her face with a
pink blush and a rose
on her costume.

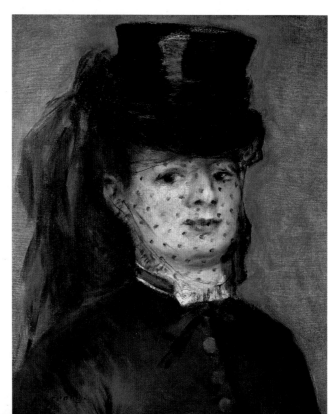

Woman with a Parasol in a Garden, 1875, oil on canvas, Museo Thyssen-Bornemisza, Madrid, Spain, 54 x 65cm (21 x 26in)

Painted in the garden of Renoir's studio on the rue Cortot, Rivière recalled: 'As soon as Renoir entered the house, he was charmed by the view of this garden, which looked like a beautiful abandoned park.' This painting is built up with small marks of lavish colours and textures. Two people are discernible, and a sense of space is created by bright foreground flowers against softer background brushwork.

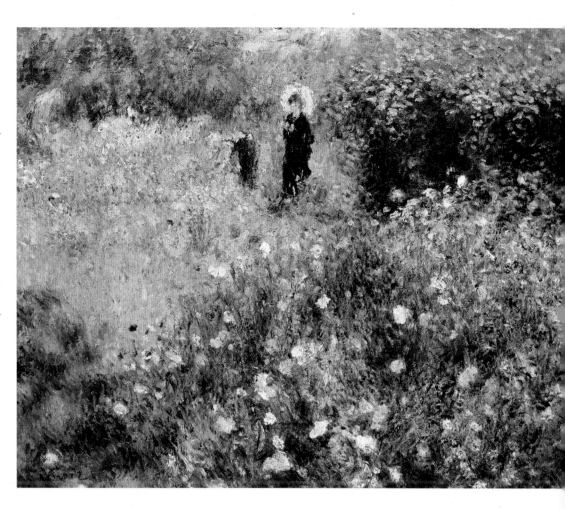

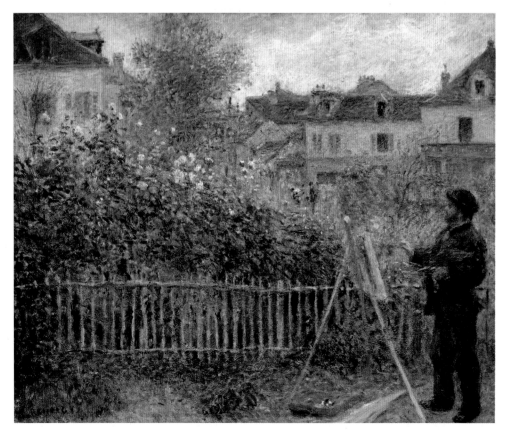

Claude Monet Painting in his Garden at Argenteuil, c.1873–4, oil on canvas, Wadsworth Atheneum Museum of Art, Hartford, CT, USA, 46 x 60cm (19 x 24in)

Monet paints on an easel in his garden, in the foreground of the painting, surrounded by a profusion of flowers, a fence and the houses beyond. Renoir applied variegated and elegant brushstrokes, using myriads of colour to build up a complex and detailed composition. Blues and yellows dominate the background and create accents in the foreground, while numerous shades of green and red prevail in the middle and foreground.

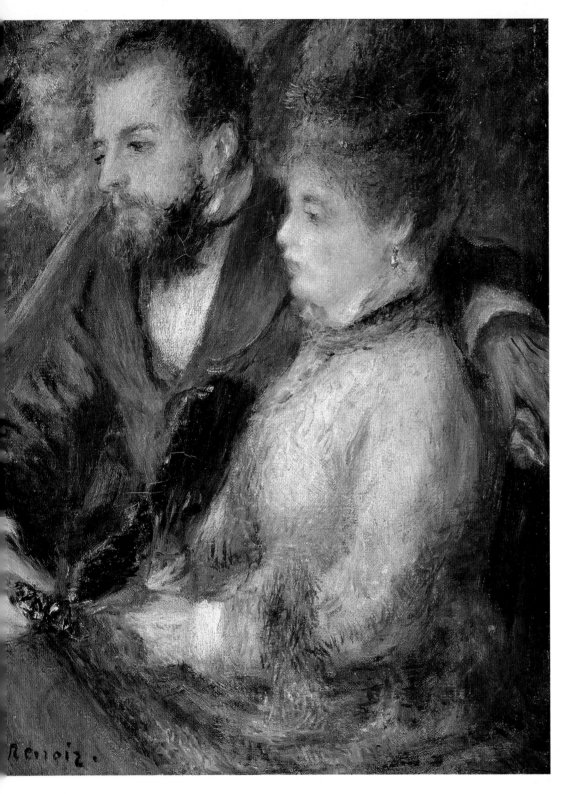

Box at the Theatre, c.1874,
oil on canvas,
Private Collection,
27 x 22cm (10 x 8in)

This tiny work demonstrates
the pleasure Renoir took
in painting small canvases.
Using tiny, agitated brush
marks, he built up his
familiar shimmering effect to
describe both the closeness
of the couple sitting in their
box, and the atmosphere of
the theatre around them.
Renoir produced several
genre paintings focusing on
individuals at the theatre,
rather than the activity on
the stage.

The Small Box, 1873–4,
oil on canvas,
Langmatt Museum,
Baden, Switzerland,
27 x 20cm (11 x 8in)

Another view of the same
subject, this work is brighter
than *Box at the Theatre*, but
is similarly small in format,
and the brushwork is just as
agitated. The husband and
wife are now completely
absorbed by the stage.
With his impressionistic
brush marks, Renoir has
blurred the programme in
the woman's hand to add
the impression of dynamism
to the image.

Woman in an Armchair,
1874, oil on canvas,
Detroit Institute of Arts,
Detroit, MI, USA,
61 x 50cm (24 x 20in)

Renoir's studio at 35 rue St
Georges in Montmartre
became a gathering place for
friends. While there, they
often socialized with Renoir's
female models. These
models came from the
working classes, but with his
ability to mix with all types,
he always put them at their
ease. In this work, he
suggests details through
freely brushed touches of
colour, so that the young
woman blends softly with
her surroundings.

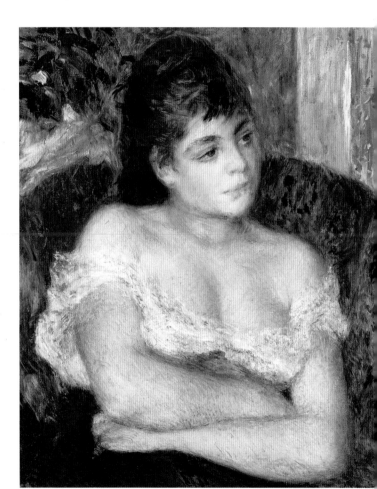

Young Woman with a Veil,
1875–7, oil on canvas,
Musée d'Orsay, Paris, France,
61 x 51cm (24 x 20in)

Portraits were particularly
popular in Paris in the
late 19th century as the
middle-classes emulated
the nobility. Renoir's portraits
appear casual and informal,
often suggesting that sitters
were unaware they were
being painted. With her
back to the viewer, and in
a veil, this young woman
is shrouded in mystery.
The dots and checks on her
clothing create a decorative,
patterned effect.

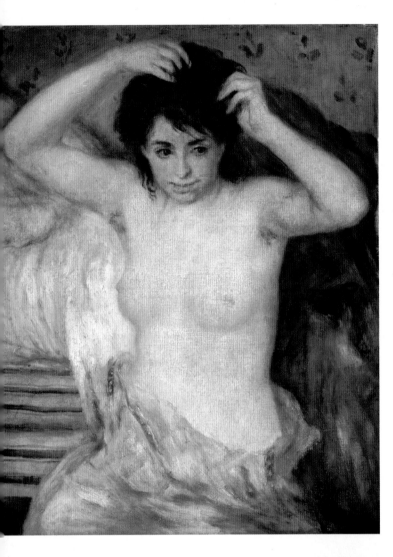

Torso or Before the Bath,
c.1873–5, oil on canvas,
The Barnes Foundation,
Philadelphia, PA, USA,
82 x 63cm (32 x 25in)

Renoir reveals his growing
maturity in this work.
Rich colour, soft transitions
between areas, and fluid
brushwork are all signs of
his confident style of this
period. By then, rather than
paint greyish-brown shadows
as he had done in past
paintings, he began applying
many subtle intermingled
tints of green and blue,
which harmonized with
the soft pinkish flesh tones
of the model.

Portrait of Charles Le Coeur,
1874, oil on canvas,
Musée d'Orsay,
Paris, France,
42 x 29cm (16 x 11in)

This lively portrait was
painted in the garden of
Charles Le Coeur's house at
Fontenay-aux-Roses in the
south-western suburbs of
Paris. The inscription at the
top right says: 'Ô Galand
Jard' (To the Gallant
Gardener). Charles was an
architect who became
friends with Renoir through
his brother Jules. Renoir was
close to the entire Le Coeur
family until the friendship
came to a sudden
end in 1874.

The Parisienne, 1874, oil on canvas, National Museum of Wales, Cardiff, UK, 160 x 106cm (63 x 41in)

In 1898, Signac recalled: 'Vuillard was kind enough to take me to see the Rouart Collection… I remember best… a large portrait of a woman in blue painted by Renoir… The dress is blue, pure, intense blue. The contrast makes the woman's skin look yellowish and the reflection makes it look green. The interaction between the colours is captured admirably. It is simple, fresh and beautiful.'

The Seine at Argenteuil, 1874, oil on canvas, Portland Art Museum, OR, USA, 51 x 65cm (20 x 25in)

Once again working side by side, Renoir painted with Monet in Argenteuil in 1874. They set up their easels near the Pont d'Argenteuil, and produced practically identical canvases of this view of yachts and rowing boats on the Seine. A man, hands in his pockets, converses with a man on the main yacht. Renoir's brushstrokes are more fragmented than usual, probably due to Monet's influence.

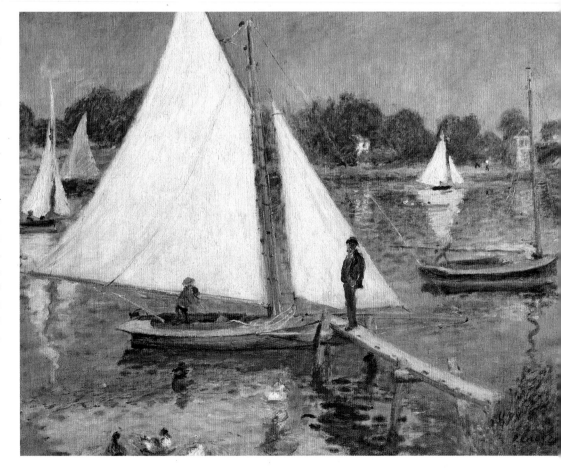

La Loge, 1874, oil on canvas, The Courtauld Gallery, London, UK, 80 x 64cm (31 x 25in)

This was Renoir's main exhibit at the first Impressionist exhibition. In building forms and textures, his skill is obvious, although the style and subject matter were radical. The models were his brother Edmond and Nini Lopez (nicknamed 'Fish-face'). The complexity of the scene is usual with Renoir. An elegantly dressed woman looks ahead while her companion gazes elsewhere. Rather than focus on the stage, Renoir emphasized the social stage and relationships.

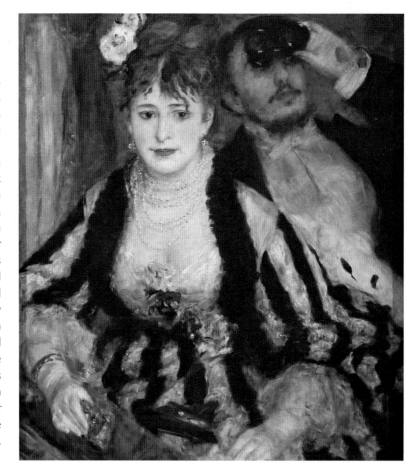

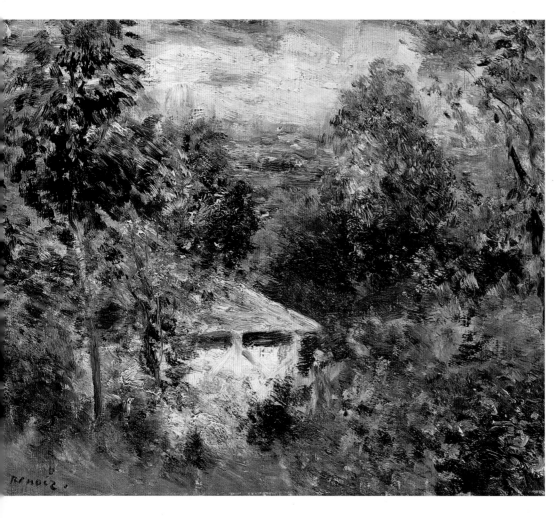

House in the Woods, c.1874–75, oil on canvas, The Barnes Foundation, Pennsylvania, Philadelphia, PA, USA, 39 x 47cm (15 x 18in)

By the mid-1870s, Renoir's usual blue-green and ivory landscapes contained more yellow. With these added bright tones the picture depicts contrasts of colour, playing them off against each other, but also incorporating Renoir's interpretation of delicate, porcelain-like 18th-century paint surfaces. His brushstrokes, loaded with intense colour, create patterns and atmosphere. Paint is applied in a creamy, velvety consistency, producing a continuous flow of colour throughout the composition.

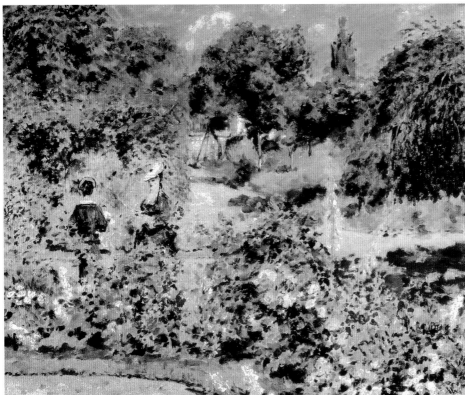

Garden at Fontenay-aux-Roses, 1873, oil on canvas, Oskar Reinhart Collection, Winterthur, Switzerland, 51 x 62cm (20 x 26in)

Although Renoir painted many landscapes, he nearly always incorporated figures and stories within them. Here, in Charles Le Coeur's garden, he has depicted two elegant ladies among the summer flowers. With no visible horizon, this work is like a tapestry. Complex and subtle dabs of modulated colours are placed across the canvas to build up the impression of dense foliage and dappled paths.

*A Waitress at Duval's Restaurant, c.*1875, oil on canvas, The Metropolitan Museum of Art, New York, NY, USA, 100 x 71cm (39 x 28in)

Monsieur Duval was a butcher in Paris who conceived the idea of selling good-quality bouillon to workmen at cheap prices, served by modestly-dressed waitresses. During the late 19th century, Duval opened several restaurants in Paris, and this was one of his waitresses. This is a typical portrait by Renoir of the mid-1870s – a pretty young woman in a natural pose, seemingly caught during a passing moment.

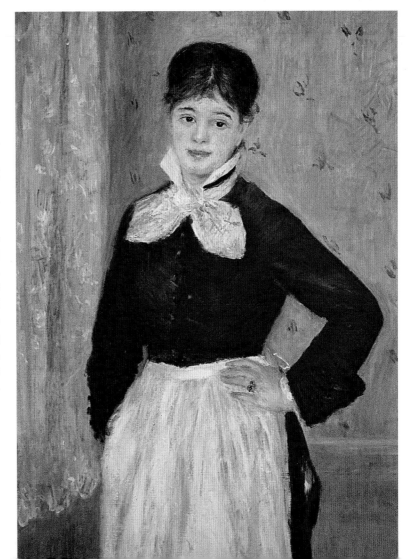

The Reader, c.1874–6, oil on canvas, Musée d'Orsay, Paris, France, 46 x 38cm (18 x 15in)

The young woman in the painting was Margot, Renoir's favourite model of the mid-1870s. Always interested in different light effects, he applied small, energetic and fine brush marks, building up an intricate mixture of colours, including juxtapositions of complementary colours and vibrant highlights in shades of white, yellow and pink to emphasize the reflections and illuminations. This painting was part of Caillebotte's legacy, and demonstrates Renoir's study of the rendering of light.

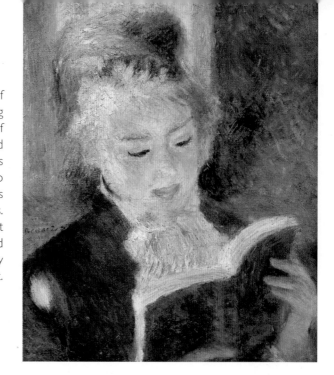

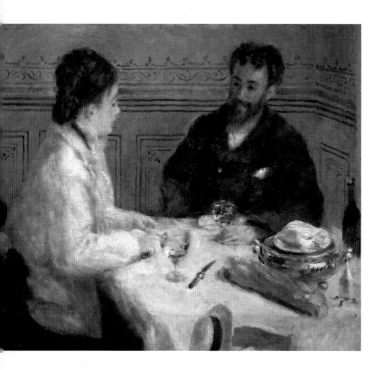

The Luncheon, Renoir, 1875, oil on canvas, The Barnes Foundation, Philadelphia, PA, USA, 49 x 58cm (19 x 23in)

Two of these models can also be seen in Renoir's painting *Luncheon at La Fournaise* of a similar date. In contrast, this is a cosy lunch indoors. A golden warmth dominates the colour scheme. It is as if we are glancing across a room at the couple, while the objects on the table appear like a Chardin still life.

Woman with a Rose, 1875, oil on canvas, Private Collection, 35 x 27cm (14 x 11in)

Once again a portrait of Margot, or Marguerite Legrand, Renoir's main model and probably mistress from 1874 until her untimely death in 1879, this charming painting shows Renoir's admiration of 18th-century styles. Her pearly skin is created from layers of delicate brush marks, while her clothes and hair are sketchily described with fewer layers. Every brushstroke defines a detail, but each detail is subsidiary to the general effect.

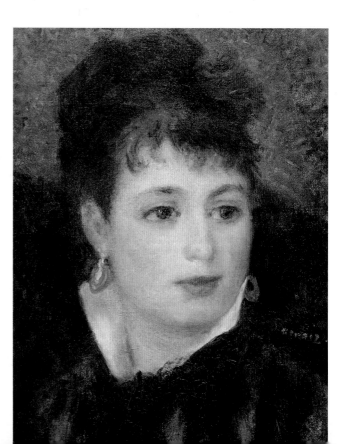

Woman at the Piano, c.1875, oil on canvas, The Art Institute of Chicago, IL, USA, 93 x 74cm (36 x 29in)

In a shadowy interior, illuminated only by the orange light of the candles, Renoir created an original composition of a classical subject. The figure and her piano dominate the centre area of the canvas, and there are hints of a room beyond in the large vase in the gloom. It is a typically middle-class scene from the period, although the feminine and fashionably dressed young woman has not been identified.

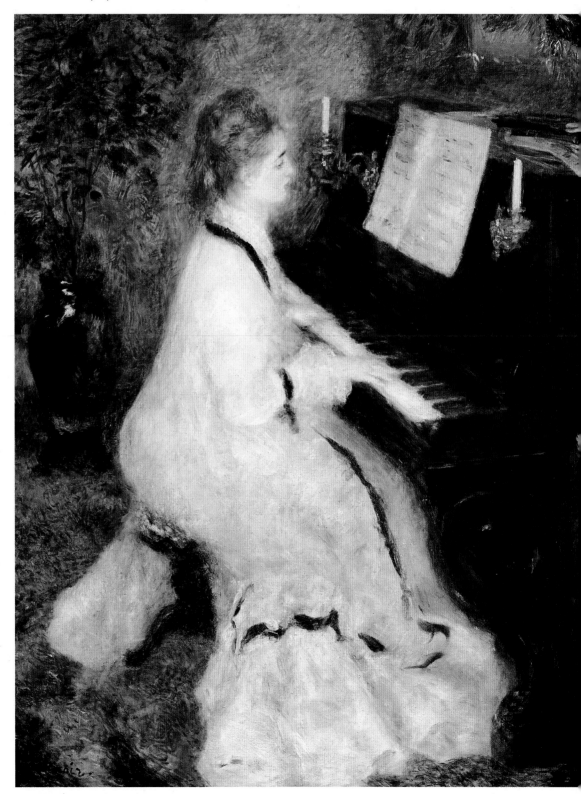

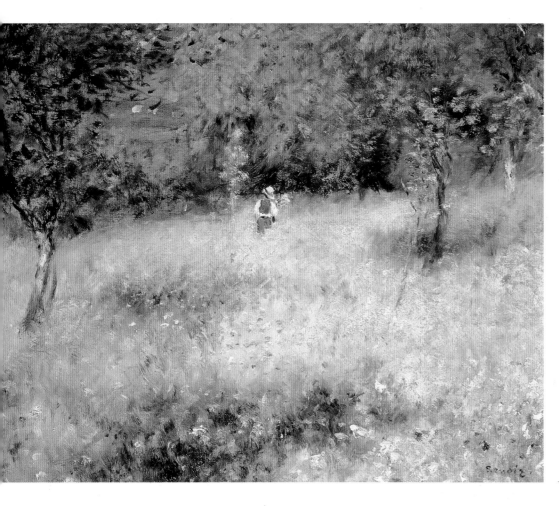

*Spring at Chatou, c.*1872–5,
oil on canvas,
Private Collection,
59 x 74cm (23 x 29in)

This is a clear example of
Renoir's Impressionist
experimentations. Taking a
stretch of grass, with trees in
the background and one
small figure, he applied
irregular brushstrokes to
build up an animated and
sparkling image. The horizon
is at an angle, and the
figure is depicted in grey,
white and yellow, while his
multicoloured marks suggest
wild flowers growing in the
sun-dappled grass.

Woman with a Cat, 1875,
oil on canvas,
National Gallery of Art,
Washington, DC, USA,
56 x 46cm (22 x 18in)

Although Renoir loved
women, he only
loved a particular type.
He frequently depicted
them with dogs, cats and
children, showing their soft,
nurturing characteristics, as
this was what he valued. 'I
like women best when they
don't know how to read;
when they wipe their baby's
behind themselves,' he said.
He was highly responsive to
radiant skin, full mouths and
almond-shaped eyes.

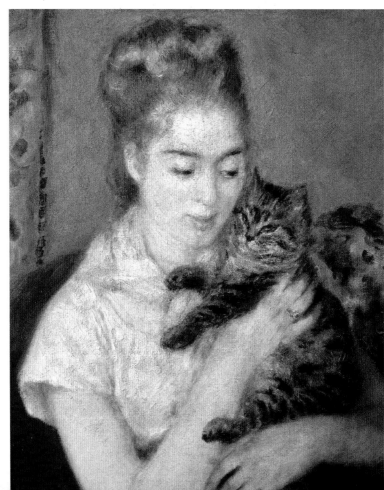

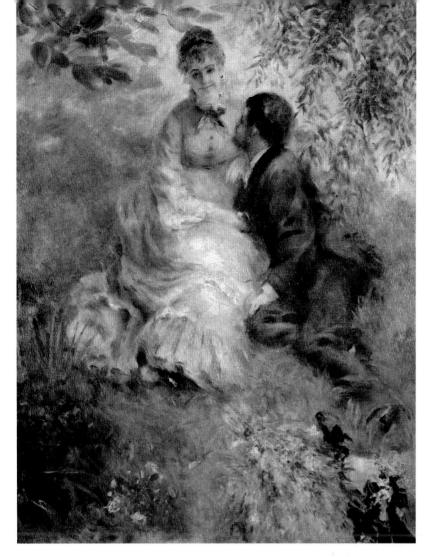

*The Lovers, c.*1875, oil on canvas, Národní Galerie, Prague, Czech Republic, 175 x 130cm (69 x 51in)

This large format of an intimate scene is a contemporary version of a traditional pastoral idyll. The man is probably the painter Franc-Lamy, and the woman is the actress Henriette Henriot. The idea for this and for several other scenes of figures in outdoor settings painted at this time, developed from Renoir's admiration of Watteau and Boucher as well as Manet's *Déjeuner sur l'Herbe* of 1863.

In the Garden (Under the Arbour of the Moulin de la Galette), 1875, oil on canvas, The State Pushkin Museum of Fine Arts, Moscow, Russia, 81 x 65cm (32 x 25in)

Painted in the garden of his studio at 12 rue Cortot in Montmartre in April 1875, Renoir worked on several studies for his painting of the Moulin de la Galette. This canvas shows a group of friends sitting under an arbour, drinking and relaxing, with a young woman standing in the foreground, her back to the viewer. With broad brushwork, Renoir captured the dappled light with colourful highlights and shadows.

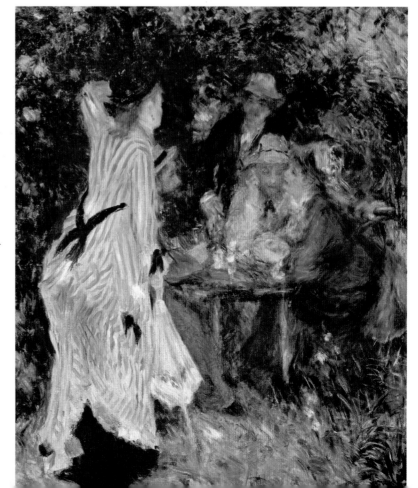

Portrait of Claude Monet,
1875, oil on canvas,
Musée d'Orsay,
Paris, France,
85 x 60cm (33 x 24in)

In a relaxed and comfortable pose, Monet glances at his friend. Light pours in from the window and illuminates his face, which is also softened by the curtain and oleander plant behind him. With different tones created by variegated and juxtaposed brushstrokes, this work was compared by Zola after the second Impressionist exhibition as being 'worthy of Rembrandt, illuminated by the brilliant light of Velázquez.'

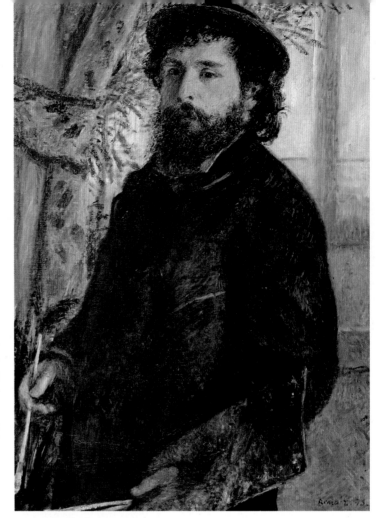

Study: Torso, Effect of Sunlight,
1875, oil on canvas, Musée d'Orsay,
Paris, France,
81 x 65cm (32 x 25in)

Displayed at the second Impressionist exhibition in 1876, this painting of the effect of light through foliage dappling a nude was admired by a few critics, but hated by more. Albert Wolff wrote: 'Would someone please explain to M. Renoir that a woman's torso is not a mass of decomposing flesh with the green and purplish blotches that indicate a state of complete putrefaction in a corpse…'

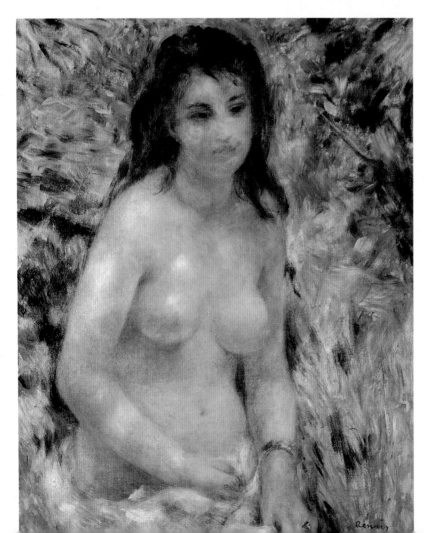

Portrait of Victor Chocquet,
1875, oil on canvas,
Fogg Art Museum,
Harvard University,
MA, USA,
46 x 37cm (18 x 14in)

An official in the Customs
Service, Victor Chocquet
admired Renoir's work from
the moment he first saw it at
the Hôtel Drouot. He
commissioned Renoir to
paint portraits of him and
his wife in front of paintings
by Delacroix that he owned.
Renoir introduced him to
his friends' work, particularly
Cézanne's. Chocquet
became a friend and
fervent champion of the
Impressionists, defending
them whenever the
opportunity arose.

*Copy of Jewish Wedding in
Morocco,* after Delacroix,
1875, oil on canvas,
Worcester Art Museum,
MA, USA,
109 x 144cm (43 x 57in)

In 1875, Renoir's friend and
patron Duret introduced
him to Jean Dollfus, an
industrialist and collector
who loved the work of
Delacroix. That summer,
Dollfus commissioned
Renoir to paint a copy of
Delacroix's painting of 1839
Jewish Wedding in Morocco,
which was in the Louvre. He
paid Renoir 500 francs for
this skilful copy of the master
they both admired.

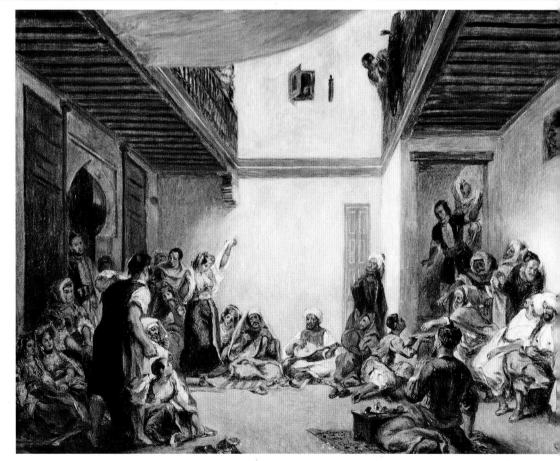

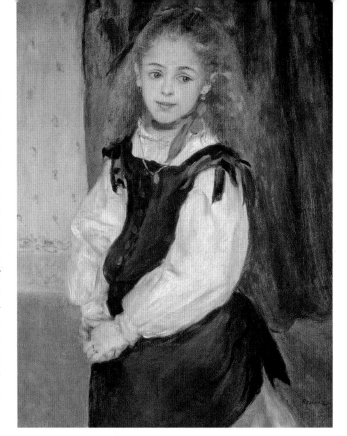

Portrait of Mademoiselle Legrand, 1875, oil on canvas, Philadelphia Museum of Art, PA, Pennsylvania, USA, 81 x 59cm (32 x 23in)

The Legrands were members of the petite bourgeoisie and this portrait of their child Adelphine, aged 8, is one of Renoir's most enchanting portraits of children. With clasped hands she glances over her shoulder, her blue scarf and delicate gold jewellery adding accents of colour. The work is dominated by Renoir's vigorous brushwork.

The Seine at Argenteuil, 1875, oil on canvas, Private Collection, 50 x 61cm (20 x 24in)

Renoir and Monet perfected the Impressionist technique while working side-by-side. Renoir was a regular visitor to Monet's home and they companionably worked in the open air together, capturing the light passing through the trees, giving a glimpse of a house on the distant riverbank. This is a rhythmic work, created from a rich palette and dynamic brushwork. The idea of viewing the landscape through natural forms was not unique, but fairly original.

The Skiff, 1875,
oil on canvas,
The National Gallery,
London, UK,
71 x 92cm (28 x 36in)

Probably painted at Chatou, this depicts two women rowing a small boat along the Seine on a sunny day. The orange skiff contrasts vividly with the blue of the water, which has been built up with delicate slabs of cobalt blue and ultramarine. In the background, an approaching train on a railway bridge exemplifies the Impressionist method of bringing modern life into their work – even though Renoir abhorred industrialization.

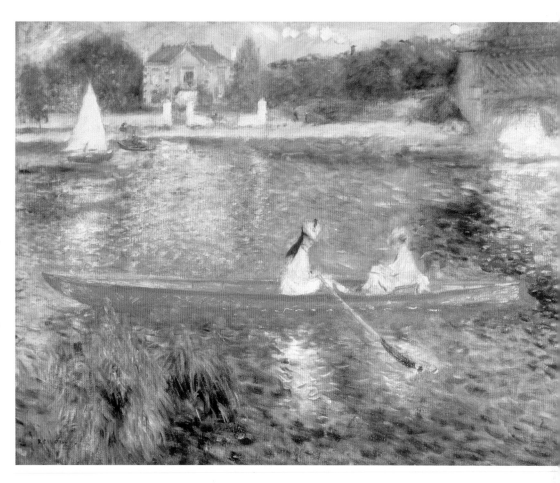

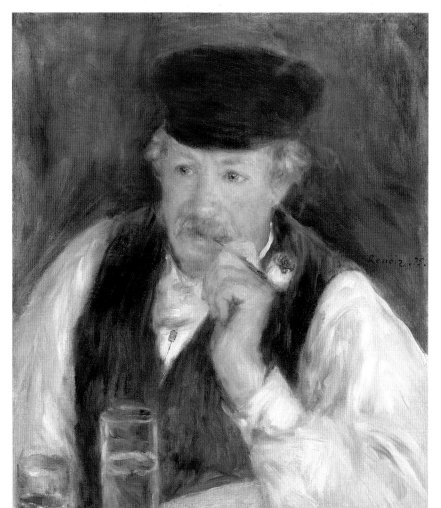

Monsieur Fournaise, 1875, oil on canvas, Sterling and Francine Clark Art Institute, Williamstown, MA, USA, 56 x 47cm (22 x 18in)

Sundays off were a new privilege for French workers, and in order to escape the pollution, many Parisians flocked to the countryside. In 1857, Alphonse Fournaise and his wife opened a small hotel and restaurant at Chatou next to his boat-building establishment. He regularly organized boating events and regattas, and genially welcomed his friends, who included many of the Impressionists. Renoir painted about 30 works there, including this affectionate portrait.

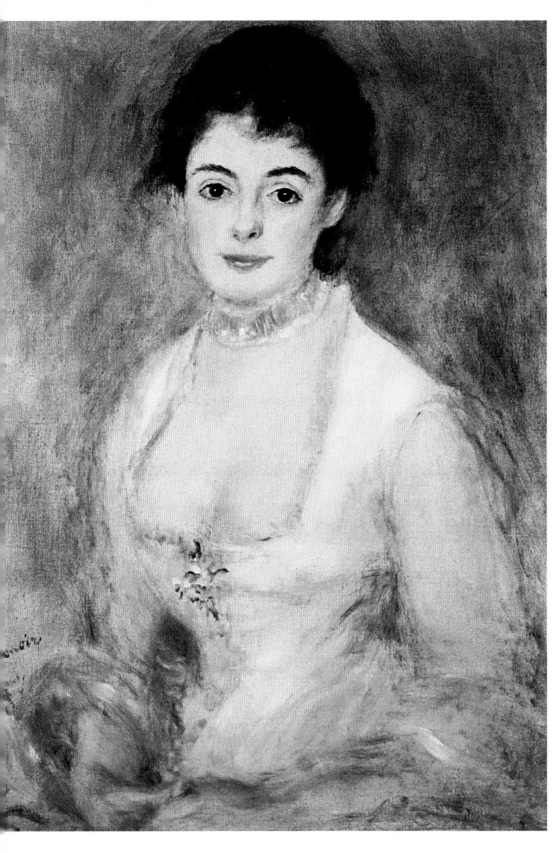

Madame Henriot, Renoir, c.1876, oil on canvas, National Art Gallery, Washington DC, USA, 66 x 50cm (26 x 19in)

Contemporary photographs reveal that Henriette Henriot, a young vaudeville actress was quite plain, but Renoir enhanced her looks with soft colours and a light touch, capturing the appearance of her gauzy dress in the manner of Watteau and Boucher. Henriette was the subject of at least 11 of Renoir's works, painted between 1874 and 1876 (she was the model for *The Parisienne*).

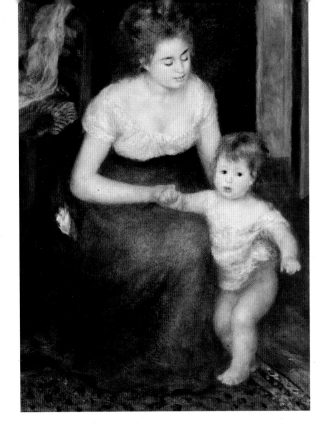

The First Step, Renoir, 1876, oil on canvas, **Private Collection,** 111 x 80.5cm (44 x 32in)

Renoir's paintings of maternity became more frequent after his own sons were born, but before that time, he occasionally portrayed tender images of mothers with their babies or children, influenced by Old Master themes of the Madonna and Child. This was inspired by *The Virgin and Child with St Anne*, 1508, by Leonardo da Vinci, which hangs in the Louvre.

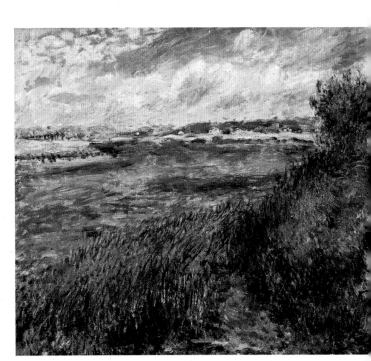

The Seine at Champrosay, 1876, oil on canvas, Musée d'Orsay, Paris, France, 55 x 66cm (22 x 26in)

One of five landscapes that Renoir submitted to the third Impressionist exhibition, this was described by one critic as: 'one of the most beautiful [landscapes] ever made.' It is a vigorous painting, created with rhythmical brushstrokes and a predominantly blue, yellow and green palette. Long, thin strokes describe the effects of wind blowing through the long grass, while short, flat marks portray the water and sky.

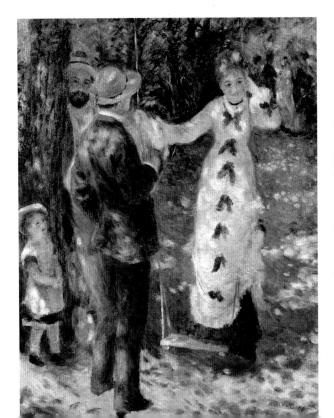

The Swing, 1876, oil on canvas, Musée d'Orsay, Paris, France, 92 x 73cm (36 x 28in)

Painted in the garden of the rue Cortot, this is another study of the effects of sunlight filtering through foliage. As if in a snapshot, two men and a woman are caught in conversation, watched by a small child. The models were Renoir's brother Edmond, the painter Goeneutte and Jeanne, a young woman from Montmartre. This was shown at the third Impressionist exhibition of 1877 and bought by Caillebotte.

Portrait of Madame Edmond Renoir, 1876, oil on canvas, Private Collection, 40 x 33cm (16 x 13in)

Mélanie Porteret came from a working-class background and became Edmond's mistress during the 1870s. Although this contradicted the brothers' aspirations to mix with the middle and upper classes, it was not unusual in their artistic circle. Mélanie gave birth to Edmond Renoir Junior in March 1884. Renoir painted her using soft, small brushwork on her face, hair and clothes, but thick slabs of paint to render the background.

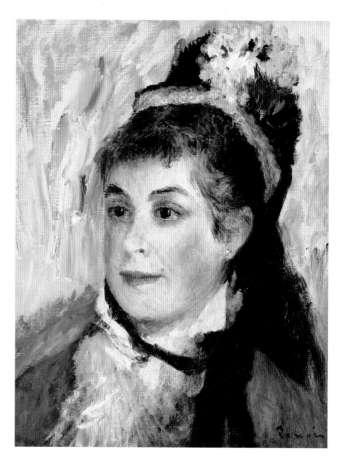

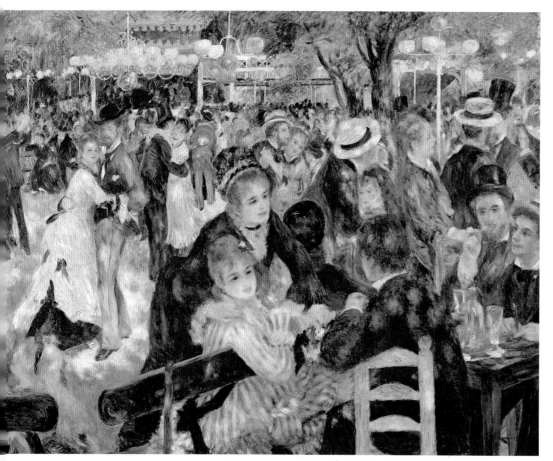

Ball at the Moulin de la Galette, 1876, oil on canvas, Musée d'Orsay, Paris, France, 131 x 175cm (51 x 69in)

Painted simultaneously with *The Swing,* this depicts a popular dance garden in Montmartre. Full of sparkling colour and dappled light, the work was exhibited at the third Impressionist exhibition and all the models are Renoir's friends. The girl in the striped dress was Estelle, Jeanne Samary's sister. Margot is in pink dancing with the painter Cardenas, and at the foreground table are Franc-Lamy, Goeneutte and Rivière.

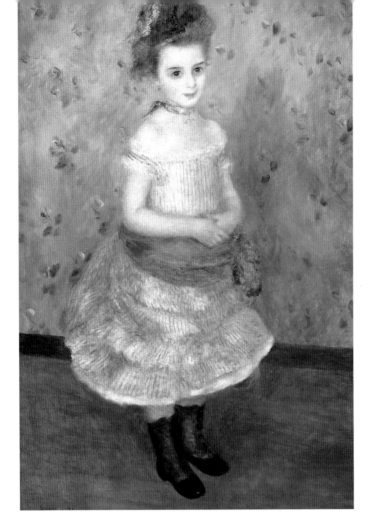

Jeanne Durand-Ruel, 1876, oil on canvas, The Barnes Foundation, Philadelphia, PA, USA, 112 x 75cm (44 x 29in)

Exemplifying the daintiness of a small child, this is executed in Renoir's preferred 18th-century style, with delicate brushwork. Jeanne was Paul Durand-Ruel's daughter; she was six when this portrait was painted. Fragile and appealing, the little girl smiles a little self-consciously, dressed in her best clothes as Renoir painted her with subtle marks, soft colours and unusually, some intricate details, creating the appearance of a porcelain statuette.

Self-portrait, 1876, oil on canvas, Fogg Art Museum, Harvard University, MA, USA, 71 x 54cm (28 x 21in)

Considering that Renoir was predominantly a painter of portraits, it is perhaps unusual that he produced relatively few self-portraits. He painted this when he was aged 35, still looking young and healthy. Applying rapid, supple and loose marks from a limited palette of browns, blues and ochre, he demonstrates how he adapted his handling of paint to the demands of specific subjects and themes.

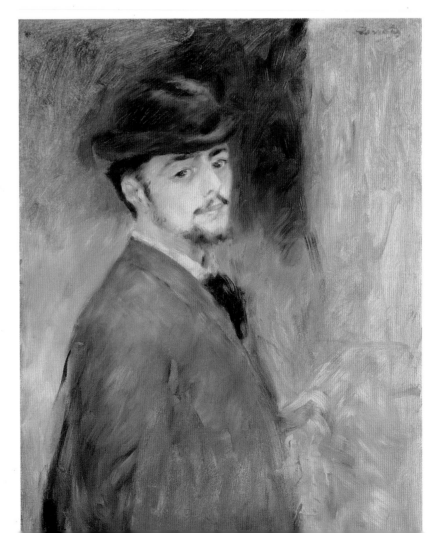

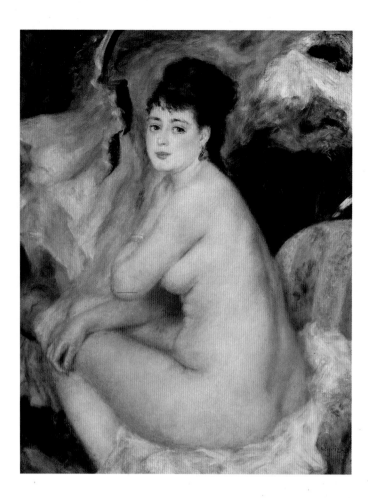

Nude, 1876, oil on canvas, The Pushkin Museum of Fine Arts, Moscow, Russia, 92 x 73cm (36 x 29in)

Renoir delighted in painting certain types of women rather than individuals. This work has also been called *Anna*, the name of one of Renoir's favourite models at the time, although it is not certain that this is Anna. He has emphasized her voluptuous curves with soft, small strokes, building an impression of translucent skin and contrasting this with the blueness of her eyes and the darkness of her hair.

*Woman in Black, c.*1876, oil on canvas, The State Hermitage Museum, St Petersburg, Russia, 66 x 56cm (26 x 22in)

With his free, impressionistic brushstrokes and intricate colour distinctions, this skilful portrait gives the impression of spontaneity. Broad strokes describe the dress and background, while smaller, more detailed marks have been used for the face. It is not certain whether the model is Madame Hartmann, wife of playwright Georges Hartmann, or whether she is Anna, the probable model for *Nude*, above.

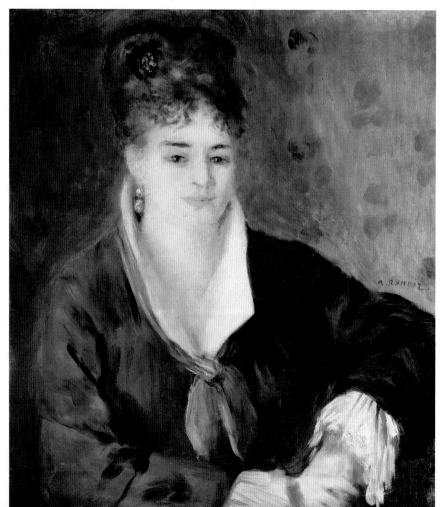

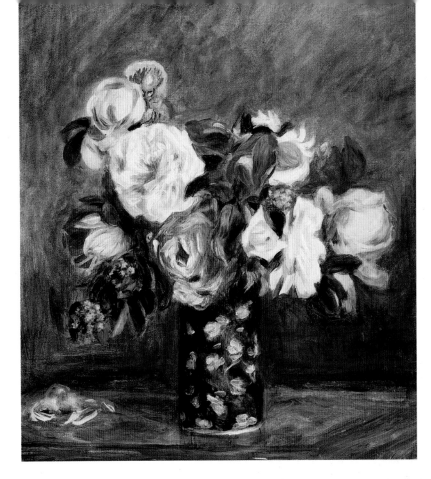

Roses in a Blue Vase, c.1876,
oil on canvas,
The Barnes Foundation,
Philadelphia, PA, USA,
55 x 46cm (22 x 18in)

Renoir said, 'What seems to
me most significant about
Impressionism is that we
have freed painting from the
importance of the subject.
I am at liberty to paint
flowers without their
needing to tell a story.'
Randomly placing the
roses in a blue vase without
prior planning, Renoir
captured them with rich
colours and different-sized
strokes, drawing inspiration
from Manet's style.

A Girl with a Watering Can,
1876, oil on canvas, National
Gallery of Art, Washington
DC, USA,
100 x 73cm (39 x 29in)

Believed to be painted in
Monet's garden in Argenteuil,
the model for this painting
has not been confirmed.
Elaborately dressed, the child
stiffly holds a watering can.
Renoir applied short, delicate
brushstrokes and subtle
nuances of colour to create
a fresh and vivacious work.
He softened the little girl's
awkwardness with glowing
colours, creating a bright
environment that conveys
her innocent appeal.

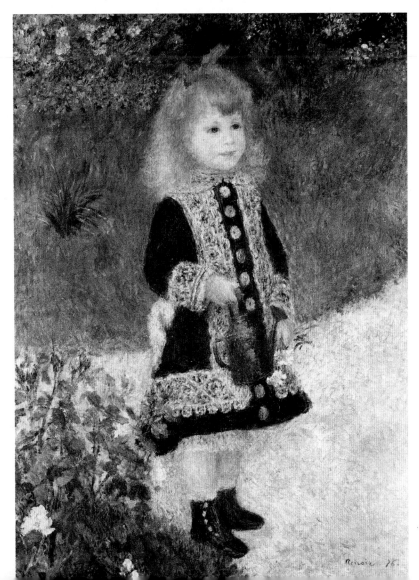

Madame Georges Charpentier, 1876–7, oil on canvas, Musée d'Orsay, Paris, France, 46 x 38cm (18 x 15in)

Because of her literary and political salons, Marguérite-Louise Charpentier, the wife of publisher Georges Charpentier, was well known. So when Charpentier commissioned Renoir to paint her portrait, Renoir knew it would be seen by other prospective patrons. He told Vollard that Madame Charpentier bore a resemblance to Marie-Antoinette, and in this work, although she looks relaxed, he imbued her with a rather stately air.

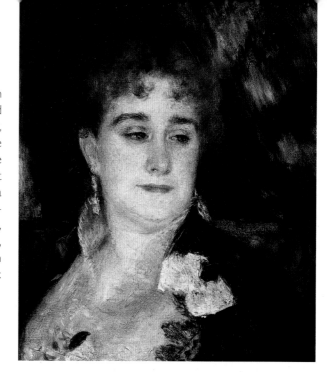

*Portrait of Madame Alphonse Daudet, c.*1876, oil on canvas, Musée d'Orsay, Paris, France, 46 x 38cm (18 x 15in)

Jeanne Daudet was the granddaughter of writer Victor Hugo and the wife of the successful novelist and playwright Daudet, who was considered one of the leading members of the Realist movement in literature, along with Zola and others. He often socialized with Renoir and his friends, and was a supporter of Impressionism. As well as buying paintings from the Impressionists, he commissioned Renoir to paint his wife's portrait.

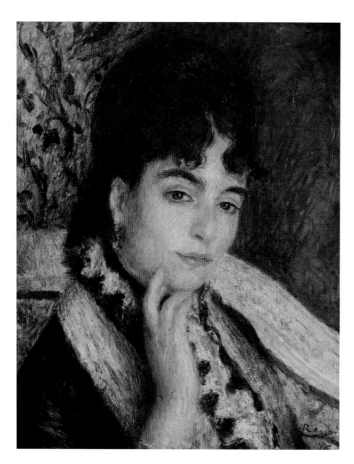

Portrait of a Young Woman, 1876, oil on canvas, Neue Pinakothek, Munich, Germany, 60 x 40cm (24 x 16in)

Having not yet abandoned black, Renoir made full use of it here. He was often faced with a dilemma with commissioned portraits: they had to resemble each sitter, yet they also needed to demonstrate a characteristic prettiness. Here, he turned his sitter to the side and painted her coyly tilting her head, making the most of the soft textures of velvet, lace and curly hair.

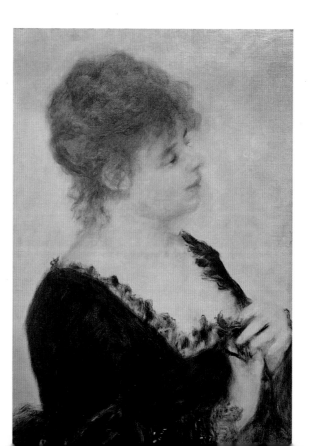

After the Concert, 1877,
oil on canvas,
The Barnes Foundation,
Philadelphia, PA, USA,
186 x 117cm (73 x 46in)

This is an experimental
genre scene capturing a
moment in time, in which
Renoir has used delicate
touches of paint reminiscent
of Fragonard and Boucher
for the two women
(modelled by Margot
and Nini). He has carefully
expressed tonal contrasts in
a similar fashion to Chardin,
while utilizing the rich
colour and light effects
of 16th-century Venetian
painting. The two men
are Edmond Renoir
and Rivière.

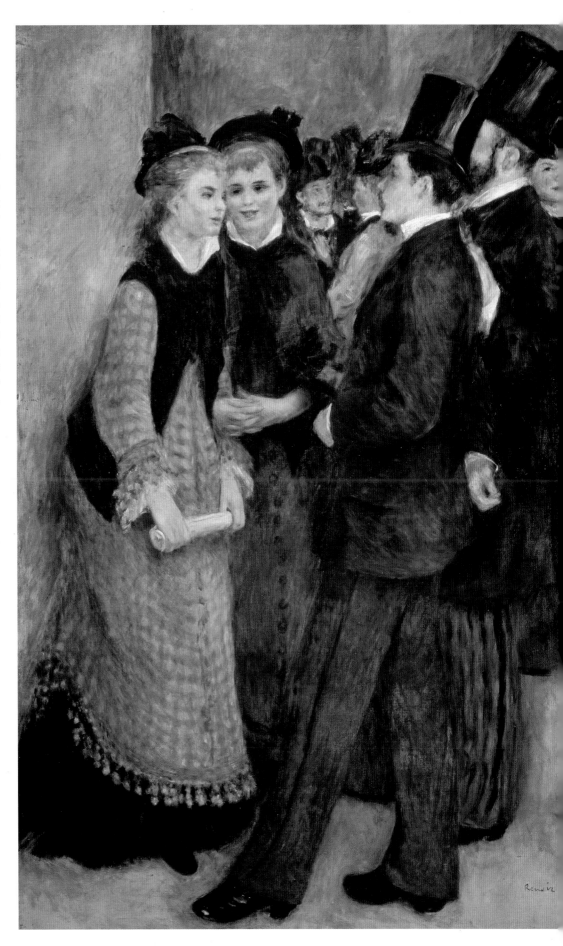

Portrait of Madame Jeanne Samary, 1877, oil on canvas, The Pushkin Museum of Fine Arts, Moscow, Russia, 56 x 47cm (22 x 18in)

Jeanne Samary was a famous actress from the Comédie-Française who became friends with Renoir through the Charpentiers. This is an affectionate portrait that reveals the warmth between two friends. The pale background harmonizes with the colour of Jeanne's hair, and serves to intensify the brilliant green of her evening gown. Her face and shoulders are modelled with cross-hatchings in vivid blues, pinks and greens, which horrified some critics.

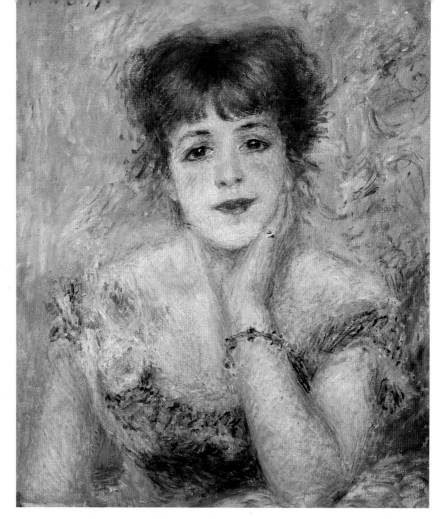

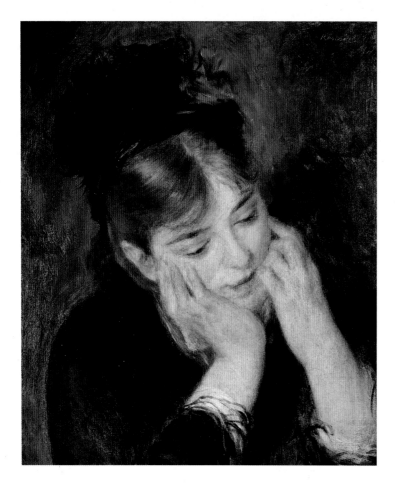

Contemplation, 1877, oil on canvas, Private Collection, 35 x 27cm (14 x 11in)

In one of Renoir's small canvases, he has portrayed a pretty young woman lost in reverie. As with most of these small genre works, he applied paint in a lush consistency, building up rich hues and tones and diversifying his brushwork across the canvas in order to capture different textures and the play of light. Colours are harmonious, and the skin of the sitter appears luminous against the dark background.

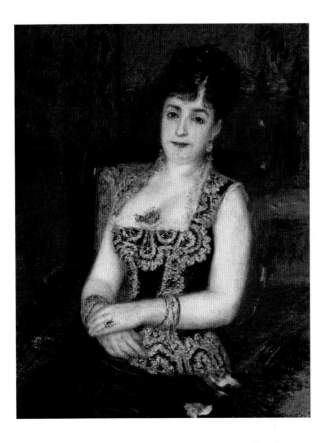

Portrait of the Countess de Pourtalès, Renoir, 1877, oil on canvas, Museu de Arte, São Paulo, Brazil, 95 x 72cm (37 x 28in)

Struggling to attract buyers for his Impressionist paintings, Renoir accepted portrait commissions whenever he could. In this painting of Mélanie Louise Sophie Renouard de Bussière, the wife of Edmond de Pourtalès and famed beauty, he incorporated some of Ingres' neoclassical ideas. Knowing that his model mixed with the highest society, he paid less attention to his Impressionist approach in an effort to attract additional wealthy buyers.

At the Café, c.1877, oil on canvas, Rijksmuseum, Kröller-Müller, Otterlo, Netherlands, 35 x 28cm (13 x 11in)

Café society was always significant in Paris, and particularly important to Renoir and the other Impressionists who needed somewhere to discuss their new ideas. This small work captures a scene of modern life, which also fascinated Manet and Degas. Renoir probably started this on the spot, but worked the heads of the three main figures (Rivière, Margot and Nini) in the studio.

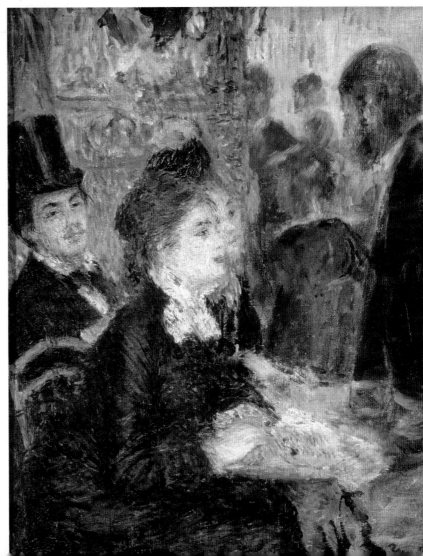

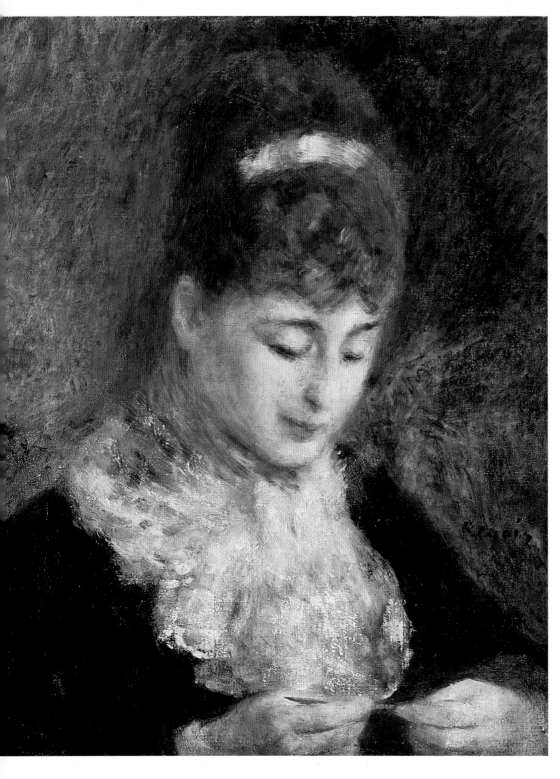

*Woman Crocheting, c.*1877, oil on canvas, The Barnes Foundation, Philadelphia, PA, USA, 40 x 32cm (16 x 13in)

Increasingly, Renoir was influenced by the 16th-century Venetian artists, particularly Titian. This painting reveals that inspiration, with strong colour contrasts used to build up the structure of the composition. The moving hands, even though they are at the bottom of the canvas, are rendered in great detail and the face is created with 'Venetian colours' of light brown, juxtaposed with greens, blues, pinks and ivories.

Young Woman in Blue Going to the Conservatory, 1877, oil on canvas, Private Collection, 78 x 49cm (31 x 19in)

With the background unpainted, it seems that this work is incomplete, yet Renoir has finished the model in meticulous detail, creating smooth contours and tones. Also, the size implies that it was intended to be a complete work. With his admiration of fashionable women, in a radiant study of ingenuousness, he has captured this chic young Parisienne on her way to her music lesson.

In the Café, 1877, oil on canvas, Private Collection, 39 x 34cm (15 x 13in)

This small canvas is thought to have been painted at the same time as *At the Café*. Once again, it explores a theme of modern life, and one that was particularly significant to the Impressionists, with their regular visits to the Café Guerbois and the Café Nouvelle Athènes. Treated vigorously with fresh, creamy paint, this gives Renoir's usual impression of spontaneity.

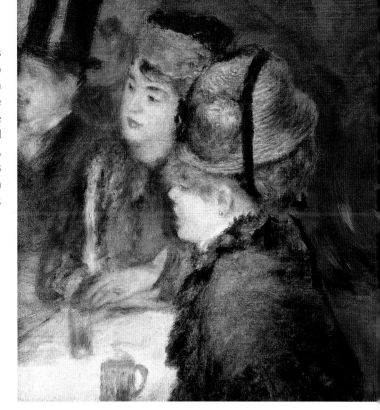

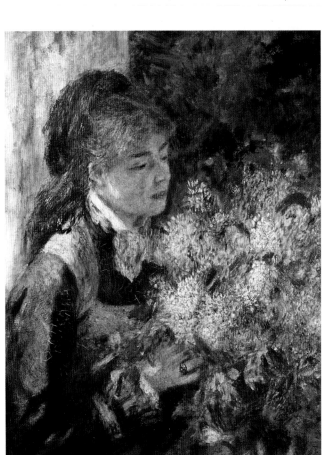

Woman with Lilacs, 1877, oil on canvas, Private Collection, 73 x 60cm (29 x 24in)

By now an expert in capturing the impression of luxuriant flowers and pretty women using variegated brushstrokes, myriads of colour and different thicknesses of paint, Renoir's painting is delicate yet vigorous. His obvious enjoyment of the subject is displayed through the profusion of soft colours and tones, which are enhanced by the play of light falling through the window and on to the figure and flowers.

Couple Reading, 1877, oil on canvas, Private Collection, 32 x 25cm (13 x 10in)

As well as his large urban scenes, Renoir painted numerous small and informal genre scenes during this period, and Edmond and Margot posed for this. As in most of these works, the face of the woman is the most finished element, while the close proximity of the couple to the fore of the work gives the viewer a feeling of intimacy with them.

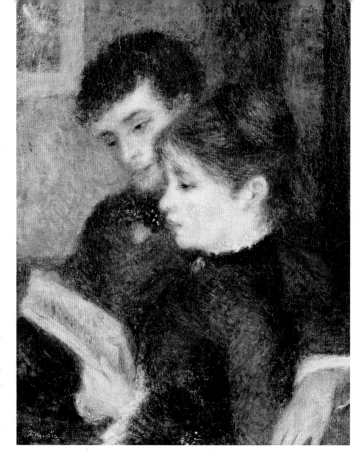

L'Ingénue (The Ingenue), c.1876, oil on canvas, Sterling and Francine Clark Art Institute, Williamstown, MA, USA, 56 x 46cm (22 x 18in)

Painted as a generic depiction of an innocent young woman rather than as a formal portrait, there is no definitive identification of the model for this work. It has been suggested that she was either the actress Henriette Henriot or Nini Lopez. Painted with feathery brush marks in a cool palette of lavenders, blues and greys, Renoir once again captured a radiant young woman.

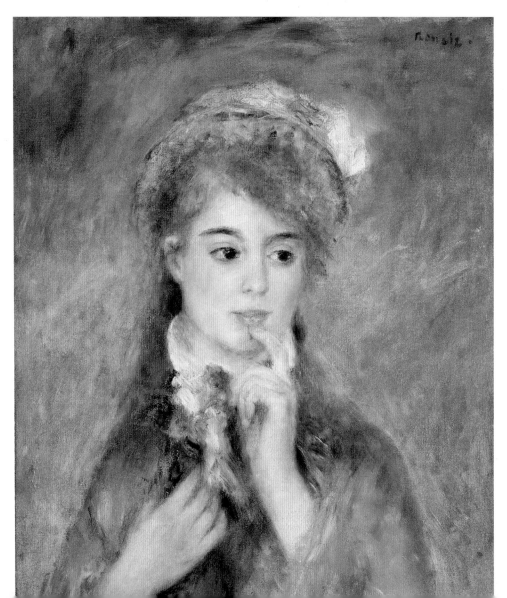

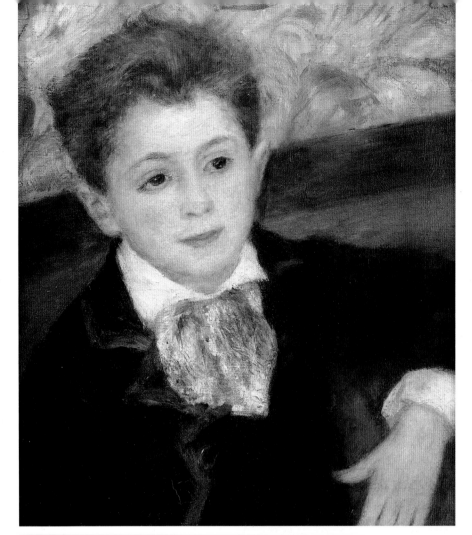

Paul Meunier, 1877,
oil on canvas,
Langmatt Museum,
Baden, Switzerland,
46 x 38cm (18 x 15in)

Painted from a high
viewpoint, this eight-year-old
boy sits in a red armchair,
dressed in his best clothes.
Delicate but not overawed,
the little boy half smiles as
Renoir paints his likeness.
This was one of four family
portraits that his father,
Eugène Murer, commissioned
in the year he met Renoir.
Colour is used boldly,
particularly touches of
reds, greens and browns
in the boy's hair.

The Conversation, c.1878,
oil on canvas,
Nationalmuseum,
Stockholm, Sweden,
45 x 38cm (18 x 15in)

Using another friend, the
artist Samuel Frédéric
Cordey (1854–1911), and
Margot for this genre work,
Renoir once again captured
an intimate study of a couple
in close proximity. With his
characteristic small and
complex layers of brush
marks and subtle nuances
of tone and colour, although
it is an interior scene and
so artificially lit, this
small work is in typical
Impressionist style.

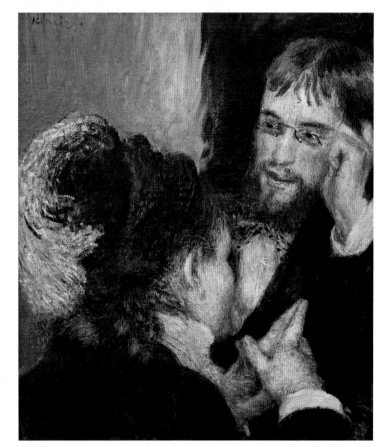

At the Milliner's, c.1878,
oil on canvas,
Private Collection,
20 x 13cm (8 x 5in)

Using Margot as the main
model for this preliminary
sketch, Renoir planned a final
work using rich, brilliantly
coloured paints. All his small
genre paintings of this period
feature his friends, were
posed and painted in his
studio, and use virtually
identically sized canvases.
In this rapid sketch, he
applied the paint with
short, overlapping strokes,
capturing the essence of
contemporary urban life.

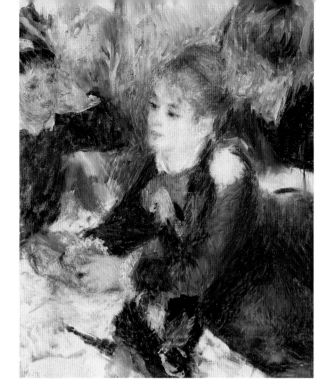

At the Milliner's, 1878, oil on canvas, Fogg Art Museum, Harvard University, MA, USA, 32 x 25cm (13 x 10in)

As with many of Renoir's small genre paintings; viewers' eyes are drawn to the central female figure – again modelled by Margot – while the peripheral figures are indistinct. Forms are packed closely into the canvas, and relationships between the figures are ambiguous. The main figure is about to try on a hat, while her friend whispers something into her ear. Deliberate blurring suggests a transient moment in time.

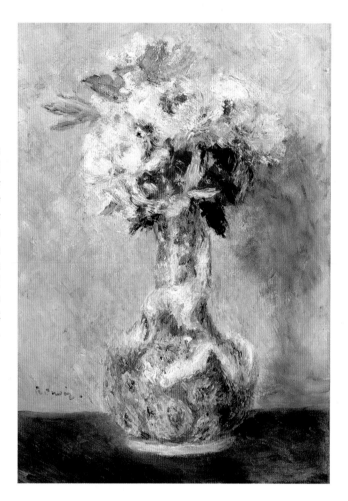

Bouquet in a Vase, 1878, oil on canvas, Indianapolis Museum of Art, Oklahoma, USA, 48 x 33cm (19 x 13 in)

Combining glowing colours and luxurious textures, flowers were perfect for Renoir's style. Applying thick impasto paint in a variety of marks, he could indulge in his Impressionist style and build up the velvety blossoms and the shiny patterned vase seemingly spontaneously. The intense and soft colours of each are thrown forward by the sharply-coloured wall behind. Luminosity has been achieved with cast shadows in shades of blue.

Portrait of the Actress Jeanne Samary, 1878, oil on canvas, The State Hermitage Museum, St Petersburg, Russia, 174 x 105cm (68 x 41in)

Renoir painted this elegant portrait of his friend, Jeanne Samary, with soft colours and reflections, for the Salon of 1879 in an attempt to attract commissions. Almost life-size, this full-length portrait in the foyer of the Comédie-Française shows her looking fashionable and appealing. Renoir wrote to Duret: 'I have finished a standing portrait of the little Samari [sic] that delights women and especially men.'

Peonies, 1878, oil on canvas,
Private Collection,
65 x 54cm (26 x 21in)

Flowers exerted a fascination
for Renoir and he pursued
some of his most searching
investigations of the effects
of light and colour in his
paintings depicting them.
This copious array allowed
him to build a vibrant
arrangement of luminous
colour across the canvas.
He said: 'An artist, under
pain of oblivion, must have
confidence in himself and
listen only to his real
master: Nature.'

Little Blue Nude, 1878,
oil on canvas,
Albright-Knox Art Gallery,
Buffalo, NY, USA,
46 x 38cm (18 x 15in)

Still influenced by Boucher,
Renoir's sitting nude draped
in a blue cloth continues to
follow 18th-century painting
techniques with smooth
paint and precise strokes in
brilliant hues. Light exudes
from the model's pearly
skin as she sits in an
Impressionist-style
background of foliage,
apparently oblivious to the
artist capturing her likeness.
As with all his nudes, she is
voluptuous, feminine and
innocent-looking – for
Renoir the epitome
of womanhood.

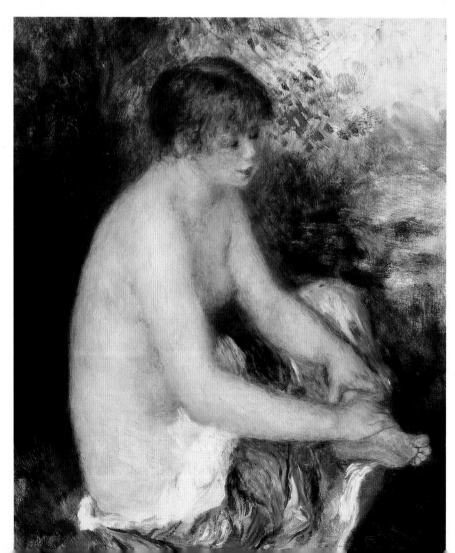

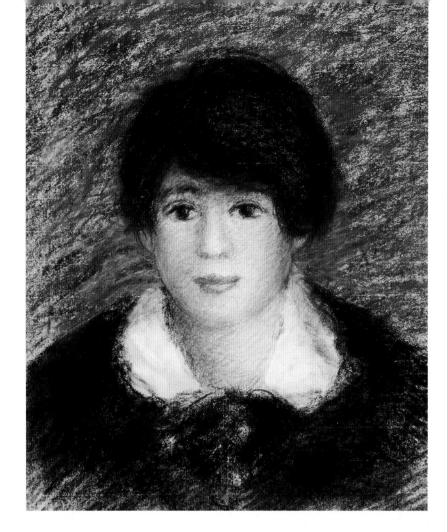

Young Woman in a Black Dress with a White Collar, 1878–9, pastel on paper, Private Collection, 47 x 38.4cm (18 x 15in)

Although most of Renoir's paintings at this time did not use black or any tertiary colours, this work is created almost entirely out of monochromatic tones. Without the tiny, directional marks that he was working in for his paintings, this seems flatter and heavier than many of the works he was producing, but the skin is still created with a smooth porcelain-like appearance.

Portrait of Madame Charpentier and Her Children, 1878, oil on canvas, The Metropolitan Museum of Art, NY, USA, 154 x 190cm (60 x 75in)

This was a success at the Salon of 1879, largely because of the importance of Marguérite-Louise Charpentier. The portrait went against formal conventions in showing the figures in relaxed, natural poses and surroundings. The children are six-year-old Georgette and three-year-old Paul (it was customary to dress all children as girls while they were young). Renoir firmed-up some of his Impressionist techniques to appeal to bourgeois tastes.

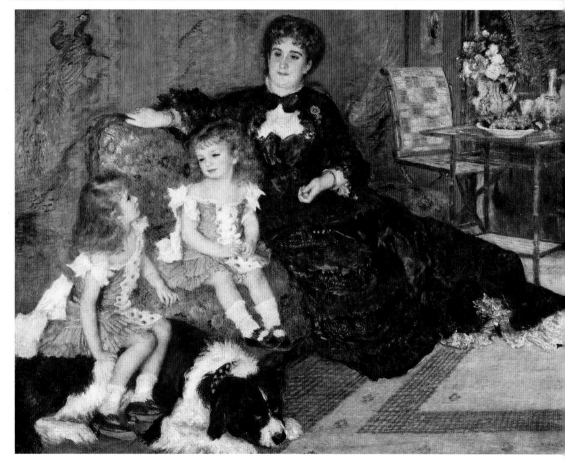

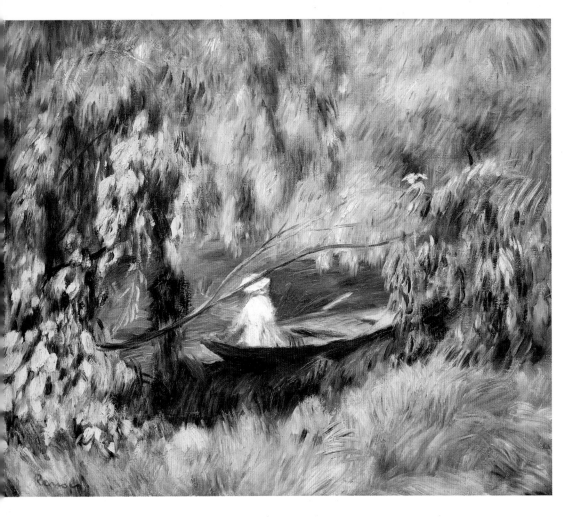

The Barque, c.1878,
oil on canvas,
Langmatt Museum,
Baden, Switzerland,
54 x 66cm (21 x 26in)

Through thick foliage created with variegated, impasto marks, the calm blue river can be seen. Renoir has combined a landscape with a genre painting: a young woman in white sits in a small boat, apparently waiting for someone to fill the space opposite her. Juxtaposing vivid reds, oranges, greens and blues, Renoir has imbued the image with brilliant colour and a sense of light.

On the Bank of a River,
c.1878, oil on canvas, Private Collection,
54 x 66cm (21 x 26in)

With juxtapositions of colour patches and lively marks of vibrant colour laid down in several directions, this work shows Renoir's development of Impressionism at this time. However, critics ignored or ridiculed his landscapes – this was the time when Impressionism was being scorned by most. Here, he has not paid close attention to reflections, but seems to use them as a means to maximize contrasts between colours.

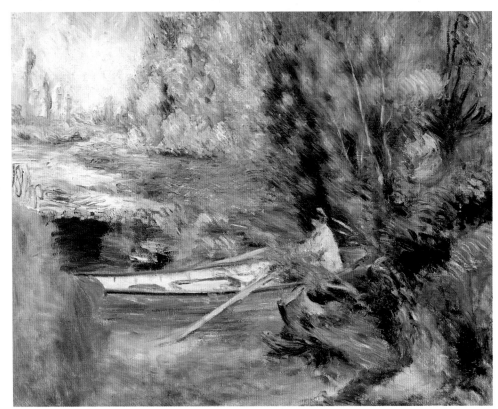

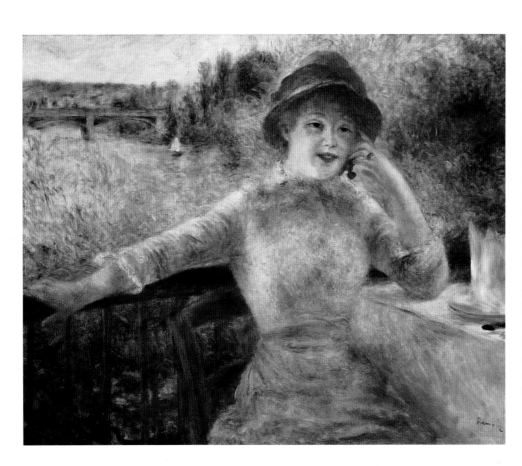

Alphonsine Fournaise, 1879,
oil on canvas,
Musée d'Orsay,
Paris, France,
74 x 93cm (29 x 37in)

Mademoiselle Alphonsine
Fournaise was the daughter
of Alphonse Fournaise, the
proprietor of the small hotel
and restaurant in Chatou,
where Renoir spent time
with his friends. Alphonsine
posed for Renoir in several
paintings and here sits at
the Restaurant Fournaise.
Behind is the Seine, and as
the Impressionists often did,
Renoir has included a hint
of modern urbanization
with a railway bridge in
the background.

Spring (the Four Seasons),
1879, pastel on paper,
Private Collection,
44 x 28 cm (17 x 11in)

Renoir found pastels
sympathetic to his aims. They
were bright, colourful and
immediate to work with. He
could lay down rapid marks
and move on. By using them,
he could explore surface
decoration and colour
combinations in ways that he
had not tried out with paint.
In his application of pastels,
he was often at his most
delicate and creative, as can
be seen in this fantasy-like
work.

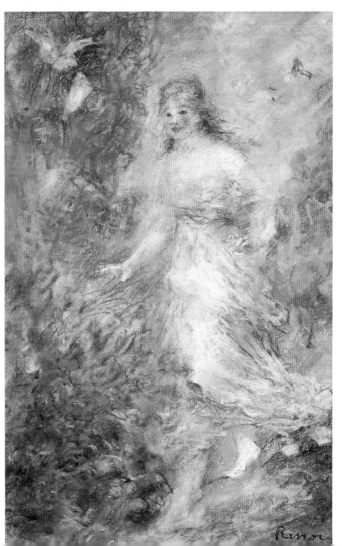

Landscape at Wargemont,
1879, oil on canvas,
The Toledo Museum of Art,
Toledo, OH, USA,
81 x 100cm (32 x 40in)

This large canvas was one of
Renoir's most successful
landscapes. It depicts the
Normandy countryside near
the Château de Wargemont
where his friend Paul Bérard
lived. From a high viewpoint,
a road meanders through a
valley punctuated with trees
and bushes. Unusually for
Renoir, the sky is overcast
and the paint is applied
in thin, delicate layers.
The palette is a mixture
of madder, emerald,
ochre and violet.

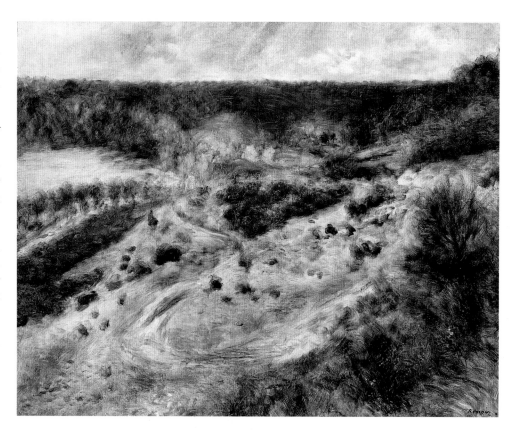

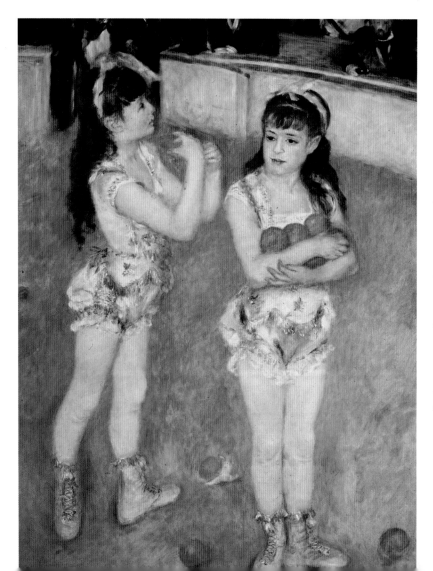

*Acrobats at the Cirque
Fernando (Francisca and
Angelina Wartenberg),*
1879, oil on canvas,
The Art Institute of
Chicago, Chicago, IL, USA,
132 x 99cm (52 x 39in)

The Cirque Fernando
opened in Montmartre in
June 1875, immediately
attracting enthusiastic
crowds. Francisca and
Angelina Wartenberg were
part of a German acrobatic
troupe and Renoir has
portrayed them as they
gathered oranges that were
thrown into the ring by
an enthusiastic audience.
The sisters actually posed for
Renoir at his studio and
were older than he depicted
them. Yellows and oranges
unify the image.

The Mussel Harvest (formerly known as The Vintagers), 1879, oil on canvas, National Gallery of Art, Washington DC, USA, 54.2 x 65.4cm (21 x 26in)

This is Berneval, a coastal village to the north of Bérard's home. Using predominantly greens, yellows and violets, Renoir built up light, luminous colours across the canvas in thin consistencies. Captured from a high viewpoint, he has painted fishermen and a fisherwoman carrying baskets full of mussels up the path from the beach, trudging toward some small buildings where they are going to leave their harvest.

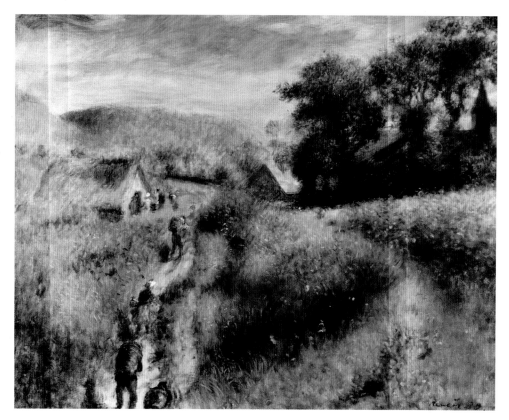

Bouquet of Roses, 1879, oil on canvas, Sterling & Francine Clark Art Institute, Williamstown, MA, USA, 83.1 x 65.7cm (33 x 25in)

On Renoir's first visit to Bérard's spacious Norman château, he painted the rose garden and also produced floral panels to decorate the interior of Wargemont. This is clearly created as a decoration, rather than one of his usual still lifes, and colours have been selected to blend with the décor. His palette included: flake white, naples yellow, yellow ochre, vermilion, rose madder, viridian, emerald green, cobalt blue and ultramarine.

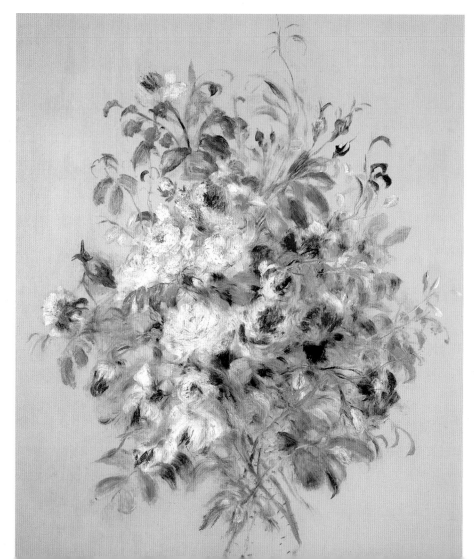

Marthe Bérard, 1879,
oil on canvas,
Museu de Arte,
São Paulo, Brazil,
128 x 75cm (50 x 29in)

Renoir met Bérard, the
diplomat and banker toward
the end of 1878. During his
lengthy stay with the family
the following summer, Renoir
painted constantly, his work
becoming reinvigorated
by the surroundings and
hospitable company.
Bérard commissioned him
to paint portraits of his
whole family, including
his wife, four children
and a niece and nephew.
This is his eldest daughter,
nine-year-old Marthe.

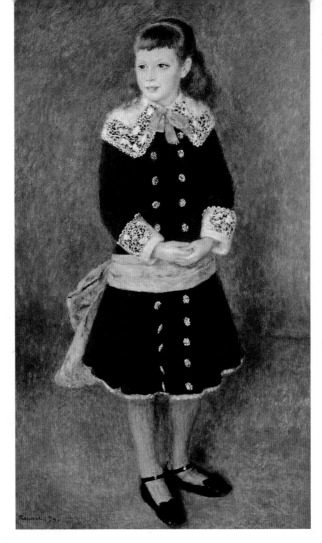

*Marguerite-Thérèse (Margot)
Bérard*, 1879, oil on canvas,
Metropolitan Museum of
Art, NY, USA,
41 x 32cm (16 x 13in)

From 1879 to 1885, Renoir
frequently stayed at the
Bérard's château for several
weeks at a time. This is
another child of the family,
Margot, Bérard's five-year-old
daughter. Renoir skilfully
depicted the freshness of the
little girl's face, emphasizing
her large, shining eyes and
unruly hair – and giving a
clear indication that she
has been stopped, but at
any moment, will rush off
to play again.

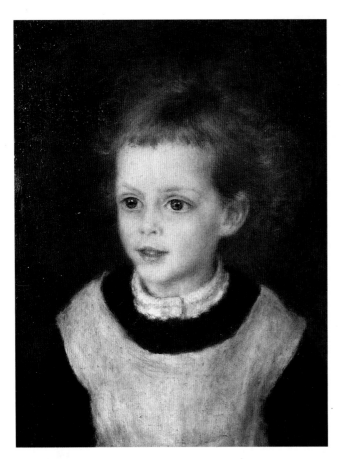

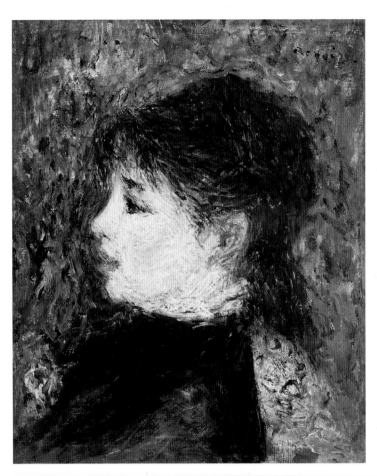

Portrait of Margot, c.1878–9,
oil on canvas,
The Barnes Foundation,
Philadelphia, PA, USA,
29 x 24cm (11 x 9in)

In an affectionate portrait
of his mistress, Renoir
applied paint thickly, with
multicoloured marks, creating
patterns across
the canvas. Working in the
Venetian tradition by
applying contrasting colours
beneath final colours, such as
orange under blue and green
below red, he has also
experimented with the
pointillist style that Pissarro
was using with comma-like
brush marks. The result
is an elegant and vibrant
little portrait.

Young Woman in Blue, 1879,
oil on canvas,
Private Collection,
41 x 32cm (16 x 13in)

Believed to be another
portrait of Alphonsine
Fournaise, this has been
fluidly painted over a light
ground, with areas of
impasto to indicate the
model's lace collar, earrings,
brooch and buttons.
Although the background is
sketchy, her face and features
have been solidly modelled.
Renoir made much of her
pale skin, striking eyes and
dark hair, and has used tones
of violet-blue in her clothes,
hair and shadows.

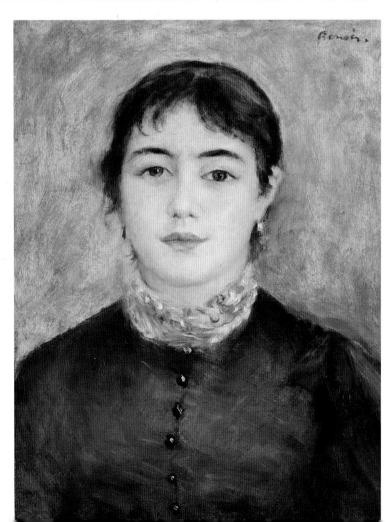

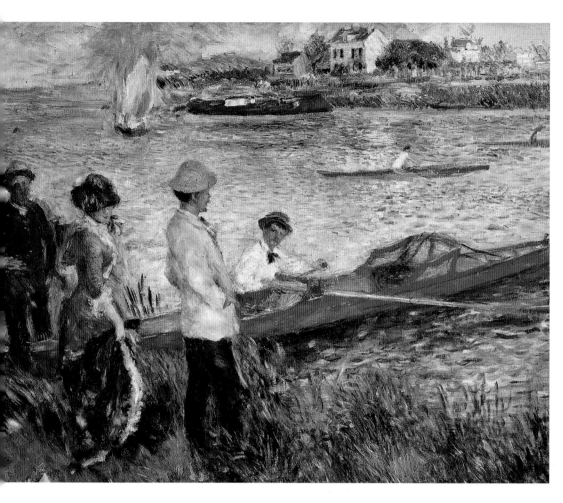

Oarsmen at Chatou, 1879,
oil on canvas,
National Gallery of Art,
Washington DC, USA,
81 x 100cm (32 x 39in)

There are similarities
between this and the
paintings Renoir produced
at La Grenouillère a decade
earlier. This was painted at
Chatou and the man in the
boat is thought to be
Edmond, the man on the
bank with his hands in his
pockets is probably
Caillebotte, and the young
woman is possibly Aline
Charigot, whom Renoir had
recently met. With smooth
brushstrokes, the painting
captures the brilliantly
intense colours
of summer.

After the Luncheon, 1879,
oil on canvas,
Städel Museum,
Frankfurt, Germany,
100 x 81cm (39 x 32in)

Painted at a little restaurant
in Montmartre where Renoir
and friends often ate, he has
captured a sunny moment
when his brother and
the actress Ellen André have
just finished lunch in
the garden and are joined
by another friend.
A snapshot of a fleeting
moment in their lives, this is
described with fine, light and
silky brush marks in richly
coloured layers.

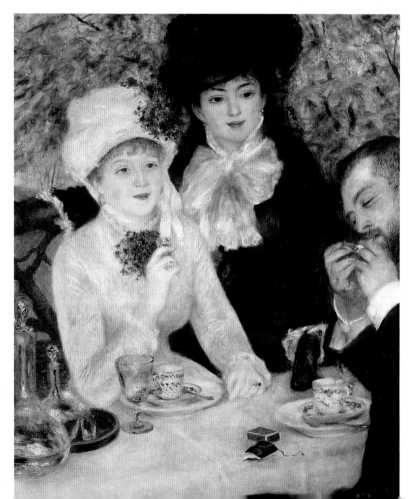

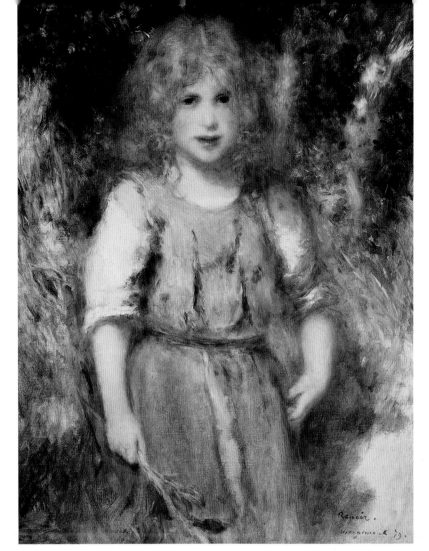

Gypsy Girl, 1879,
oil on canvas,
Private Collection,
73 x 54cm (29 x 21in)

In the summer of 1879, while staying with the Bérards in Wargemont, Renoir produced all kinds of paintings, including landscapes, portraits and genre works. This image of a country child, with her sweet face, tangled hair and torn clothes, was painted there. Appealing-looking waifs were often depicted in Salon paintings, but this work, in loose, fluent strokes and bright colours, was sketchier and less sentimental than most.

Lunch at the Restaurant Fournaise, (Rowers' lunch), c.1879, oil on canvas, The Art Institute of Chicago, IL, USA, 55 x 66cm (22 x 26in)

In another 'slice of life' painting, three boaters relax after a meal at the Restaurant Fournaise. Soft summer light filters through the leaves and trellis and on the River Seine behind, dappling two reclining young men and a young woman with her back to the viewer. Renoir's palette sparkles with fresh, clear hues and his brushwork is loose and feathery, making the entire scene appear spontaneous and fleeting.

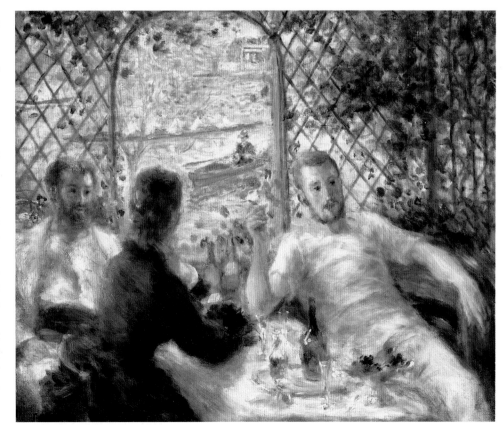

Bather, 1879, oil on canvas,
Private Collection,
48 x 38cm (19 x 15in)

Throughout his career,
Renoir never abandoned
painting nudes in natural
surroundings, although
during his Impressionist
associations he focused
more on landscapes, scenes
of modern life and

portraits. This plump
and translucent-skinned
model is the type that
he always favoured. Soft
and sketchily rendered,
it reveals his leanings
toward 18th-century
French painting, particularly
those by artists such
as Fragonard and Boucher,
with their delicate
hues and brushstrokes.

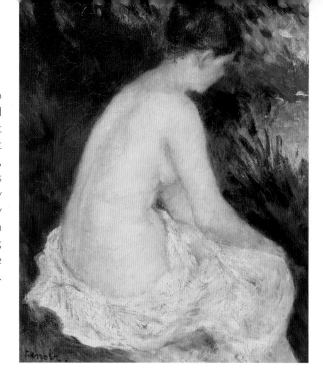

Cliffs at Berneval, also known
as *Cliffs at Pourville,* 1879, oil
on canvas,
Private Collection,
54 x 65cm (21 x 25in)

During the two months
that Renoir stayed with the
Bérard family in 1879, he
painted prolifically. Seeking to
capture the essence of the

surrounding landscape, he
applied subtle washes of
paint quickly and without
details. This painting is an
abbreviated view, painted
from a cliff. The main
elements are sky, sea and
sand, captured with Renoir's
characteristic decorative
effects. Figures give scale
to the work.

*Roses, c.*1879, oil on canvas,
Private Collection,
65 x 54cm (26 x 21in)

Along with his portraits and
some genre canvases, Renoir
made a steady income from
his still lifes, particularly
paintings of flowers, for
which he had a natural

affinity since his porcelain-
painting days. With its jewel
colours, this has been
painted with creamy
strokes of paint, an intensely
dark background having the
effect of throwing the
vibrant blooms forward,
while flecks of white create
the glittering glass jug.

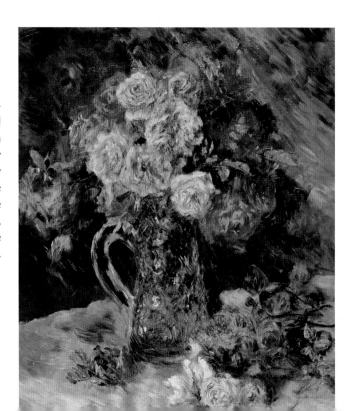

Roses in a Window, 1879,
oil on wooden panel,
Private Collection,
63 x 84cm (25 x 33in)

This was another of the
floral panels that decorated
rooms at the Wargemont
Château. It was painted
along with the other

wooden panel, *Bouquet of
Roses*. Renoir's stay there in
1879 must have been a
most satisfying holiday for
him – he was welcomed

warmly by his hosts, able to
relax and enjoy extremely
comfortable surroundings,
and he was being paid
for his work.

Portrait of a Woman, 1879,
oil on canvas,
Private Collection,
42 x 31cm (16 x 12in)

This is probably Alphonsine,
of the Restaurant Fournaise.
She had married in 1864
but was widowed during
the siege of Paris in 1871,
so returned to help run
her father's restaurant and
boat-rental business. She sat
for at least four of Renoir's
single-figure portraits at
this time. Here, he has
focused on the 33-year-old's
porcelain-pale skin, dark hair,
gleaming eyes and full lips.

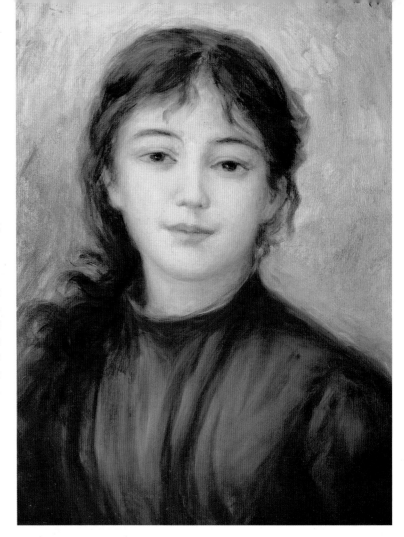

Mussel Fishers at Berneval,
1879, oil on canvas, The
Barnes Foundation,
Philadelphia, PA, USA,
176 x 130cm (69 x 51in)

Painted while Renoir was
staying with the Bérards, this
huge work was exhibited at
the 1880 Salon. Following
many academic artists with
a romanticized image of the
poor, he painted the children
of a local fisherman, but it
was not received well.
No longer spontaneously
expressive, contours are
fluid, paint application is
delicate and the rich colours
resemble enamel, but the
work was considered
superficial and insubstantial.

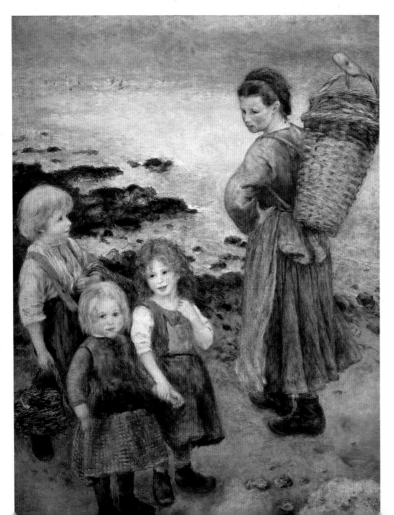

Landscape at the Seine, 1879,
oil on canvas,
Private Collection,
37 x 66cm (14 x 26in)

With white priming,
Renoir built up a typical
Impressionist view of a sunlit
field, bordered by trees
and distant buildings in
translucent layers of paint.
A sense of instantaneity has
been created by the short
brush marks speckled with
highlights of greens, yellows
and white. The sky is slightly
cloudy, but flecks of gold and
silver convey the effects of
sunlight glinting through.

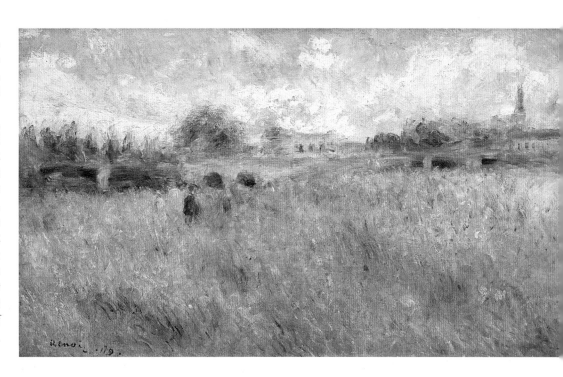

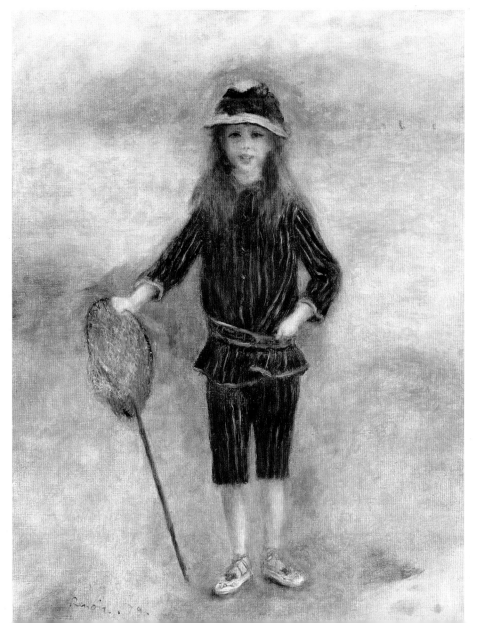

The Little Fisherwoman,
(Marthe Bérard), 1879,
oil on canvas,
Private Collection,
60 x 45cm (24 x 18in)

In his biography of his father,
Renoir's son Jean recalled: 'It
is because of [his] eager
childlike curiosity that Renoir
was so fond of children.' In
contrast with the formal
portrait he painted of her, his
sensitive, affectionate painting
of Bérard's daughter Marthe,
shows her having fun on the
beach. With delicate and free
paint application, he has
captured her standing and
smiling before she dashes off
to play.

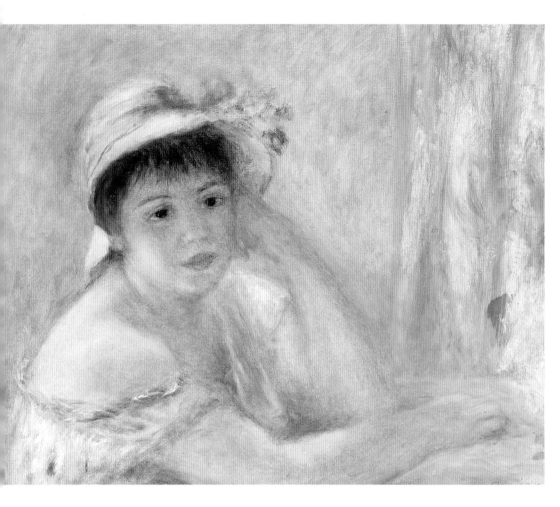

Woman in a Straw Hat,
1879, oil on canvas,
Private Collection,
50 x 61cm (20 x 24in)

This is another portrait of
Alphonsine. Whereas in
Portrait of a Woman, Renoir
focused on her striking
features and colouring, in
this version, he has depicted
a soft, harmonious image,
bathed in golden sunlight,
using sketchy marks and
soft tonal contrasts. It is a
strongly impressionistic work,
with gently defined contours.
Emphasis is given to the
play of light.

Young Woman Sewing, 1879,
oil on canvas,
The Art Institute of
Chicago, IL, USA,
62 x 50cm (24 x 20in)

In appealing to the upper
and middle classes, Renoir
depicted pretty young
women involved in typical
bourgeois activities, such
as playing music and
sewing. Here, the
model concentrates on
her needlework as she sits
bathed in natural light.
The bouquet beside her
brightens the whole picture,
and the entire work
demonstrates the proficiency
Renoir had attained as an
Impressionist, in his
expression of light and
exuberant colour.

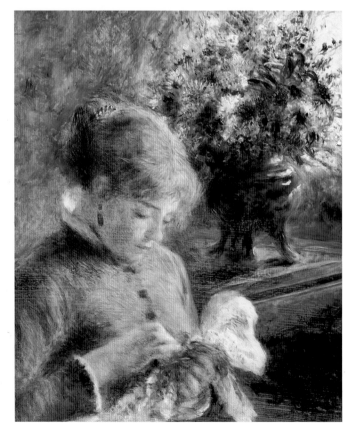

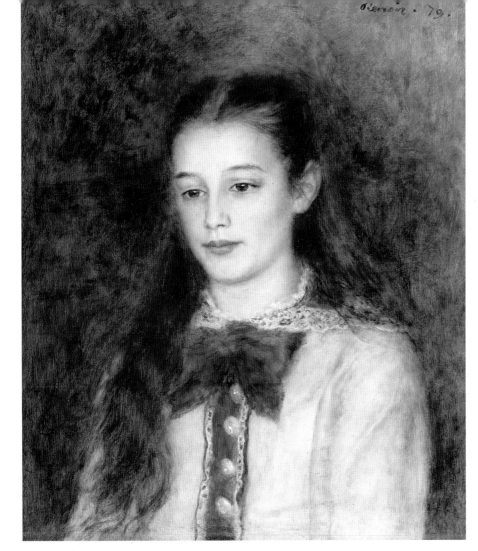

Thérèse Bérard, 1879, oil on canvas, Sterling and Francine Clark Art Institute, Williamstown, MA, USA, 56 x 47cm (22 x 18in)

This sensitive portrait of Paul Bérard's niece Thérèse is slightly more reserved than most of Renoir's paintings of children, but he has emphasized her chestnut hair and the translucency of her warm skin tones against the blue and white of her dress and the reddish-blue background. The luminosity of her skin has also been achieved with the application of glazes, a method that most Impressionists did not use.

Wheatfield, 1879, oil on canvas, Museo Thyssen-Bornemisza, Madrid, Spain, 50 x 61cm (20 x 24in)

Painted *en plein air* during Renoir's stay with the Bérard family, this ripe field of wheat is created with translucent dabs and strokes of colour. This is a pure landscape, without any figures or idealism. Across the field, accents of bright colour render the fleeting effects of light, while softer marks in deeper hues create the impression of distant hills. The slightly overcast sky suggests changeable weather.

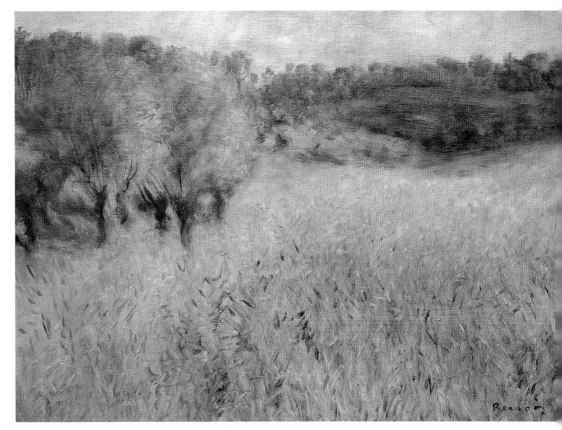

Portrait of a Young Girl with Brown Hair, 1879, pastel on paper, Musée d'Orsay, Paris, France, 60 x 47cm (24 x 18in)

Renoir enjoyed using pastels. With all the control of a pencil, yet all the colour of paint, they were an ideal medium for him. Here, he has layered them to build up smoothly, gradating tonal areas, and to render the facial features of this young girl in detail. His pastel work is often more detailed than his paintings, especially during this Impressionist period.

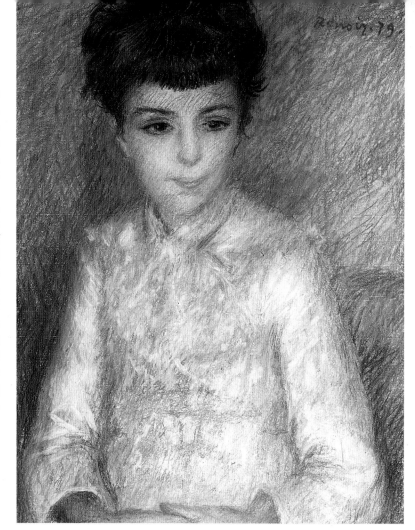

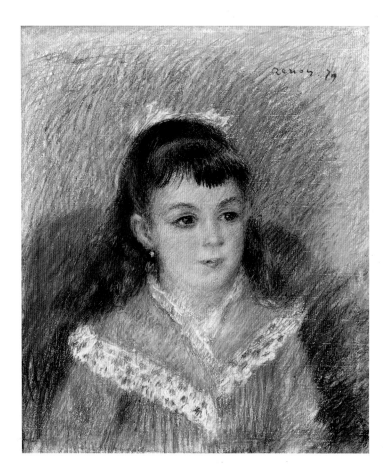

Portrait of a Little Girl (Elisabeth Maitre), 1879, pastel on paper, Private Collection, 53 x 44cm (21 x 17in)

The niece of his friend the musician Edmond Maitre, Elisabeth Maitre was six when Renoir produced this along with several other portraits for his first solo exhibition at Georges Charpentier's offices. Capitalizing on his Salon success with *Madame Charpentier and her Children* and *Jeanne Samary*, Renoir painted several portraits which he believed would attract more buyers. Among the other works, this little girl's portrait was well received.

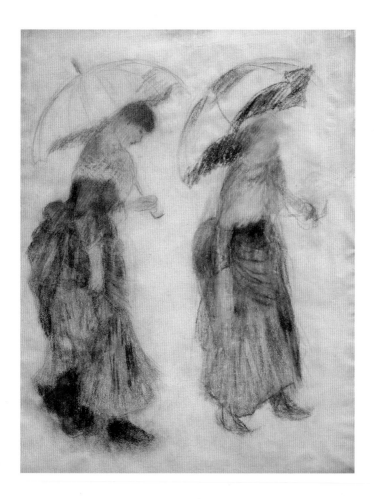

Girl with Umbrella, 1879, pastel on paper, National Museum of Belgrade, Belgrade, Serbia, 63 x 48cm (25 x 19in)

These impromptu sketches of a young woman walking with an umbrella demonstrate Renoir's ability to assimilate and interpret observations instantly, using just a few strokes of the pastel. The young woman's stance, clothes and attitude have all been captured and rendered with about six or seven coloured pastels. This natural ability and spontaneity was a feature of even his most complex oil paintings.

La Loge (the theatre box), 1879, pastel on paper, laid down on board, Private Collection, dimensions unknown

With varied marks, Renoir's pastel of a young girl in a theatre box is a version of one of his preferred themes. In oils, he usually focused on relationships between two people. Here, with fluid, expressive marks and colours, a pretty young girl is lost in thought as she watches the audience below. In this picture, Renoir creates a mystery – who or what is the girl looking at?

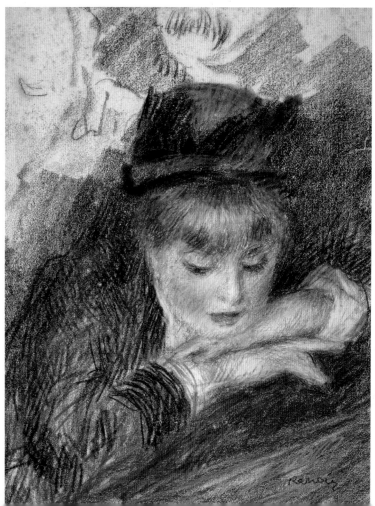

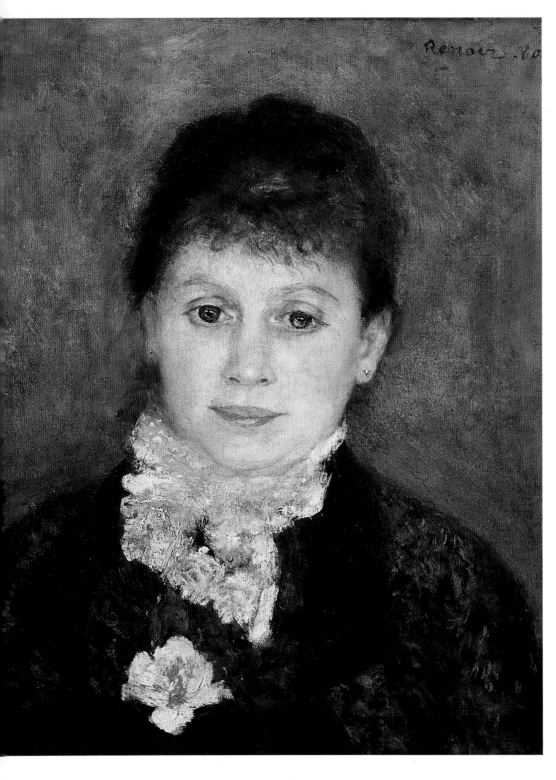

Woman with a White Jabot,
1880, oil on canvas,
Musée d'Orsay,
Paris, France,
46 x 38cm (18 x 15in)

The identity of this woman is
not known, but the work
was produced at a time
when Renoir had many
portrait commissions, so she
was probably just a model
that he used for portrait-
painting practice. The clearly
lit, frontal portrait is taken
closely so he could
concentrate on rendering
details. There are few
shadows and the paint
is applied in both thin,
delicate washes and
thick, impasto marks.

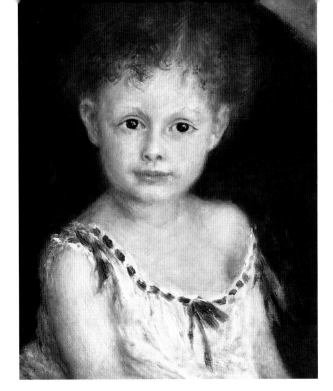

Jacques Bergeret as a Child,
c.1880, oil on canvas,
Museum of Fine Arts,
Boston, MA, USA,
41 x 32cm (16 x 13in)

Resembling the delicacy of
porcelain, this little boy's skin
appears to be translucent.
Renoir has adhered to
the Impressionist methods
of applying small marks in
many different colours,
building up tones with
layers of bright pigments
and concentrating on the
effects of light. He has
also followed Old Master
ideas, setting the pale-
skinned model against a
dark background. The result
is a glowing, Ingres-like
portrait of an appealing
little child.

The Sleeper, 1880,
oil on canvas,
Private Collection,
49 x 60cm (19 x 24in)

Oblivious to the painter's
gaze, this young woman
sleeps in the lush landscape.
Using an economy of
means and a warm, glowing
palette, Renoir succeeded
in depicting the sensuousness
of this young woman
sleeping and a mood of
gracious and spontaneous
intimacy. With the sun
dappling the figure, this is
reminiscent of his painting
Nude in Sunlight or *Study:
Torso, Effect of Sunlight* of
1875, but it is closer to
the classical paintings of
women by artists such as
Velázquez and Ingres.

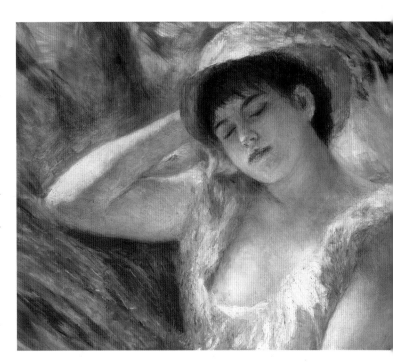

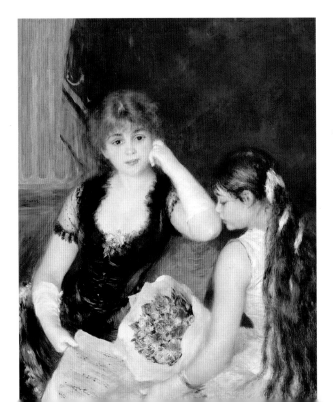

At the Concert, 1880,
oil on canvas,
Sterling and Francine Clark
Art Institute,
Williamstown, MA, USA,
99 x 81cm (39 x 32in)

This original composition
is something that Renoir
had tried in various forms
before. Influenced by
photography, which was
becoming widely used
by this time, he cropped
the figures as a camera
might, creating the
impression that they are
not remote, but are part
of the viewers' own space.
As usual, out of charming
models, brilliant colours
and patterns, he has
created a story for
viewers to interpret.

Portrait of Mademoiselle Irène Cahen d'Anvers, 1880, oil on canvas, Emil Bührle Collection, Zürich, Switzerland, 65 x 54cm (25 x 21in)

The banker Louis Cahen d'Anvers commissioned Renoir to paint his daughter Irène. Over two sittings in Cahen d'Anvers' Paris town house, Renoir painted the eight-year-old girl in her best pale blue dress. Unusually for him, he has painted her in profile, but this was probably to maximize her abundant red hair. Her delicate features stand out clearly against a background of dark green foliage.

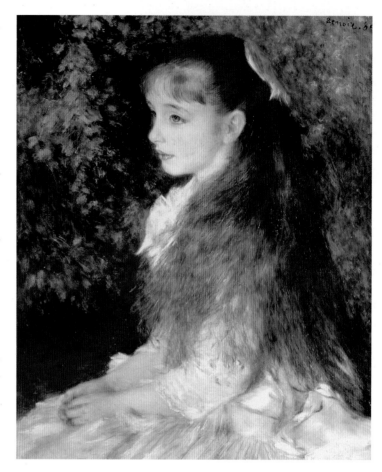

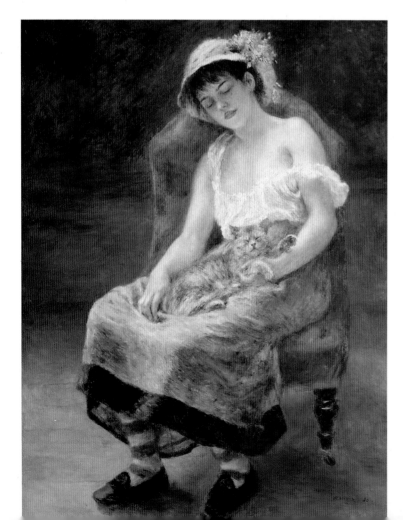

Sleeping Girl or Girl with a Cat, 1880, oil on canvas, Sterling and Francine Clark Art Institute, Williamstown, MA, USA, 120 x 94cm (47 x 37in)

A young peasant girl in a hat sleeps on an expensive chair with a cat on her lap. The model and actress Angèle Legault came from Montmartre and occasionally sat for Renoir. Although this was exhibited at the 1880 election, it was badly hung and so attracted little notice. The colours and contrasts are striking, and the play of light is masterful.

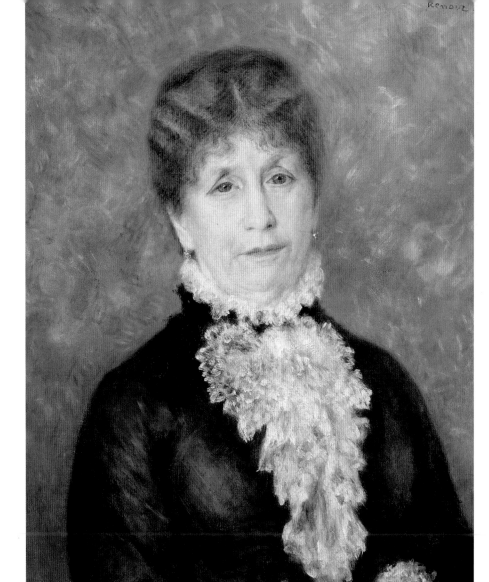

Madame Eugène Fould, née Delphine Marchand, 1880, oil on canvas, Private Collection, 56 x 46cm (22 x 18in)

Through the banker, critic and art collector Charles Ephrussi, Renoir attained many introductions and commissions. This lady was the mother-in-law of Ephrussi's half-sister and the wife of another banker. When first seen, the portrait was considered 'a marvel' by some, and attracted even more commissions in the Ephrussi circle. As with so many of Renoir's patrons, a number of these wealthy buyers became friends.

The Banks of the Seine at Argenteuil, 1880, oil on canvas, Private Collection, 55 x 66cm (22 x 26in)

Using multi-directional brush marks and brilliant colour contrasts, this painting is characterized by light and feathery touches of the brush. Renoir's palette included Naples yellow, yellow ochre, raw sienna, red ochre, red madder, terra verte, Veronese green, ultramarine, cobalt blue and white. The work captures a moment on a summer day, as clouds scud across the sky, and yachts sail by as two women enjoy the view.

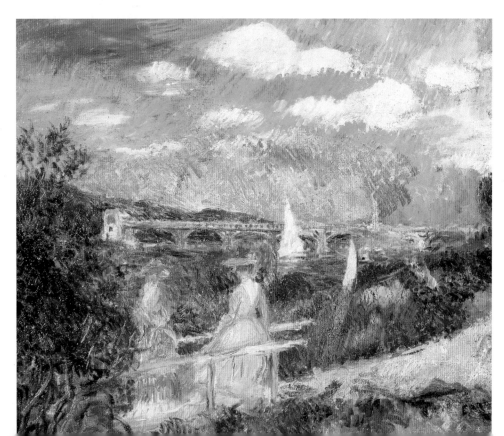

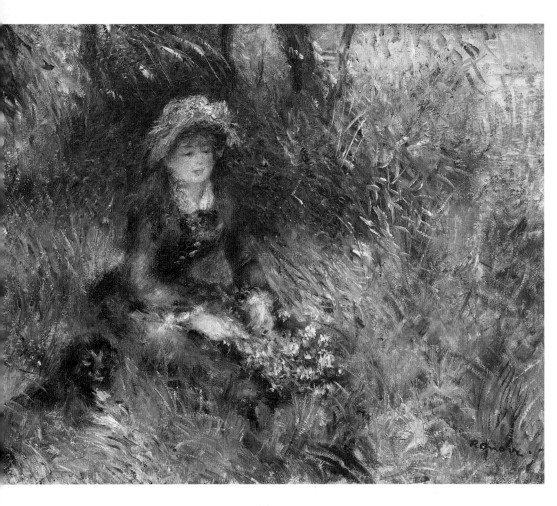

Aline Charigot with a Dog,
1880, oil on canvas,
Private Collection,
32 x 41cm (13 x 16in)

Renoir met Aline in a café
in Montmartre. She began
modelling for him, and on
Sundays they often went
to the country. This was
painted on one of these
trips. Aline was just 20 years
old when she sat on the
grass with her dog, and
Renoir has captured her
on this small canvas using
several different styles. In the
corner, the silvery river can
just be seen.

*Portrait of Fernand Halphen
as a Boy,* 1880,
oil on canvas,
Musée d'Orsay,
Paris, France,
46 x 38cm (18 x 15in)

Fernand Halphen's parents
were middle class and
influential. Fernand was the
youngest of their five
children and eight years old
at this time. He grew up to
become a dedicated
musician, but was killed
during World War I when
he was 45. Using his
characteristic bright palette
and small brushstrokes,
Renoir was nevertheless not
adhering to the Impressionist
style, but beginning to apply
firmer, smoother contours
and sharper colours.

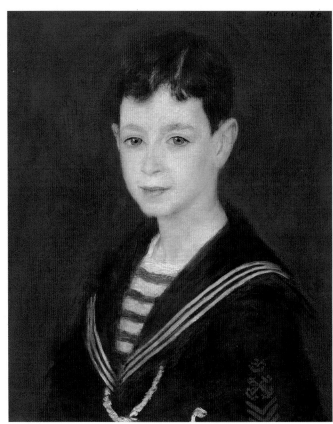

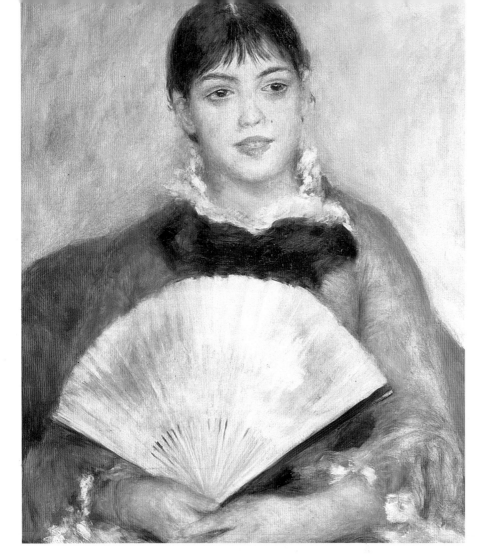

*Girl with a Fan, c.*1880-81, oil on canvas, The State Hermitage Museum, St Petersburg, Russia, 65 x 50cm (25 x 20in)

Another portrait of Alphonsine Fournaise, this emphasizes curves and rounded shapes. The contrasting colours and plain background show the influence of the Spanish masters whom Renoir had long admired. Nicknamed 'la belle Alphonsine', this young woman with her dark hair and eyes, porcelain-like skin and youthful charm appealed to Renoir, and he was pleased with this work. Durand-Ruel exhibited it at the seventh Impressionist exhibition in 1882.

*Bouquet in a Theatre Box, c.*1878-80, oil on canvas, Musée de l'Orangerie, 40 x 51cm (16 x 20in)

At the Parisian theatre, social interaction was in evidence and Renoir often used this as a subject. This work features a theatre box, but for once, he omitted figures. Instead, he painted a bouquet of tightly furled roses on a seat, hinting at who may have left them there. His buttery brush marks, rich colours and intense highlights and shadows capture a moment in modern life.

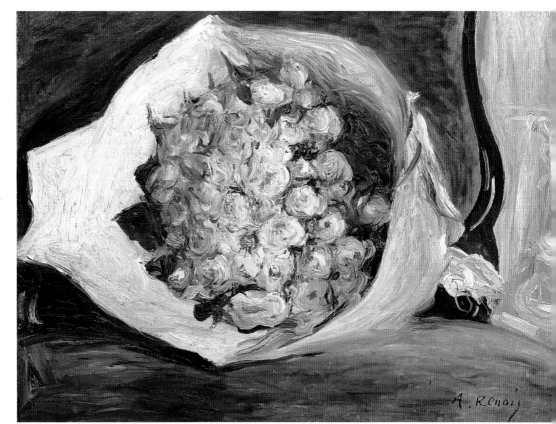

Portrait of Monsieur Bernard in a Fedora, 1880, oil on canvas, Neue Pinakothek, Munich, Germany, 40 x 52cm (16 x 20in)

Renoir's male portraits demonstrated his dexterity differently from his female portraits. With prettiness not required, he portrayed personal characteristics. Bernard had a studio in Montmartre, and acted as a model for Renoir in the 1880s. In disregarding conventional standards of behaviour, he was considered a bohemian – as Renoir also was by many. Renoir captured a thoughtful pose by his friend in his characteristic fedora and glasses.

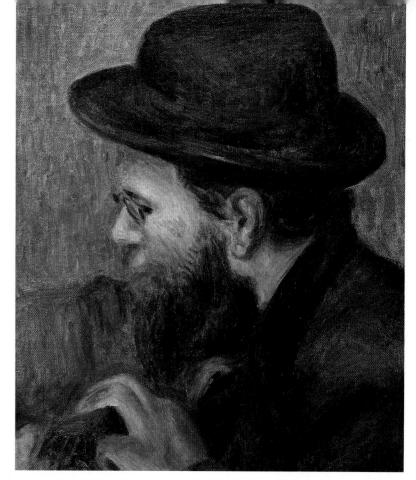

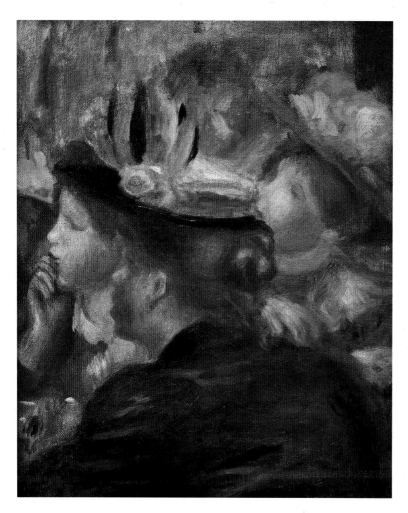

At the Theatre, 1880, oil on canvas, Staatsgalerie, Stuttgart, Germany, 41 x 33cm (16 x 13in)

Renoir made much of showing relationships between people at the theatre. Here, three girls look intently beyond the canvas. They appear to be gossiping about something that is taking place. Using short, downy brush marks, Renoir has suggested the girls' delicate complexions and rosy cheeks as they sit closely together. Few elements are prominent here, as the painting is made up of predominantly pastel colours.

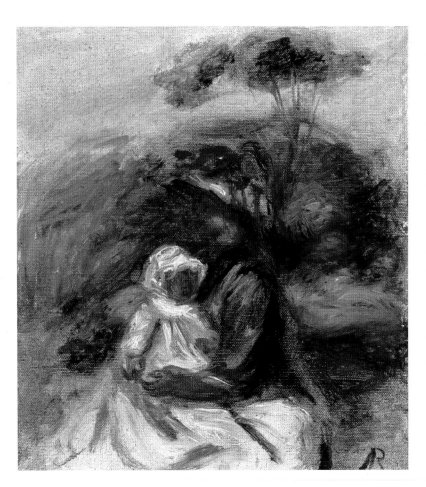

Mother and Child, 1880,
oil on canvas,
Private Collection,
16 x 14cm (6 x 51/2in)

A tiny work, this was clearly
a preparatory sketch to help
Renoir work out colours,
composition and brushwork
for a larger painting.
Over his career, he produced
several mother and child
paintings, seeing them as
contemporary versions of a
classical theme. The lively
marks have been laid on the
canvas quickly and freely. His
colours are sure and definite,
and tonal contrasts are
clearly defined.

Portrait of a Young Girl, 1880,
pastel on paper laid
down on board,
Private Collection,
38 x 29cm (15 x 11in)

Renoir enjoyed using pastels,
reviving the medium that
Watteau, Boucher and
Fragonard had all employed.
With chalks, he softened and
blurred contours, applying
curving and broken lines,
creating depth, texture and
form with carefully blended
tones. Here he has carefully
rendered the play of light
and shadow in harmonious
and contrasting colours to
capture the radiance and
luminosity of the child's skin.

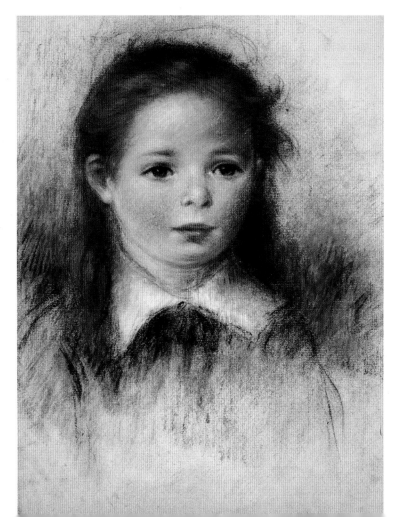

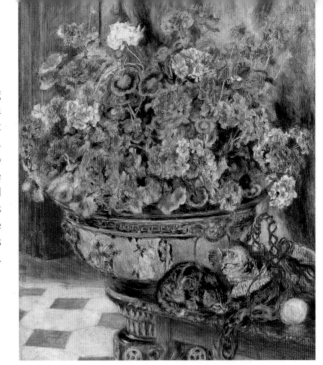

Flowers and Cats, 1881,
oil on canvas,
Private Collection,
93 × 74cm (37 × 29in)

Brilliantly coloured and
composed, this and the
painting opposite were
exhibited by Durand-Ruel at
the seventh Impressionist
exhibition, when Renoir
distanced himself, hoping
to avoid being called a
revolutionary, which he felt
alienated potential patrons.
Here, the geraniums echo
the vibrant colours of the
wool that has been tangled
by two tiny kittens. The reds
contrast boldly with the
blue and white floor tiles
and the background curtain.

The Mosque or *Arab Festival*,
1881, oil on canvas,
Musée d'Orsay,
Paris, France,
74 × 92cm (29 × 36in)

It is not certain which
festival Renoir was
representing here. Mixing
Impressionism with
Orientalism, he painted the
ruins of ancient Turkish
ramparts behind Algiers. Five
dancing musicians play
tambourines and flutes in
the centre of a throng.
Behind is the Kasbah
and Mediterranean Sea.
In Algeria, Renoir mastered
the use of white. He wrote,
'In Algeria I discovered
white. Everything is white…
the walls, the minaret,
the road…'

Field of Banana Trees, 1881,
oil on canvas, Musée
d'Orsay, Paris, France,
51 × 64cm (20 × 25in)

In Algeria, Renoir wrote: 'I
have never seen anything
more sumptuous and more
fertile… a marvellous green
with the mixture of prickly
pear and aloes…'. Yet one of
the first paintings he
executed was a banana
plantation – not even
Algerian. From a high
viewpoint, he introduced a
complex interlacing of leaves
and fronds to create an
animated surface. Glimpsed
beyond the tallest trees are
the buildings of Algiers.

*Girl with a Fan, c.*1881,
oil on canvas,
Sterling and Francine
Clark Art Institute,
Williamstown, MA, USA,
65 x 54cm (25 x 21in)

This stylish young Parisian
woman (Jeanne Samary)
is placed low in the
composition in order to
emphasize the fan, flowers
and striped wallpaper.
The fan refers to the
popularity of all things
Japanese and the fresh
colours are precursors of
subsequent Art Nouveau
styles. With thinly applied
paint, the canvas is both
luminous and delicate.
The softly modelled manner
of the work indicates that
it may have been painted
around 1879, rather than
two years later.

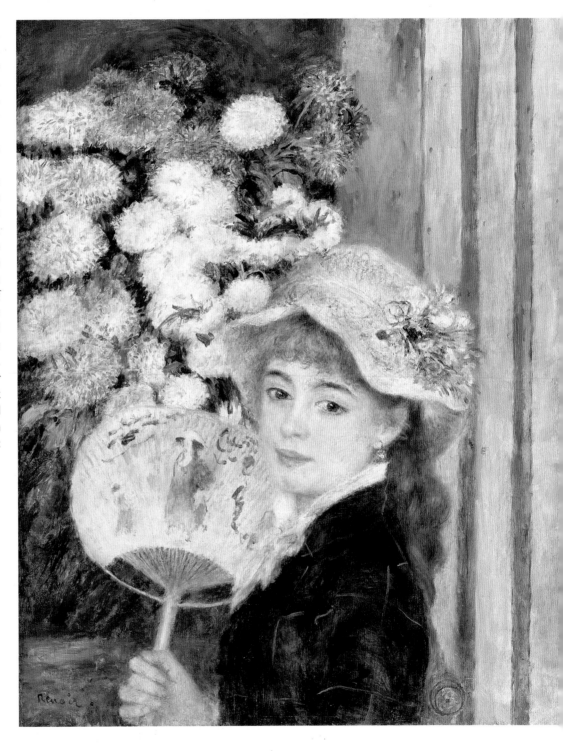

Algerian Landscape, 'The Ravine of the Wild Woman', 1881, oil on canvas, Musée d'Orsay, Paris, France, 65 x 81cm (25 x 32in)

Although it has a rather romantic title, this painting is a pure landscape, with no hidden meaning. Capturing the lush foliage of a ravine outside Algiers, Renoir has embraced the splendour of the natural landscape, using a jewel-like palette. Applying densely packed brush marks, in different lengths, thicknesses and directions, he created a deliberately dramatic and animated view, focusing on the abundance of colours and textures before him.

*Little Algerian Girl, c.*1881, oil on canvas, Private Collection, 35 x 30cm (14 x 12in)

Renoir had long wanted to follow in the footsteps of Delacroix and visit Algeria, to experience for himself the light, colour and exotic surroundings. He was not disappointed, and the dazzling light and scenery inspired a bolder palette, but his choice of subjects did not vary much. Here he has captured a charming little girl, giving her a sufficiently European appearance to attract buyers back in Paris.

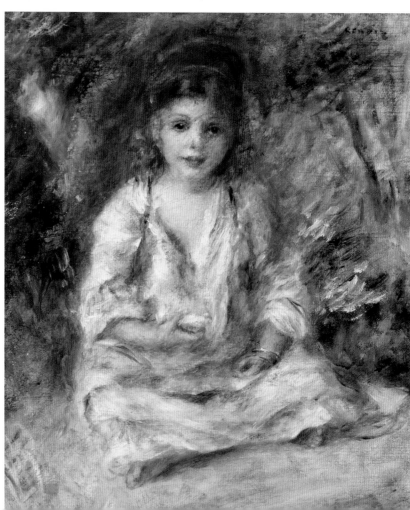

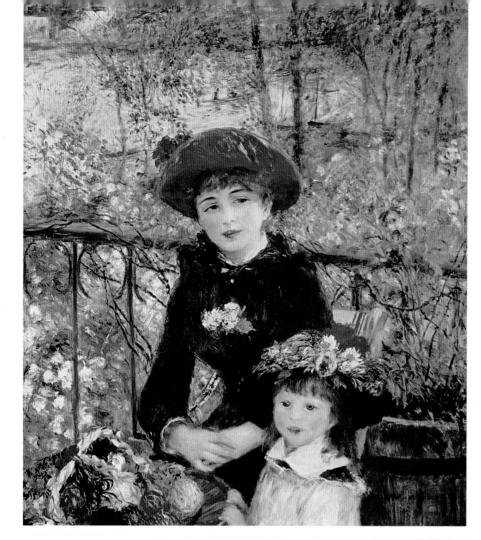

Two Sisters (on the terrace), 1881, oil on canvas, The Art Institute of Chicago, IL, USA, 101 x 81cm (40 x 32in)

Two girls sit on the upper terrace of the Restaurant Fournaise. They were not actually sisters, but two unrelated models, sitting in front of the spring plants wearing strong colours in contrast with the more delicate palette behind them. Renoir's downy Impressionist brushwork was beginning to firm up and, in particular, the faces show his developing 'dry' style. Durand-Ruel exhibited this at the seventh Impressionist exhibition of 1882.

The Railway Bridge at Chatou, 1881, oil on canvas, Musée d'Orsay, Paris, France, 54 x 66cm (21 x 26in)

This work was part of the Caillebotte bequest. Caillebotte owned four of Renoir's landscapes, and this was painted between April and July 1881 on the west bank of the River Seine. Although it features a railway bridge, the luxuriant grass, trees and flowers almost completely obscure it. Renoir applied paint closely, building up encrusted layers and creating a compact composition that is densely filled with rich colours and textures.

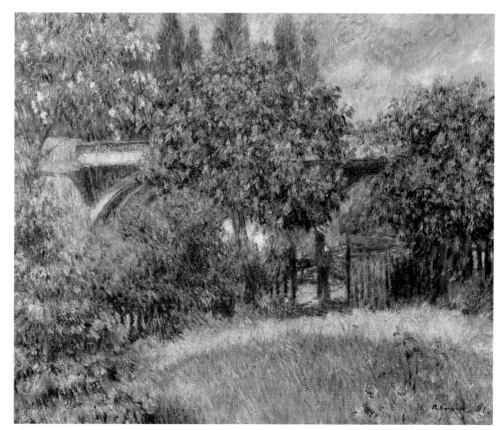

Luncheon of the Boating Party, 1881, oil on canvas, The Phillips Collection, Washington DC, USA, 130 x 173cm (51 x 68in)

Renoir greatly enjoyed the convivial atmosphere of the Restaurant Fournaise and here, using flourishes of expressive colour with clearly applied lines and tones, he has painted his friends socializing on the terrace. They include Charles Ephrussi, Jules Laforgue, Ellen Andrée, Raoul Barbier, Alphonsine and her brother Jules-Alphonse, Lhote, Lestringuez, Jeanne, Caillebotte, Angèle and Adrien Maggiolo. The woman holding her dog is Aline.

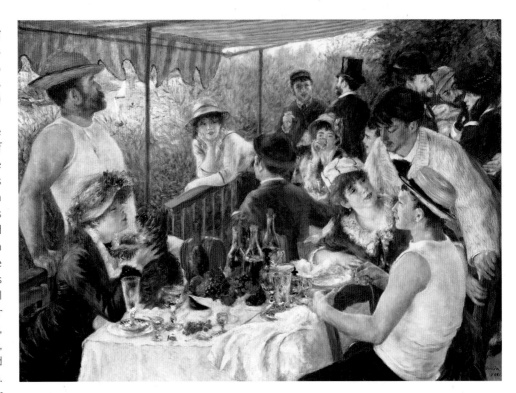

Grand Canal, Venice, 1881, Museum of Fine Arts, Boston, USA, 54 x 65cm (21 x 26in)

Renoir's main aim in travelling to Italy in 1881–2 was to study the Old Masters, but when he reached Venice, he felt compelled to paint sights that had inspired so many others. Unconventionally though, he rendered the shimmering light on the water and on the fine old buildings, capturing the effects of dissolving forms and changing colours. The striped mooring poles and dark gondolas give weight to the scene.

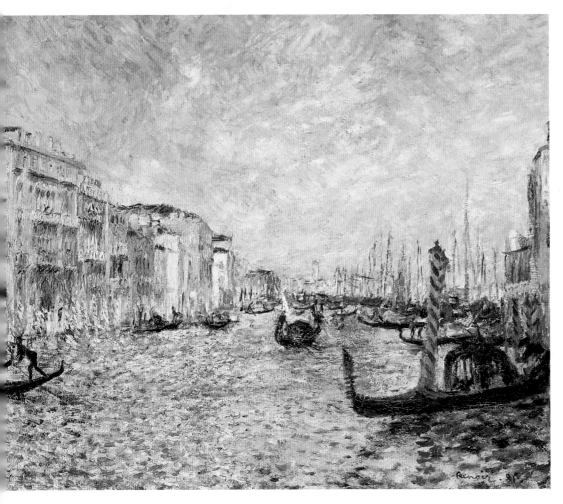

Piazza San Marco, Venice,
1881, oil on canvas,
Minneapolis Institute of
Arts, Minneapolis,
MN, USA,
66 x 81cm (26 x 32in)

When Durand-Ruel included
them in the seventh
Impressionist exhibition,
Manet called Renoir's
Venetian works 'detestable'.
Without any studio
reworking, the loose marks
and bright, unmixed colours
of this painting capture the
light falling across the façade
of the building, the passers-
by and the pigeons in the
square, in an animated
manner. This free handling
with the white priming
showing through,
did not appeal to
19th-century viewers.

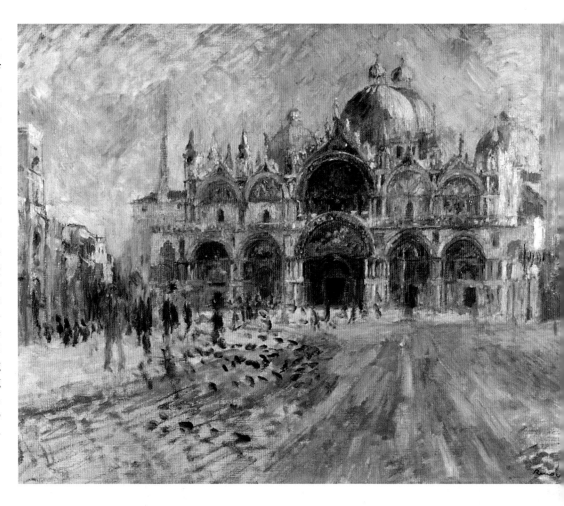

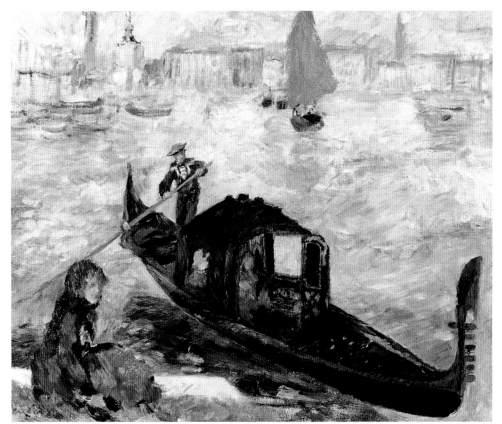

Gondola, Venice, 1881,
oil on canvas,
Philadelphia Museum of Art,
PA, USA,
32 x 66cm (12½ x 26in)

The light in Italy inspired
Renoir to paint with a bolder
palette, as he had done in
Algeria. Here, a gondolier
in a striped shirt takes two
women across the lagoon,
the buildings of Venice
distinguishable in the
distance. An Italian girl sits
by the water, her head
turned away from the
approaching gondola.
The language barrier gave
Renoir problems in relaxing
his Italian sitters.

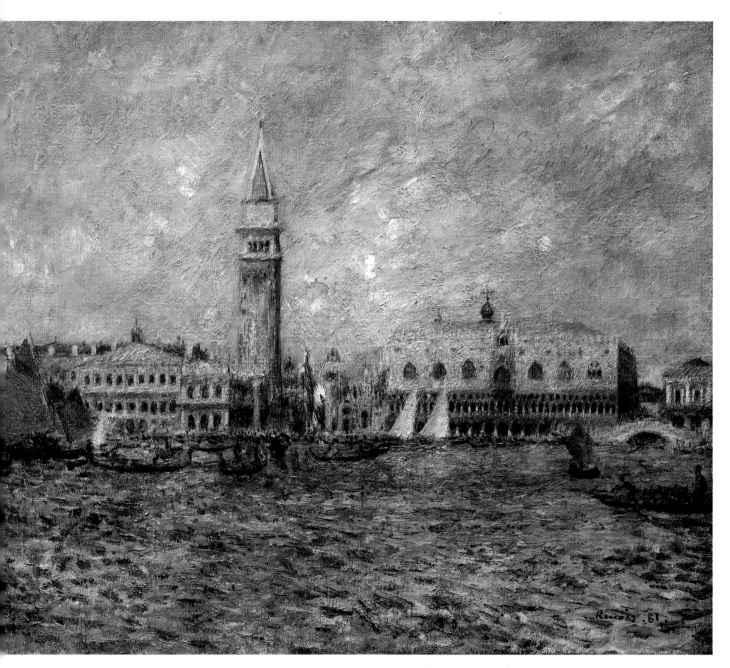

The Doge's Palace, 1881, oil on canvas, Sterling and Francine Clark Institute of Arts, Williamstown, MA, USA, 54 x 65cm (21 x 26in)

With dappled brushwork, Renoir has rendered the forms of the buildings in coloured dabs and touches. Deep shadows are captured in rich colours, including blues, mauves, pinks and greens, while the façades are depicted in creams, yellows and oranges to evoke the idea of warm golden sunlight on stone. The same colours are repeated in the water, while the sky dominates the palette in a brilliant cobalt blue.

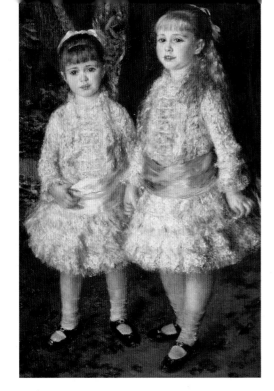

The Cahen d'Anvers Girls, 1881, oil on canvas, Museu de Arte, São Paulo, Brazil, 119 x 74cm (47 x 29in)

This was commissioned after Renoir had painted the little girls' older sister Irène. Elisabeth, in blue, was nearly seven and Alice, in pink, was five when he painted this just before he left for Algiers. The children stand in a richly decorated room wearing their best lacy dresses with satin sashes and matching socks. Despite the setting's formality, Renoir portrayed their natural, childish charm.

Fruits of the Midi, 1881, oil on canvas, The Art Institute of Chicago, IL, USA, 51 x 65cm (20 x 26in)

This is one of the paintings that Durand-Ruel showed in his second New York exhibition in 1887. Renoir always arranged his still lifes carefully, so they appeared accidental. This composition is vividly coloured, but stable, set on a plain white cloth and against a green wall. Applying long, diagonal brushstrokes and using only coloured shadows, it blends Chardin's approach with the transient appearance of Impressionism.

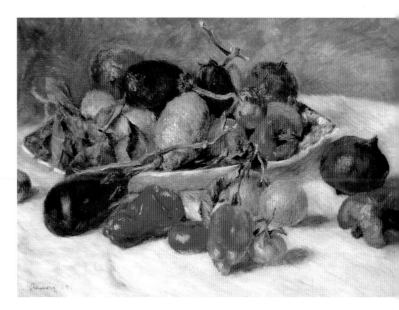

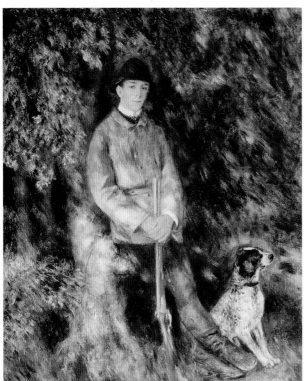

Portrait of Alfred Bérard with his Dog, 1881, oil on canvas, Philadelphia Museum of Art, Philadelphia, PA, USA, 65 x 51cm (26 x 20in)

Renoir frequently mixed his landscape and figure styles, placing loose, directional brush marks adjacent to each other with more detailed application for figures. This is a portrait of Bérard's nephew Alfred, painted during one of Renoir's lengthy visits to Wargemont. The loose, impressionistic background serves as a frame for the clearer contoured full-length rendering of the 19-year-old and his dog.

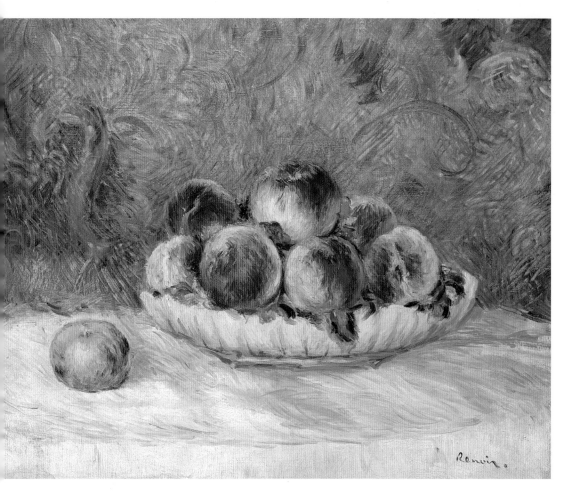

Peaches, 1881–2, oil on canvas, Musée de l'Orangerie, Paris, France, 38 x 47cm (15 x 18in)

Renoir has created a juicy looking arrangement of velvety peaches, which appear to be practically floating on the snowy white tablecloth. The background has been rendered for maximum decorative effect, using minimal detail, in sympathetic colours and swirling, cross-hatched marks. Still lifes continued to sell to the Parisian middle classes, so between his portrait commissions, genre and landscape paintings, Renoir continued to produce small, saleable works such as this.

Portrait of Richard Wagner, 1882, oil on canvas, Musée d'Orsay, Paris, France, 53 x 46cm (21 x 18in)

Renoir was one of the first Frenchmen to admire Wagner, thus he could not resist the opportunity of trying to visit the composer at the beginning of 1882, when Wagner was staying in Palermo. After two unsuccessful attempts, the men were finally introduced, and Renoir managed to persuade the reluctant musician to sit for 35 minutes while he painted this. 'I look like a Protestant minister,' Wagner observed.

Mosque in Algiers, 1882, oil on canvas, Private Collection, 50 x 67cm (19 x 26in)

After suffering with pneumonia, in 1882, Renoir took his second trip to Algeria. This close study of Islamic architecture was the only finished view he produced that time. It is one of the holiest Islamic shrines in Algeria, the mosque of Sidi Abd-er-Rahman, built in 1696. Because of French colonialism, much of Algeria's trademark buildings had been destroyed, but this holy site was preserved.

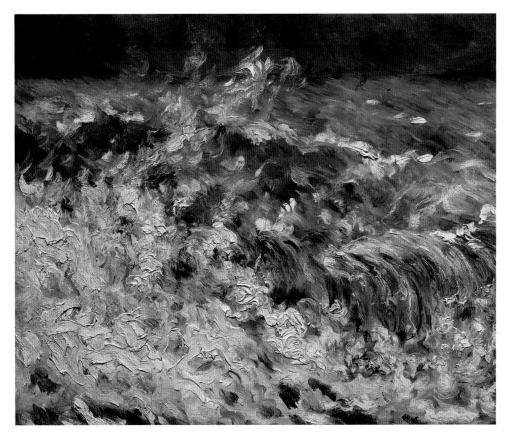

The Wave, 1882, oil on canvas, Dixon Gallery and Gardens, Memphis, TN, USA, 53 x 64cm (21 x 25in)

Dynamic, jewel-bright and effervescent, this painting expresses the full force of a crashing wave. Renoir painted this in Normandy. Tiny ships can just be perceived along the horizon, showing the insignificance of humans against nature. Paint is thickly applied in the foreground, while in the distance, thinner pigment has been smeared and dabbed in shades of green, blue and yellows, while white impasto denotes the frothy tips of foam.

Mademoiselle Fleury in Algerian Costume, 1882, oil on canvas, Sterling and Francine Clark Art Institute, Williamstown, MA, USA, 127 x 78cm (50 x 31in)

Europeans had long been fascinated by what they called Orientalism: romanticized depictions of North African and Middle Eastern subjects. Many artists travelled in search of 'exotic' subjects. When Renoir visited Algeria for the second time, he picked up on the tradition, interpreting it in his own way with several figure paintings such as this little girl, in her colourful, foreign attire.

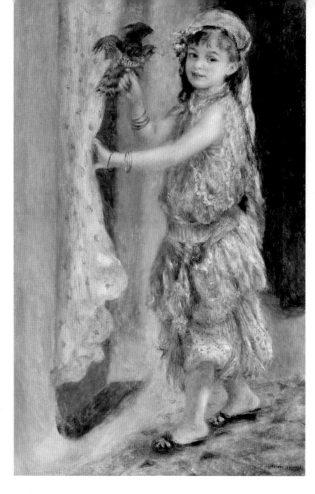

Portrait of Mademoiselle Demarsy, (woman leaning), 1882, oil on canvas, Private Collection, 61 x 51cm (24 x 20in)

This was 16-year-old Anne-Marie-Joséphine Brochard, who became a well-known actress. Brought up by her dressmaker mother, she joined the Comédie Française from 1883 to 1886. Renoir painted this model's sister, Mademoiselle Darland, in *Two Sisters (On the Terrace)*. The girls' similarities are palpable. Here, Mademoiselle Demarsy sits sideways, holding the back of a chair, her right hand supporting her head.

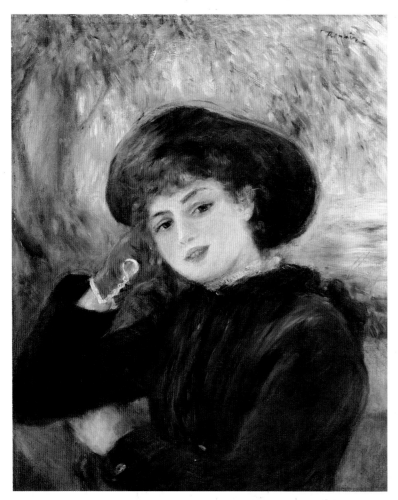

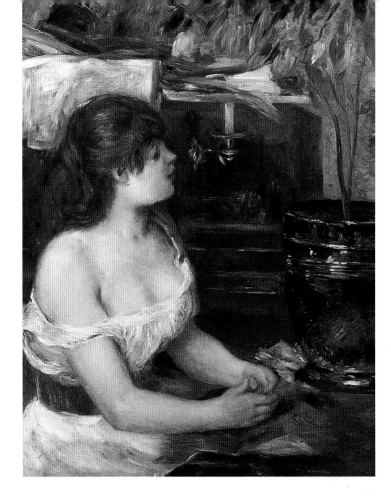

The Green Jardinière, 1882, oil on canvas, Toledo Museum of Art, OH, USA, 93 x 68cm (37 x 27in)

Many of Renoir's paintings feature fashionable and elegant women engaged in indoor pursuits. Here, a fashionable young woman sits in a stylish room bathed in soft, diffused light. Colours appear to be restricted to greens, creams and browns, although many others are also used to build up this intimate view of a bourgeois interior, complete with a piano and a flourishing plant in a jardinière.

Madame Hériot, 1882, oil on canvas, Hamburger Kunsthalle, Hamburg, Germany, 65 x 54cm (25 x 21in)

The fashion for Japanese design was increasing in the second half of the 19th century. Renoir was not as interested in it as were many other avant-garde artists in his circle, but he often included aspects of it in his work, since it was so popular. To wear a kimono as a dressing gown was considered chic and stylish, and Renoir rendered this portrait in warm and contrasting colours.

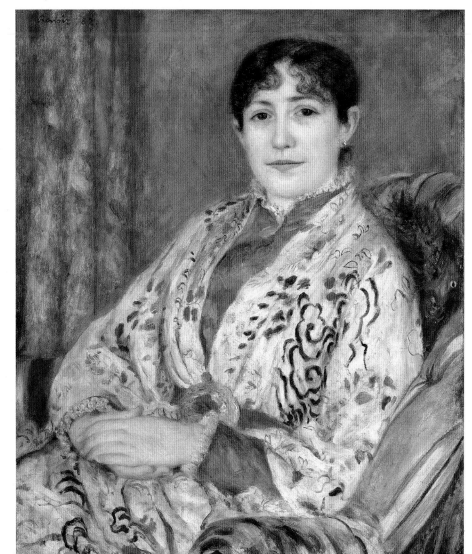

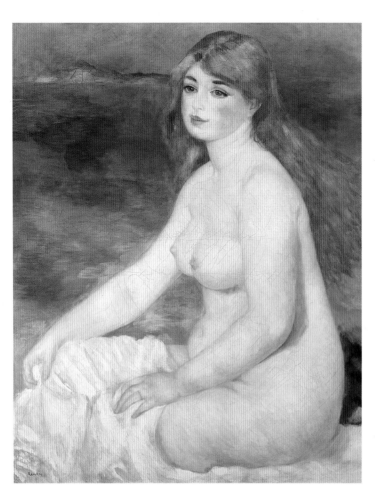

Blonde Bather (II), 1882,
oil on canvas, Pinacoteca
Agnelli, Turin, Italy,
90 x 63cm (35 x 25in)

Renoir painted two
practically identical
versions of this nude with
a suggestion of the coastline
of Naples in the background.
Influenced by ancient Roman
and Italian Renaissance art
that he had seen in Italy, this
young woman's milky-white
skin and smooth, classic
contours proved to his
friends that he was moving
away from Impressionism.
The solidity and defined
forms were far more
classical in style.

Henri Prignot, 1882,
oil on canvas, Kunstmuseum
Saint Gall, Saint Gallen,
Switzerland,
29 x 23cm (11 x 9in)

Léon Clapisson was a man
of independent means
who bought a diversity
of paintings and drawings
in the later years of the
19th century. When he
discovered Renoir's work in
1882, he commissioned
several portraits of his
family members from him.
This delicate, almost ethereal
painting is of Clapisson's
baby nephew, Léon Henri
Prignot, whom Renoir
painted as a gift for
the family.

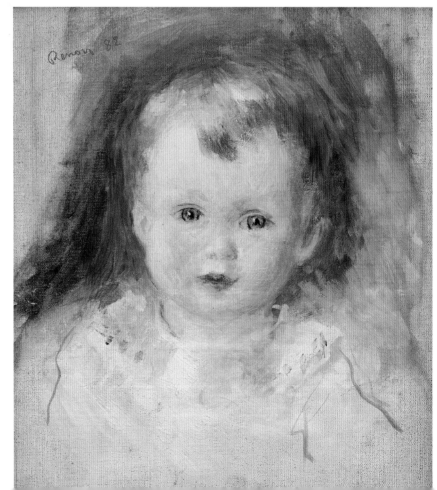

The House of Blanche Pierson, 1882, oil on canvas, Private Collection, 54 x 65cm (21 x 26in)

This is the summer cottage of Blanche Pierson, an actress and member of the Comédie-Française. Renoir hoped she would commission him to paint her portrait, but she never did. His desire to paint another famed beauty was more about consolidating his reputation than earning money. This scene captures something he once described to a friend: 'I like a painting that makes me want to stroll in it.'

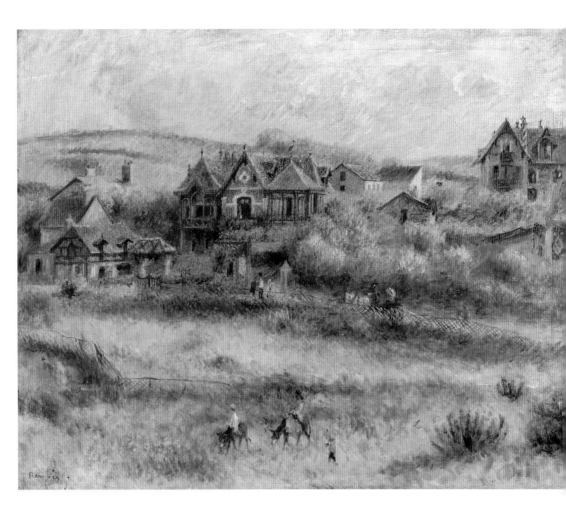

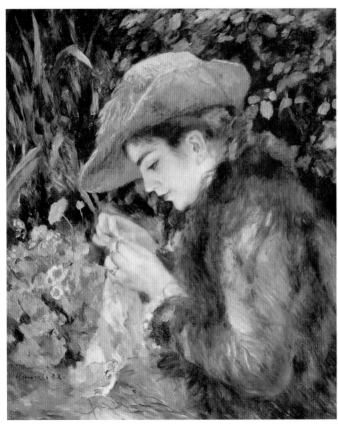

Marie-Thérèse Durand-Ruel Sewing, 1882, oil on canvas, Sterling and Francine Clark Art Institute, Williamstown, MA, USA, 65 x 54cm (26 x 21in)

In this work, commissioned by Durand-Ruel of his eldest daughter, it is clear that Renoir was changing his style, using stronger modelling and more controlled lighting than he had done in recent years. He nevertheless placed his subject in an outdoor, summer setting. Marie-Thérèse wears a hat, and Renoir's pure and bold pigments play off each other to create a particularly flamboyant painting.

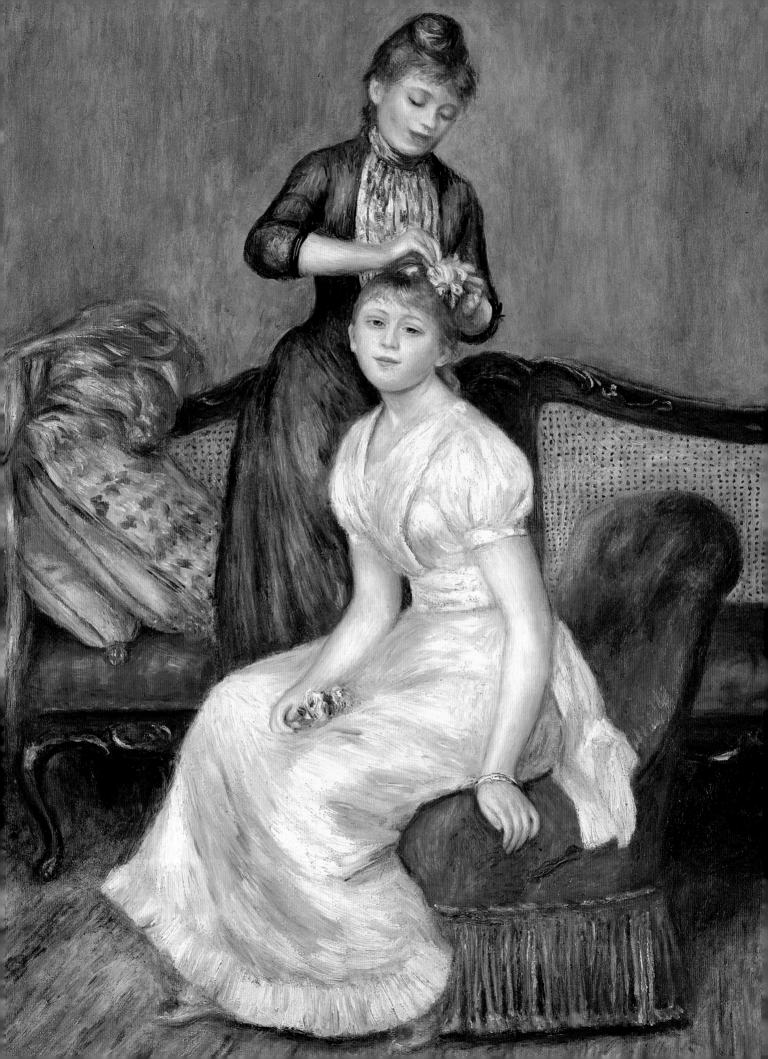

MATURITY AND RENOWN

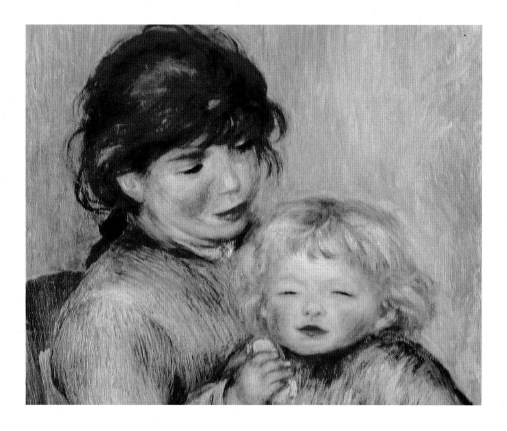

After the linear period of the 1880s, Renoir's work became even more vibrantly coloured and sensuous, but less delicate and refined than it had been during the 1870s. By this period, he became profoundly popular and despite his growing health problems and infirmity, he continued to produce more and more canvases to satisfy the art collectors clamouring to buy his paintings. He never had any pretensions about his art and continued to find his subjects as appealing in later life as he had when starting out as an artist. In 1919, he wrote to a friend: 'Now that I can no longer rely on my arms and legs, I would like to paint large canvases. I dream only of Veronese, of his *Marriage at Cana*. What misery!'

Left: La Coiffure *was painted in 1888, during Renoir's 'Dry Period,' purposely modulating the size and direction of every mark so there is rich variation between every element, while retaining the solid lines and clean-cut details he favoured at the time.*
Above: Maternity *or* Child with a Biscuit, *1887, is a charming portrait of Renoir's two-year-old son Pierre, oblivious to his father's attentions as he enjoys a biscuit.*

Dance at Bougival, 1883,
oil on canvas, Museum of
Fine Arts, Boston, USA,
182 x 98 cm (72 x 39in)

This was the third of
three paintings that Renoir
produced in 1883, featuring
couples dancing. They were
commissioned by Durand-
Ruel as decorations for his
home. The models were
Suzanne Valadon and Paul
Lhote, acting as a bourgeois
couple in an open-air café
at Bougival, near Paris.
With dazzling colour,
directional brushwork and
expressive marks, this
conveys the pleasure of the
couple as they waltz around
the dance floor.

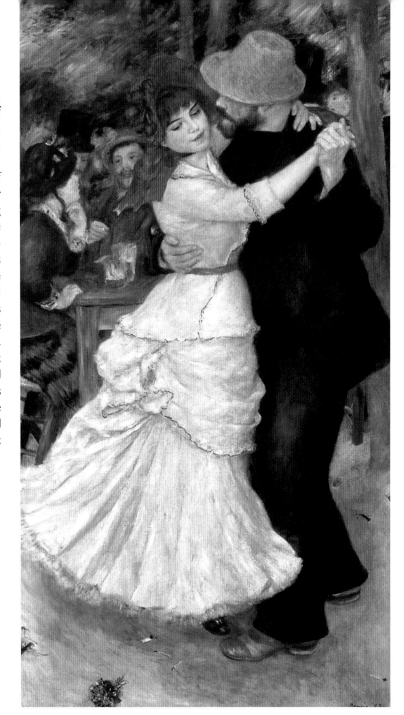

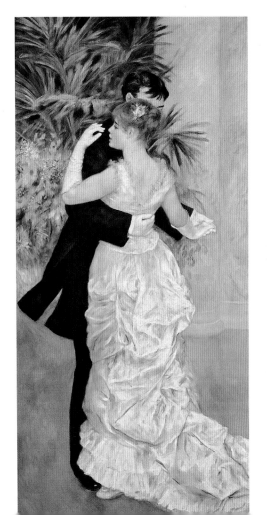

Dance in the Town, 1883,
oil on canvas, Musée
d'Orsay, Paris, France,
180 x 90cm (71 x 35in)

In the same format as the
other two works, the
models this time are Renoir's
friends Suzanne Valadon and
Lestringuez. The figures
represent graceful, upper-
class city dancers waltzing in
an elegant ballroom. Renoir's
marks had become more
precise and distinct after
seeing Raphael's paintings
in Italy, contrasting with the
vibrant brushstrokes of his
earlier works, even though
he still used colour with
great freedom to model
the forms.

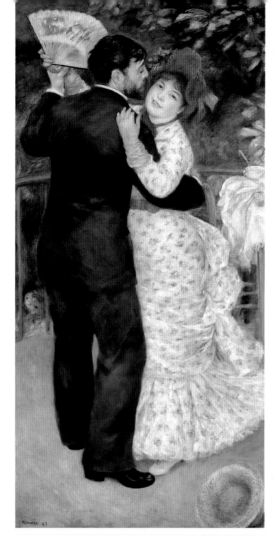

Dance in the Country, 1883,
oil on canvas, Musée
d'Orsay, Paris, France,
180 x 90cm (71 x 35in)

Musical open-air cafés
were some of the
most fashionable French
pastimes at the end of
the 19th century. Here, a
working-class couple have
left their table suddenly, their
belongings strewn as they
are captivated by the music.
The models, Aline Charigot,
Renoir's future wife, and
his friend Lhote dance
exuberantly. Aline wears a
red hat and flower-patterned
dress, laughing as she swirls
happily with her partner.

Apples in a Dish, 1883, oil on
canvas, Sterling and Francine
Clark Institute
of Art, Williamstown,
MA, USA,
54 x 65cm (21 x 25in)

This was painted a
few months after Renoir
had stayed with Cézanne,
and realized that they both
had many aims in common.
After seeing Cézanne's
efforts in producing new
forms of representation,
Renoir was certain that
Impressionism was not right
for him, and he followed
Cézanne's lead in focusing on
the simplest objects, such as
apples, to develop new visual
interpretations of the world.

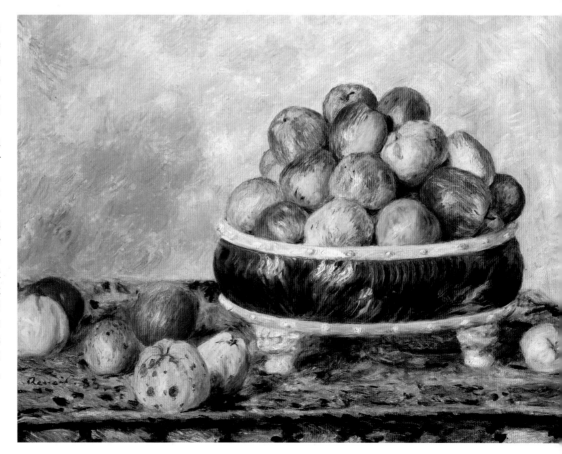

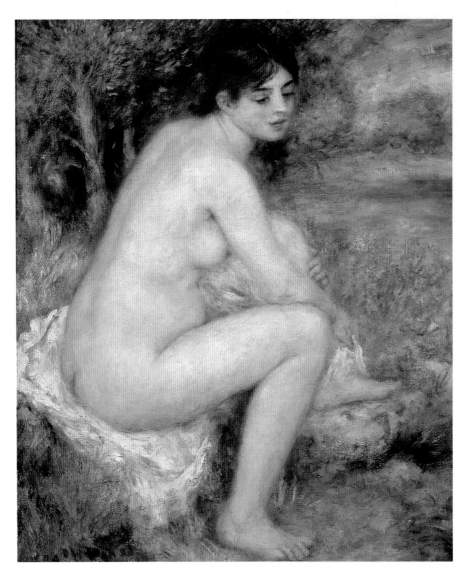

Nude in a Landscape, 1883, oil on canvas, Musée de l'Orangerie, Paris, France, 65 x 54cm (25 x 21in)

The figure stands out against the grass, trees and river in the background, but her contours are gentle as Renoir has applied the short and feathery marks of Impressionism. He would soon change this style completely, but for now the nude appears in soft focus, his usual preference for the striking contrast of dark hair and pale skin standing out against the almost misty background.

Landscape near Menton, 1883, oil on canvas, Museum of Fine Arts, Boston, MA, USA, 66 x 81cm (26 x 32in)

Rather than paint the bright blue Mediterranean and sky, Renoir depicted this group of trees, showing only glimpses of the sea beyond. It is typical of him not to adhere to classical landscape compositions, but to focus on the gnarled tree trunks and stubby grass beneath. His intention was to express the fall of light through the trees using expressive brushstrokes and colour.

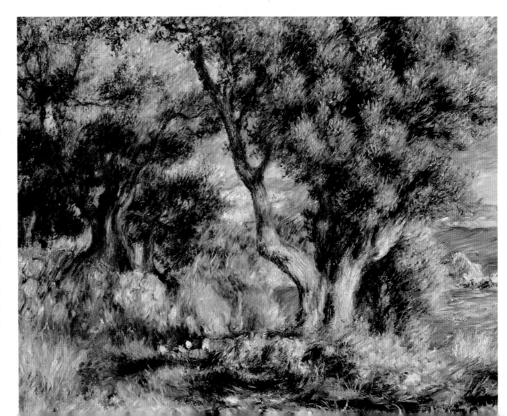

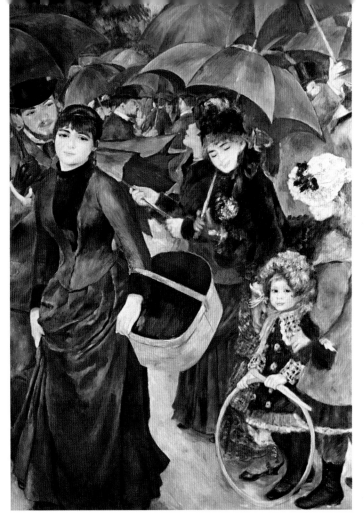

The Umbrellas, 1881-86, oil on canvas, The National Gallery, London, UK, 180 x 115cm (71 x 45in)

This picture shows two distinct painting styles. When Renoir began it in 1880–1 he was still working with impressionistic loose brushwork and pure colours. But as he became increasingly disenchanted with that style, when he returned to the painting in 1886, he repainted the figure on the left with crisper contours and more subdued colours. The changes in women's fashions help to date the two stages of the painting.

Still Life with a Melon and a Vase of Flowers, 1883, oil on canvas, Private Collection, 54 x 65.4cm (21 x 26in)

Renoir noticed that Monet's still lifes were sought after by collectors and dealers, so he painted this. A bowl with slices of cantaloupe melon sits on a wooden table next to a small glass vase containing three flowers. By placing a large object in the foreground, he created an illusion of depth, and his fluid impressionistic brushwork loosely shows the textures and patterns of the objects.

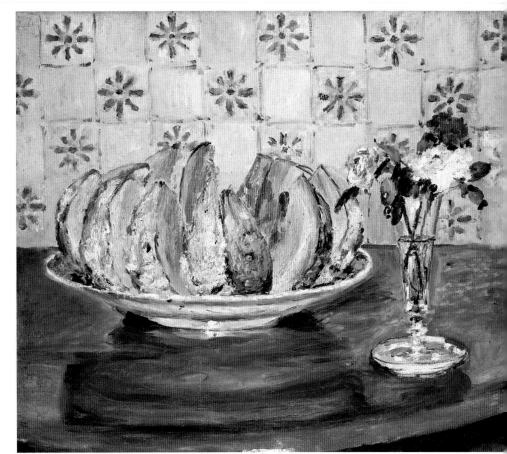

Guernsey Landscape, 1883,
oil on canvas,
Private Collection,
22 x 34cm (9 x 13in)

During his stay in Guernsey
in the late summer of 1883,
Renoir aimed to capture the
effects of light as it fell on
the water as well as on the
abundant and lush foliage.
Although his landscapes had
been harshly criticized in the
past, he believed he could
find a market for them at
this point, and he set to
work with a rich palette
and lively brushwork.

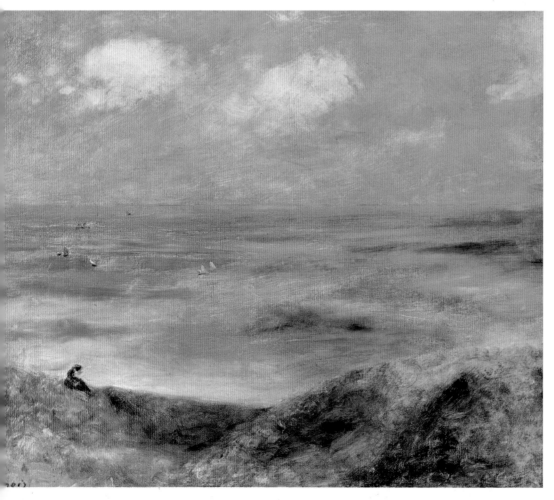

View of the Sea, Guernsey,
1883, oil on canvas,
Kunsthaus, Zürich,
Switzerland,
51 x 62cm (20 x 24in)

While in Guernsey, as well
as painting the changing light,
Renoir concentrated on
painting Moulin Huet Bay
from various different
viewpoints. Here, he has
added a tiny figure in red
to establish the scale of the
work, and to emphasize
the airiness of the scene.
Paint is applied thinly,
and colours in at least
two-thirds of the canvas
are predominantly cool.

Guernsey, 1883, oil on canvas, Musée d'Orsay, Paris, France, 46 x 56cm (18 x 22in)

The varied landscape of Guernsey captured Renoir's imagination. While there, he produced more than 15 canvases. He probably painted this to assist his memory on his return to France to include additional works. With rapidly brushed directional strokes in thick paint, just as he was on the cusp of changing his painting style, this is a typical example of a *plein air* Impressionist work.

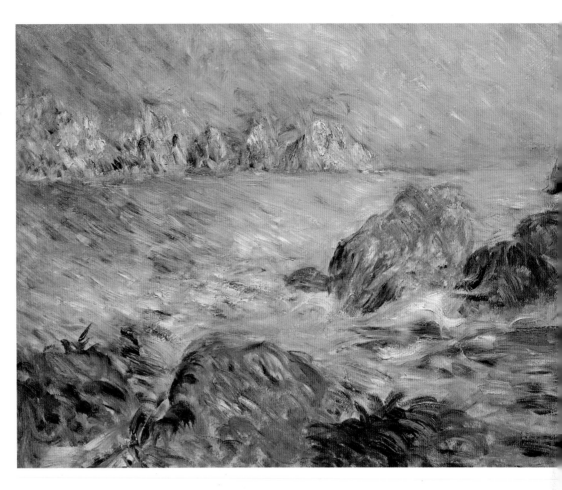

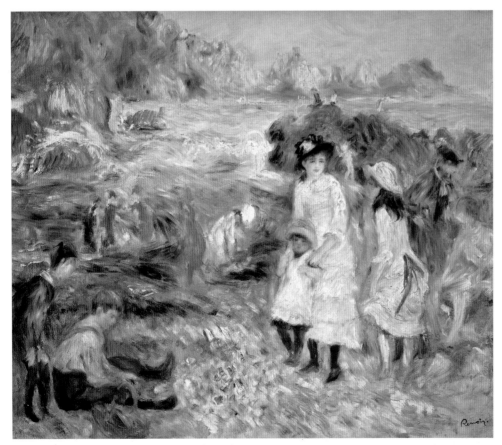

Beach Scene, Guernsey, 1883, oil on canvas, The Barnes Foundation, Philadelphia, PA, USA, 54 x 65cm (22 x 25in)

Writing of his experiences in Guernsey, Renoir explained: '…nothing is more attractive than the mixture of men and women crowded on these rocks. One would think oneself in a landscape by Watteau rather than the real world.' With painterly brush marks and a palette of green, blue, red, white and gold, this work expresses an overall feeling of innocence and happiness.

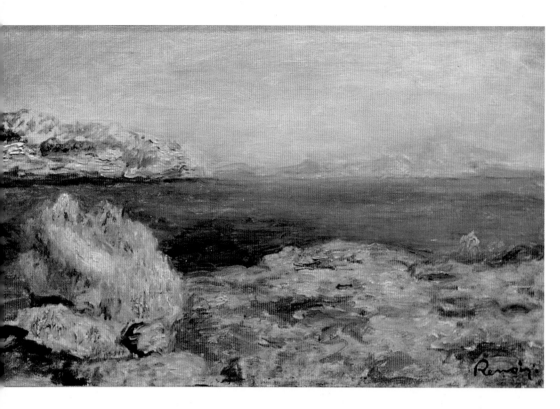

Coastal Landscape, 1883,
oil on canvas,
Niedersächsisches
Landesmuseum, Hanover,
Germany,
22 x 33cm (9 x 13in)

This small canvas has been
produced quickly and on
the spot, with an extremely
limited palette of white,
yellow ochre, ultramarine,
cobalt blue and tiny touches
of viridian and raw sienna.
Exuberant and expressive,
its loose structure and
execution show that it
was not intended to be a
finished work, but rather
a preparatory painting
for something larger and
more detailed.

By the Seashore, 1883,
oil on canvas, Metropolitan
Museum of Art,
New York, USA,
92 x 72cm (36 x 28in)

Painted on the beach,
the model sitting sewing is
thought to be Aline, who
accompanied Renoir on
this trip, along with his
friend Lhote. She has been
rendered quite classically – in
response to Renoir's
renewed interest
in Renaissance art and
ancient Roman frescoes.
Yet the details of the
figure and rattan chair
in the foreground are in
complete contrast with
the unfinished application
of the background.

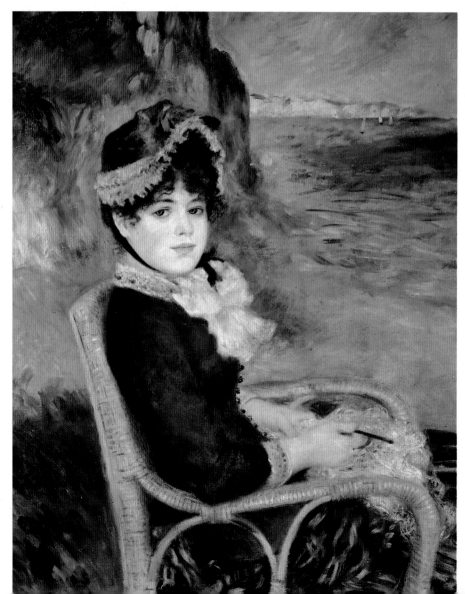

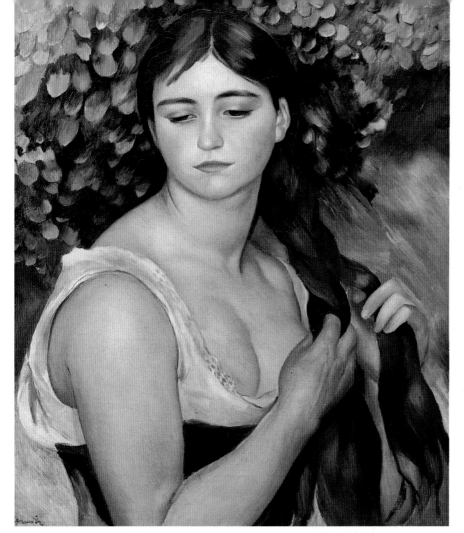

Suzanne Valadon, 1884, oil on canvas, Langmatt Museum, Baden, Switzerland, 57 x 47cm (22 x 18in)

Suzanne Valadon modelled for Renoir intermittently between 1883 and 1887. By 1884, he had abandoned any allusion to his Impressionist style, applying paint in smooth, firm contours and tonal gradations. He was particularly close to Suzanne, who had artistic talents of her own, and he clearly appreciated her heart-shaped face, large eyes, smooth skin and figure. While she posed for him, he advised her on painting.

Children's Afternoon at Wargemont, 1884, oil on canvas, Staatliche Museen Preussischer Kulturbesitz, Nationalgalerie, Berlin, Germany, 127 x 173cm (50 x 68in)

This was the largest commission that Renoir carried out for his friend Bérard. It is of the interior of Bérard's château in Wargemont, and these are his three daughters: Marthe, aged fourteen, Marguerite, aged ten and Lucie, aged four. In Renoir's new formal style, none of his previous spontaneity is evident, and the clear, crisp contours are created with sharp lines and opaque colours.

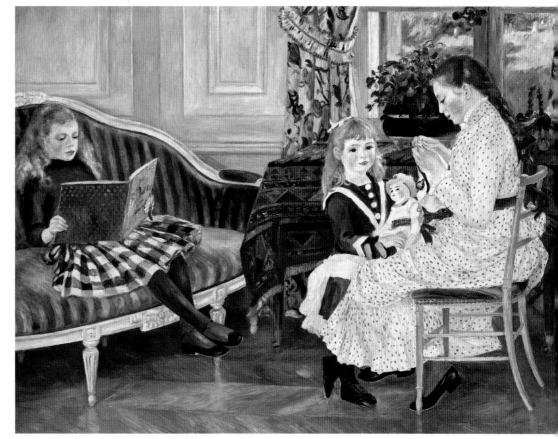

Young Girl with Long Hair or *Young Girl in a Straw Hat,* *c.*1884, oil on canvas, Private Collection, 54 x 43cm (21 x 17in)

Renoir loved exotic-looking dark-haired women, the softness of blondes and the radiance of redheads. As in his Portrait of Mademoiselle Irène Cahen d'Anvers, 1880, he has made a feature of this model's abundant red hair. Although painted in his new *manière aigre*, which embraced cooler colours, he captured the brilliance of her luxuriant locks.

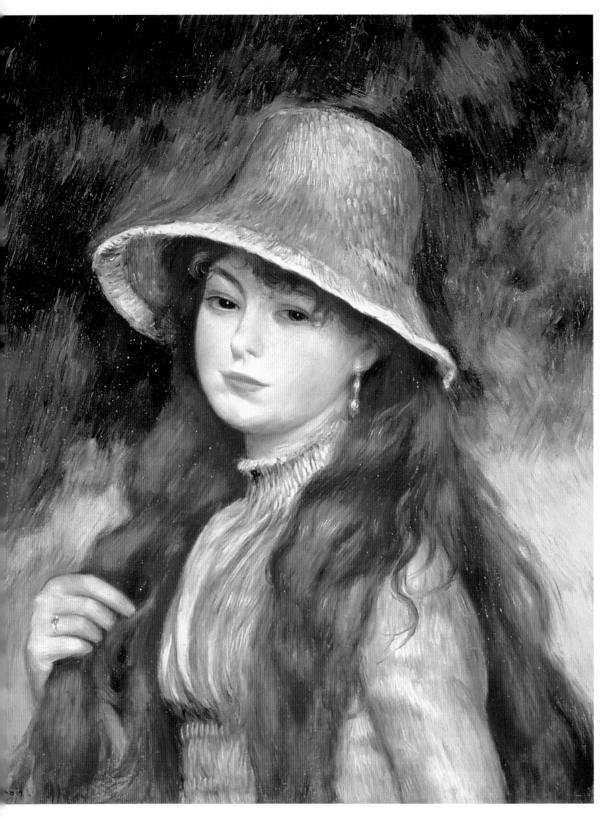

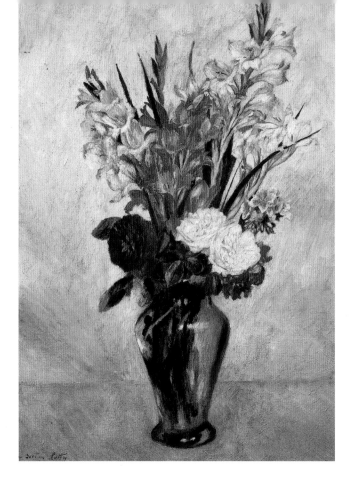

Gladioli, 1884, oil on canvas, Private Collection, 66 x 54cm (26 x 21in)

This period was particularly difficult for Renoir. After his taste of success in selling paintings to Durand-Ruel, the art dealer was experiencing financial difficulties so had stopped buying his work. His new style did not appeal to his friends and patrons. This fairly large work is a deliberate step back into his old exuberant style, at a time when he was feeling unhappy and isolated.

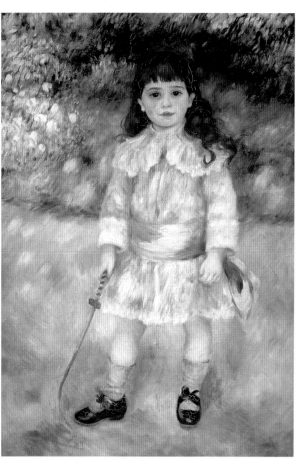

Child with a Whip, 1885, oil on canvas, Hermitage State Museum, St Petersburg, Russia, 107 x 75cm (42 x 29in)

This is Etienne, the five-year-old son of Dr Goujon, who commissioned portraits of all four of his children from Renoir. The work was created to hang as a pair with the following painting. With crisp outlines and bold colours, this was painted in the open air. The little boy's face, hair and hands were defined clearly, but all else is loose and freshly rendered.

Girl with a Hoop, 1885, oil on canvas, National Gallery of Art, Washington DC, USA, 125 x 77cm (49 x 30in)

Still working out how he could make his paintings appear more permanent and classical, Renoir painted Marie Goujon, the nine-year-old sister of the boy in the previous painting. Once again, the face and hair are depicted in a tight style, with fluid and smoothly blended paint, while other areas are softer. Blues and greens have been used to portray the whiteness of her dress.

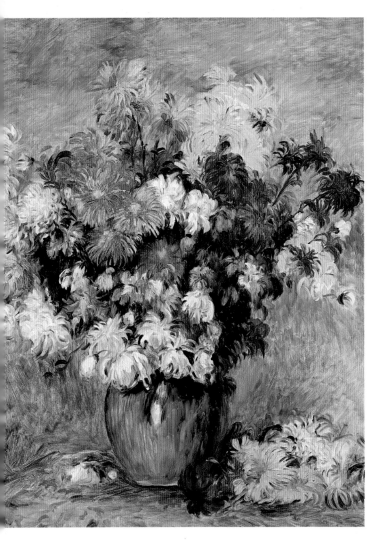

Bouquet of Chrysanthemums,
c.1885, oil on canvas,
Musée des Beaux-Arts,
Rouen, France,
81 x 65cm (32 x 25in)

Not knowing where he was heading, Renoir was quite dissatisfied with his efforts. He wanted to produce serious art that others admired and bought, but he seemed no nearer to this than he had been at the beginning of Impressionism. Thus, while most of his work at this time shows his 'sour' manner, others still retain some of the vibrant hues and loose brushwork of his earlier paintings.

The Child at the Breast
(known as Maternity), 1886,
oil on canvas,
74 x 54cm (29 x 21in)

Renoir's first son Pierre was born in March 1885, and that summer, he began several canvases of Aline breastfeeding the baby in the garden. This is the third of those paintings, dated 1886. All show Pierre aged about six months and mother and child in the same position; Aline feeding him and Pierre clutching his foot. While each composition remains unchanged, the executions show stylistic experimentations.

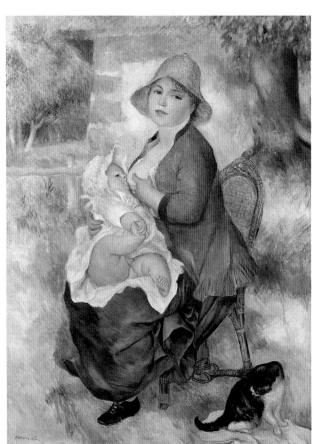

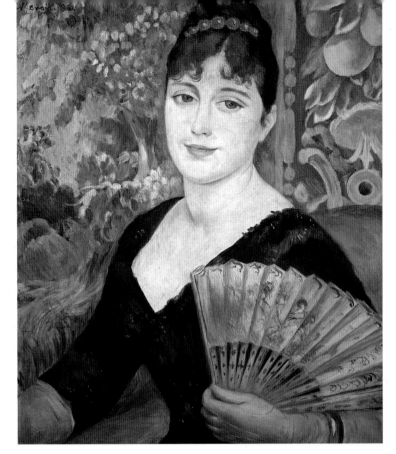

Woman with a Fan, 1886,
oil on canvas,
The Barnes Foundation,
Philadelphia, PA, USA,
56 x 46cm (22 x 18in)

In *Maternity*, Renoir applied
pastel colours in a dry style,
emulating the effects of
fresco painting. In this
work, he has continued
to experiment with a similar
application, with firm lines
and colours applied in a
more fluid manner, following
fresco painting but imbuing
the work with a finish
that resembles enamel.
The overall effect however,
resembles 18th-century
watercolours.

Young Girl Reading, 1886,
Städel Museum,
Frankfurt, Germany,
56 x 46cm (22 x 18in)

After working with detailed
precision, Renoir began
once again softening features,
particularly in his paintings
of children. This is more
freely worked than many of
his contemporary canvases
and focuses on one of his
favoured themes: a female
sitting, relaxed and yet
concentrating on a passive
activity. The flowered hat and
vase of flowers also serve to
give the painting greater
appeal.

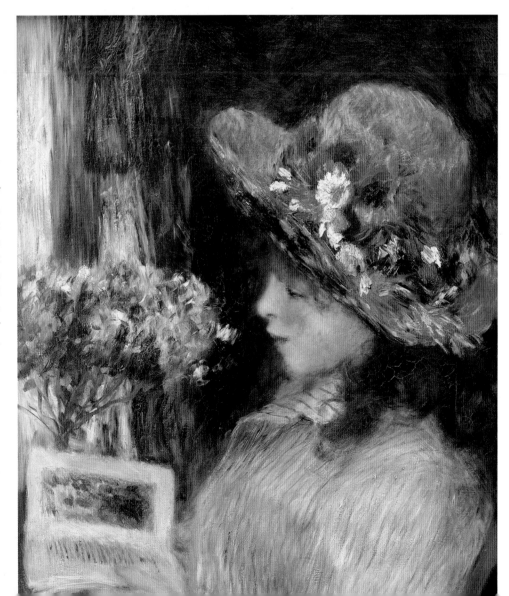

Garden Scene in Brittany,
*c.*1886, oil on canvas,
The Barnes Foundation,
Philadelphia, PA, USA,
54 x 65cm (21 x 25.75in)

The clean-cut, mother-of-
pearl appearance of this
work demonstrates how
Renoir focused on the
relationships between
drawing and colour at this
time. His dry, almost brittle
style is expressive and
detailed; his paint application
is careful and measured, and
the colours are bright and
intense. Richly decorative,
this shows the influence
of Boucher as well as
being inspired by all
Renoir had seen
in Italy.

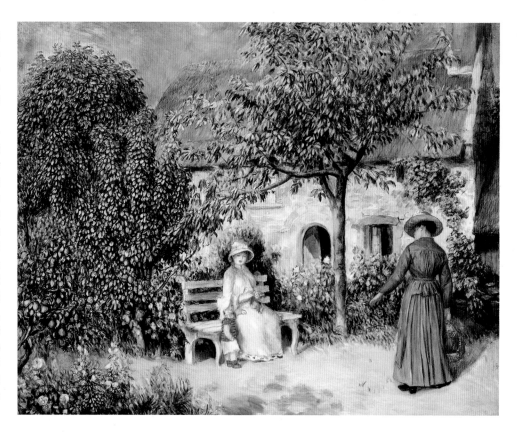

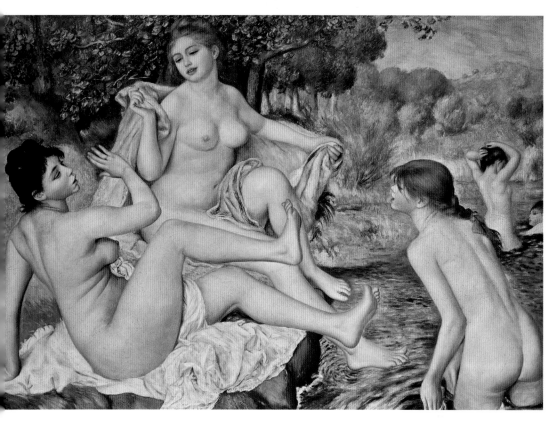

The Large Bathers, 1887,
oil on canvas, Philadelphia
Museum of Art, PA, USA,
118 x 171cm (46 x 67in)

When first exhibited in the
gallery of Georges Petit in
1887, this painting was
initially received well,
then criticized for being
retrograde. Renoir made
over 20 preparatory studies
for it over a period of three
or four years. The classical
composition reflects his
admiration for Ingres,
Goujon, Raphael, Boucher
and the bas-relief at
Versailles by Girardon. The
starkly lit, precisely painted
models include Aline and
Suzanne Valadon.

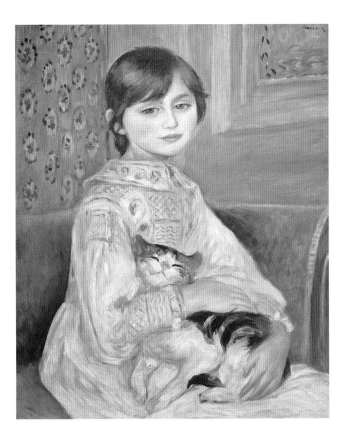

Julie Manet or *Child with Cat,*
1887, oil on canvas,
Musée d'Orsay,
Paris, France,
65 x 54cm (25 x 21in)

In the summer of 1887, Berthe Morisot and her husband Eugène Manet commissioned Renoir to paint a portrait of their eight-year-old daughter Julie. He produced five preparatory drawings for it, and when she was 85, Julie recalled his working methods: priming the canvas with white, tracing the final drawing exactly and finally painting the work 'bit by bit'. He emphasized similarities between Julie and her cat's features.

Bather, 1885–7,
oil on canvas,
Nasjonalgalleriet,
Oslo, Norway,
60 x 54cm (24 x 21in)

Painted at the height of Renoir's 'Dry Period', the influence of Ingres can be seen in the palette, smooth finish and clear contours of this work, while the formal pose against a classical landscape evolved from the frescoes he had seen in Italy. This work reveals Renoir's problems in reconciling his crisp drawing style with traditional methods of modelling form and tone.

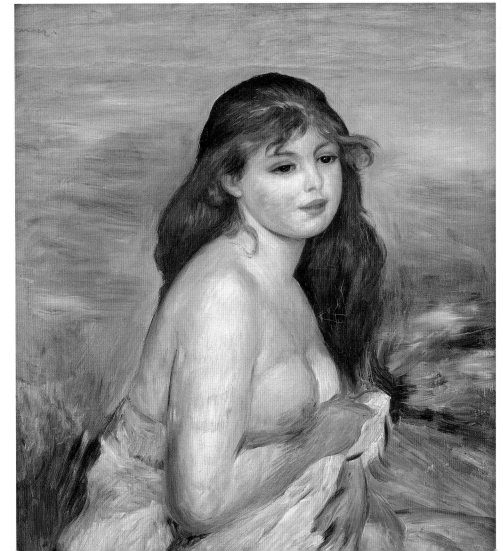

Young Girls Reading or *The Two Sisters*, 1889, oil on canvas, Private Collection, 64 x 54cm (25 x 21in)

Two girls, almost identical in appearance with the same hairstyles and matching outfits, read a book together. By 1889, Renoir had emerged from his 'Dry Period' and was again working toward a new style. He painted this with great care, paying particular attention to the composition and the flowing, decorative brush marks. His palette was brighter once again, and the red-orange resonates against the blue background.

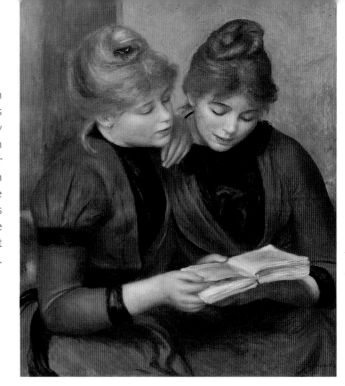

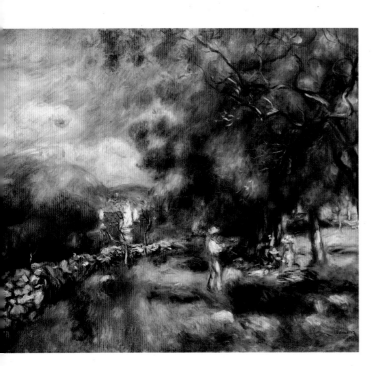

Landscape with Harvester, 1888, oil on canvas, The Barnes Foundation, Philadelphia, PA, USA, 64 x 81cm (25 x 32in)

Between about 1885 and 1887, Renoir sought to make his landscapes appear dynamic and solid. In the year he painted this, he spent time with Cézanne and the depiction of solidity became even more important to him. The tones, palette and the landscape itself show Cézanne's influence, while Renoir's application of colour also shows the influence of 16th-century Venetian painting.

The Two Sisters, c.1889, pastel on paper, Bristol City Art Museum, Bristol, UK, 79 x 64cm (31 x 25in)

Using the same two models as in *Young Girls Reading*, above, Renoir has captured another charming moment as the identically-dressed sisters look at a journal together. This fits in with Renoir's proclivity for painting chic and elegant young women in feminine, submissive activities. The journal was probably a fashion journal. Using pastels in richly textured layers, this resembles an oil painting.

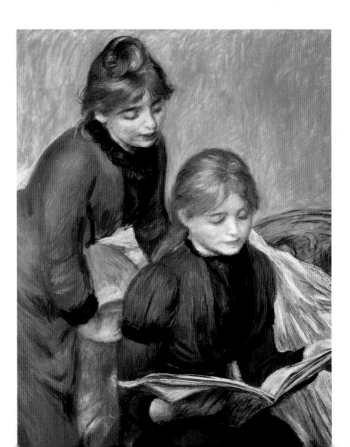

Girl with Pink Bonnet,
c.1890–94, oil on canvas,
The Barnes Foundation,
Philadelphia, PA, USA,
41.2 x 33cm (16 x 13in)

With this classical triangular
composition, Renoir no
longer followed the
16th-century Venetian
masters in layering
contrasting colours.
Instead, he worked on
creating the impression of
solidity through expressive
marks and tones, creating
strong definitions without
harsh outlines. Once again
he followed ways artists such
as Delacroix had handled
colour, creating unexpected
juxtapositions and controlled
areas of light and dark tones.

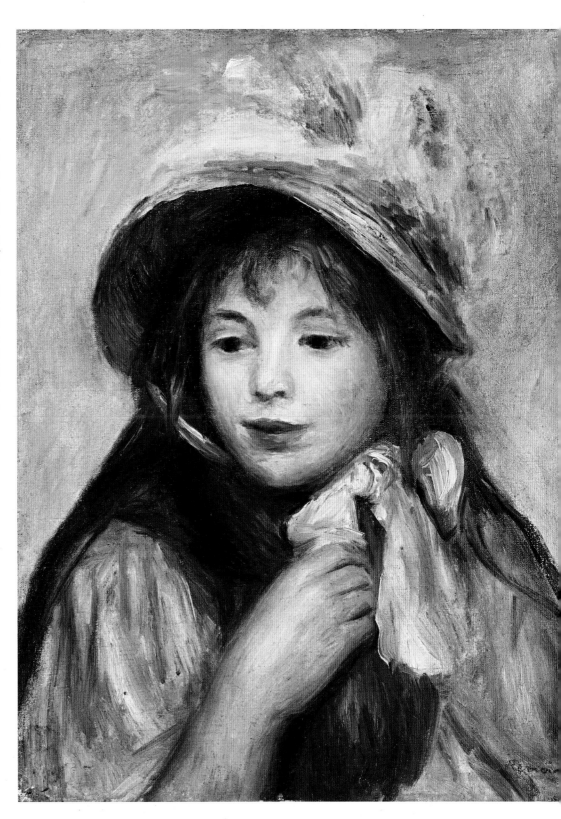

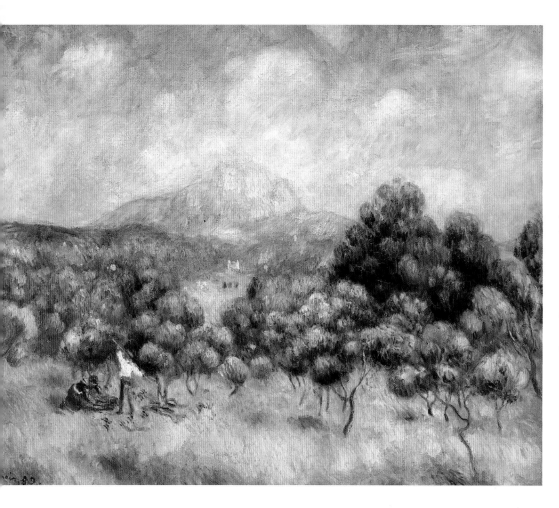

Montagne Sainte-Victoire,
1889, oil on canvas,
Yale University Art Gallery,
New Haven, CT, USA,
53 x 64cm (21 x 25in)

After suffering the first symptoms of arthritis, Renoir and his family stayed near Cézanne in the summer of 1889. Renoir painted at least three of Cézanne's favourite views. This was one of them, and it demonstrates Renoir's love of the countryside in Provence. Applying repeated parallel brush marks, Renoir was trying to fuse all elements of the picture together, giving structure and coherence to the scene.

Flowers and Fruit, 1889,
oil on canvas,
Private Collection,
66 x 54cm (26 x 21in)

Durand-Ruel purchased this from Renoir several months after he had painted it. Renoir continued to produce still lifes regularly as they remained saleable. This shows the consolidation of the style that followed his 'Dry Period', with interrelating colours and shapes creating rhythms across the canvas. Colours are bright and refreshing, the drawing and brushwork are quite loose, and tones are balanced.

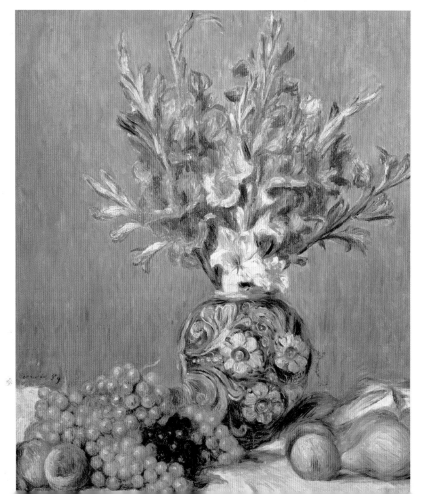

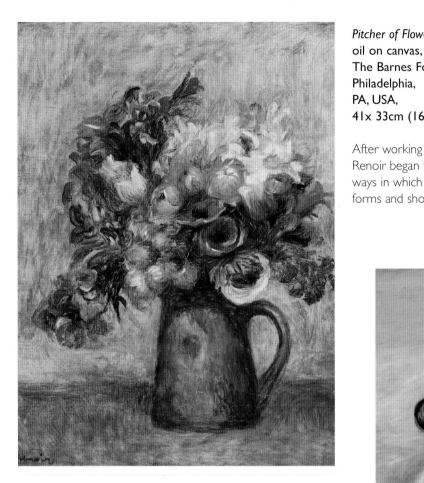

Pitcher of Flowers, 1889,
oil on canvas,
The Barnes Foundation,
Philadelphia,
PA, USA,
41 x 33cm (16 x 13in)

After working with Cézanne,
Renoir began firming the
ways in which he modelled
forms and showed structure
through colour. By using
a warm palette expressively,
he has given the impression
of solidity and has enlivened
the entire composition.
Although his marks were
softer than they had been
for several years, his use
of strong, bright and
soft colours create both
harmony and depth.

Girl with a Basket of Fish,
1889, oil on canvas, National
Gallery of Art, Washington
DC, USA,
130 x 41cm (51 x 16in)

Renoir created this as one of
a pair for the salon doors
of Durand-Ruel's apartment.
In warm colours, the young
woman stands on a southern
beach. Taken from a fairly
high viewpoint, he has
focused on the traditional
trades (the opposite door
shows a woman with a
basket of fruit). Paint
application is smooth and
fluent, and details are
restricted to her basket of
fish and facial features.

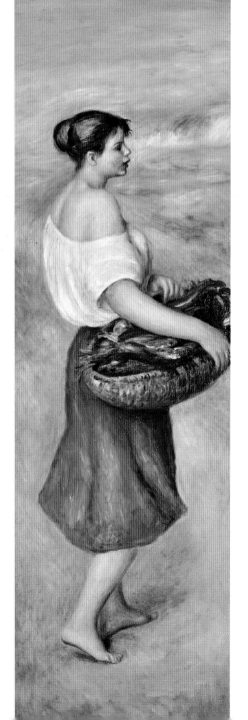

The Apple Seller, 1889, oil on canvas, The Cleveland Museum of Art, OH, USA, 66 x 54cm (26 x 21in)

With flicking, curving marks, paint has been applied in rich colours that evoke light and shade dappling the figures and area. Unlike his previous representations of dappled light, however, the play of light in this work is more generalized and appears more like patterns across the canvas. The seated woman is Aline, and the little boy at the edge of the canvas is Pierre.

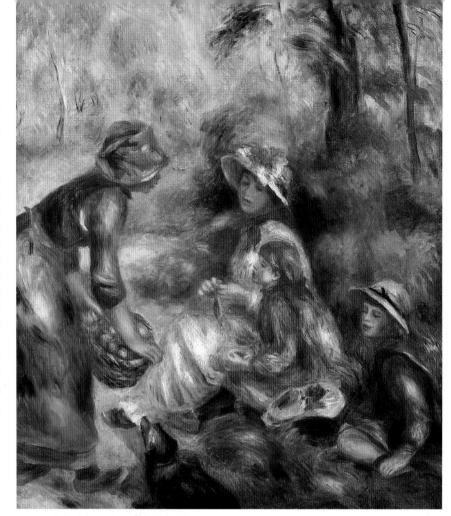

Moss Roses, 1890, oil on canvas, Musée d'Orsay, Paris, France, 36 x 27cm (14 x 11in)

In the year of his marriage, Renoir painted this small canvas. His depiction of the vase of roses is masterful. Lavishly applied impasto paint in complex, multi-directional marks and rich colours are woven together to form a luscious picture of depth and texture. Contrasts of velvety reds, creams and greens in bright and muted shades have been modelled by his carefully applied brushwork.

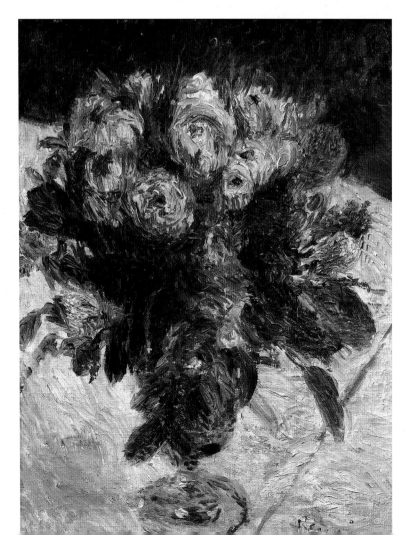

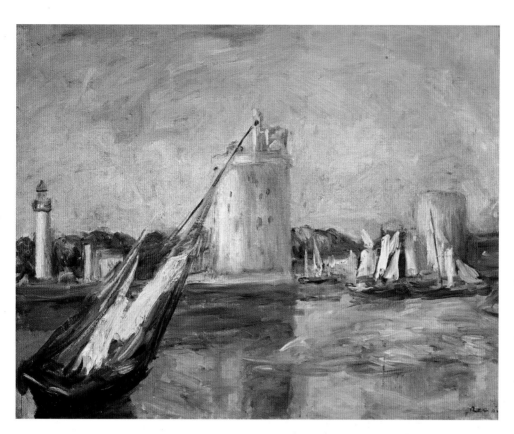

The Port of La Rochelle, 1890,
oil on canvas, Langmatt
Museum,
Baden, Switzerland,
32 x 41cm (12 x 16in)

Completely abandoning the
definite lines and contours of
his 1880s paintings, by the
1890s, Renoir adopted a
freer, more assured style. In
some circles, this became
called his 'Iridescent Period'.
He also began moving about
France in an attempt to keep
warm and to ward off the
increasing symptoms of
rheumatoid-arthritis. With
shimmering effects, he
portrayed the Port of La
Rochelle while he stayed
there from May to June.

Portrait of Two Girls,
c.1890–92, oil on canvas,
Musée de l'Orangerie,
Paris, France,
46 x 55cm (18 x 22in)

The two young girls here
are of the appearance that
Renoir loved to paint, with
their plump cheeks and
figures, long, lustrous hair and
apparent artlessness.
Absorbed in their own
world, they are seemingly
unaware of the artist
painting them. At this point,
Renoir was beginning to
command higher prices for
his works and feeling more
confident; once again he
began working toward
applying for the Salon.

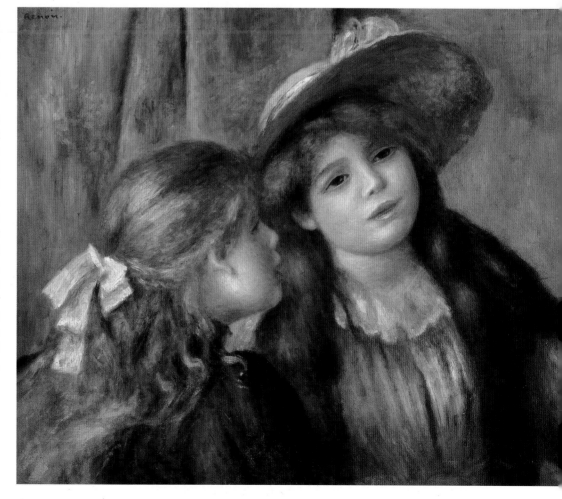

Young Girls at the Piano,
*c.*1892, oil on canvas,
Musée de l'Orangerie,
Paris, France,
112 x 79cm (44 x 31in)

This is an oil sketch for the
following painting, which is in
the Musée d'Orsay. Renoir
painted six versions of this
subject, in order to perfect
the final work, which was
commissioned by the state.
By sketching this quickly
in bright colours, he has
omitted several details of the
final work, leaving this a pure
and fresh study of the two
young girls at the piano.

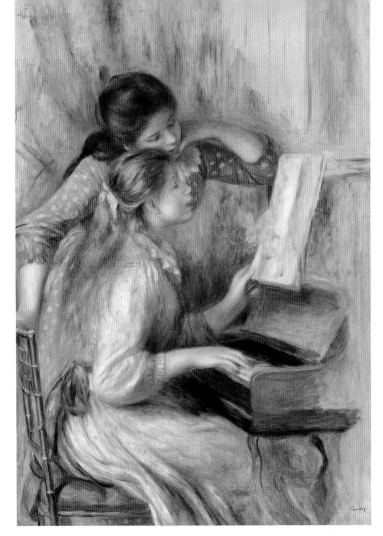

Girls at the Piano, 1892,
oil on canvas,
Musée d'Orsay,
Paris, France,
116 x 90cm (45 x 35in)

Late in 1891 or early in 1892,
the French government
asked Renoir to produce a
painting for a new museum
in Paris, the Musée du
Luxembourg, which was
to be devoted to the work
of living artists. He chose to
depict two girls at a piano in
a bourgeois interior, and
in preparation produced
a pastel, an oil sketch and
three other finished versions
of the same composition.

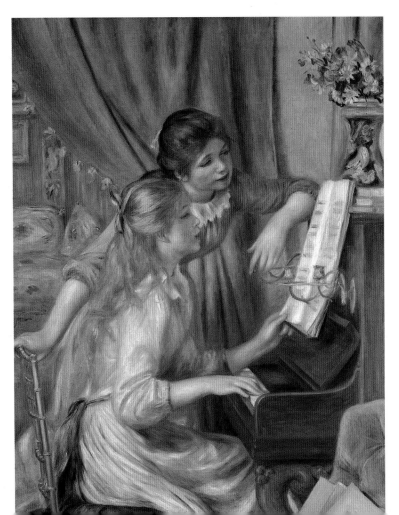

Two Girls Reading, 1892,
oil on canvas,
The Barnes Foundation,
Philadelphia,
PA, USA,
46 x 56cm (18 x 22in)

After 1890, when Renoir returned to using thinly brushed colour to dissolve his outlines, he produced several domestic scenes, usually featuring young girls in everyday pursuits. Here, strong, supple drawing clearly defines the figures, while loose, free paint application creates a modern version of Fragonard's style of painting; Renoir has depicted the ideal world of two modern girls in a sun-dappled garden.

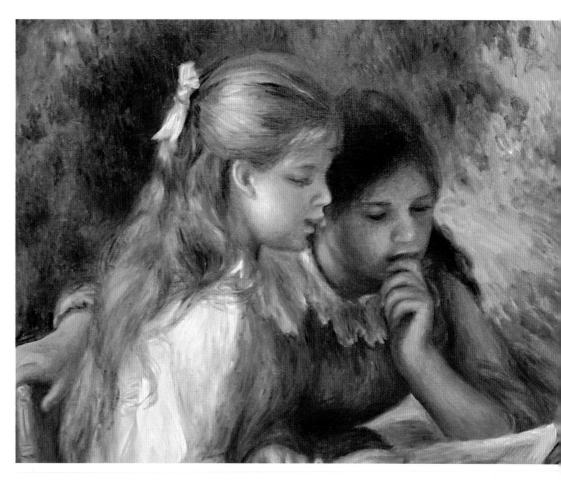

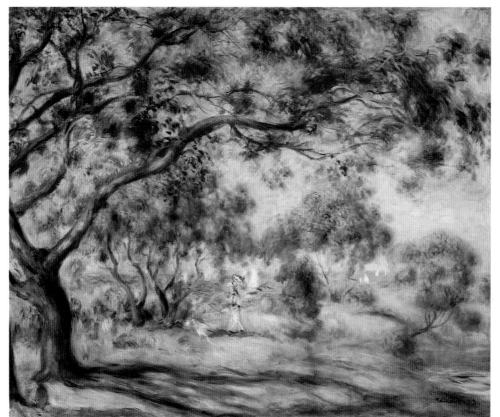

Noirmoutiers, 1892,
oil on canvas,
The Barnes Foundation,
Philadelphia, PA, USA,
65 x 81.2cm (26 x 32in)

In August 1892, Renoir stayed at Noirmoutiers, an island just off the French mainland in the Atlantic Ocean. He loved the location. Combining his elegant lines from the 1870s and his more articulated patterns of the 1880s, he emphasized the curvilinear shapes of this landscape. His long, narrow brushstrokes and multi-coloured dabs create iridescent accents. The painting is a mixture of realism, expression and decoration.

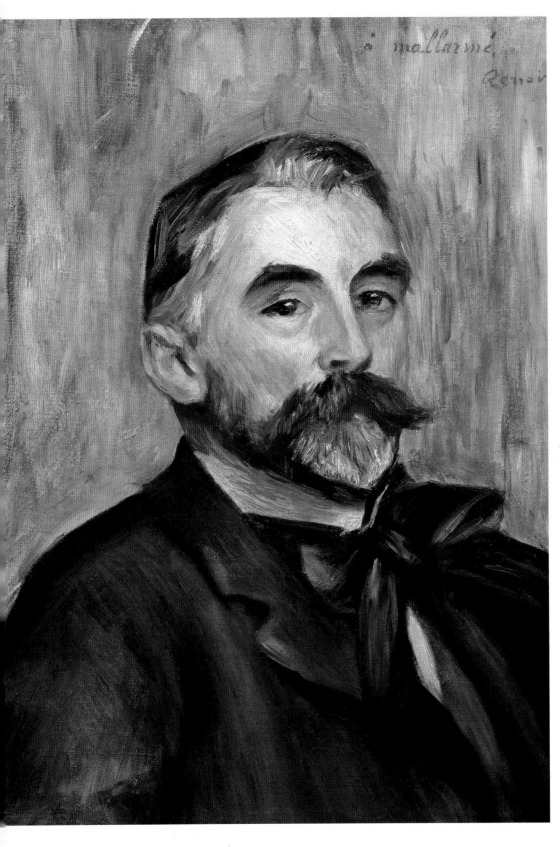

Portrait of Stéphane Mallarmé, 1892,
oil on canvas,
Musée National du Château
et Trianons,
Versailles, France,
50 x 40cm (20 x 16in)

In 1892, Renoir's friend,
poet and critic Stéphane
Mallarmé, assisted by Claude
Roger Marx, a playwright,
critic, art historian and
inspector of the École des
Beaux-Arts, made positive
attempts to bring
Impressionist works into
French national museums.
Mallarmé believed that
Impressionism was 'the
principal and authentic
movement in contemporary
painting' and he published
constructive articles about
the Impressionist artists. In
gratitude for his support,
Renoir painted this portrait.

Young Girls by the Sea, 1894,
oil on canvas,
Private Collection,
55 × 46 cm (22 × 18in)

Renoir painted many
pictures depicting the
recreations of young
bourgeois girls. Often in
pairs, they are well dressed,
and although they seem
spontaneous, as with his still
lifes, the arrangements were
carefully worked out, usually
with the help of preparatory
drawings, and they are
invariably sharing something
– a piano lesson, reading a
book or journal, or as here,
appreciating a view as
they sit in harmonious
companionship.

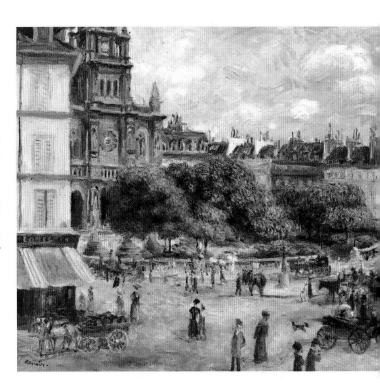

Place de la Trinité, 1893,
oil on canvas,
Private Collection,
54 × 65cm (21 × 26in)

Renoir painted the
fashionable area around
the church of La Trinité in
Paris several times. Now
more secure financially, and
with a good reputation
established, he wrote to
Durand-Ruel: 'I have lost
much time in looking for a
style which will give me
satisfaction. I think I have
found it.' By partly obscuring
the church façade and
cropping the steeple, he
created a surface of
interlocking forms and a
striking composition.

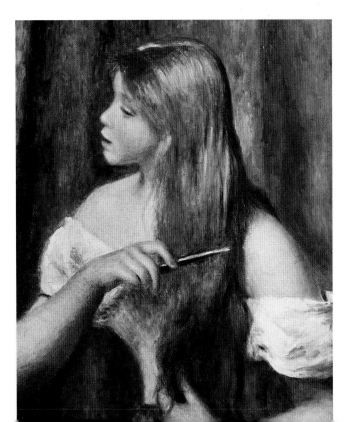

Young Girl Combing her Hair,
1894, oil on canvas,
Private Collection,
54 × 46cm (21 × 18in)

Painted when Renoir was
53 and at a time when he
was experiencing his first
severe attacks of arthritis,
this reveals none of the pain
and fear he was enduring.
Built up with translucent
veils of colour over a
densely primed ground,
he was deliberately moving
away from any suggestion
of the fleeting moment
and aiming for a more
timeless vision of woman
within nature.

Portrait of Julie Manet, 1894,
oil on canvas,
Musée Marmottan,
Paris, France,
55 x 46cm (22 x 18in)

The daughter of his great
friend Berthe Morisot, Julie
remained close to Renoir
throughout his life.
He became her guardian
after her mother died
in 1895. She was described
by a friend of Mallarmé's
as 'a silent, wild girl, with
naïvely coloured cheeks', but
his vision of the 15-year-old
was far gentler. She appears
as thoughtful and sensitive, as
she did in her
diary writings.

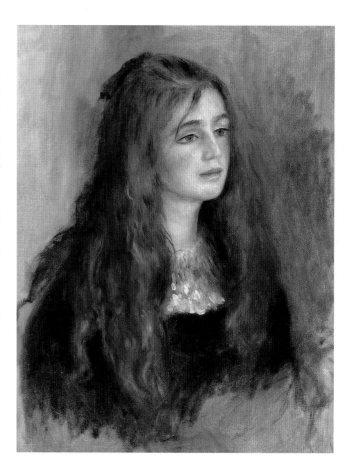

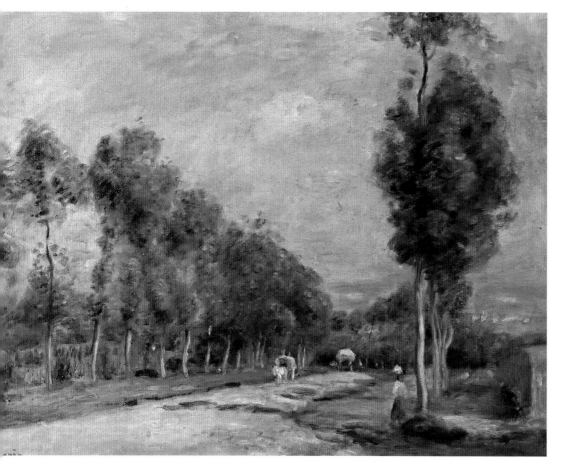

*The Road to Versailles at
Louveciennes*, 1895,
oil on canvas,
Musée des Beaux-Arts,
Lille, France,
33 x 41cm (13 x 16in)

Continuing to travel
about France, painting and
generally trying to ignore his
increasing symptoms, Renoir
was also establishing the
style that made him wealthy.
With a composition, palette
and certain marks that
resemble Impressionism, he
brought to this work some
of the richness of the
enamel-type paintings he had
been producing since he
visited Italy. The details and
the vivid colours are
expressive and accomplished.

The Children of Martial Caillebotte, 1895, oil on canvas, Private Collection, 65 x 82cm (25 x 32in)

Caillebotte's younger brother Martial and Renoir became close friends while they were negotiating with the state over Caillebotte's bequest. During that time, Renoir painted this double portrait of Martial's children, Jean and Geneviève. Taking a close viewpoint so the children practically fill the canvas, he has shown Geneviève with all the books while Jean strains to see them – a witty observation of sibling rivalry.

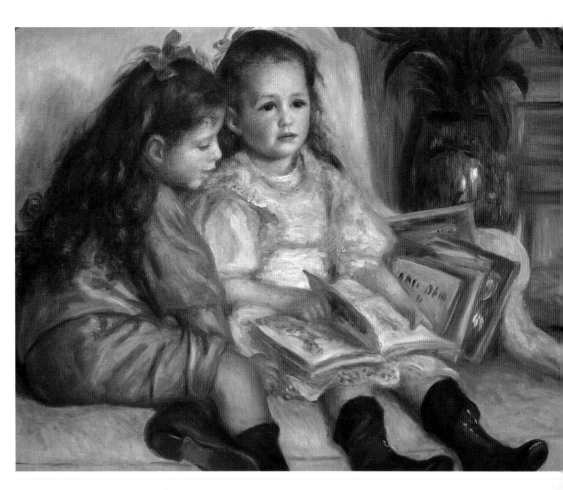

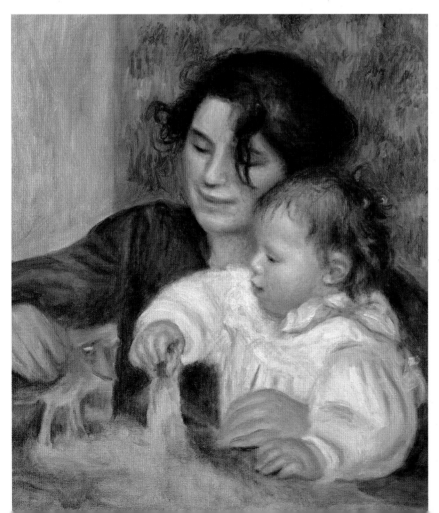

*Gabrielle and Jean, c.*1895, oil on canvas, Musée de l'Orangerie, Paris, France, 65 x 54cm (25 x 21in)

Renoir was a proud father and produced numerous paintings, pastels and drawings of his second son Jean, even before he was two years old. Most of these works also feature the protective presence of Gabrielle Renard, Aline's teenage cousin who had moved in with the Renoirs as Jean's nurse. Here, Gabrielle – who became one of Renoir's regular models – holds a toy bull, while Jean clutches a figure of a shepherdess.

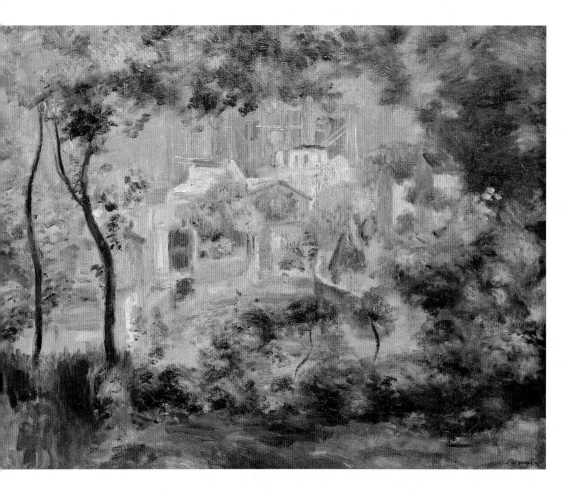

The Gardens of Montmartre with a View of Sacré-Coeur under Construction, 1896, oil on canvas, Neue Pinakothek, Munich, Germany, 33 x 41cm (13 x 16in)

Seen through the trees, high on the hill of Montmartre is a view of the Sacré Coeur under construction. The white cathedral made of travertine stone was designed in an unusual Romanesque-Byzantine style. Its foundation stone was laid in 1875, but it was not completed until 1914, and not officially opened for worship until 1919, after the end of the World War I.

The Artist's Family, 1896, oil on canvas, The Barnes Foundation, Philadelphia, PA, USA, 173 x 137cm (68 x 54in)

Renoir created this life-size painting for an exhibition at Durand-Ruel's gallery. It was probably inspired by Velázquez's epic work *Las Meninas*, which he had seen in Madrid in 1892. Posing in the garden of their Montmartre home, the family appears bourgeois. Aline links arms with 11-year-old Pierre, and Gabrielle, in her maid's uniform, crouches with 2-year-old Jean. The girl is a neighbour.

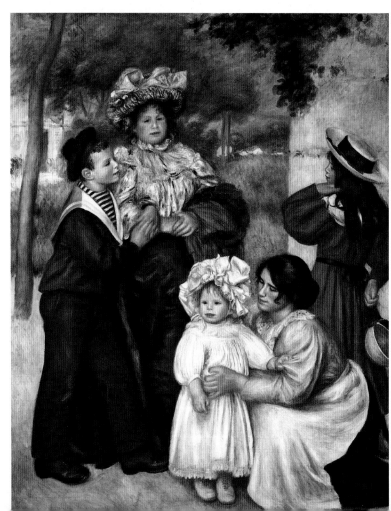

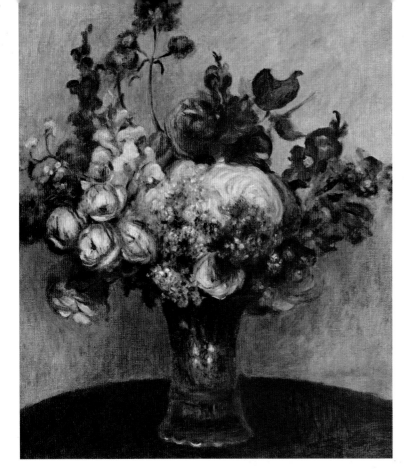

Flowers in a Vase, 1896–8,
oil on canvas,
Musée de l'Orangerie,
Paris, France,
55 x 46cm (22 x 18in)

With an almost classical
composition and application
of paint, this subject and style
of painting appealed
to many of the wealthy art
buyers in and around Paris at
the end of the 19th century.
Keeping to a limited and
strongly contrasting palette,
Renoir built up delicate
nuances of closely related
hues, building a harmonious
arrangement of colour and
tone using carefully placed
directional brush marks.

Sleeping Bather, 1897,
oil on canvas,
Oskar Reinhart Collection,
Winterthur, Switzerland,
81 x 63cm (32 x 25in)

By the end of the
19th century, Renoir's
nudes became more
opulent-looking, although
he still painted them as
young and pretty, with soft,
pearly skin and flowing hair.
Here the lighting is diffused,
the background is sketchily
rendered and the colour
harmonies are quite
restricted, with soft oranges
complemented by cool
blues. The theme is
ageless, as Renoir
said late in his life:
'The simplest subjects
are eternal.'

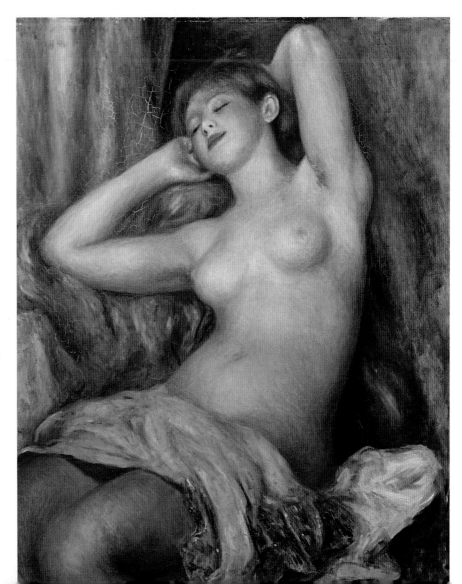

Yvonne and Christine Lerolle at the Piano, 1897, oil on canvas, Musée de l'Orangerie, Paris, France, 73 x 92cm (28 x 36in)

Yvonne and Christine were the daughters of painter and art collector Henri Lerolle, who befriended Renoir in about 1890. When Julie

Manet saw this painting in Renoir's studio she wrote: 'It's ravishing, Christine has a delicious expression, Yvonne is not a very good likeness, but her white dress is beautifully painted; the background, with Degas' *Little Dancers* in pink with their plaits and *The Races* is lovingly painted.'

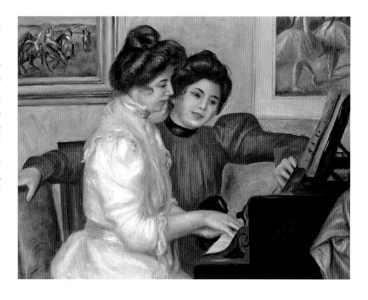

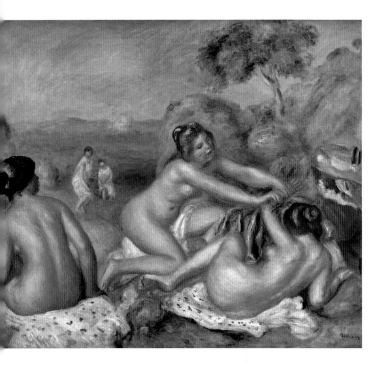

Three Bathers with a Crab, 1897, oil on canvas, The Cleveland Museum of Art, OH, USA, 45 x 65cm (18 x 25in)

Still aiming to bring Renaissance qualities and a sense of permanence to his painting, Renoir continued painting nude bathers frequently, exploring

the subject through different styles and techniques. Here, he applied fairly loose brushstrokes in pure colours as he had done during his Impressionist period, blending these with the shimmering effects, radiant colours and sinuous curves he had been exploiting since the start of the 1890s.

Woman Playing a Guitar, c.1897, oil on canvas, Musée des Beaux-Arts, Lyon, France, 81 x 65cm (32 x 25in)

This is one of a series of paintings that Renoir produced, depicting women in Spanish dress playing the guitar. It shows how his work

had evolved into his own version of classicism. Inspired by a Spanish entertainer from the Folies-Bergère, the woman's white chiffon dress with pink bows and the guitar are balanced with warm and cool colours, creating a harmonious composition reminiscent of Corot's figure paintings.

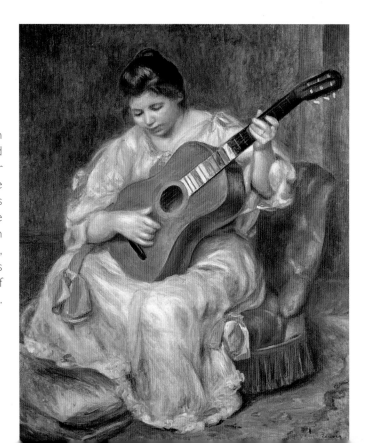

*Bathers in the Forest, c.*1897, oil on canvas, The Barnes Foundation, Philadelphia, PA, USA,
74 x 100cm (29 x 39in)

With small, detailed brush marks, this work glows with brilliant colours. It is a large work and seems to have reconciled the problems Renoir had with *The Large Bathers* of 1887. Here, the figures blend comfortably with their surroundings, and the outlines, while defined, are sympathetic and not too rigid. Although the painting seems more decorative than realistic in many ways, relationships between figures appear natural.

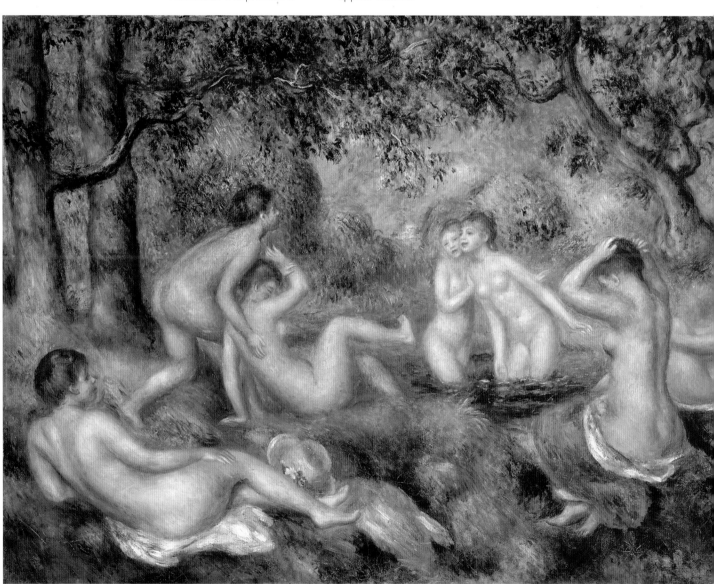

Seated Bather, 1898,
oil on canvas,
Private Collection,
33 x 33cm (13 x 13in)

With diffused lighting and
gentle gradations of tone,
this work draws comparisons
with Degas' paintings of
bathing women, only this
figure is plumper and more
Rubenesque. With her back
to us, the woman is drying
herself after a bath and
preparing to dress.
Colours are restricted
to soft versions of the
complementaries, mainly
pinks and greens, lifted by
white highlights and the
model's lustrous skin.

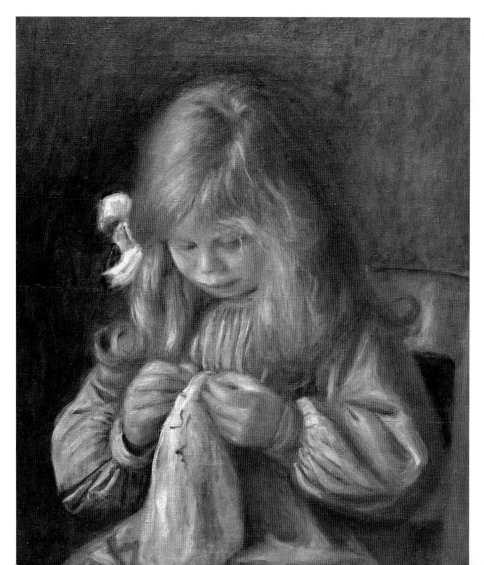

Jean Renoir Sewing, c.1899,
oil on canvas,
The Art Institute of
Chicago, IL, USA,
56 x 46cm (22 x 18in)

Long hair, ribbons and
dresses were the usual attire
for young children of both
sexes until the early 20th
century. Here five-year-old
Jean sits and sews. Renoir
often painted his sons
absorbed in a similar way, in
stationary activities such as
sewing, playing or drawing,
since this guaranteed that
they would be absorbed. In
1901, he painted Jean
drawing – by then, his hair
had been cut short.

The Anemones, 1899, oil on canvas, Musée des Beaux-Arts, Nantes, France, 25 x 32cm (10 x 12in)

During the 19th century, it was accepted that flowers symbolized specific meanings, such as lilies for purity or beauty, violets for faithfulness, daisies for innocence and roses for love. The Impressionists abandoned that notion. As Renoir once said: 'What seems to me most significant about our movement [Impressionism] is that… I am at liberty to paint flowers and call them flowers, without their needing to tell a story.'

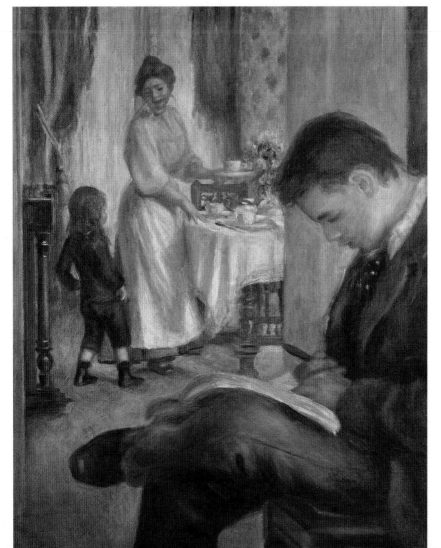

Breakfast at Berneval, 1898, oil on canvas, Private Collection, 82 x 66cm (32 x 26in)

In the summer of 1898, 13-year-old Pierre was home from boarding school, so Renoir took the opportunity to paint him, while Jean chatted to Gabrielle, who was clearing the breakfast table. In a passing moment, with his usual economy of colour and adept brushstrokes, he caught the character of each figure: the thoughtful, broody teenager; the inquisitive, lively little boy; and the capable, warm-hearted young woman.

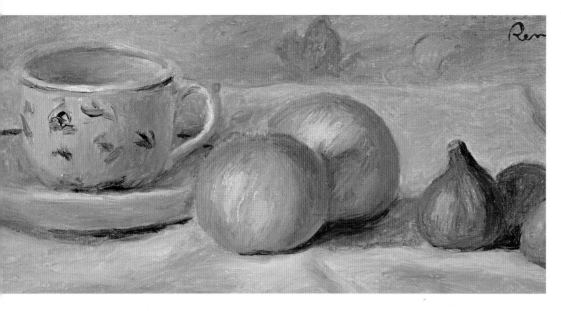

Still Life with Blue Cup,
c.1900, oil on canvas,
Brooklyn Museum of Art,
New York, USA,
15 x 33cm (6 x 13in)

A small canvas, featuring a
blue-patterned porcelain
cup and some fruit arranged
on a white cloth, recalls the
still-life paintings of Chardin,
whom Renoir had always
admired. Brushstrokes are
modulated around each
object, and strong tones are
created out of reflected and
cast colours.

View of Cagnes, 1900,
oil on canvas, Saarland
Museum, Saarbruecken,
Germany, 36.7 x 49.3cm
(14.4 x 19.4in)

Renoir loved the peaceful,
unspoilt, sunlit landscape
of Cagnes-sur-Mer. In 1900
his career was going well.
He accepted the Légion
d'Honneur, his canvases
were commanding high
prices and he participated
in numerous exhibitions.

Landscape near Cagnes,
1900, oil on canvas,
Langmatt Foundation,
Baden, Switzerland,
33 x 41cm (13 x 16in)

In 1899, Renoir underwent
treatment for rheumatism in
Cagnes-sur-Mer. He loved the
location and decided
to spend more time there.
This painting shows the blend
of Impressionist, Renaissance
and 18th-century styles
that epitomized many of
his later works.

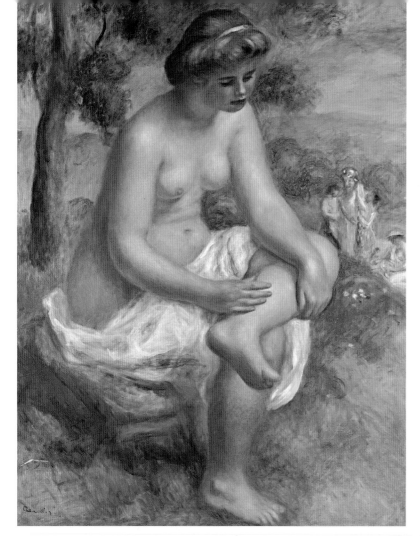

Seated Bather in a Landscape or Eurydice, 1895–1900, oil on canvas, Musée Picasso, Paris, France, 116 x 89cm (46 x 35in)

Renoir famously said: 'I never think I have finished a nude until I think I could pinch it.' This is one of seven Renoirs that Picasso owned. After his trip to Italy in 1881, Renoir spent the rest of his life striving to achieve the monumentality of Renaissance art. Years later, Picasso bought this and six other Renoirs, which he acknowledged influenced his art.

Bather and Maid, 1899–1900, oil on canvas, The Barnes Foundation, Philadelphia, PA, USA, 144 x 95cm (57 x 37in)

Renoir said: 'Out of doors there is a greater variety of light than in the studio, where the light is always the same. But that is just the trouble; one is carried away with the light.' So he often painted both in the studio and outdoors as in this work. This large work of a maid brushing a young woman's hair was produced with the Salon in mind.

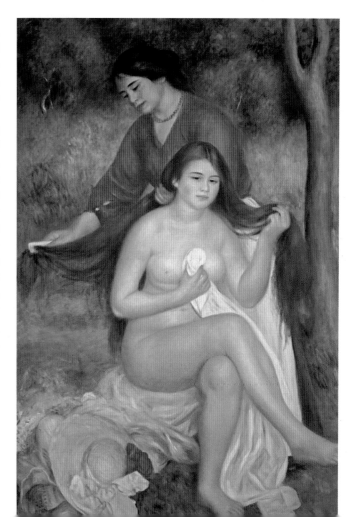

Madame Gaston Bernheim de Villers, 1901, oil on canvas, Musée d'Orsay, Paris, France, 93 x 73cm (37 x 29in)

Alexandre Bernheim-Jeune was an important Parisian art dealer who had started buying Renoir's work recently. In 1901, Bernheim's 31-year-old twin sons Josse Bernheim-Dauberville and Gaston Bernheim de Villers commissioned Renoir to paint portraits of their fiancées and cousins. He stayed with them in Fontainebleau during the late summer and produced several elegant portraits demonstrating a style that blended Impressionism with Classicism.

Le Cannet, 1902, oil on canvas, The Barnes Foundation, Philadelphia, PA, USA, 39 x 53cm (15 x 21in)

While staying in various locations around France, either for the warmth or for specific therapeutic treatments, Renoir painted his surroundings. Although he had started landscape painting by following artists such as Corot, the sumptuous colours and softly-rendered foliage here owes more to the colours and styles of 16th-century Venetian artists and Rubens. Even the way he has organized the composition recalls Venetian-style arrangements and balance.

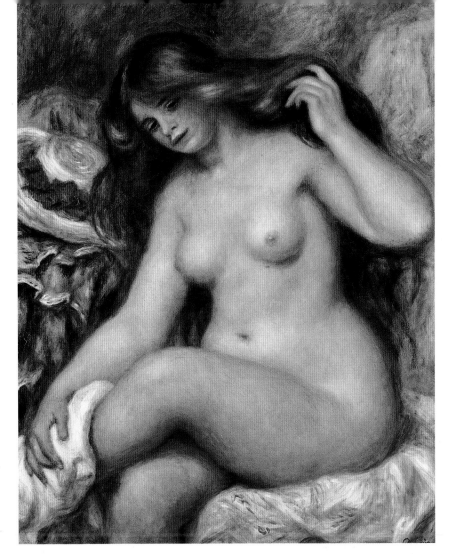

*Bather, c.*1903, oil on canvas, Kunsthistorisches Museum, Vienna, Austria, 92 x 73cm (36 x 29in)

Between about 1902 and 1903, Renoir painted at least four versions of this composition with the same model, always in an identical position. They are among the last bathers he painted who had shed contemporary clothing. After this, he gave no link to modernity in his nude paintings. Holding her hair back with one hand, this young woman dries her leg with her other hand. The style closely resembles Rubens' figure painting.

Misia Sert, 1904, oil on canvas, The National Gallery, London, UK, 92 x 73cm (36 x 29in)

Misia Sert, née Godebska (1872–1950), was considered a great society beauty in Paris at the turn of the 20th century. Introduced to her through friends, Renoir painted her at least four times. An accomplished pianist, Misia married three times, and she became the muse of artists Vuillard, Bonnard and Vallotton. For this, Renoir painted a flake white ground before establishing tones, which gives the work a luminous appearance.

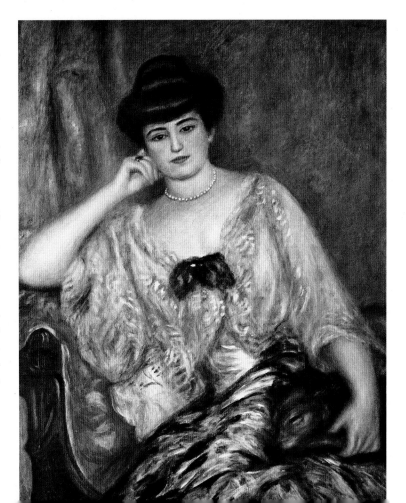

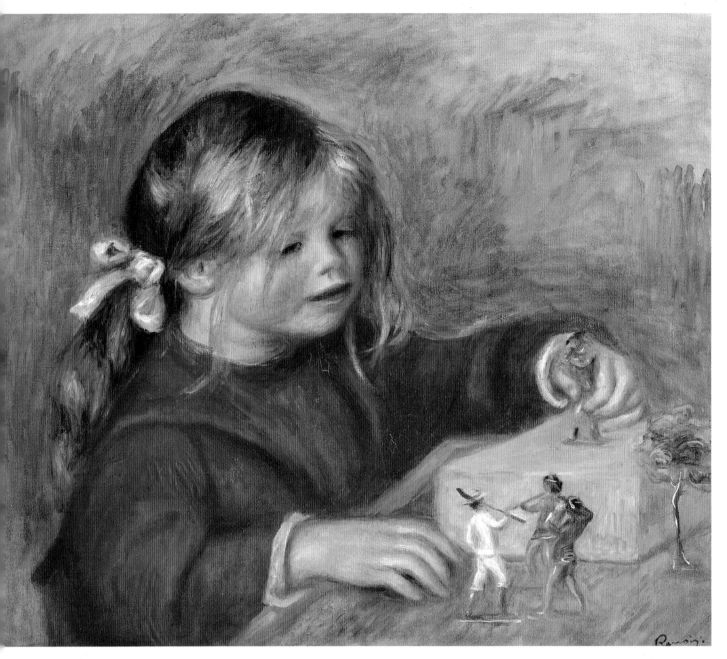

Claude Renoir Playing, 1905,
oil on canvas,
Musée de l'Orangerie, Paris,
France,
46 x 55cm (18 x 22in)

Claude, who became known
as Coco, was four years old
when Renoir painted this. As
he did with his other two
sons, Renoir used Coco as a
model for many works as he
grew up. Relishing the long
curls as a sign of innocence
and babyhood, Renoir
emphasized the soft round
cheeks and innocent
preoccupation in his painting,
while Coco was absorbed
with his toys.

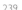

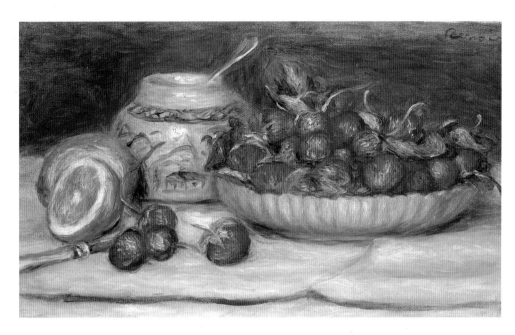

Strawberries, c.1905,
oil on canvas, Musée de l'Orangerie, Paris, France, 28 x 46cm (11 x 18in)

By the 20th century, Renoir was producing many small canvases, because they sold well. This fresh colour scheme of mainly red, yellow and blue is accented with highlights of white, making a simple, pleasing arrangement. He took care with the placement and modelling of objects, and ensured that his brushwork was simple but effective.

Writing Lesson or Gabrielle and Claude, 1905, oil on canvas, The Barnes Foundation, Philadelphia, PA, USA, 54 x 65cm (21 x 26in)

With a predominantly warm palette, Renoir has created a composition of overlapping forms and iridescent colours. The whole is a tableau of closeness between Coco and Gabrielle, who are sitting at a table in front of a vase of flowers, while Gabrielle oversees the little boy as he learns to write. Accentuating colours and textures with expressive brushwork, Renoir has created a shimmering interpretation of a domestic scene.

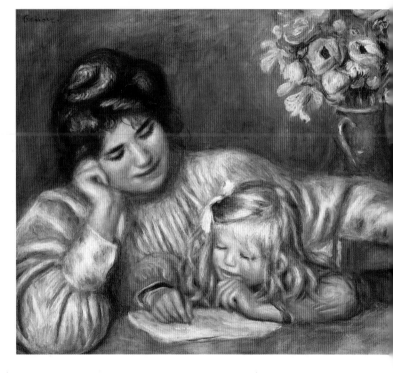

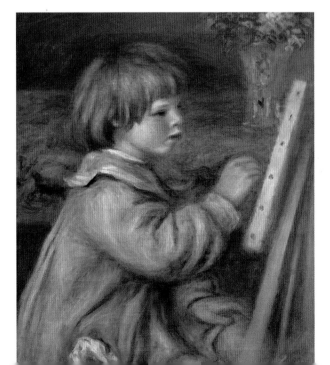

Claude Renoir Painting, 1907, oil on canvas, Private Collection, 55 x 46cm (22 x 18in)

Coco concentrates intently on his own painting while his father captures his likeness. Emulating his parent, wearing a painter's smock with a brush cloth emerging from the pocket, and seemingly oblivious to his father, the little boy concentrates on his own work. Renoir painted the scene with clear, soft brushwork and an unusual combination of cool colours in the foreground with warmer hues in the room behind Coco.

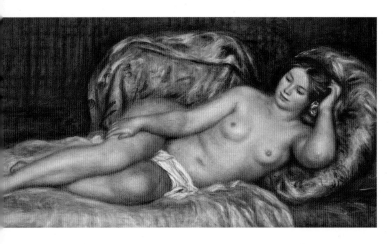

Large Nude, 1907, oil on canvas, Musée d'Orsay, Paris, France, 70 x 155cm (27 x 61in)

Contemporary writers often considered Renoir's later nudes to be successors of Rubens, Titian and Ingres. This is the third and last of one particular series of reclining nudes that he painted between 1903 and 1907. For this, he restricted his palette to a harmonious range of subtle colours with an economy of means. The ample and elegant figure reclines on soft cushions and draperies of varied patterns.

Olive Garden, c.1907–12, oil on canvas, Museum Folkwang, Essen, Germany, 32 x 48cm (13 x 19in)

In the summer of 1907, Renoir bought Les Collettes; a house and plot of land in Cagnes with ancient olive trees in the garden. Although he was advised to chop down the old olive trees, he insisted that they were retained. This exuberant, colourful work confirmed the pleasure he attained from them.

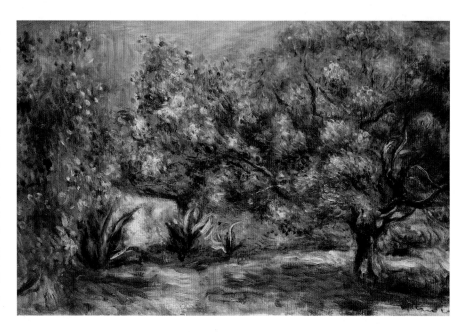

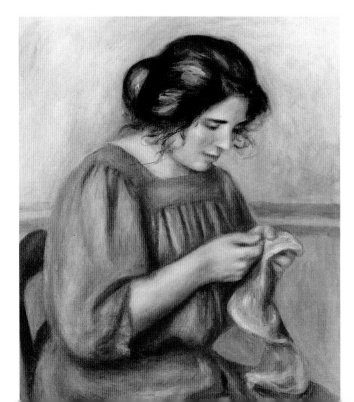

Gabrielle Mending, 1908, oil on canvas, Private Collection, 64 x 54cm (25 x 21in)

Throughout his career, Renoir never tired of painting women engaged in handiwork, which has precedents in traditional painting. He painted Gabrielle more than any other model, and as here, spent his life trying to find a balance between what he saw and what he actually painted. Gabrielle loved wearing bright colours, and that, combined with the plain interior, has the visual effect of projecting the subject forward.

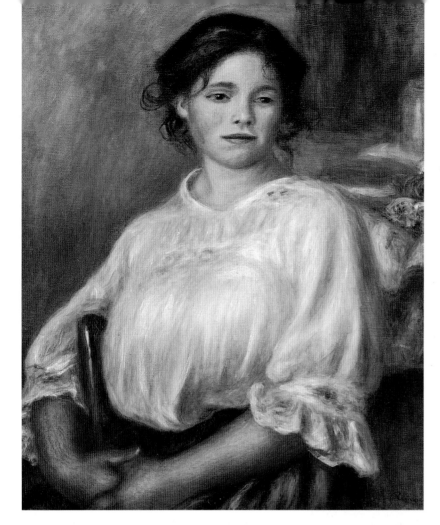

*Young Girl Seated, c.*1909, oil on canvas, Musée d'Orsay, Paris, France, 66 x 54cm (26 x 21in)

In 1909, Renoir was 68. Although he was enduring further debilitating symptoms, his painting style had evolved sufficiently to have won him many admirers. By the time he painted this rather classical-looking portrait, many younger artists were experimenting with new ideas, such as Fauvism and Expressionism, so Renoir's work no longer seemed revolutionary. The theme and handling of the subject and paint evokes the 18th century once again.

*Vase of Flowers, c.*1909, oil on canvas, Private Collection, 39.5 x 29.5cm (15 x 12in)

Deliberately evoking an impromptu moment, using vivid, loose brushwork, the lush appearance of this vase of flowers is almost expressionistic. Considering how restricted Renoir was physically, his work demonstrates an exuberant energy. As his son Jean later recalled of his painting process, rather than painting bit by bit, Renoir would cover the canvas in colour, and from the misty image: 'the motif gradually emerged from the seeming confusion, with each brushstroke, as though on a photographic plate.'

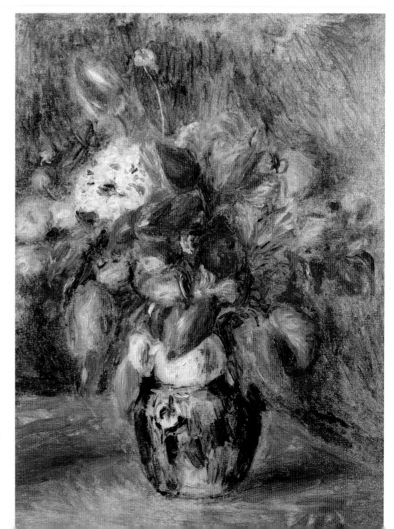

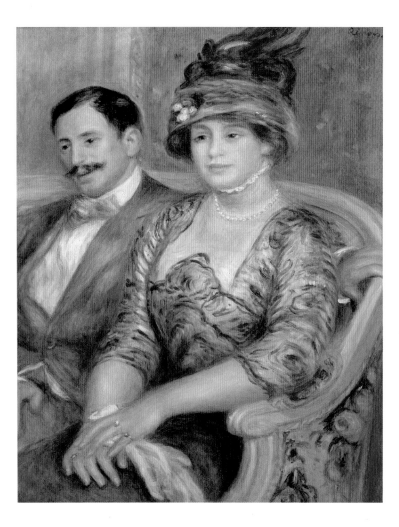

Monsieur and Madame Bernheim de Villers, 1910, oil on canvas, Musée d'Orsay, Paris, France, 81 x 66cm (32 x 26in)

Gaston Bernheim de Villers followed his father into his art dealership business. In this picture, he is 40 years old and sits with his wife Suzanne, née Adler, whom Renoir painted in the portrait *Madame Gaston Bernheim de Villers*. They are both handsome-looking members of the bourgeoisie, and they loved Renoir's work. They commissioned several other portraits, all of which Renoir painted in this soft, shimmering style.

Self-portrait, 1910, oil on canvas, Galerie Daniel Malingue, Paris, France, 47 x 39cm (18½ x 15¼in)

This is the last (of the few) self-portraits that Renoir painted. He was 69 years old. With thin washes of paint, he shows himself to be frail, but with no indication of self-pity. It is an unflattering work; his eyes are small and his beard is almost white, while the white hat he wears to protect his eyes shows how he had moved on from his youthful stylishness.

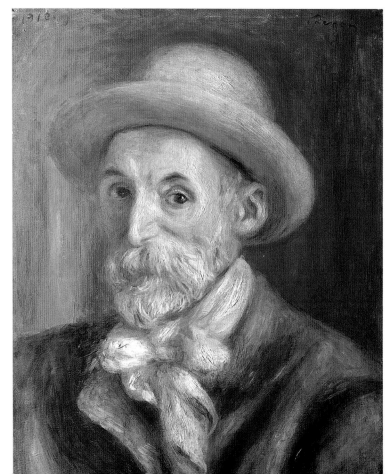

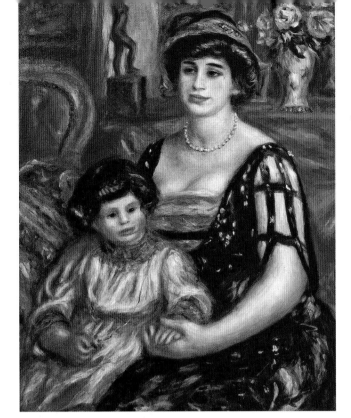

Madame Josse Bernheim-Jeune and her Son, 1911, oil on canvas, Musée d'Orsay, Paris, France, 93 x 73cm (37 x 29in)

In 1910, Gaston and Josse set up their own art-dealing business. Nine years earlier, they had married in a double wedding – two brothers to two sisters. Their wives, Mathilde and Suzanne belonged to the bourgeoisie, and were famed for their beauty and elegance. As Renoir's close friends, the brothers asked a Viennese doctor to treat his condition, and they commissioned several portraits of their wives and children.

Gabrielle with a Rose in her Hair, 1911, oil on canvas, Musée d'Orsay, Paris, France, 56 x 47cm (22 x 18in)

Several years after she had first moved into the household, Gabrielle became one of Renoir's favourite models. He disliked professional models, and Gabrielle had all the qualities he believed were crucial, including clear skin and a voluptuous figure. Here, in a three-quarter-angle portrait, Renoir has used the roses in her hair and hand as a means to highlight the bloom and freshness of her skin.

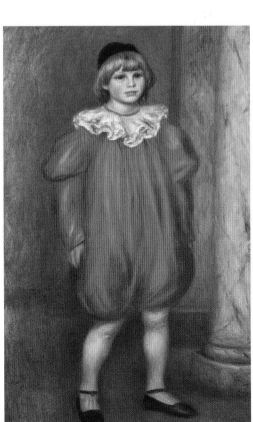

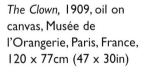

The Clown, 1909, oil on canvas, Musée de l'Orangerie, Paris, France, 120 x 77cm (47 x 30in)

According to Claude's recollections 40 years after this was painted, Renoir worked on this portrait over several sessions. Claude, known to his family as Coco, who had recently started school, had a new haircut and was reluctant to don the clown's costume. Renoir liked to work quickly over the entire composition, but this took several sessions as he tried to persuade his young son to put on the white stockings.

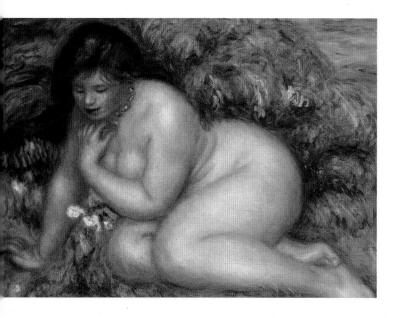

Psyche, c.1911,
oil on canvas,
The Barnes Foundation,
Philadelphia, PA, USA,
65 x 81.2cm (26 x 32in)

By the time Renoir was living in Cagnes, his methods of painting nudes had changed again from his earlier styles. The gradations of tone and nuances of colour to depict the skin had become subtler, with smaller strokes and a narrower range of colours. His models were plumper and more like the nudes of Rubens. Depictions of foliage on the other hand, had become more expressive and dynamic.

A *Cup of Chocolate*, c.1912,
oil on canvas, The Barnes Foundation, Philadelphia, PA, USA,
55 x 65cm (22 x 26in)

This is a topic that Renoir had painted with some success in 1878 when a painting of the same title, posed by Margot, was accepted for the Salon. This work, posed by Gabrielle, is a solid-looking work, again with a diagonal composition, and with a careful arrangement of colours in rich golds, silvers and white, with a flash of purple in the bouquet of violets.

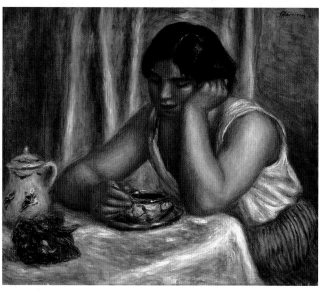

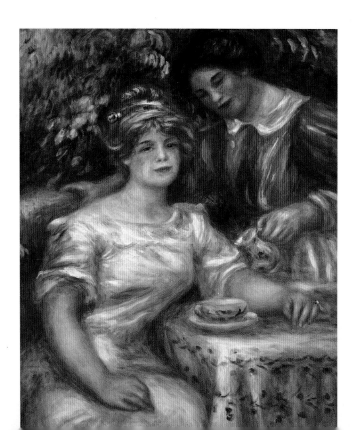

Tea Time, 1911, oil on canvas, The Barnes Foundation, Philadelphia, PA, USA,
92 x 74cm (36 x 29in)

With a brilliantly coloured, diagonally composed canvas, Renoir created a dramatic image out of an everyday theme: a woman in white taking tea in the garden, served by a brightly dressed maid. Chiefly painted in shades of green, red and ivory, this shows Renoir's continuing fascination with the artists he had studied in the Louvre as a young man and on his travels, particularly, Veronese, Tintoretto, Titian and Velázquez.

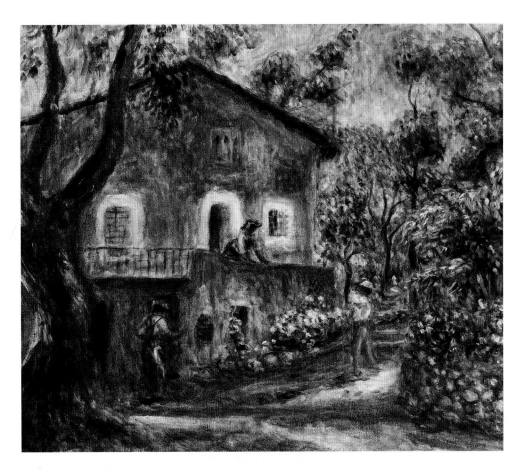

House in Cagnes, 1912,
oil on canvas,
Private Collection,
55 x 65cm (22 x 26in)

Between 1908 and 1914,
Renoir painted several
pictures of this little
farmhouse, bathed in the
golden light of southern
France. This became one of
his favourite motifs, and he
always finished the paintings
on site. Here he has created
interplays of light and shade
with directional brushstrokes
and a balance of warm and
cool tones. However, he
never painted the massive
stone house he built at
Les Collettes.

Conversation, 1912,
oil on canvas, National
Museum Wales, Cardiff, UK,
54.2 x 65.2cm (21 x 26 in)

Probably painted in the
garden of his house at
Essoyes, these softly
rendered, statuesque figures
are typical of Renoir's late
style. Reminiscent of
Venetian Renaissance
painting with the figures
depicted in warm colours in
a landscape, it is as if viewers
have chanced upon a private
conversation between two
people, but it can also be
seen as a generalized image
of warmth and wellbeing.

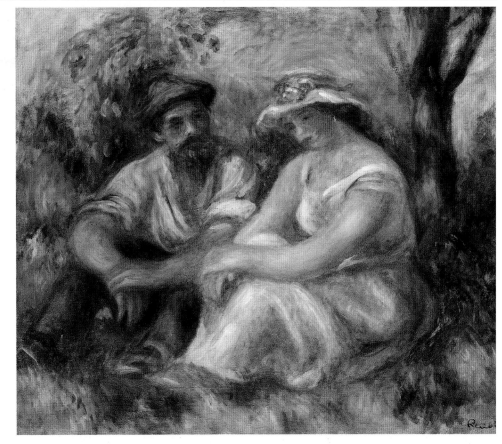

Dancing Girl with Tambourine,
1909, oil on canvas,
The National Gallery,
London, UK,
155 x 64.8cm (61 x 25in)

This painting is one of a pair,
produced as a decoration for
the dining room of a wealthy
patron's Paris apartment.
Renoir painted the two
works to hang on either
side of a mirror in the
dining room, and the models
were originally going to
hold dishes of fruit, but in
the end, he changed to a
livelier interpretation of the
figures, playing musical
instruments and dancing.

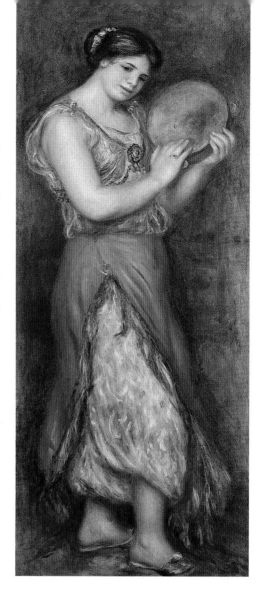

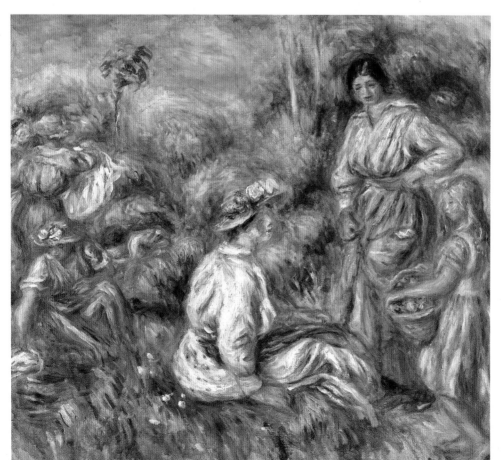

Women in a Landscape, 1912,
oil on canvas,
Private Collection,
51 x 55.5cm (20 x 22in)

Renoir had painted women
gathered together in rural
scenes several times before,
particularly washerwomen as
here, but by about 1912, he
returned to the theme with
more intensity. Here, the
figures are treated with soft
flowing rhythms; no single
figure is the principal focus,
and they seem to blend with
their surroundings even
more than in many of his
earlier works.

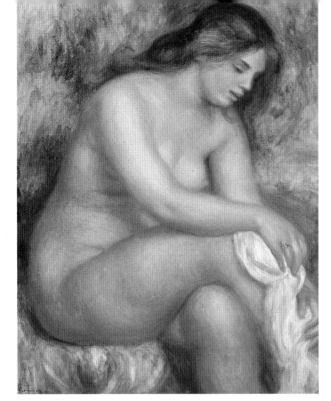

Bather Drying her Leg,
c.1910–3,
oil on canvas,
Museu de Arte,
São Paulo, Brazil,
84 x 65cm (33 x 26in)

Once again painting a nude as a monumental figure, almost filling the canvas, Renoir has blended the imagery of goddess-like figures with the mundane, as explored by his friend Degas. This young woman is in the act of drying herself after a bath. Although she looks like a classical goddess, she is in fact an ordinary woman, wearing a ring, and serenely dabbing her skin with a towel.

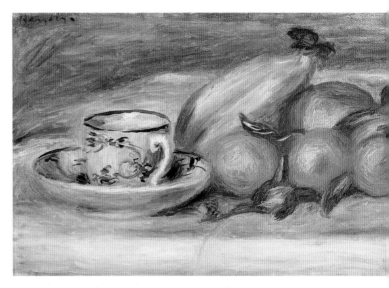

Fruit and Cup, 1913, oil on canvas, The Barnes Foundation, Philadelphia, PA, USA, 23 x 36cm (9 x 14in)

The glow of colours in this painting is vivid and expressive. The simple arrangement, as usual with Renoir's work, belies the thought that went into the placement of objects. Every element was intended to become part of an intricate network of shapes, making the picture appear as a powerful, unified whole, in a style similar to Chardin's still lifes of the 18th century.

Portrait of the Poet Alice Vallières-Merzbach, 1913, oil on canvas, Musée du Petit Palais, Geneva, Switzerland, 92 x 73cm (36 x 29in)

In 1913, Alice Merzbach had not yet started her career as a poet, but she commissioned Renoir to paint her portrait when she was in her early 30s. Initially, Renoir, who was unwell, was reluctant, but he eventually agreed, and became excited at the prospect of painting her white satin dress. After 17 sittings, he completed the work in the direct style of successful society portraitists of the day.

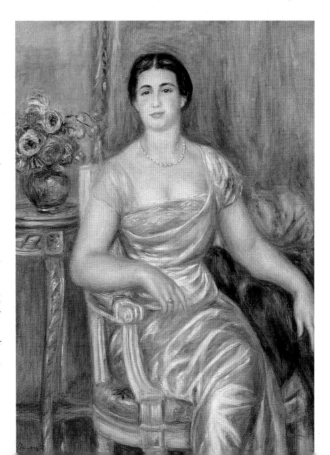

Still Life with Strawberries,
1914, oil on canvas,
Brooklyn Museum of Art,
New York, NY, USA,
24 x 44cm (9 x 17in)

Renoir always loved painting
luscious fruits, such as these
juicy vermilion strawberries,
which he could capture with
a few characteristic loose
brushstrokes, rich colours
and accents of light.

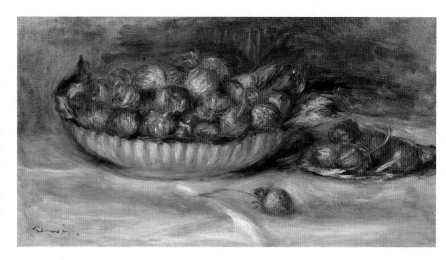

Dancer with a Veil, Renoir
and Guino, 1913, bronze
with green patina,
Private Collection,
height: 69cm (27in)

As Renoir became severely
crippled, under Vollard's
entreaties he began working
in sculpture, assisted by
Richard Guino. Together
they created many works

that were based on Renoir's
paintings. Although the
sculpture was produced
by Guino's hands, Renoir
gave detailed instructions
before and while he worked,
to make sure the piece
turned out exactly as he
wanted it. During this
time, nudes became his
chief subject in both painting
and sculpture.

Blonde with a Rose,
c.1915–7, oil on canvas,
Musée de l'Orangerie, Paris,
France,
64 x 54cm (25 x 21in)

During his later years, Renoir
often painted women in the
presence of roses – either as
apparel or in the background,
drawing comparisons with

women's bodies and flowers,
and the juxtaposition allowed
him to portray sumptuous
textures and colours.
This was Andrée Madeleine
Heuschling, known as Dedée
among her friends, although
she worked as an actress
under the name of Catherine
Hessling. She married
Jean Renoir in 1920.

Madame Renoir, 1916, polychrome mortar, Musée d'Orsay, Paris, France, 82 x 53 x 34cm (32 x 21 x 13in)

This bust of Aline was created after her death in 1915, intended for her grave at Essoyes. As Renoir's hands were almost completely paralyzed, Guino modelled this sculpture from a portrait that Renoir had painted of Aline 20 years earlier. The final version of this bust was cast in bronze, but this copy was made of mortar and painted while it was still damp, like a fresco.

The Farm at Les Collettes, 1915, oil on canvas, Musée Renoir, Cagnes-sur-Mer, France, 46 x 51cm (18 x 20in)

By 1915, Renoir had lived in his house on the estate of Les Collettes for seven years, but his dream of a serene old age was shattered when Aline died that year. Yet no sadness enters this scene, where light filters through trees that separate the house from the foreground. As Renoir's mobility became more limited, he adapted his methods and continued painting sunny scenes.

Portrait of a Model, Bust Length, 1916, oil on canvas, Musée National Picasso, Paris, France, 56 x 46cm (22 x 18in)

This was another of the seven Renoir paintings that Picasso owned and that he said inspired him. The model is unidentified and the background is vague, but the work shows Renoir's aims near the end of his life. He explained: 'I battle with my figures until they are simply one with the landscape that serves as their background and I want people to feel that they are not flat.

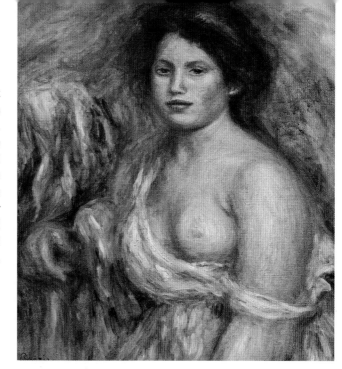

Woman with Hat, Reading, 1917–8, oil on canvas, The Barnes Foundation, Philadelphia, PA, USA, 41 x 50cm (16 x 20in)

In the 20th century, Renoir's interpretations of 18th-century painting styles became even more apparent, but these notions were often blended with other elements and ideas. Here, for example, the figure's daintiness, lightness and delicacy are tempered by the vigour of Venetian concepts, and Rubens' voluptuous imagery. Yet, however his style evolved, Renoir never tired of painting pretty young women occupied with feminine, passive pursuits.

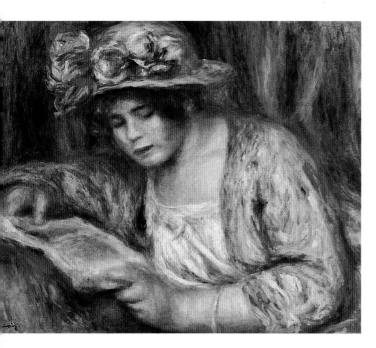

Two Bathers, 1918, oil on canvas, Staatsgalerie, Stuttgart, Germany, 41 x 38cm (16 x 15in)

Even though by this time, assistants mixed Renoir's paints and pushed brushes into his deformed hands, he continued to work every day, remaining determined to develop a powerful and solid style of art that would convey some of the monumentality of the Old Masters he had always revered. These supple, sensual figures are painted with soft marks and clear colours that recall the aspirations he had held throughout his life.

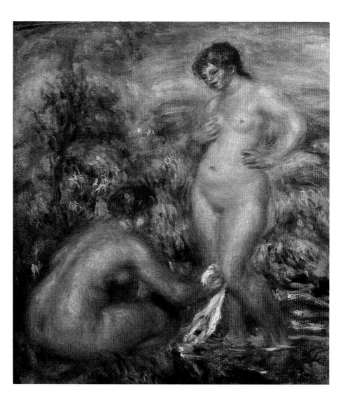

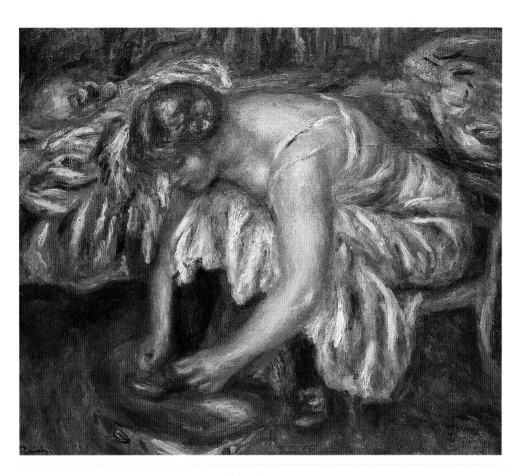

Woman Tying her Shoe,
*c.*1918, oil on canvas,
The Courtauld Institute,
London, UK,
51 x 56cm (20 x 22in)

As life around him was
changing, Renoir clung to his
ideals of women being
simple, beautiful and practical
creatures who supported,
but remained separate from,
worldly, sophisticated and
intellectual men. He evolved
a technique that emphasized
the decorative aspects of
femininity, painting no longer
with short marks, but with
ribbons and threads of paint
in swirls of rich colour.

The Bathers, 1918–19, oil on
canvas, Musée d'Orsay,
Paris, France,
110 x 160cm (43 x 63in)

Painted after the armistice at
the end of the World War I,
this is Renoir's last large-scale
painting. To facilitate
application, his paint was
thinned with turpentine.
Reclining in the olive tree-
filled garden of Les Collettes,
the elongated, full-figured
nudes recall Titian and
Rubens' figures in warm,
glowing colours. They are
Renoir's interpretation of
a timeless, idyllic vision
of a modern classicism
that influenced many
younger artists after him.

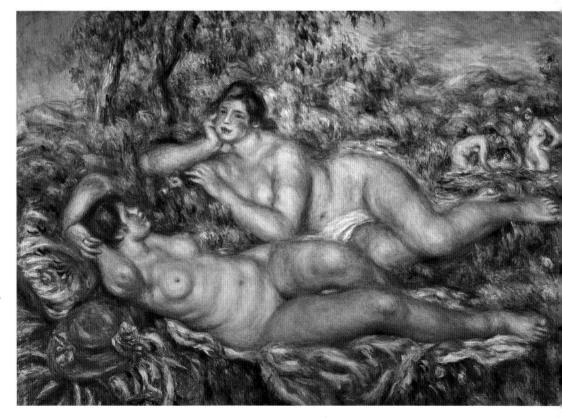

Dancing Girl with Castanets,
1909, oil on canvas,
The National Gallery,
London, UK,
155 x 64.8cm (61 x 25in)

This dynamic work was
painted to decorate the
Paris apartment of Maurice
Gangnat and was one of two
paintings of a similar theme.
Intended to hang opposite
to it was the companion
work, *Dancing Girl with
Tambourine*. Although the
model for the two paintings
was a young woman called
Georgette Pigeot, Renoir
painted Gabrielle's head on
this figure instead.

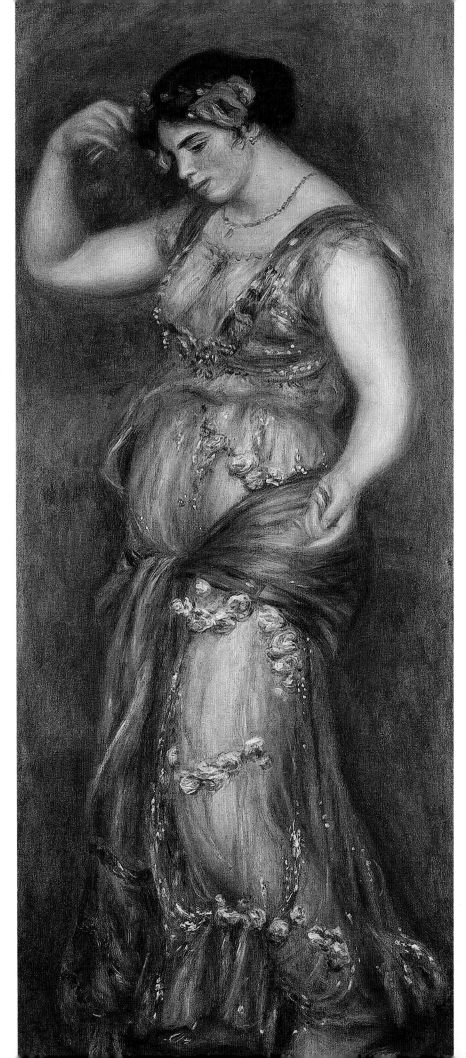

Reclining Odalisque, 1917-19,
oil on canvas,
The Barnes Foundation,
Philadelphia, PA, USA,
22.8 x 30.4cm (9 x 12in)

In open homage to
Delacroix, Renoir continued
painting exotic women
reclining as if in harems – a
tradition that was later
followed by Matisse. In this
late work, the paint has been
applied thinly, revealing the
canvas beneath in places.
The textures of the floral,
multicoloured drapery in the
background, on the cushion
and on the woman herself
appear apparent, even
though they have
been captured with just a
few judicious brushstrokes.

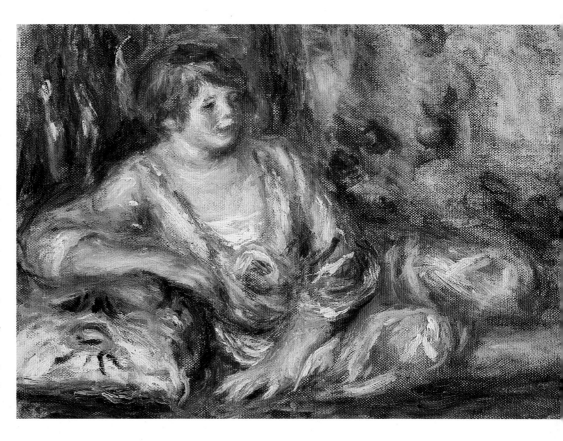

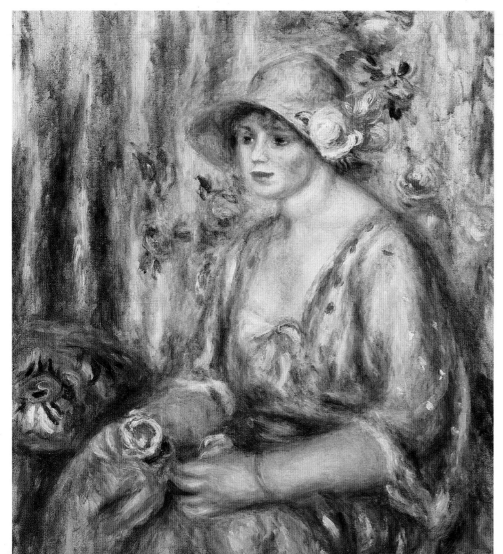

Woman in Muslin Dress,
*c.*1917–9, oil on canvas,
The Barnes Foundation,
Philadelphia, PA, USA,
64 x 59cm (25 x 23in)

Despite all his suffering,
Renoir continued to work,
and more than any other
subject, he painted women –
plumper, more voluptuous
and statuesque women than
ever before. Increasingly, as in
this work, his paintings were
created with loose drawing
and fluid and iridescent
colours. As his figures
became larger, his paint
effects became more
decorative. These late
figures were reinterpreted
by several younger artists,
particularly Matisse
and Picasso.

INDEX

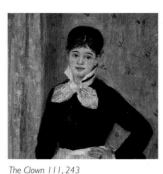

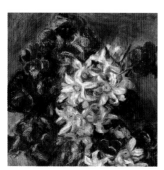

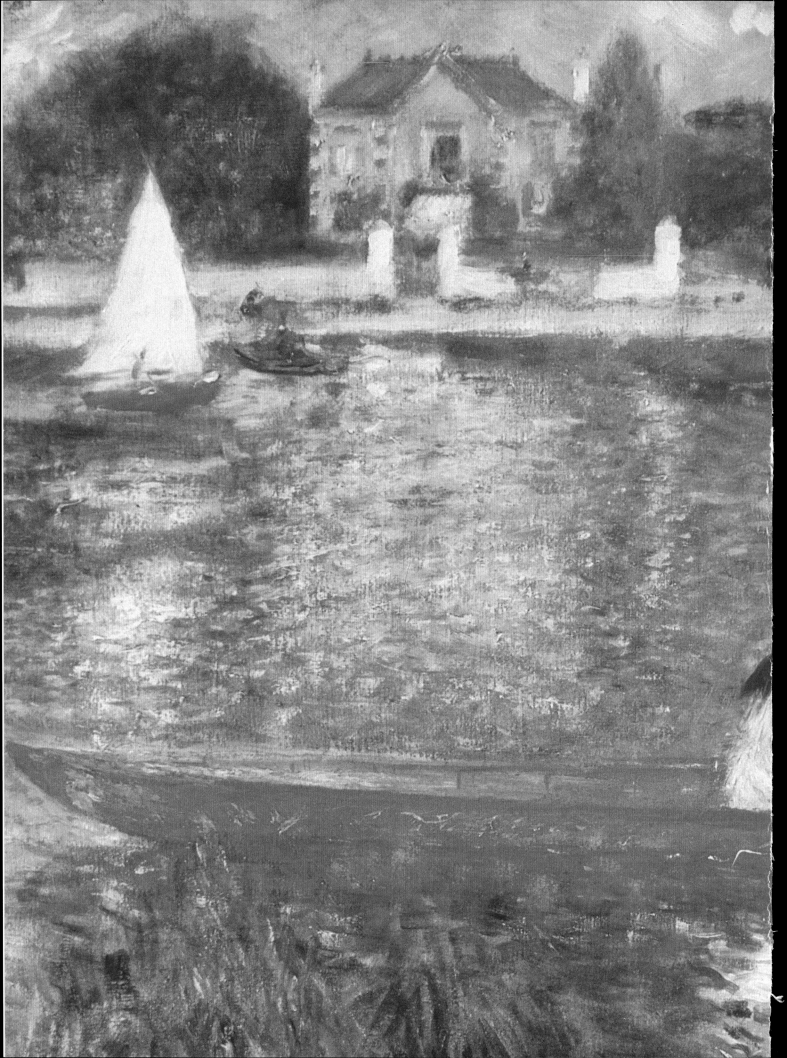